JAKOB
ROSENBERG

REMBRANDT

PHAIDON

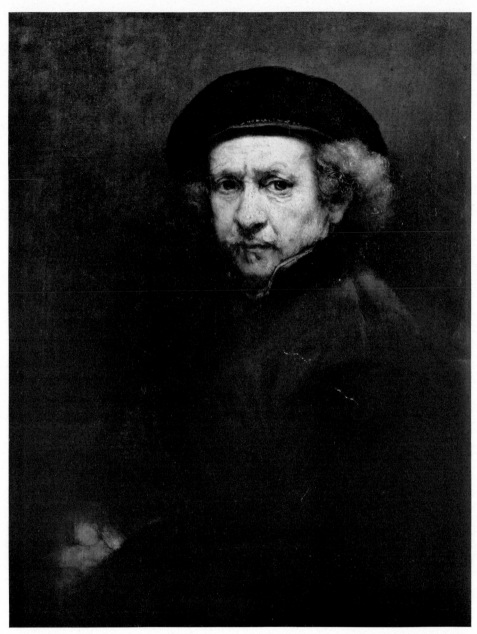

SELF-PORTRAIT. 1659. Washington, National Gallery of Art, Mellon Collection

REMBRANDT
LIFE & WORK

BY JAKOB ROSENBERG

REVISED EDITION · WITH 282 ILLUSTRATIONS

PHAIDON PUBLISHERS INC
DISTRIBUTED BY
NEW YORK GRAPHIC SOCIETY PUBLISHERS LTD
GREENWICH · CONNECTICUT

MADE IN GREAT BRITAIN 1964
PRINTED BY GEO. GIBBONS LTD · LEICESTER

TO MY WIFE

ELISABETH HUSSERL ROSENBERG

CONTENTS

PREFACE

FOR THE READER who is interested in the author's approach and his method of organizing the material, a few comments are offered here.

It seemed natural to begin with an account of Rembrandt's life, and to consider the relationship between his life and his art. The chapters which follow centre on the discussion of the artist's work, with divisions according to subject matter. Such an arrangement helps to focus the interest on the content, although it may tend to split the artist's course of development into several parallel currents. Rembrandt's production flowed in one broad stream, with many subjects—portraits, landscapes, Biblical scenes, and others—side by side, and with constant interrelationship. But each subject had its own inner coherence, and its own specific problems which need to be clarified before one can reach a more comprehensive judgement. If, for example, one considers three such important paintings of exactly the same period as the *Syndics*, the *Denial of St. Peter*, and the *Conspiracy of Julius Civilis*, without realizing the problems peculiar to each as a group portrait, a religious painting, and a historical picture respectively, one can hardly come to a full appreciation of Rembrandt's achievement in each of these masterworks. It is hoped that this division according to subject matter, as worked out here, will not break the coherence of the artist's development but will serve rather to build up gradually a comprehensive understanding of Rembrandt's art, with the analysis of the single works as its foundation.

The chapter on 'Rembrandt in His Century', can therefore dispense with detailed analysis and centre on the broad problems of Rembrandt's place within the Baroque period and the significance of his art for his contemporaries. Finally, there is a brief discussion of technique and style in Rembrandt's work. Technical and stylistic points are dealt with throughout the book but may also need summing up in a separate chapter. A concordance of the paintings, which follows the text, indicates the writer's position as to the problem of authenticity in every case.

The reader will observe an endeavour to take into full account both form and content in Rembrandt's art. If the viewpoint varies, at times, from a stylistic approach to a psychological, ideological, or sociological one, the writer hopes to avoid confusion by keeping in mind the specific value and also the limitations of each of these approaches. To follow one of them exclusively may seem safest from the scholarly standpoint, but often leads to a one-sided interpretation. In any attempt to strike the right balance it is important to remember that we are here concerned with works of art and with the world of an artist, and that therefore, in addition to all that scholarship can provide, we must rely upon the less tangible faculty of artistic perception. How much of this faculty an art historian has at his

disposal, he can hardly judge for himself, but he has to face the fact that in his field scholarship, indispensable as it is, does not guarantee an adequate interpretation.

All of the viewpoints mentioned above are embraced by the historical approach. In taking the historian's attitude, therefore, our first questions are: what did Rembrandt himself intend to express in his work, and how did he respond to the conditions and challenges of his own period? Rembrandt's relation to us and to our time is something that comes into our interpretation whether we wish it or not. This relationship is likely to be subjective and should be controlled by an objective historical approach in order to bring us as close as possible to the original meaning of the artist's work. Besides, it may be difficult to define precisely the present-day attitude toward Rembrandt. While his reputation as one of the greatest masters of all time has remained unbroken for about a century, the reactions of today will widely differ. Some people will say that Rembrandt's art, with all its pictorial power and originality, is too much out of key with our age of science and mechanization, of intellectual adventure and spiritual homelessness, to have any deep effect. Others will not be so sceptical. They will feel that the great Dutch master can still impart to us the same message he brought to his contemporaries through the medium of his art: that the human soul lives on, even under the thick crust of a materialistic civilization, ever striving to reach its true destination.

Since the preliminary studies for this book extend over a period of more than twenty years, the author can no longer acknowledge every kindness he has been so fortunate as to receive from the staff members of the galleries and print rooms in Europe and the United States, and from private owners of works by Rembrandt. He remembers with particular gratitude his visits to the Rijksmuseum in Amsterdam and the Hermitage in Leningrad, the world's most outstanding Rembrandt collections.

The writer feels deeply indebted to Miss Ruth S. Magurn for her loyal, conscientious, and intelligent help in the revision of the text; she not only polished the language but also contributed to the clarification of the content with many a valuable suggestion. He expresses his due appreciation to Harvard University for the aid received from the Clark Bequest in 1945. Finally, he wishes to express his gratitude to his colleagues and friends at the Fogg Museum, in particular to Edward W. Forbes, Paul J. Sachs, and Arthur Pope, for the many kindnesses they have shown him in the pursuit of his research.

J.R.

Fogg Museum of Art
Harvard University
April 1948

PREFACE TO THE SECOND EDITION

FIFTEEN years have passed since the first edition of this book appeared, and I am grateful for the friendly reception which it has been accorded by scholars and laymen alike. After such a span of time, it is only natural that some revision is needed, but I do not feel that I have to change the basic concepts. Research on Rembrandt has been active in various ways: further documents have been unearthed about the artist's family; more technical investigation has been forthcoming and—by X-ray in particular—has brought some insight into the genesis of important pictures; the contested beginnings of the artist have been further clarified by a few discoveries, and much research has concentrated on the reinterpretation of Rembrandt's most famous masterworks such as the *Anatomy Lesson of Dr. Tulp*, the *Night Watch*, the *Syndics*, and the *Conspiracy of Julius Civilis*. Finally, Otto Benesch's monumental catalogue has widened our knowledge of the master's drawings. To all this new literature consideration has been given in the revision of the book, largely by additional footnotes. Only a few changes were needed in the listings which indicate the author's opinion on the authenticity of the individual paintings. Altogether I have kept the alteration of the text to the necessary minimum, bearing in mind that, while the reader ought to be informed about the important new literature, the original character of the book should not be changed by extensive discussions.

I am very grateful to the Phaidon Press for its decision to undertake a new edition, and to the Harvard University Press for having released all rights for this purpose. The expert care which the Phaidon Press has given to this volume is nothing new to the art world—and I am pleased that the book will now be made available to a still larger public. As in the first edition I am much indebted to Miss Ruth S. Magurn for her kind and efficient help in the revision of the additional text. To my colleague Professor Seymour Slive I owe gratitude for his active support and advice in this whole matter of re-editing. I have profited greatly from his rich knowledge in the Rembrandt field.

J.R.

Cambridge, Massachusetts
March 1964

ABBREVIATIONS
USED IN THE TEXT AND NOTES

Ben. Benesch, *The Drawings of Rembrandt.*

Br. Bredius, *The Paintings of Rembrandt.*

H. Hind, *Catalogue of Rembrandt's Etchings.*

HdG. Hofstede de Groot, *Die Handzeichnungen Rembrandts.*

Urk. *Die Urkunden über Rembrandt,* compiled by Hofstede de Groot.

Val. Valentiner, *Die Handzeichnungen Rembrandts.*

Further details appear in the Bibliography on pages 367–369.

Dimensions of works illustrated are given in centimetres.

REMBRANDT

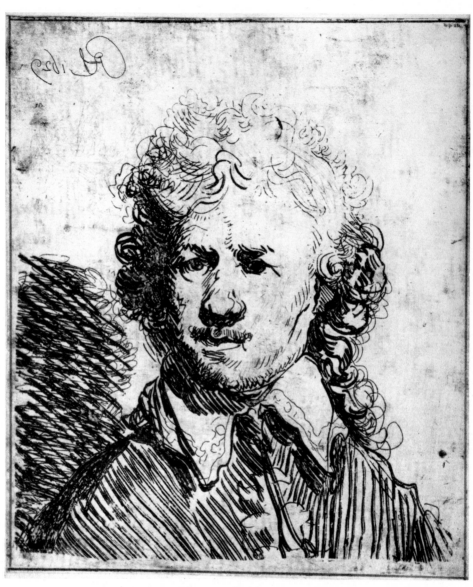

1. SELF-PORTRAIT. 1629. Etching (H.4). (17·8 × 15·4)

REMBRANDT'S LIFE

EMBRANDT'S life, with its dramatic sequence of success and disaster, offers abundant material to the novelist. The biographer who is inclined to a romantic interpretation will exploit the contrast between worldly exuberance and spiritual introspection which Rembrandt's work reveals, and will not pass over the painter's relations with Saskia and Hendrickje without far-reaching conclusions as to his emotional life and the happiness and tragedy in his intimate family circle.

The writer who endeavours to avoid an arbitrary interpretation of Rembrandt's life must rely upon documentary evidence. He must consider the contemporary culture in the artist's time, as known to us from authentic literary and pictorial sources. Rembrandt's own work, moreover, is a source of no small importance in providing information about the man's life and character, although here the utmost caution is needed in drawing conclusions. The relationship between art and life is not easily perceived in the case of Rembrandt. In his work the borderline between the realistic and the imaginary cannot be sharply drawn; both aspects contribute to our knowledge of the artist, and we shall try to exploit both with this end in view. The reader, however, will not find in this chapter all he wishes to learn about a great man's life. The documentary evidence is, after all, scarce, and some important points will come out more strikingly later, in the chapters dealing directly with Rembrandt's work.

Rembrandt Harmensz van Rijn was born in Leyden on July 15, 1606, the son of Harmen Gerritsz van Rijn and Cornelia Willemsdochter van Zuytbrouck. The year of birth is significant for everyone. Even for the greatest individuals the direction and the range of their activity are largely conditioned by the historical circumstances attending their birth. Rembrandt's generation grew up under comparatively peaceful conditions. During his boyhood Holland began to emerge as a world power under the able leadership of Prince Maurice of Orange. The Twelve-Year Truce with Spain, contracted in 1609, marked the virtual end of the long and heroic struggle for independence on the part of the young Dutch nation. A flourishing trade and expanding colonial possessions, protected by an unrivalled sea power, gave Holland in this period an air of confidence and vitality and also contributed to its rapid cultural growth.

We may best understand the character of Rembrandt's generation if we realize its intermediary position between that of Frans Hals (born c. 1580) and that of Jan Vermeer (born 1632). Frans Hals's compatriots, as he represented them, are filled

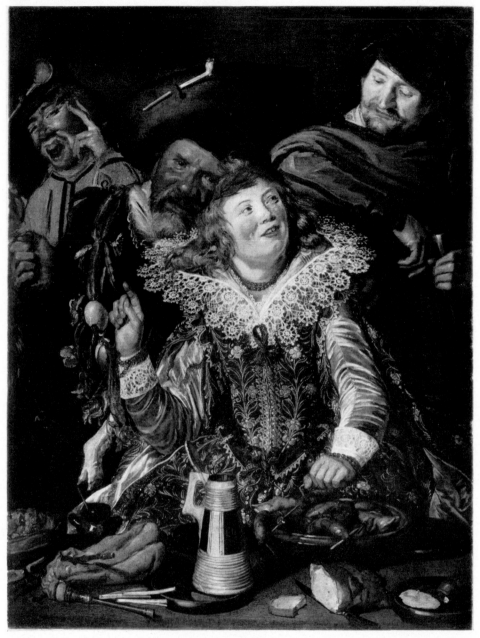

2. Frans Hals: THE MERRY COMPANY. New York, Metropolitan Museum. Oil on canvas (131 × 99)

with vigour, optimism, and self-assurance (fig. 2). They laugh and talk, eat and drink, display their gay costumes; there is little concern for the more subtle spiritual aspects of life. In contrast, Vermeer's subjects reflect the advanced phase of seventeenth-century culture in Holland, when the buoyant vitality of the Frans

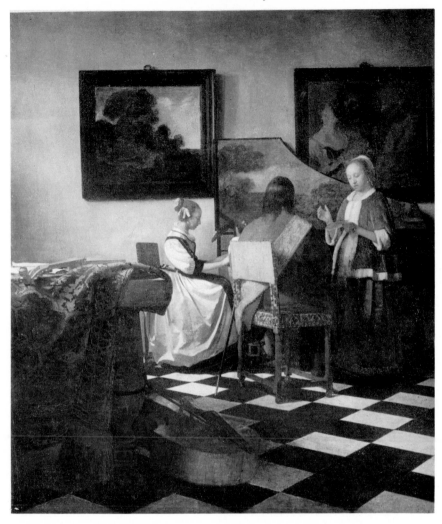

3. Jan Vermeer: THE CONCERT. Boston, Isabella Stewart Gardner Museum. Oil on canvas (69 × 63)

Hals generation was replaced by a quiet refinement (fig. 3). By the middle of the century the Dutch burghers had become accustomed to peace and national security. They were able to retire to domestic activities, to enjoy the pleasures of music and painting, and their social life assumed a more intimate character. The dramatic events on the troubled political stage of Europe seemed no longer to interfere with their private pursuits, and there finally developed a slightly effeminate atmosphere which prepared the way for Holland's decline as a world power. Although Louis XIV's invasion of Holland in 1672 was checked by William III, most capable descendant of the great William of Orange, the glorious role of the Dutch nation was over by the end of the century.

4. REMBRANDT'S MOTHER (copy?). The Hague, Mauritshuis.
Oil on panel (17 × 13)

Rembrandt's generation flourished between the two phases briefly described above. In their youth Rembrandt and his contemporaries were still animated by the enthusiasm of the Frans Hals period. But their mature years coincided with the advanced stage of Holland's cultural history which allowed the individual to devote himself to his personal life, with freedom and seclusion to concentrate on problems of his own choice.[1] The fact that Rembrandt turned this advantage to the development of a highly subjective and spiritual tendency in his art distinguishes him from all his Dutch contemporaries. Nevertheless, the opportunity was provided by the circumstances of his time; it would be hard to imagine Rembrandt's personality and his achievement transplanted into any other phase of Holland's history.

Rembrandt's father was a miller, his mother the daughter of a baker (figs. 4, 5).[1a] The parents lived close to the 'Rijnmill' and the family name 'van Rijn' was

5. REMBRANDT'S FATHER. The Hague, Mauritshuis. Oil on panel (47 × 39)

derived from this malt mill. At the mother's death in 1640—the father had died in 1630—an inventory was taken of her estate. She owned half of the mill and some houses. The total value amounted to nearly 10,000 guilders and was to be divided among her heirs. Rembrandt was the eighth of nine children, but at the mother's death only four were still living: Adriaen, a shoemaker, Willem, a baker, Rembrandt, and his sister Lysbeth. Thus it is clear that the artist came from the lower middle class, like most Dutch painters. The youthful self-portraits of Rembrandt

6. SELF-PORTRAIT. London, British Museum. Drawing (12·7 × 9·5)

reveal this primitive stock in his rather vulgar face, with its large nose and ill-proportioned features (fig. 6). But from his humble origin he may have gained that inexhaustible vitality which remained characteristic of his art throughout his life. In the democratic Holland of the early seventeenth century the lower middle class was by no means looked down upon. On the contrary, Dutch culture in its prime drew its main force from the ranks of the small burghers. A sharper division between the patricians and the lower middle class developed only later in the century, when French culture impregnated the higher strata of Dutch society with its aristocratic ideals. Therefore the decision of Rembrandt's parents to prepare their gifted son for a learned profession does not indicate any extravagant ambition on their part. They simply wished to take advantage of the opportunities offered to the more promising members of their class.

Rembrandt entered the Latin School in Leyden at the age of about seven, and

seven years later, on May 20, 1620, he was enrolled at the University.[2] But his stay at this distinguished centre of humanistic studies was of very short duration. After a few months Rembrandt's parents realized that the boy's inclination for the painter's profession was too strong to be discouraged. And so, in 1621, at the age of about fifteen, he was allowed to enter the workshop of Jacob Isaacsz van Swanenburgh, a minor architectural painter who also did scenes of hell, for a three-year apprenticeship.

One wonders how much of his training at the Latin School and University was retained in Rembrandt's mind, and whether early impressions from these years bore any fruit in his later activity. The intellectual instruction of that time was dry and didactic. As the name *Lateinsche School* implies, the students received thorough courses in Latin, along with the indispensable religious teaching. Other subjects were only slightly touched upon. The educational aim was not so much the stimulation of thought as the presentation of a standard body of 'humanistic' knowledge, with an exaggerated emphasis upon the mastery of purely rhetorical phrases. The repeated occurrence in Rembrandt's early work of subjects drawn from Ovid's *Metamorphoses*, and their close adherence to the text, could lead to the assumption that the young artist gained a familiarity with this classic poet during his intensive training at the Latin School. But it is doubtful whether the type of intellectual foundation provided by the humanistic education of those days appealed to the youthful Rembrandt. Throughout his life he showed an indifference to the rather stilted products of humanistic culture, particularly its allegories and artificial intellectual exercises. The widespread 'emblematic' literature,[3] so typical of seventeenth-century humanism, could hardly have interested Rembrandt. Its approach was entirely devoid of the directness of feeling which was to him the essential basis of experience. Rembrandt's inclination toward the classics as a literary source was never, in fact, a strong one. His interest in the Bible, on the other hand, steadily increased in intensity. This interest and his thorough familiarity with Biblical sources might also be traced to the artist's school years. It is probable, however, that the atmosphere at home played an even greater role in the formation of his personality and religious outlook.

We may assume that Rembrandt's parents were simple and pious people with firmly rooted religious convictions, for these were features which characterized their class. When young Rembrandt painted his mother devoutly praying, or as an old prophetess reading the Bible (fig. 7), we feel that religion was a primary concern in the woman's life, and that the Scriptures were her never-failing solace. No doubt the son acquired from his mother a deep reverence for the Book of Books, and this became the foundation for his later spiritual development.

There was a conservative vein in the young Rembrandt which made him remain close to his own soil and intimate surroundings. Most of the artists of his day were

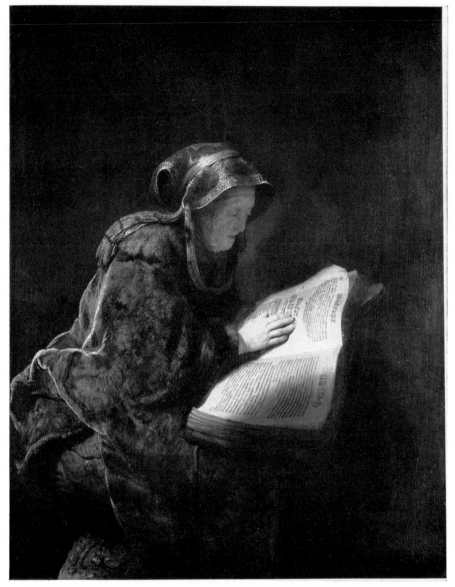

7. REMBRANDT'S MOTHER AS THE PROPHETESS HANNAH. 1631. Amsterdam, Rijksmuseum.
Oil on panel (60 × 48)

eager to go to Italy, where they hoped to find the highest standards of taste in the
great classical tradition. This had been the case with Rubens and Van Dyck, with
Rembrandt's most influential teacher, Pieter Lastman, and with many others. The
highly cultivated Hollander, Constantyn Huygens, when he visited Rembrandt and
his fellow artist Jan Lievens at Leyden, spoke with considerable appreciation of the
talents of these two young painters, but criticized their unwillingness to go to Italy

for the improvement of their standards.[4] In the case of Rembrandt the vein which we have called conservative was linked with another, rather revolutionary one. This latter tendency sprang from the extraordinary depth and directness of his human reactions and led him to discover a rich field for psychological and pictorial study in his immediate surroundings. He realized that models were to be found on every side, especially at home among the members of his own family. Rembrandt was never inclined to separate the human point of view from the pictorial one, and we shall fail to understand his personality unless we grasp this important feature at the outset.

After leaving the University of Leyden, as mentioned above, Rembrandt spent three years in the workshop of Jacob Isaacsz van Swanenburgh. But no traces of this first teacher's influence appear in Rembrandt's work.[5] His apprenticeship with this painter seems to have provided him with no more than an elementary technical training. Far more important for Rembrandt's artistic future were the following six months spent with Pieter Lastman in Amsterdam, in 1624–5. In Lastman young Rembrandt met a personality of considerable vigour, and he received impressions of enduring influence. Although Rembrandt soon surpassed his teacher, and transformed the Lastman formula by a deeper understanding of the religious content, it was Lastman's example which first kindled his ambition to compose great historical and Biblical paintings (fig. 8).

The teacher–pupil relationship between Lastman and Rembrandt may be compared to that between Verrocchio and Leonardo, or Wolgemut and Dürer. In each case the teacher was the more robust personality and the pupil an extraordinary genius. But it was the masters' firm instruction which provided these sensitive disciples with a solid foundation before they soared to lofty heights. Pieter Lastman had received his own earliest training from a pupil of Cornelis Cornelisz van Haarlem, one of the leading Mannerists in Holland. His formative years were spent in Rome, where he met Elsheimer about 1603. He may also have come into contact with Caravaggio. His art therefore presents a curious combination of Italianate and Dutch characteristics. After his return to Holland in about 1605, Lastman developed a new type of historical painting, with subjects drawn mainly from the Bible, but also from classical mythology. These works impressed his countrymen by their realistic narrative quality and vivid dramatic animation. Lastman often heightened the illusion of historical accuracy by an abundance of archaeological detail. He had no rival in Holland. No other painter could represent mass scenes with the same drastic realism and surface brilliance, with so much inventiveness and variety of action.

In looking back from Rembrandt's art to that of Lastman, it is easy to see the teacher's limitations. Yet the youthful Rembrandt was deeply impressed by the performance of the older artist, and Lastman's vigorous configurations are

8. Pieter Lastman: THE RAISING OF LAZARUS. 1622. The Hague, Mauritshuis. Oil on panel (63 × 92)

9. THE CLEMENCY OF EMPEROR TITUS. 16(2)6. Leyden, Stedelijk Museum. Oil on panel (91 × 121)

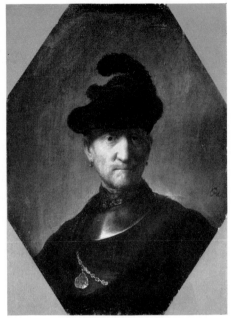

10. REMBRANDT'S SISTER. 1632. Boston, Richard C. Paine Collection. Oil on panel (59 × 44)
11. REMBRANDT'S FATHER. Leningrad, Hermitage. Oil on panel (36 × 27)

reflected for some time in Rembrandt's work. In the *Clemency of Emperor Titus*,[6] of 16[2]6 in Leyden (fig. 9), we find the pupil closely following his master's manner. There is Lastman's crowded arrangement, there are his theatrical gestures, his glossy surfaces and colours. Rembrandt even tried to outdo his teacher in all these respects. He failed to approach Lastman in clarity of grouping, but the more subtle gradation of tones and the intensity of expression give some indication of Rembrandt's growing superiority. Other influences can be seen in Rembrandt's earliest works after he left his teacher, prominent among them being the influence of the Utrecht School, of Gerard Honthorst in particular (the *Feast of Esther*, Br. 631, in Raleigh, North Carolina), and also of the young Jan Lievens, likewise a Lastman pupil, with whom Rembrandt collaborated frequently. Thus the very young artist showed himself susceptible to a wide range of artistic impressions.[7]

The early period of activity in Leyden, from 1625 to 1631, has provided little documentary evidence about Rembrandt's life. But from his extensive production we gain definite impressions as to his surroundings, his experiences, and his interests.

The numerous portraits of members of Rembrandt's family are primarily physiognomical studies and exercises in pictorial arrangement (figs. 10, 11). The models are often dressed in Oriental or pseudo-Oriental attire, such as turbans, rich embroidery, or exotic armour, thus reflecting the artist's indebtedness to the

romanticism of Lastman. It was Lastman's example also which stirred Rembrandt's ambition to master a variety of facial expressions, as a necessary feature of every dramatic representation. Many of Rembrandt's early etched self-portraits had no other purpose than to depict a wide range of emotional expressions, from joy and surprise to horror and pain.

While the majority of the early portrait studies are drawn from the inner circle of the Rembrandt family, the young artist's representations of genre subjects, as well as Biblical and mythological scenes, reflect something of the intellectual and artistic atmosphere of Leyden (figs. 12, 13). The paintings are now on a smaller scale, the tonality subdued, with cool and subtly graded colours and delicate execution. The minute figures are set into spacious landscapes or interiors. These are features which Rembrandt derived from Elsheimer rather than from Lastman. And this new preference for the intimate and the refined may be attributed to the scholarly taste of this university town. It is definitely felt in the numerous representations of single figures of old prophets, saints, or philosophers, absorbed in deep meditation and dimly seen in the mysterious gloom of half-lighted interiors (fig. 14). But whatever the outside influences, let us not forget that Rembrandt was now entering his

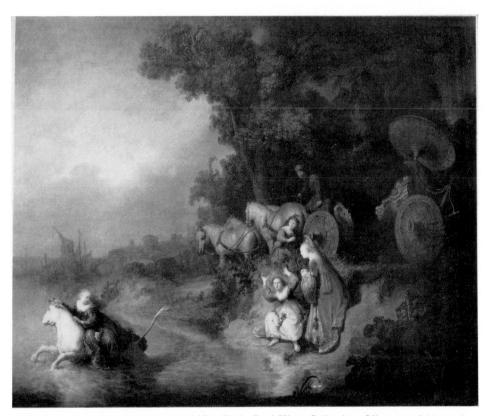

12. THE RAPE OF EUROPA. 1632. New York, Paul Klotz Collection. Oil on panel (60 × 77)

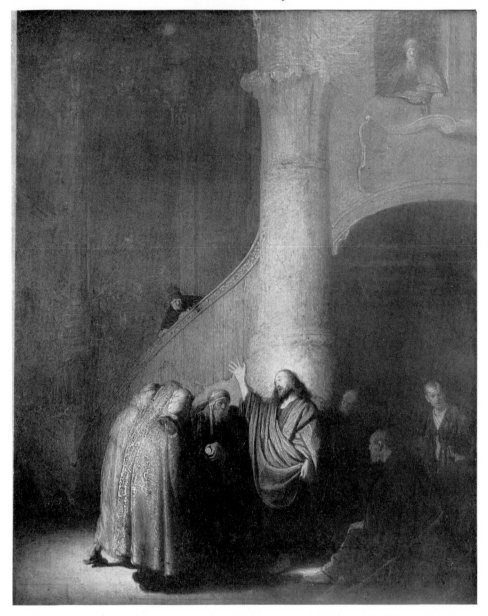

13. THE TRIBUTE MONEY. 1629. London, Lady Beit. Oil on panel (41 × 33)

twenties, and beginning to unfold his own personality. This he did with a sureness of instinct that was a part of his rare nature.

The Leyden period, upon closer study, already reveals the complete Rembrandt, although on a most intimate scale. The youthful genius has marked out his range and found those subjects and moods which correspond best to his inner disposition.

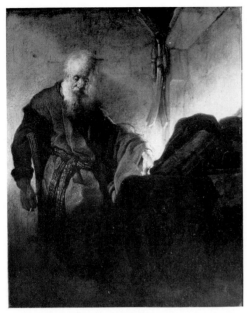

14. THE APOSTLE PAUL. Nuremberg, Museum.
Oil on panel (47 × 37)

15. STUDY OF AN OLD MAN. Berlin,
Print Room. Drawing (22·6 × 15·7)

In addition to his skill as a storyteller, his predilection for the contemplative side of life comes out fully in this early period, and his deep reverence for the dignity of old age (fig. 15). This choice of old people as models is unusual in a young artist, but even more remarkable in Rembrandt's case is his profound understanding of his subjects. He approached them not with mere curiosity, but with a feeling for the richness of inner experience which lends character to their worn faces. It may be that this fondness for old age was implanted during Rembrandt's childhood by his Bible-reading elders, and resulted from the deep impression made upon his imagination by the venerable patriarchs of the Old Testament. But such early influences cannot fully explain Rembrandt's lifelong affinity for the spiritual and emotional qualities of age. This feeling must have arisen, in the first place, from an inner predisposition.

It appears that young Rembrandt's contemporaries were not unaware of the unusual calibre of his art while he was still in Leyden. Constantyn Huygens, as already mentioned, found words of genuine admiration for both Rembrandt and his fellow painter Jan Lievens. Huygens observed that Rembrandt surpassed Lievens in judgement (*judicio*) and in vivacity of emotional expression (*affectuum vivacitate*), but that Lievens was superior in a certain grandeur of invention and of bold subjects and forms (*inventionis et quadam audacium argumentorum formarumque superbia*). Lievens,[8] who had come from a two-year apprenticeship with Pieter

16. Jan Lievens: SAMSON AND DELILAH. Amsterdam, Rijksmuseum. Oil on canvas (131 × 111)

Lastman, collaborated frequently with Rembrandt during this period, and a mutual influence is apparent in their work (figs. 16, 17).

The success which Rembrandt found in Leyden is confirmed by the fact that he already had pupils of some distinction, among them Gerard Dou. After Rembrandt's departure for Amsterdam in 1631, Dou carried on the refined and delicate manner of painting which he had learned from Rembrandt, and developed a type of small-scale genre picture which became very popular. The pupil had little understanding of the deeper implications of his master's art. In his work the chiaroscuro lost all its mystery, the pictorial touch lost its freedom. But Dou's art found great favour in Leyden, where there was a fondness for minute and delicate treatment rather than for the more sumptuous style prevailing in Amsterdam.

Rembrandt's move to the Dutch capital was obviously induced by the greater

17. SAMSON AND DELILAH. 1628. Berlin-Dahlem, Staatliche Museen. Oil on panel (59·5 × 49·5)

advantages which this wealthy city offered to artists, particularly to gifted por-
traitists. The patronage in a small university town like Leyden was limited, and
Rembrandt sought wider opportunities. Amsterdam was at this time one of the most
flourishing trade centres of the world, and its colourful, cosmopolitan atmosphere
must have attracted the young painter. A document[9] of June 20, 1631, proves that
Rembrandt had already formed a business connexion with the Amsterdam art
dealer and painter, Hendrik van Uylenburgh. It was shortly after this date that he

18. SASKIA. 1633. Dresden, Museum. Oil on panel (52·5 × 44·5)

moved to the capital and took up residence in van Uylenburgh's house in the
Breestraat. Rembrandt's reputation as a portrait painter was very soon established
by his first large-scale group portrait, the *Anatomy Lesson of Dr. Tulp* (fig. 120), now
in the Mauritshuis in The Hague. In this work the twenty-six-year-old artist sur-
passed all the painters of Amsterdam in forceful illusionism and dramatic vividness
of representation, the very qualities by which his teacher, Pieter Lastman, had

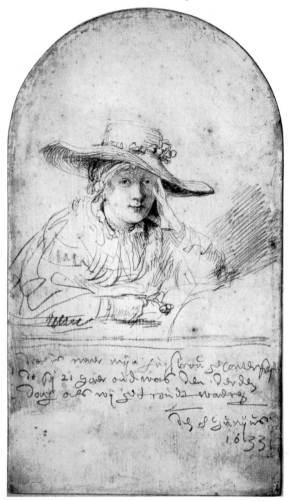

19. SASKIA. 1633. Berlin, Print Room. Drawing (18·5 × 10·7)

previously captured the favour of the Amsterdam public. From 1632 on, Rembrandt's fame increased steadily, reaching its climax at the end of the decade.[10]

Simultaneously with his professional success, Rembrandt enjoyed a rapid rise in his social position through his marriage to Saskia van Uylenburgh, cousin of Rembrandt's landlord and daughter of the late burgomaster of Leeuwarden (figs. 18, 19). Saskia brought with her a substantial fortune and, as a member of a patrician family, she was able to help Rembrandt in extending his contacts in Amsterdam's wealthy circles.

This first period in Amsterdam, which lasted until Saskia's death in 1642, was marked by prosperity in every respect. Rembrandt's pictures were greatly in demand, and he was able to ask the highest prices from his patrons. His house was

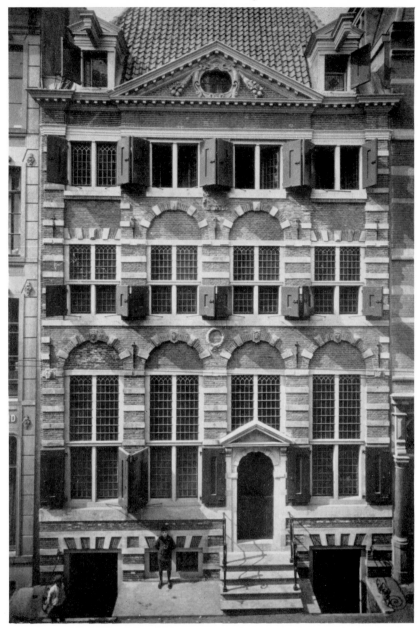

20. Rembrandt's House in Amsterdam

filled with pupils who had to pay dearly for the privilege of his instruction. Rembrandt was not the man to enjoy his new wealth soberly, and to build up a lasting fortune. He indulged all his extravagant tastes, and plunged impulsively into the collecting of objects of art and curiosities. Baldinucci describes Rembrandt's activity as a collector, and his extravagance as follows: 'He often went to public

sales by auction; and here he acquired clothes that were old-fashioned and disused as long as they struck him as bizarre and picturesque, and those, even though at times they were downright dirty, he hung on the walls of his studio among the beautiful curiosities which he also took pleasure in possessing, such as every kind of old and modern arms—arrows, halberds, daggers, sabres, knives and so on—and innumerable quantities of drawings, engravings and medals and every other thing which he thought a painter might ever need.' Baldinucci goes on to describe Rembrandt's rather provocative conduct at such public auctions, where he 'bid so high at the outset that no one else came forward to bid; and he said that he did this in order to emphasize the prestige of his profession.'[11]

Rembrandt's possessions accumulated rapidly during these years, and in 1639 he purchased a large house[12] in the Joden-Breestraat (fig. 20). This was an undertaking which strained his resources and contributed to his financial collapse. It may have been the mercantile atmosphere of Amsterdam which exerted a strong effect upon Rembrandt, or the pompous and exuberant taste of the Baroque, with some influence coming from Rubens. At any rate, Rembrandt appears to have been more of an extrovert at this period, more ambitious and materially minded, than at any other phase of his career.[13] He idolized his wife and represented her in a long series of portraits and allegories, not always in good taste (fig. 21). In the numerous Biblical and historical scenes of the thirties she appears as the ideal of womanhood as Rembrandt understood it. The conclusion has been drawn that Saskia's influence upon her husband was not a steadying one, that she encouraged this life of prodigality and ostentation, and that Rembrandt's lowly origin led him to overrate the qualities of finer breeding in her.

Too much emphasis should not be laid upon these external influences; Rembrandt's attitude may rather be explained by the strong contrasts in his own disposition. His human and artistic development cannot be fully understood without considering the exuberance of his first decade in Amsterdam. This period played an essential part in the dynamic unfolding of his nature, which swung to extremes before finding its ultimate balance. The power of his senses, the violence of his temperament, which burst forth so freely in this prosperous period (fig. 22), bore a clear relationship to the humility and spirituality of Rembrandt's maturity. Had the contrast been less, the inner crisis of his middle years would hardly have produced such profundity of feeling. Seen as a whole, the sensuous and the spiritual Rembrandt are two component parts of one vital personality. Each conditioned the other in strength and significance. Only a superficial judgement can separate the early from the late Rembrandt, or see a fundamental break in his development.

With the early 1640's began the series of tragic events which had some bearing upon the inner change in Rembrandt's human and artistic outlook. His mother died in 1640. In 1642 he lost his wife, Saskia, after a year of failing health following the

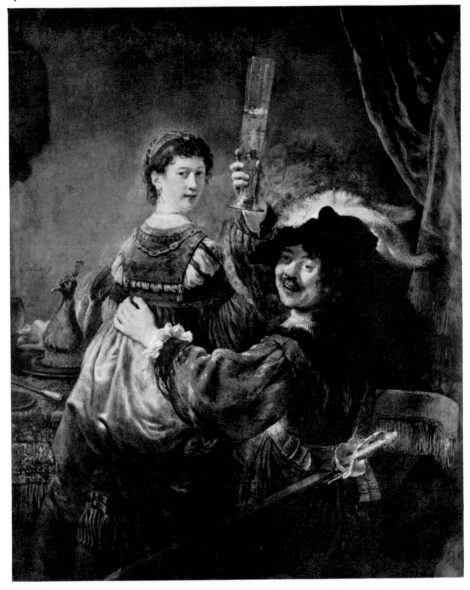

21. REMBRANDT AND SASKIA. Dresden, Museum.
Oil on canvas (161 × 131)

birth of Titus, their only surviving child. Three other children had died in infancy
(Rumbartus in 1635, Cornelia I in 1638, and Cornelia II in 1640). An etching of
1642 (H. 196), picturing Saskia as hopelessly weak, may be the last record Rem-
brandt was able to make of her features (figs. 23, 24). The sad situation at home was
not improved by the presence of Geertghe Dircx, a trumpeter's widow whom
Rembrandt engaged as a nurse for Titus, after Saskia's death (fig. 25). The outcome

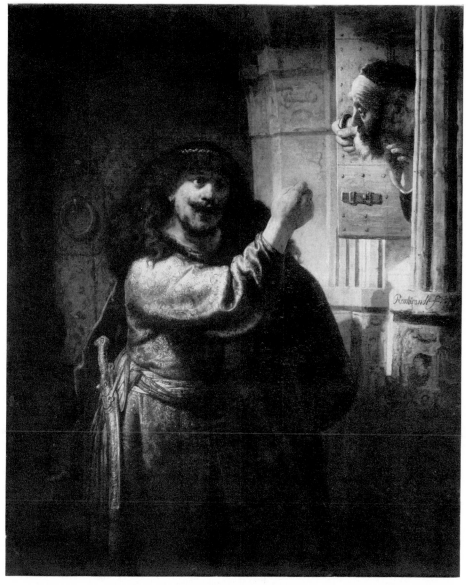

22. SAMSON THREATENING HIS FATHER-IN-LAW. 163(5). Berlin-Dahlem, Staatliche Museen. Oil on canvas (156 × 129)

of this unfortunate relationship was a breach-of-promise suit which dragged on until 1650, and ended only with Geertghe's confinement in a mental hospital.

In addition to all these blows, Rembrandt's financial situation, already strained by the purchase of the large house, grew steadily worse. His popularity as the foremost portrait painter of Amsterdam began to suffer. Rembrandt's increasing use of chiaroscuro, with less and less regard for merely naturalistic effects, caused dis-

23. SICK WOMAN (SASKIA). Etching
(H.196) (6·1 × 5·1)

satisfaction and contributed to the decline of his reputation. The brighter and more elegant style of Van Dyck was at this time coming into fashion. Rembrandt's pupils, such as Ferdinand Bol, Govaert Flinck, and Jacob Backer, who yielded readily to the public taste, were soon more successful than their master and received the important commissions.

Such a piling up of misfortunes must have made these years bitter ones for Rembrandt. But disillusionment and suffering seem to have had only a purifying effect upon his human outlook. He began to regard man and nature with an even more penetrating eye, no longer distracted by outward splendour or theatrical display (fig. 26). A new contact with nature resulted in a large number of landscape drawings and etchings representing the environs of Amsterdam, and this contact must have helped to clarify, to widen, and to balance the artist's vision. It was not by chance that a change from Baroque theatricality to a more natural simplicity coincided

24. DEATH APPEARING TO A WEDDED COUPLE. 1639. Etching (H.165) (10·8 × 7·8)
25. GEERTGHE DIRCX, NURSE OF TITUS. Haarlem, Teyler Museum. Drawing (22 × 15)

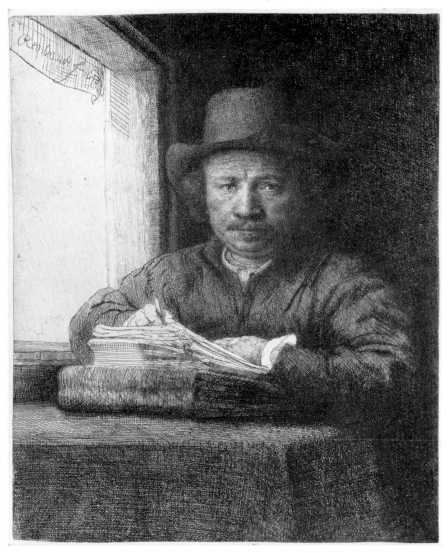

26. REMBRANDT DRAWING AT A WINDOW. 1648. Etching (H.229) (15·7 × 12·8)

with Rembrandt's new experiences in the open air. An altered sense of values is revealed in his art of this middle period. He was able to approach his immediate surroundings and his fellow men with a heightened sensitiveness to true human values and to interpret the Bible with a deeper sincerity. Rembrandt now began to study the Jewish population of Amsterdam, discovering there an inexhaustible source for Biblical types of an unprecedented verity. Such distinguished Jewish personalities as the Rabbi Manasseh Ben Israel and the physician Ephraim Bonus were among his acquaintances.[14] His fond delight in his son Titus (fig. 27), as the boy began to grow up, Rembrandt expressed in many of the Biblical scenes of these

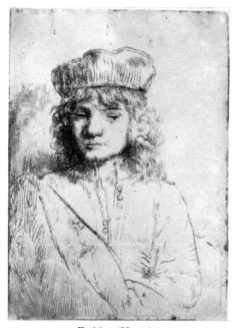

27. TITUS. Etching (H.261) (10·1 × 7·2)

years. We find Titus appearing again and again, as the young Christ, as Tobias, Daniel, or the young Joseph. It was also at this time that Rembrandt learned to appreciate the simple charm and warm-heartedness of Hendrickje Stoffels, who entered his home about 1645 as a servant girl, to remain as his life companion (fig. 28).

Thus we see that a close interrelationship between life and art continued into Rembrandt's middle period. His new 'inwardness' did not lead to a withdrawal from life. But the attraction which life exerted upon the maturing Rembrandt was now of a different sort, and caused him to react with a keener and more sensitive feeling for enduring human qualities.

The outward events of Rembrandt's late years, in the fifties and sixties, took a final turn for the worse. Financial collapse came closer, and desperate efforts to avert it were unsuccessful. In 1656 he had to transfer his great house in the Joden-Breestraat to Titus in order to save his son's inheritance which had been entrusted to him. For the removal of debts on the house Rembrandt had to pledge all his property, resulting in the declaration of his insolvency. In July 1656, Rembrandt asked the authorities to grant him a *cessio bonorum*, to avoid outright bankruptcy. This procedure was considered less degrading, and permission for it could be obtained on the basis of losses in trade or at sea. The *cessio* was granted, and the liquidation of Rembrandt's property was put into the hands of the Chamber of Insolvency. The results of the entire sale were disappointing, when compared to the purchase value of Rembrandt's estate,[15] and the artist remained under a serious financial strain for the rest of his life. His son Titus and the faithful Hendrickje united to protect him from his creditors. The two formed a business partnership for dealing in paintings and objects of art, and in 1660 they made Rembrandt their employee.[16] He was to deliver to them all he produced in return for his support, and by this subterfuge the old painter was able to save at least the earnings from his work.[17]

An inventory[18] bearing the date of July 25, 1656, lists every item in Rembrandt's collection at the time of the sale, and provides an illuminating insight into the artist's tastes and diversity of interests. Baldinucci's report, already quoted, is

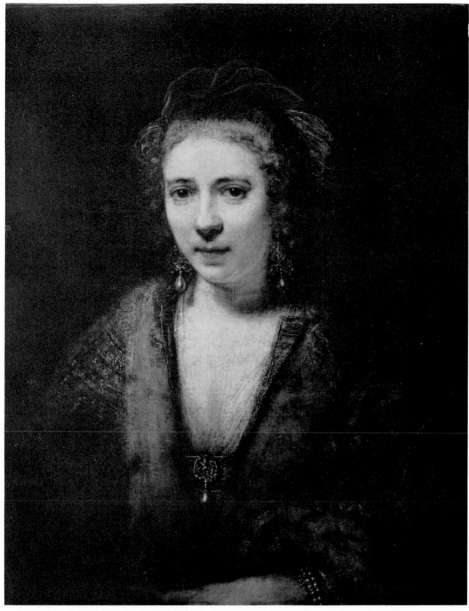

28. HENDRICKJE STOFFELS. Paris, Louvre. Oil on canvas (72 × 60)

confirmed by this detailed document. In addition to a number of Rembrandt's own works, the collection included paintings by masters of the Italian Renaissance, the early Flemish School, and above all, by contemporary Dutch artists. We read the names of Adriaen Brouwer, Jan Lievens, Hercules Seghers, Palma Vecchio, Giorgione, Pieter Lastman, Jan Porcellis, Jacopo Bassano, Lucas van Valckenborch, Jan

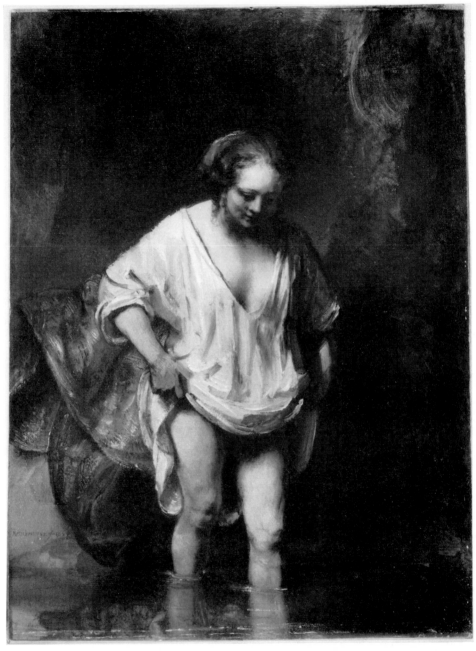

29. WOMAN BATHING (HENDRICKJE). 1654. London, National Gallery. Oil on panel (61 × 45·5)

Pynas, Lucas van Leyden, Raphael, van Eyck, Lelio Orsi, and Simon de Vlieger. The same wide range of interests is displayed in the large collection of graphic art. The drawings were mostly by Rembrandt's own hand, but there were some by

Pieter Lastman, Roelant Savery, and Adriaen Brouwer. The ancient sculpture included both originals and plaster casts. There were examples of Far Eastern art, and a great variety of weapons and armour, as well as natural curiosities such as shells, rare formations of stone, and the skin of a lion. The collection of books, on the other hand, was surprisingly small. The inventory lists an old Bible, a German edition of Flavius Josephus' *The Jewish War* with woodcuts by Tobias Stimmer, Dürer's book on human proportion, a few more illustrated volumes, and finally, a group of fifteen unidentified items.

This odd assortment of works of art and curiosities should not be taken as completely reliable evidence of Rembrandt's personal taste as a collector, since he had also been active as a dealer. But we may assume that in the choice of these objects he was more impulsive than calculating. A number of them appear as accessories in his paintings.[19] Even after his financial collapse this passion for collecting lingered on. Just as soon as Rembrandt found himself protected against the claims of his former creditors, he began again to buy works of art, although no longer on a large scale.

In spite of economic hardship, an atmosphere of harmony seems to have prevailed in Rembrandt's home life through the devotion of Hendrickje Stoffels. The will of Saskia prevented the artist from re-marrying at the risk of losing the small income from her estate. Thus Hendrickje never enjoyed the status of a legal wife. But there is little reason to assume that there was any objection raised against this relationship—at least not in the rather poor neighbourhood of the Rozengracht, where Rembrandt moved after the loss of his property. In a document[20] of 1661, describing a neighbourhood incident, Hendrickje is mentioned as Rembrandt's wife. However, the church authorities objected to the illegal relationship. Hendrickje was repeatedly called before the Church Council and sternly admonished; she was punished by exclusion from the Lord's Supper. Rembrandt's many portraits of Hendrickje (fig. 29), and the long series of representations of her in Biblical roles reveal the artist's feelings for this woman. She was very different from Saskia. Houbraken describes her as a 'peasant woman from Raarep, or Ransdorp, in the district of Waterland, small in figure but well-shaped of face and plump of body.'[21] Hendrickje's motherly nature, her simple warmheartedness are clearly apparent in her portraits. Titus seems to have shared his father's affection for her, as indicated by his testaments of 1654 and 1657.[22]

The death of Hendrickje, which occurred in 1663[22a]—she had made her will in 1661—was a most serious blow to Rembrandt. Titus, who came of age in 1665, continued to care for his ageing father and carry on the management of the business. In February 1668, he married Magdalena van Loo, daughter of a silversmith. Only a few months after this Titus died, and Rembrandt was left alone during the last year of his life with the young daughter Cornelia whom Hendrickje had borne him in 1654. Rembrandt's own death in October 1669, must have come as a release to

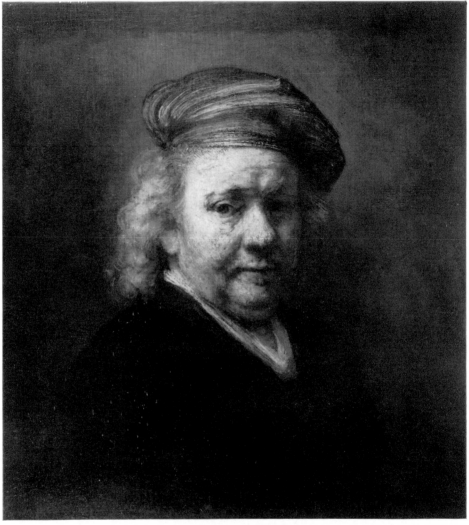

30. SELF-PORTRAIT. 1669. The Hague, Mauritshuis. Oil on canvas (59 × 51)

the sixty-three-year-old master, if one interprets rightly his last self-portrait, painted in that year (fig. 30). His features here seem to have lost their inner vitality. He was buried on October 8 in the Westerkerk in Amsterdam.

The loneliness of Rembrandt's late years has often been exaggerated by his biographers. Throughout his life Rembrandt was most closely attached to his family circle, and seldom felt the need of wider social contacts. One of his few patrician friends was Jan Six, afterward Burgomaster of Amsterdam. The painter's retirement from the public stage of Amsterdam, on which he had played a certain role during his prosperous period, was not wholly enforced upon him, but was partly his own decision. Most of the contemporary writers blamed Rembrandt for his

slight regard for contacts with educated people and his constant association with common folk. Joachim von Sandrart remarks: 'He did not know in the least how to keep his station, and always associated with the lower orders.'[23] Houbraken makes a similar observation, but with a more specific reference to the older Rembrandt: 'In the autumn of his life Rembrandt kept company mostly with common people and such as practised art.'[24] The extremely introspective character of Rembrandt's art required the utmost concentration on his part. Baldinucci has the following to say about his extraordinary intensity of application: 'When Rembrandt worked he would not have granted an audience to the first monarch in the world, who would have had to return again and again until he found him no longer engaged.'[25] According to Houbraken, visitors to Rembrandt's studio who wished to examine his paintings too closely he frightened away by the words: 'The smell of the colours will bother you.'[26] Baldinucci, who received his information on good authority,[27] calls Rembrandt 'a most temperamental man' (*umorista di prima classe*) who was inclined to 'disparage everyone'. As for the artist's appearance, he writes: 'The ugly and plebeian face with which Rembrandt was ill-favoured was accompanied by untidy and dirty clothes, since it was his custom, when working, to wipe his brushes on himself, and to do other things of a similar nature' (fig. 31). Rembrandt in his late years clearly cared nothing for fine manners, nor had he any desire to be a gentleman-painter like Van Dyck or so many of his Dutch contemporaries. All the idiosyncrasies just mentioned fit convincingly into the picture of a man of overpowering directness, and with a complete disregard for social convention.

All the contemporary accounts of Rembrandt's life, even those which criticize him most severely, show a certain respect for the master's power and originality. And that Rembrandt in his old age was not an altogether forgotten figure we may confirm from a number of records. His international reputation had been established in the early 1640's. About that time some of his paintings came into the collection of Charles I of England. And as late as 1667, Cosimo de' Medici, afterward Grand Duke Cosimo III of Tuscany, visited the old painter in his studio. It was probably on this occasion that one of the two Rembrandt self-portraits which are now in the Uffizi (Br. 45, 60) was acquired.[28] Even though most of the public patronage went to his pupils who catered to the prevailing taste, Rembrandt still received a few large commissions during the fifties and early sixties. In 1656 he painted the *Anatomy Lesson of Dr. Deijman*, of which only a fragment has survived, and in 1661–2 he created his greatest group portrait, the *Syndics*. In 1661 he was asked to contribute to the decoration of Amsterdam's new Town Hall. His painting, a large historical subject representing the *Conspiracy of Julius Civilis*, was delivered and hung, but apparently did not meet with favour. It was removed soon afterward and a work by Juriaen Ovens, one of Rembrandt's less gifted pupils, was put in its place. After this humiliating public rebuff, the canvas was cut down on all sides

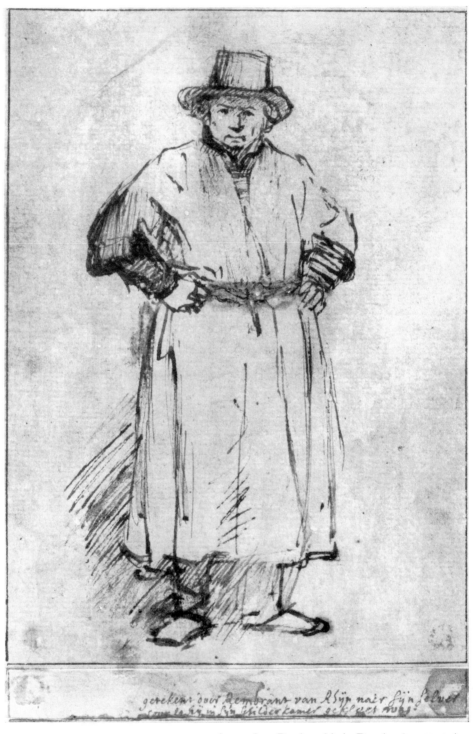

31. SELF-PORTRAIT IN STUDIO ATTIRE. Amsterdam, Rembrandthuis. Drawing (20·3 × 13·4)

(probably by Rembrandt himself) in order to make the picture more saleable. As for privately commissioned portraits, Rembrandt seems to have produced a fair number during the last ten years of his life.

There was, however, enough of failure and catastrophe in Rembrandt's late period—not to mention the burden of advancing age—to account for the sombre undertone of his work. But the relationship between life and art is no longer so easily perceived. The old artist's innermost reactions found expression in a pictorial style that rose to symbolical heights. Without distorting visual reality, he expressed in this way a growing awareness of the transcendental background of human life. A deep feeling of humility penetrates the gloom of his late works and raises his art to a spiritual level in which individual experience takes on universal significance.

Rembrandt, in reaching this phase, went far beyond the bounds of ordinary Dutch realism. His contemporaries described the life and the world around them, but Rembrandt mirrored the world within himself.

PORTRAITURE

INTRODUCTION

THE FIELD of portraiture was a most profitable one for the seventeenth-century painter, and this was true in democratic Holland even more than in Spain, France, or England, where the Court provided artists with most of their commissions. For in the Dutch cities almost every burgher wished to own portraits of family members, and there was also the rather large category of group portraits destined for more official places such as town halls, guild houses, or the buildings of charitable societies.

While the courtly portraitist was expected to flatter his subject and to place *noblesse*, if not *majesté*, and in the case of ladies *beauté* and *grace*, before any truth to nature,[1] the Dutch burghers did not cherish such high ambitions. They were satisfied with a good likeness and took a certain pride in the neat and proper dress that was their own. Thus the great mass of average Dutch portraiture reflects a sober bourgeois taste and shows a decent standard of craftsmanship without any exciting features. Frans Hals, of course, stands out from this average production by his brilliant and ingenious technique and by the unusual vitality with which he endows his subjects. But he too satisfied the primary demands of the burghers for a good likeness and a realistic rendering of costume.

No one will blame the young Rembrandt for throwing himself into this field once he had discovered it as the great opportunity of his life to gain fame and prosperity. As we shall see later, his energy was vast enough to keep up production in other fields, particularly in that of Biblical painting, which he had chosen first as his calling. He was naturally disposed toward portraiture by his human and psychological interest. A facile draughtsman, a keen observer, and a gifted technician, he had no difficulty in surpassing the successful portraitists of the older type in the Dutch capital.

At first it seemed that Rembrandt would not greatly alter the course of Dutch portraiture but would only amplify its tendency toward a most realistic rendering of a likeness. After a decade, however, it became evident that he could not remain satisfied with the conventional type. By that time he felt the strong urge to go deeper in his characterization than the average patron expected, and to describe not only man's outward appearance but to express his inner life, his spiritual existence. Thus Rembrandt's way was bound to deviate from the path of those who craved public success, and the development of his portraiture, like every other category in his production, reflects the changing phases of his personality.

Rembrandt's portraiture divides itself naturally into three types: the Self-

Portraits, the Single Portraits, and the Group Portraits. The self-portraits in particular reveal that blend of the subjective with the universal which characterizes Rembrandt's genius. The single portraits strongly reflect Rembrandt's susceptibility to the spiritual side of man and show both his breadth and profundity in the interpretation of human character. The group portraits manifest, in addition to these basic qualities, the artist's ability to relate individual figures in common activity or in co-operative situations.

SELF-PORTRAITS

The extraordinary phenomenon of Rembrandt's self-portraits has no parallel in the seventeenth century or even in the entire history of art. We know altogether about sixty painted self-portraits by the master, in addition to more than twenty etchings and about ten drawings. This means that almost ten per cent. of Rembrandt's tremendous output in painting consisted in likenesses of himself. The importance of this category within Rembrandt's work is further emphasized by its continuity of production. Allowing for a certain amount of loss—perhaps about thirty per cent.— it is a fair guess that Rembrandt painted an average of two self-portraits every year. Even in limiting our consideration to extant material, there is hardly any phase of the artist's life without its painted record of his likeness, making it possible for us to reconstruct the entire history of his outward appearance as well as the development of his personality.

If it were ever possible to assemble all the painted self-portraits of the master in one exhibition, we should be surprised to find so little repetition in arrangement and expression, and so consistent and intense an interest in the psychological content. The scope of Rembrandt's emotional life and the diversity of his moods would be strikingly brought out by such an exhibition and the visitor could not fail to be impressed by the ceaseless and unsparing observation which the paintings reflect, showing a gradual change from outward description and characterization to the most penetrating self-analysis and self-contemplation.

Why did Rembrandt show such an untiring interest in his own features? It is true that in the beginning his face often served as a convenient model for studies in expression. Thus he may have come into the habit of looking at himself with a painter's eye. But this reason alone cannot explain the tremendous quantity and the deep significance of his self-portrait production, for which there was no demand on the part of the public.[2] Rembrandt seems to have felt that he had to know himself if he wished to penetrate the problem of man's inner life. The phenomenon of the soul attracted him as strongly in his own personality as it did in that of others, and such profound self-realization was, it seems, indispensable for his access to the spiritual and the transcendental.

The objectivity which Rembrandt displayed in his self-characterizations does not permit interpreting them as products of an egocentric disposition. In this constant and penetrating exploration of his own self, his range went far beyond an egotistic perspective to one of universal significance. In fact, this rare accumulation of so many self-portraits offers a key to Rembrandt's whole approach to the world: the search for the spiritual through the channel of his innermost personality.

The number of self-portraits dating from Rembrandt's years in Leyden, 1629–31, is exceedingly high, both in

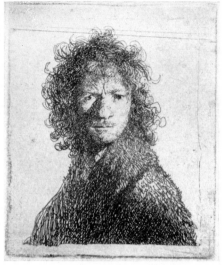

32. SELF-PORTRAIT, BAREHEADED. 1630.
Etching (H.30) (7·2 × 6·1)

painting and etching. Particularly in the etchings he used his own features for the study of emotional expression. But we find also examples in which the sharp self-observation anticipates the psychological depth of his later work.

In the etching of 1630 called *Rembrandt bareheaded, looking over his shoulder* (H. 30, fig. 32), the young artist turns toward the spectator with an energetic movement and a resolute, rather grim expression. His full, disorderly hair, like a lion's mane, surrounds the sharply lighted face with a dark cluster of curls. The diagonal shadow cast by the nose across the right cheek heightens the dramatic character of the expression, as do the dark spots of the small, piercing eyes and the intense muscular contraction of the forehead. Rembrandt was about twenty-three when he etched this portrait, but his technique shows little sign of inexperience. The free,

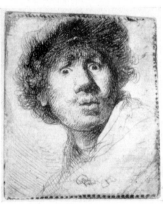

33. SELF-PORTRAIT IN A CAP,
OPEN-MOUTHED AND STARING.
1630. Etching (H.32) (5·1 × 4·6)

scribbling stroke is both descriptive and suggestive. The organization of lights and darks is firmly controlled and gives a striking emphasis to the psychological content.

In another small etching of the same year, *Rembrandt open-mouthed and staring* (H. 32, fig. 33), the youthful artist tried to catch the expression of an instantaneous emotion. His features are distorted in horror, the eyes with a fixed stare, the mouth contracted with a sudden gasp of breath. The position of the shoulder suggests a shrinking movement into the background. Obviously such a study had little to do with self-characterization,

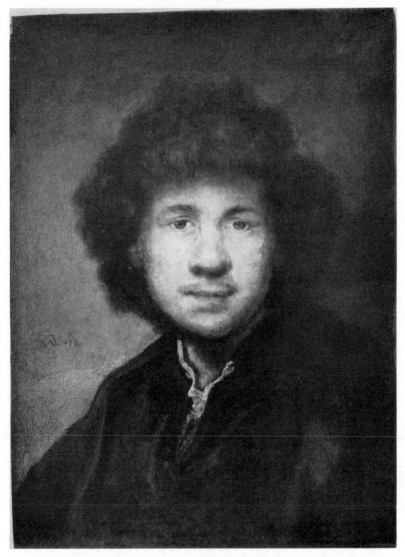

34. SELF-PORTRAIT. 1630. Aerdenhout, I. H. Loudon Collection.
Oil on panel (49 × 39)

but was intended simply to enrich the artist's repertory of facial expressions. Nothing of equal intensity can be found in the entire work of his teacher Lastman. Nevertheless, one feels certain shortcomings in this early work. The transitory nature of the emotion is not sufficiently brought out, and the result is a somewhat frozen grimace, resembling a snapshot photograph.

In the painted self-portraits of the Leyden period Rembrandt experimented boldly with the chiaroscuro device of massing and contrasting lights and darks to gain pictorial animation. The light in the portrait of 1630, now in the I. H. Loudon

Collection, falls strikingly upon the full face of the young artist, with its heavy and rather formless features (fig. 34). He made no effort here to conceal or to modify the vulgar breadth of his nose or the crudeness of his appearance. Only in the small bright eyes and the sensitive movement about the mouth is there any suggestion of an alert and vital personality. No one, in looking at this uncouth young man, would dare to predict the tremendous range of his future development, even though a flavour of originality will be granted. In this painting, as in most of the early self-portraits, the directness of statement is surprising, and the boldness of composition as well. The colours are subdued and cool, tending toward monochrome; the brushwork is intimate and lively. The pictorial genius of the young Rembrandt is already apparent.

The self-portraits dating from the early years in Amsterdam exhibit a more manly and more elegant appearance. The painting of 1634 in Berlin can almost rival a Van Dyck (fig. 35). The artist has dressed himself in precious materials—an embroidered silk scarf, a fur coat, and a velvet beret. By distributing the light and shade on his face into two halves, with a vertical division along the nose, he has cleverly modified the coarse breadth of his features, giving the impression of an oval countenance. A daring movement animates the composition. The artist turns energetically toward the spectator, glancing over his right shoulder. The curvilinear rhythm of the silhouette lends an additional flair to his appearance. This lively contour co-operates with the sequence of lights and darks to lead the eye actively into the picture. Such an integration of the chiaroscuro pattern with both spatial depth and psychological content marks a climax of Rembrandt's Baroque tendencies.

Although Rembrandt here displays a good deal of showmanship—this is the period of his greatest success and prosperity—the painting does not lack that element of mystery which belongs to all of his best works. By means of the transparent shadow which the artist throws over his eyes and his left cheek he heightens rather than diminishes our interest in his expression, which remains just clear enough to penetrate this dim shade. Rembrandt realized early that the half tones are best suited to the suggestion of psychological content. Only within the half tones can one slip subtly from the distinct to the indistinct and play that game of veiling and disclosing which Rembrandt employed so masterfully in suggesting content of a less tangible nature.

Turning to the middle period we encounter in the self-portrait of 1640 in the National Gallery in London a more penetrating characterization (fig. 36). The artist's attire is no less elegant or fanciful than before. He wears a richly embroidered shirt and waistcoat and a heavy, fur-trimmed velvet coat. A broad velvet beret completes his costume. The strongest accent of the picture, however, lies in the man's critical, almost misanthropic expression which seems to contradict the

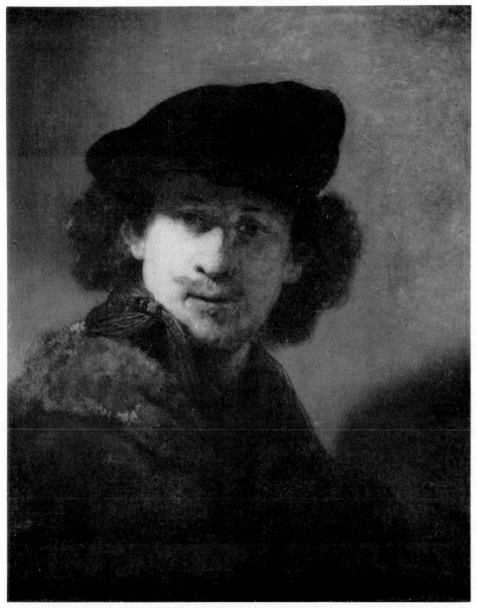

35. SELF-PORTRAIT. 1634. Berlin-Dahlem, Staatliche Museen.
Oil on panel (57 × 46)

emphasis upon his rich attire. This is the phase of Rembrandt's life in which the first symptoms of inner crisis appear. We detect that uneasiness which frequently foreshadows profound change.

In the pictorial organization of this portrait we observe a wider range of the chiaroscuro, with more room for the display of transparent half tones between the

dark and the lighted areas. The strongest light accent strikes the face, which is almost fully illuminated, but additional lights on the shirt, the hand, and the sill relieve the harshness of contrast. In general the light is softer than in the earlier period, and has lost its spotlight character. The roundness of form is increased through the more subtly graded modelling. There is more spaciousness and atmosphere about the figure.

Compared to the self-portrait of 1634 just discussed, the London portrait shows a greater stability in the composition. The somewhat extravagant Baroque movement of the silhouette in the former has given way to a new emphasis upon horizontals, contributing to the quieter and more stately character of the London picture. This is the period when a classic influence makes its first appearance in Dutch painting, and Rembrandt's work of the forties, in its formal organization, clearly responds to the tendencies of the time. In this particular portrait, however, we know of a definite link between Rembrandt and Italian Renaissance art; it was provided by Raphael's portrait of Baldassare Castiglione, which the painter saw in 1639 at a sale in Amsterdam. He made a quick pen sketch of this portrait, noting also the price of the picture (3,500 florins) and the total amount of the sale, as well as its date. The etched self-portrait of the same year (H. 168) is obviously based on this drawing (now in the Albertina, Vienna; Val. 626B). The London painted portrait of the following year reflects only broadly and in reverse the arrangement and style of the Castiglione.[2a] Yet in its more static character this London self-portrait comes closer to the essence of Raphael's style than does Rembrandt's immediate sketch after the Castiglione, or the etching based upon that sketch. In both drawing and etching the hat shows a sharp diagonal slant which transforms the original round form in the Raphael for the sake of a more sweeping Baroque effect. The painting, on the other hand, displays something of the quiet dignity of a true Renaissance portrait.

The self-portrait from the Widener Collection, now in the National Gallery in Washington, shows Rembrandt's appearance ten years later, in 1650 (fig. 37). This date can be called the end of his middle period, or equally well, the beginning of his late one. The artist looks considerably older here. The characteristic locks of bushy brown hair by his cheekbone have begun to turn grey. As for the costume, it is the richest we have yet seen. Rembrandt here wears no overcoat and exhibits freely the precious gold embroidery of his fancy dress. Equally ornate is the brocade cap under the red beret. Red and gold tones are fused into a warm colouristic harmony. Rembrandt's romantic interest in precious things is shown most pointedly in the large pearl that dangles from the artist's right ear. This is a pictorial touch of the most delicate charm. But in spite of the importance given to outward display in this picture, the psychological content is dominant. Here again there is an interesting relationship between two contrasting features: the artist's obvious delight in

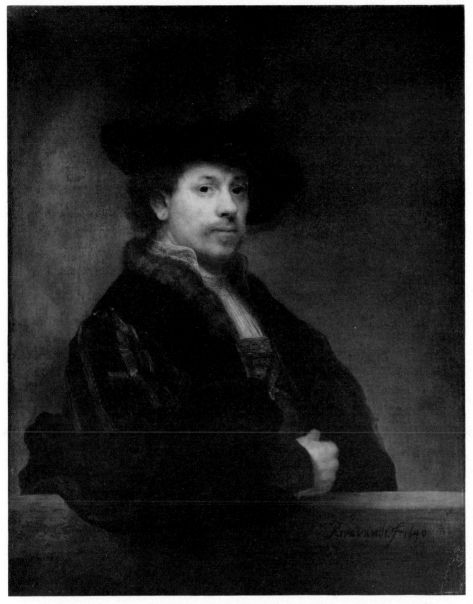

36. SELF-PORTRAIT. 1640. London, National Gallery. Oil on canvas (97·5 × 79)

picturesque attire and glittering materials and, on the other hand, his critical and deeply questioning expression. Whether or not we call these features contradictory, they are here united in one personality with an extraordinary effectiveness and betray Rembrandt's double disposition to romanticism and to psychological penetration.

In comparison to the self-portrait of 1640, the pictorial organization is again

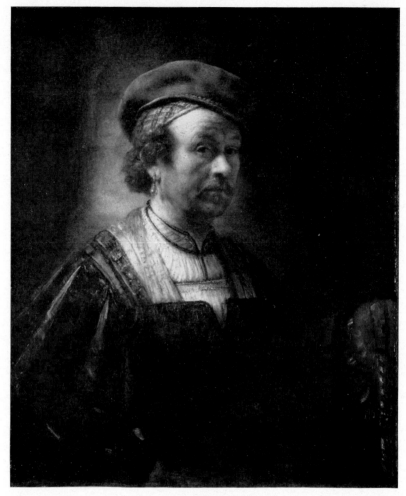

37. SELF-PORTRAIT. 1650. Washington, National Gallery of Art (Widener Collection).
Oil on canvas (88·5 × 71)

tremendously enriched. The area of attraction through light, colour, and textural qualities is extended over a wider field, and the treatment is more varied, from subtle glazing to full impasto. The dominance of the artist's features within this rich pictorial performance relies upon larger compositional accents which lead up from both sides to his head: from the left the diagonal of the sloping shoulders directs our attention to the ear-ring and to the questioning glance of his eyes; on the right, one instinctively relates the half-tone area of the gloved hand resting upon an ornate walking stick to the same tonality in his slightly shadowed face.

Within the development of Rembrandt's self-portraits we may say that this Widener picture shows, in addition to richly romantic implications, a significant advance from self-description to self-analysis. If, however, we compare Poussin's

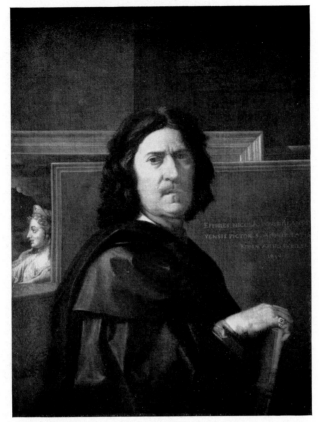

38. Nicolas Poussin: SELF-PORTRAIT. 1650. Paris, Louvre.
Oil on canvas (95 × 75)

self-portrait of the very same year, 1650 (fig. 38), we feel a contrast between the intellectual approach of the great French artist and Rembrandt's more intuitive one. Poussin's use of rectangular shapes lends his composition an architectural severity and order that contrast strikingly with the more flexible pictorial arrangement in the Rembrandt. Poussin's vigorous personality is brought out, but within the limits of rather rigid aesthetic principles, while Rembrandt appears freer from any theoretical considerations.

From the group of Rembrandt's late self-portraits, dating from 1658 on, we have chosen a fairly large number for reproduction, not only because of their singular power and significance but also because of their amazing variety. Even though each one gives an overwhelmingly vivid idea of the mature Rembrandt's personality, only a larger group can show the range of his emotional life and the flexibility of his pictorial expression.

All these late self-portraits have in common a monumentality which Rembrandt attained only in his last decade, and which expressed itself in mightier forms and

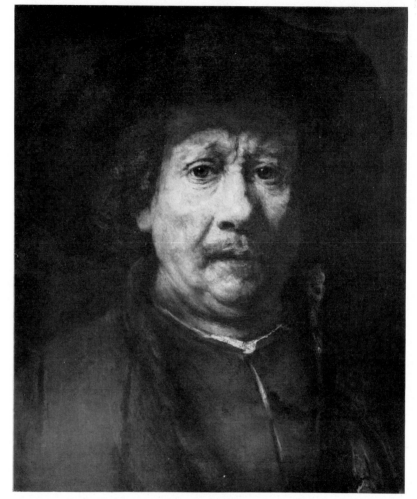

39. SELF-PORTRAIT. Vienna, Museum. Oil on panel (50×41)

more powerful brushwork. The bitter experiences of Rembrandt's last years, his bankruptcy, his dwindling popularity, and his loneliness have often been associated with the gloomy mood of many of his late works. There is a sombre undertone in the late self-portraits; they reflect advancing age as well as inner suffering. But we cannot necessarily link Rembrandt's facial expression with actual events in his life. We feel that the artist has recorded and characterized his own moods with an imposing objectivity that is free from resentment, self-pity or any trivial, sentimental reaction, and shows, at times, a touch of sarcastic humour. Rembrandt's eyes, in these late portraits, have grown large and dominating. To the keen self-observation of his earlier years has been added a profound thoughtfulness. He seems to look not only at, but within himself, seeing his personal life in its broader and more universal relationships. The dignity which speaks to us through these self-portraits

seems to be rooted in an uncompromising search for truth, and there is expressed the most intense integration of the artist's physical and spiritual existence.

The self-portrait in Vienna, from about 1658, exhibits in striking fashion the monumentality of Rembrandt's late compositions and the mellowness of his mood (fig. 39). His head and bust now fill the picture plane completely, but with all its massive frontality the form is free from any classical rigidity, and is softened by the broadest painterly treatment.

In the majestic portrait in the Frick Collection (fig. 40) Rembrandt appears in rich Oriental garments, leaning back in an armchair like an old pasha. He sees himself as a sovereign in his realm of pictorial fancy. The composition presents a Titian-like grandeur in the broad frontal display of this mighty figure. The warm and glowing colours perform a symphony in orange-red and gold, in white and black, with shadowy browns fluctuating in the background. The rich texture of the paint and the vibrating surface add to the pictorial attraction. The colourful splendour is matched by the richness of psychological content. Here is represented an impulsive, volcanic personality, controlled under a calm exterior just as the glowing and vibrant painterly performance is controlled by a firm yet complex organization.

The self-portrait in the National Gallery of Art in Washington (frontispiece) is close to these two portraits in period, but different in conception and arrangement. The artist here is seated in profile, turning his full face over his left shoulder toward the spectator. His hands are folded in his lap. He wears a greyish coat which contrasts mildly with the dull red mantle thrown over his right arm. The power of this picture lies in its utter simplicity and in its concentration upon the man's expression. The light is reserved almost entirely for his face, but it now seems to shine from within, more than from an outside source. The broad shadow accents of his eye sockets and under his nose intensify this effect, but help also to model the form. Rembrandt has represented himself here as most vulnerable, yet we feel that sorrow has only deepened his understanding and human sympathy. From this portrait we may realize how Rembrandt was able to interpret so profoundly the Biblical figures of King Saul, the Apostle Peter, or the Prodigal Son, in their hours of trial. Among all contemporary self-portraits this one has no equal, for sheer power of paint or depth of psychological revelation. Velazquez, for example, in his self-portrait in Valencia, cannot hold our interest with the same intensity. He remains much more reserved in his self-characterization, and does not allow the spectator to participate so closely in his innermost life.

In Rembrandt's famous self-portrait in the Louvre, dating about 1660, the artist stands before his easel, looking more relaxed, as if he were taking a few moments from his absorbing work in order to collect his thoughts (fig. 41). The light focuses here on his white cap, thus drawing the eye to the top of the canvas. For the area of

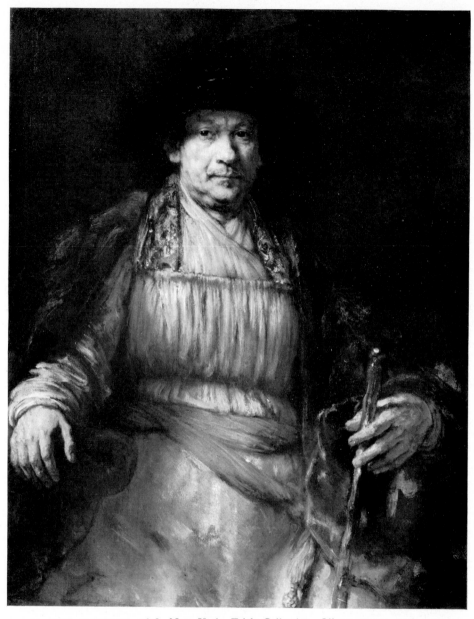

40. SELF-PORTRAIT. 1658. New York, Frick Collection. Oil on canvas (129 × 101)

his face the painter has reserved a subtle play of light and dark with soft inter-
mediary half tones which contribute so much to the suggestion of mood. Most
sensitive of all is the treatment of the mouth, with almost parted lips. Rembrandt in
this picture is a quiet and thoughtful observer of his own appearance. His right
hand holding the maulstick attracts attention by the suggestion of its momentarily

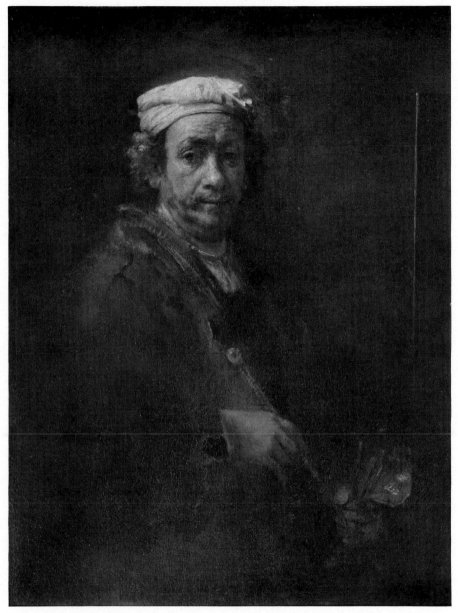

41. SELF-PORTRAIT AT THE EASEL. Paris, Louvre. Oil on canvas (111 × 85)

relaxed attitude. The spacing between the artist and his easel, and the vertical and diagonal accents resulting from this arrangement, are consciously exploited for the sake of the composition. A secondary light accent on the palette and the edge of the easel extends our interest over the whole picture plane without weakening the central attraction of the head.

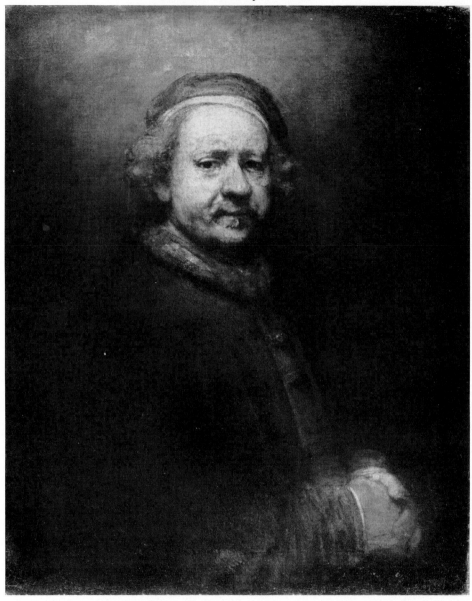

42. SELF-PORTRAIT. London, National Gallery. Oil on canvas (85 × 69·5)

The self-portrait in the London National Gallery shows a compact composition not unlike that of the Washington portrait, although the position is reversed (fig. 42). Quite different, however, is the mood of the artist, who looks at us with a slightly sarcastic humour. This portrait seems to confirm the reports of Baldinucci and Houbraken as to Rembrandt's impetuous disposition, and his tendency to make brusque, ironical remarks. It recalls to mind the fact that he was by no means a

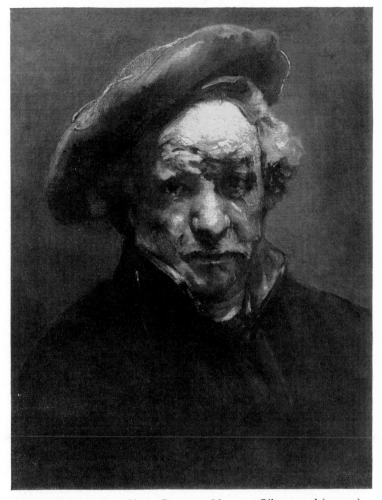

43. SELF-PORTRAIT. Aix-en-Provence, Museum. Oil on panel (30 × 24)

saint in actual life. Yet even in this self-portrait the implications of the mature artist's humanity are not wanting.

The small panel portrait in Aix-en-Provence (fig. 43) has all the boldness and immediacy of a Goya, with broad patches of light and dark merged by fluid half tones. This is obviously a preliminary study for a larger life-sized portrait. Oil sketches of this sort are rare in Rembrandt's work and always show a greater freedom of handling than the final painting. They possess to some degree the fleeting suggestiveness of Rembrandt's drawings. The excessive sadness of the man's gaze and his dishevelled appearance reflect a critical stage of his life. This may well be the year in which he had to endure the loss of Hendrickje. Rembrandt's precarious emotional balance finds a most telling expression in the daring composition, with the sharp diagonal of the hat, and the violent, eruptive character of the brushwork.

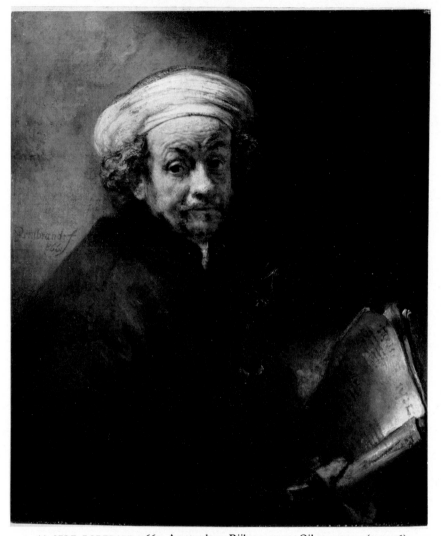

44. SELF-PORTRAIT. 1661. Amsterdam, Rijksmuseum. Oil on canvas (91 × 76)

It is interesting to compare this portrait with any study of emotional expression from Rembrandt's Leyden period, perhaps with the self-portrait etching of 1630 (H. 32, fig. 33). Such a comparison shows the self-contemplation implied in the late work and a deep consciousness of man's fateful destiny. In early self-portraits Rembrandt described his reaction to certain isolated occurrences; here the ageing artist relates his own experience to the universal insecurity of human existence.

A very different impression we receive from the self-portrait of 1661 now in the Rijksmuseum, Amsterdam (fig. 44). Here Rembrandt portrays himself holding an old manuscript with indistinct Hebrew lettering. The handle of a dagger is visible, projecting from under his coat. His head, covered with a large white and yellow

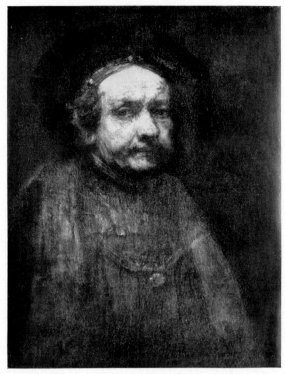

45. SELF-PORTRAIT. Florence, Uffizi. Oil on canvas (70 × 55·5)

turban, turns directly toward the spectator. It has been assumed that Rembrandt meant to represent himself in this picture as the Apostle Paul.[3] We do not feel any certainty about this interpretation, but it is clear that the portrait is that of a thinker, deeply concerned with spiritual problems.

A glance back to the Widener portrait of 1650 will prove Rembrandt's advance to the monumental style of his last years. The composition in the Amsterdam portrait shows a gain both in concentration and power. The questioning expression, already suggested in the Widener picture, now reflects a quiet superiority, attained through greater knowledge, unhampered by fear or scepticism. There is nothing, it seems, in the realm of human experience that this searching mind could not embrace. The gaze is deeply human, yet of an almost mythical grandeur and dignity. The signs of advancing age are clearly apparent in this likeness, but the man's spirit has risen to a lofty height.

This discussion of Rembrandt's self-portraits may conclude with the painting in the Uffizi, dated about 1664–5, and the one in the Museum in Cologne, which obviously belongs to Rembrandt's last years. Both are forceful documents of the aged master's undiminished artistic power. The Uffizi picture (fig. 45) with its broad frontal arrangement and ornate costume, recalls Renaissance portraits of the

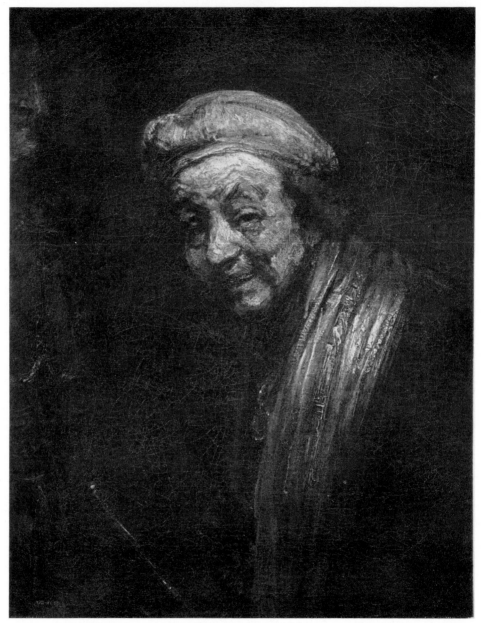

46. SELF-PORTRAIT. Cologne, Museum. Oil on canvas (82 × 63)

time of Mabuse and Holbein, but its strong chiaroscuro lends it a definite Baroque flavour. The expression is hardly less tragic than in the small oil sketch in Aix. But the artist here expresses his own gloomy mood with an uncompromising, almost cold detachment that has little of the mellowness of other late self-portraits, yet much of their majestic character.

In the Cologne portrait (fig. 46) Rembrandt surprises us by a laughing expression which brings reminiscences of Frans Hals's gay figures. But in this face the laughter is not without tragic implications. We feel a philosophic superiority and a flavour of wit, but also a faint hint of senility. Bent with age, the artist stands before his easel, on which a painted half-figure is dimly visible. The suggestion has been made[1] that Rembrandt represents himself here as the laughing Democritus painting an image of the weeping Heraclitus. Whether or not this is true, the self-portrait character is dominant. Over the painter's left shoulder is draped a broad silk scarf, falling like a cascade in gleaming gold and yellow tones. The brushwork revels in bold impasto and highly spontaneous strokes, bearing eloquent witness to the old Rembrandt's technical genius.

It is only in the self-portrait of 1669, the year of Rembrandt's death, that we detect some decline in the aged artist's expressive power (fig. 30). His painterly skill has not failed him, but the psychological content shows a diminished intensity. The facial expression here is mild and slightly empty, when compared to all the others in the imposing group of late self-portraits.

SINGLE PORTRAITS

If, in addition to Rembrandt's self-portraits and group portraits, we include the large number of fanciful portraits and studies of heads, we reach the striking total of more than four hundred paintings in this category alone. This means that Rembrandt's portraiture comprises at least two-thirds of his painted work. In etching the number of portraits is smaller, but still considerable, covering approximately one-fourth of his entire output in graphic art.

The work of Van Dyck, Velazquez, and Frans Hals, as well as all the minor Dutch portraitists, consisted chiefly in the painting of commissioned portraits, with comparatively few subjects of their own choosing. With Rembrandt the opposite was true, and this, in itself, makes his position as a portraitist unique. The greater part of his output consisted in self-chosen subjects, which allowed him to indulge his pictorial fancy and enrich his imaginary world from his own experience and human contacts. To this group belong first the self-portraits just discussed. Then there is the large number of approximately seventy portraits and studies of members of Rembrandt's family, including many representations of his mother, his father, his sister, of Saskia, Titus, and Hendrickje, and also presumably his brother Adriaen and the brother's wife.

Also among the self-chosen subjects may be considered the group of more than thirty small studies of heads, mostly of older men, and including many Jewish types. Rembrandt was obviously interested in the latter as potential models for his Biblical painting. Particularly from his middle period on, while he lived on the edge

of the Jewish quarter, he became a tireless observer of his Jewish neighbours, and the Biblical scenes of this period were enlivened by genuine Oriental types and characters.

We may finally add to this group of subjects of the artist's own choosing the majority of those numerous life-sized, finished portraits (about seventy of them) which usually bear such vague titles as *Rabbi, Jew, Oriental, Old Man,* or *Old Woman,* etc. There are also some younger figures whose fanciful costume or unusual attitude place them outside the standard type of Dutch portraiture. Even allowing for a few cases where patrons might have been willing to accept the painter's suggestions as to costume and pose, or themselves asked for an allegorical disguise, the number of such commissioned portraits cannot be large. The Dutch burghers, as a rule, did not favour any deviation from the standard fashion, and this is confirmed in all the portraits by Rembrandt in which we can clearly identify the sitter.

As for the Jewish costume, there is little evidence from contemporary representations, outside of those by Rembrandt and his school, as to their style of dress and possible demands in portraiture. Apparently the Spanish Jews, who were the first of their people to come to Holland and whose cultural level was fairly high, accepted the Dutch fashion more readily than did the Polish Jews. These latter had arrived more recently and their costume and bearing retained an Oriental or half-Oriental flavour. All available facts point to the probability that it was through Rembrandt's own initiative that he portrayed most of his Jewish sitters, because of his intense interest in their appearance and their human character.

From these brief statistics we may conclude that about 270 out of an approximate total of 420 painted portraits and portrait studies were subjects of Rembrandt's own choosing. Even granting a larger proportion of commissioned works in the group of life-sized figures of Jews, rabbis, etc., there still remains a clear majority of self-chosen subjects in the artist's entire output in portraiture.[5]

While Rembrandt thus allowed himself a great deal of freedom to portray the types that interested him most, the body of his commissioned works was still large enough to expose him to the dangers which every professional portrait painter has to face. In portraiture the inventive spirit of the artist is confined within a rather narrow formula. In most cases the arrangement has to be a half-figure with a neutral background. Variations can consist only in slight changes of position; faces and hands are bound to be prominent. The emphasis on costume easily leads to superficial or routine treatment. Colour has little free play (especially in the drab Dutch costumes of Rembrandt's time). Light remains a factor of a certain flexibility and brushwork, too, can often animate the pictorial impression.

Frans Hals's success in overcoming the limitations set by portraiture and saving it from dull conventionalism, was largely due to two features. The first was his amazing emphasis upon momentary expression, causing his figures to palpitate with

life and gaiety; the second was his brilliant, impressionistic brushwork, which lent a sparkling pictorial attraction to the surfaces and heightened also the spontaneous quality of the representation.

During Rembrandt's first years in Amsterdam, when commissions for portraits poured in so fast, the young artist was not yet fully prepared to meet the dangers of routine work in this field with the same success as the great Haarlem painter. His formulas still lacked flexibility, although he at once surpassed the fashionable portraitists of Amsterdam on their own grounds. Not until his middle period did Rembrandt learn to make nearly every portrait a unique artistic performance. By that time the art of Frans Hals could offer him little inspiration. Frans Hals's strong emphasis on the momentary aspect of life was not in accord with his own concepts. In Rembrandt's mature portraits we feel, to a certain degree, the sitter's past coming into the present and even some premonition of the future. The momentary aspect, although not overlooked, is subordinate to the more comprehensive and profound visualization of man's whole existence.

Rembrandt was also unwilling to accept the spirited impressionistic treatment by which Frans Hals enlivened his surfaces. He had to go his own slow and thorough way before developing an equally free and spontaneous technique which fully expressed his own intentions. Chiaroscuro, on the other hand, Rembrandt recognized early as an appropriate means of suggesting mood and those intangible things which, for him, belonged to a full characterization of man. But this device, too, attained its full range and power only in his mature period. Then, instead of providing a general surface animation through impressionistic lighting, Rembrandt's light becomes most selective and evocative, through its peculiar interpenetration with the darks. The expressive power of the chiaroscuro in his late portraiture is best indicated by the fact that even the aged Frans Hals himself came under Rembrandt's influence in this respect. This has often been noticed in Frans Hals's latest group portraits in Haarlem.

Some of the features already anticipated in Rembrandt's earliest representations of old philosophers, done in Leyden, become in his later period more generally characteristic of his portraiture. Rembrandt had come to realize that man's true self is revealed only in moments of inner concentration and detachment from the outside world. His subjects, therefore, seem to exist in an atmosphere of their own, wrapped in silence and meditation. The richer the model's inner life, the stronger was its appeal to Rembrandt, and this, as we noticed in his Leyden period, explains his preference for old people rather than young ones. Even when his sitters turn to the spectator, as they sometimes do, for this was a most natural and common attitude in contemporary portraiture, their faces always reflect something of their inner mood. They retain, so to speak, their introvert character, even in such moments of outward distraction, and it was part of Rembrandt's rare genius to express this complex

situation subtly and convincingly. Often they seem to listen to an inner voice, giving no attention to their surroundings, and the spectator finds himself drawn gently but irresistibly into their contemplative mood.

For a portraitist of the Baroque period, Rembrandt gave comparatively little emphasis to the social standing of his subjects. It is true that Holland was not strongly imbued with the autocratic spirit and class consciousness of the century, but social distinctions were, nevertheless, clearly maintained and deeply respected. Equally slight interest he showed in the gay and uninhibited human qualities which Frans Hals brought out with such success. Rembrandt seems to have regarded the vitality directed to the outside world and its enjoyment as of little consequence beside the more passive qualities of introspection, sympathy, and humility. Whether he represented a Dutch patrician, an old Jew, or an unknown Amsterdam housewife, all of Rembrandt's most moving portraits reflect that common quality of the human soul which the great religious teachers sought to reach. Thus Rembrandt's subjects seem to form a community of their own, within the multitude of Holland's citizens as other artists portrayed them.

While Rembrandt, especially in his mature period, instinctively drew his subjects into the sphere of his own humanity, he never imposed such psychological content upon them. Subjective and objective elements in his interpretation maintained a reasonable balance, as with any great portraitist. It is true that only in his first years in Amsterdam did Rembrandt fully satisfy the Dutch burghers' taste for meticulous verisimilitude. It was not long before he began to displease many of his patrons by his increasing emphasis upon the representation of inner mood at the expense of a complete outward description. But this does not mean that the artist arbitrarily distorted the visual appearance of his sitters. He simply put a stronger emphasis upon features which to him became most essential. There is abundant evidence of Rembrandt's faithful rendering of likenesses by comparisons with portraits of the same sitters by other Dutch painters.[6] But such documentation of Rembrandt's respect for reality and his ability to grasp essential features in his subjects is hardly needed. Is there any picture in Dutch seventeenth-century painting that expresses more convincingly the outward appearance and the inner spirit of the Dutch burghers at the time of their cultural prime than Rembrandt's *Syndics*? In this group portrait alone he has told us more than any other Dutch portraitist was able to convey.

PORTRAIT painting in Amsterdam had attained a respectable level at the time when the youthful Rembrandt moved from Leyden to capture the favour of the Amsterdam public through the striking likeness and the intense illusionism in his portraits. These qualities were not wanting in the work of his forerunners; Rembrandt only enhanced and combined them with greater psychological and pictorial subtlety. There was a solid tradition of realism in Holland. Portraitists such as Nicolaes Elias

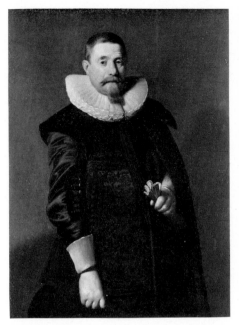 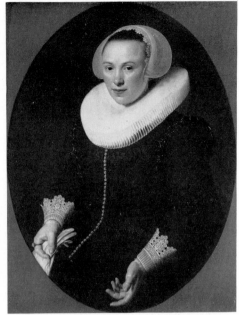

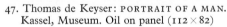

47. Thomas de Keyser: PORTRAIT OF A MAN. Kassel, Museum. Oil on panel (112 × 82)

48. Nicolaes Elias: MARIA SWARTENHOUT. 1627. Amsterdam, Rijksmuseum. Oil on panel (99 × 74)

(fig. 48) and Thomas de Keyser (fig. 47), who may be called Rembrandt's most immediate predecessors in Amsterdam, were competent draughtsmen and painters. Theirs was an unimaginative but fully descriptive style which combined the qualities of good photography with pronounced modelling and a moderate pictorial attraction. Thomas de Keyser, the younger of the two, intensified the pictorial effect by chiaroscuro accents and glossy surfaces. The deep blacks in his pictures often form an impressive contrast to the surrounding blond tones. His touch was more lively than that of Elias, giving a foretaste of Rembrandt's freer technique.

The portraits of Rembrandt's early period in Amsterdam show an even stronger illusionism than either Elias or Thomas de Keyser was able to attain (figs. 49, 50). The features are more sensitively animated and the lighting is more dramatic. The gestures of his sitters are no less conspicuous than those in portraits by his predecessors, and there is a similar meticulous description of the costume and detailed rendering of the flesh. But the treatment in Rembrandt's portraits is a little more fluid, more lively and suggestive. The position of the figures in space becomes more convincing through the competent handling of the chiaroscuro. This pictorial device creates an ambience for the figures, in which they can breathe and move. One may realize this by following the silhouette in one of these portraits, and observing how subtly the background is varied in value in order to set off the figure from its surroundings and avoid any hardness or flatness of form. Rembrandt

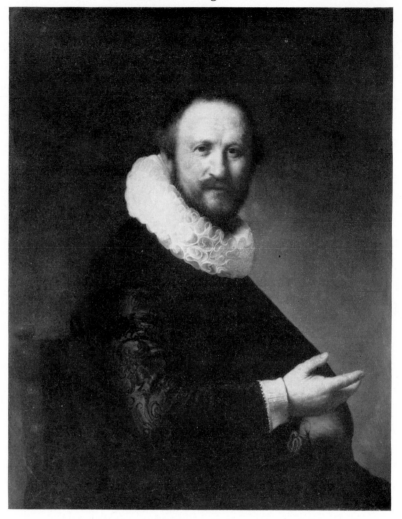

49. PORTRAIT OF A MAN. Vienna, Museum. Oil on panel (90 × 67·5)

understood also how to exploit the light and dark accents for the unification of the pictorial composition, although these early works do not show the intense integration which his later portraits do. Heads, hands, and the bright parts of the costume, such as white collars and cuffs, sometimes rival one another as centres of attraction. But how much greater is the coherence of design than in any of the portraits by Rembrandt's immediate forerunners, and how much more animated is his characterization!

Rembrandt, in these portraits, did not yet undertake to express more of the inner life than could be absorbed by a passing glance at the subject. The colours, like those in his Leyden paintings, tend toward the cool harmonies of greyish olive, pale blue and yellow, and a delicate copper red. A restrained warmth, however, begins to

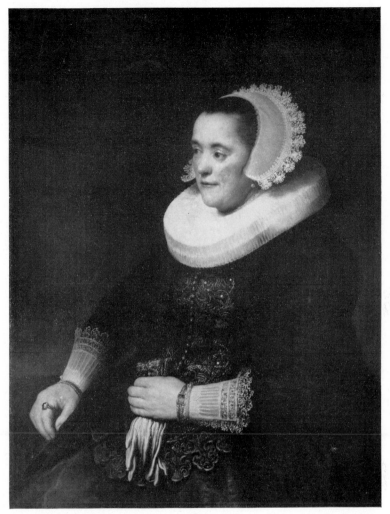

50. PORTRAIT OF A LADY SEATED. Vienna, Museum. Oil on panel (90 × 67·5)

appear in the brownish shadows. His brushwork already shows a certain range, from subtle glazing to broader impasto touches. But the glazing technique still predominates, and the paint surfaces are for the most part smooth, compared to the bold, thick strokes of his later brushwork.

The group of commissioned portraits dating from these first years in Amsterdam is very large, furnishing a clear proof of Rembrandt's unparalleled popularity at the outset of his career in the Dutch capital. Only minor variations in composition and treatment are noticeable. The oval form with half-figure or bust occurs frequently and appears to have been in vogue at this time. A number of the portraits, like those represented here, were intended as companion pieces, where the attitudes of the sitters correspond to one another. The man is always on the left and usually makes

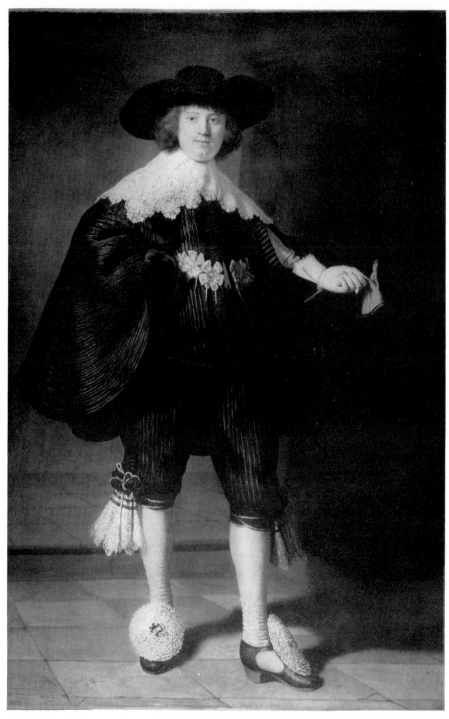

51. PORTRAIT OF MARTEN SOOLMANS. 1634. Paris, Baron Robert de Rothschild Collection.
Oil on canvas (207 × 132)

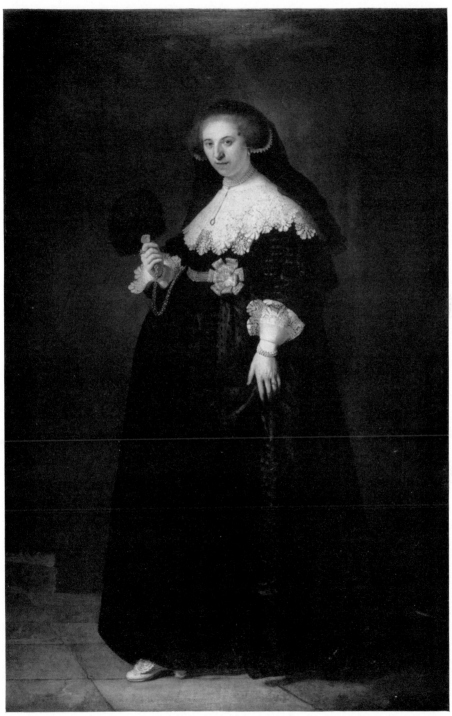

52. PORTRAIT OF OOPJEN COPPIT. 1634. Paris, Baron Robert de Rothschild Collection.
Oil on canvas (207 × 132)

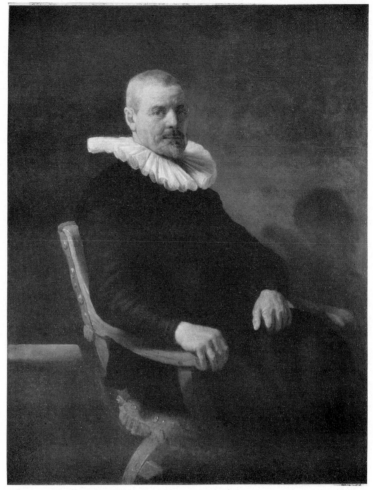

53. PORTRAIT OF A MAN SEATED IN AN ARMCHAIR. Washington, Corcoran Gallery of Art
(W. A. Clark Collection). Oil on canvas (124 × 95)

some gesture toward his wife in the other picture. Beside these half-length portraits, which are the most numerous, we find a good many three-quarter or full-length ones. As fine examples of the latter type, we reproduce here the portraits of Marten Soolmans and his wife, Oopjen Coppit,[6a] of 1634, from the collection of Baron Robert de Rothschild in Paris (figs. 51, 52). This type of standing, life-size portrait also had its tradition in Amsterdam before Rembrandt. We may look, for comparison, at Nicolaes Elias's portraits of the Burgomaster Cornelis de Graeff and his wife, now in Berlin.[7] Here again Rembrandt's advance over his forerunner is considerable, although he made no basic changes in the arrangement of the two figures. Rembrandt rendered the costumes with equal care, but he avoided the dryness of such meticulous treatment by a more vivid play of light and shade

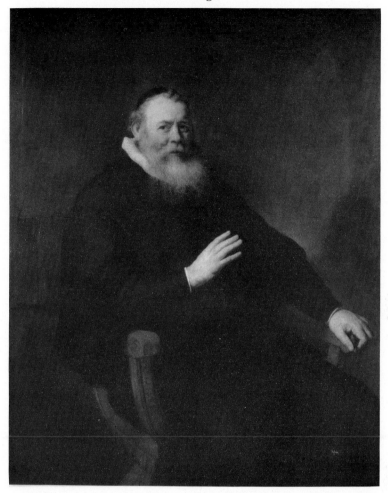

54. PORTRAIT OF THE PREACHER ELEAZAR SWALMIUS. 1637. Antwerp, Museum.
Oil on canvas (139 × 103)

and a subtle atmospheric quality which creates air and depth around the figures, enlivens the modelling, and heightens the general pictorial effect. In spite of all the emphasis upon costume in Rembrandt's early portraits, the expression already dominates, far more than in the dry co-ordination of forms which characterizes Elias's style.

As we go through the commissioned portraits of the later 1630's we find paintings such as the *Seated Man* in the Corcoran Gallery (fig. 53) or *The Preacher Eleazar Swalmius* of 1637 (fig. 54) which show a slight but significant development. The rendering of costume is still fairly explicit but is now subordinated to the chiaroscuro organization which more successfully embraces the whole composition. Thus the pictures gain in unity of pictorial design and our interest is more strongly focused on

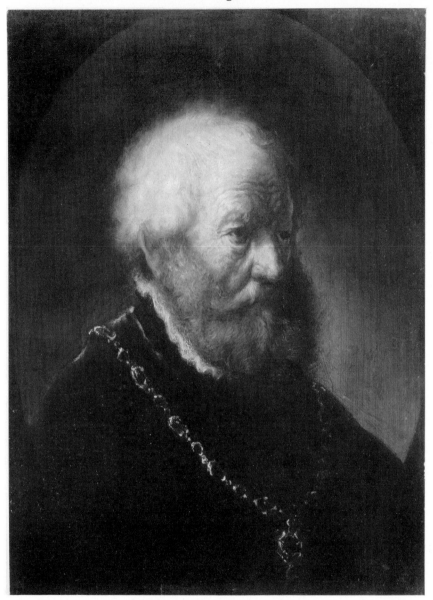

55. PORTRAIT OF AN OLD MAN. Los Angeles, Hans Cohn Collection. Oil on panel (64 × 45)

the essentials, such as the facial expression and the hands. The tonality is growing warmer and approaches the transparent blondness characteristic of Rembrandt's middle period. Obvious gestures are still to be found, as in the Swalmius portrait, but their effect is restrained by the softening quality of the enveloping atmosphere. Correspondingly the silhouettes of the figures are relieved from the slight hardness still noticeable in the earliest of his Amsterdam portraits.

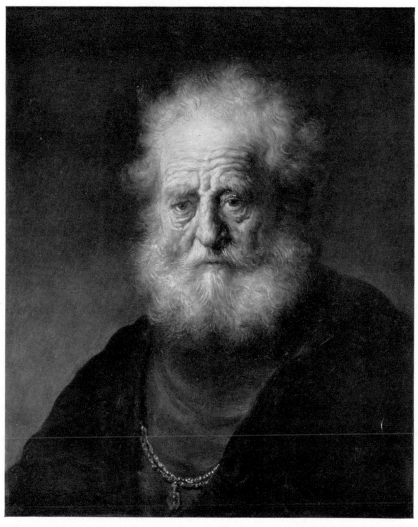

56. PORTRAIT OF AN OLD MAN. 1632. Kassel, Museum. Oil on panel (59 × 49)

There is a sizeable group of fanciful portraits and studies of heads dating from the thirties. The Jewish types do not begin to predominate until the following decade. Models of a general Oriental character were easy to find among the cosmopolitan crowds of Amsterdam. During the early years of his residence there Rembrandt seems to have discovered a number of old bearded types in his immediate neighbourhood. An impressive patriarchal head that recurs frequently in the early Biblical pictures is to be found portrayed in the panels belonging to the Hans Cohn Collection in Los Angeles (fig. 55) and to the Museum in Kassel (fig. 56), the latter dated 1632. Rembrandt has dressed the old man in a velvet mantle with a heavy gold chain. Both portraits are incisive studies in life size. The chiaroscuro is more lively

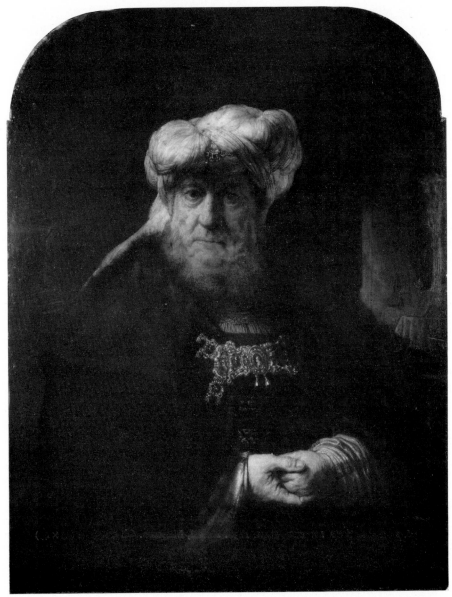

57. PORTRAIT OF AN ORIENTAL. 1633. Chatsworth, Devonshire Collection. Oil on panel (105 × 80)

here than in the commissioned portraits of the same time, the handling bolder and more spontaneous. Much of the profundity of Rembrandt's later Biblical types is anticipated in these striking characterizations.

The same model may have served for the impressive portrait of an Oriental belonging to the Devonshire Collection in Chatsworth (fig. 57). The rich attire and the elaborate jewelled clasp on the old man's cloak point to the representation of a

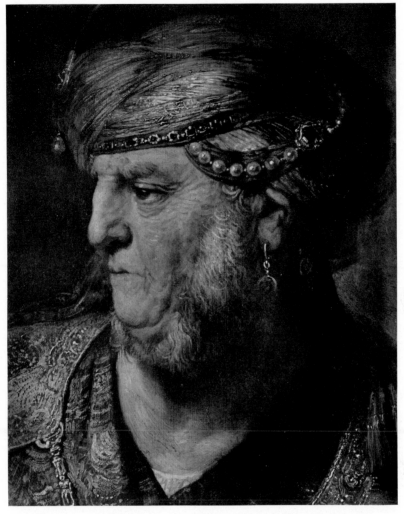

58. PORTRAIT OF AN ORIENTAL. Detail. 1633. Munich, Alte Pinakothek.
Oil on panel (86 × 64)

high priest. Perhaps it is Aaron, since the attribute of the brazen serpent is seen in the background.[8] The Baroque character is very strong in this picture, and still reflects the pompous and theatrical kind of Orientalism which Rembrandt first encountered in the art of his teacher Lastman, but which he developed to much greater power under the influence of Rubens.

Rembrandt's profile portrait of an Oriental in Munich (fig. 58) is a vivid reminder of Rubens' forceful representations of Orientals. A detail of the costume shows the unusual bravura of the brushwork, which Rembrandt would not have dared to exhibit at this time (1633) in a commissioned portrait. He even surpasses Rubens here in the bold impasto and fluidity of his technique.

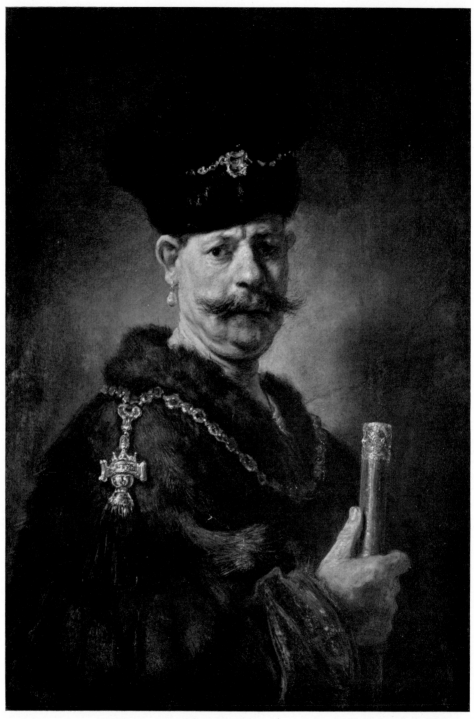

59. A POLISH NOBLEMAN. 1637. Washington, National Gallery of Art (Mellon Collection).
Oil on panel (97 × 66)

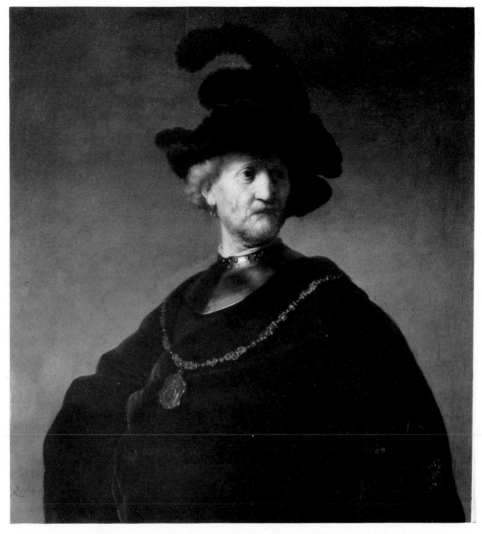

60. REMBRANDT'S FATHER. Chicago, Art Institute. Oil on canvas (81 × 75)

In all probability the portrait of a *Polish Nobleman* in Washington, of 1637 (fig. 59), is a fanciful representation rather than the actual likeness of a Slavonic prince who favoured Rembrandt with a commission. In any case, the romantic Orientalism of the young Rembrandt and his Baroque exuberance are here impressively displayed. A comparison with the fanciful portrait in Chicago, probably of the artist's father (fig. 60) and dating from the end of the Leyden period, makes it clear how Rembrandt's style, in the course of the thirties, has gained in plasticity, spaciousness, and articulation. The chiaroscuro has a more comprehensive function, is more effectively graduated, and considerably enriched by transparent half tones.

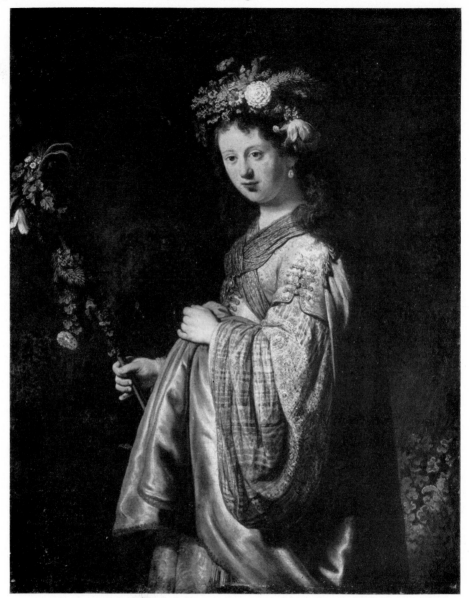

61. SASKIA AS FLORA. 1634. Leningrad, Hermitage. Oil on canvas (125 × 101)

The many portraits of Saskia give us a vivid picture of Rembrandt's romanticism and pictorial imagination during that decade. He disguised his young wife as *Bellona, Minerva,* or *Flora* (fig. 61), not to mention her appearance in numerous Biblical roles. Rembrandt thus paid tribute to the mythological and allegorical trend of the international Baroque. In many of these representations the artist overdid the Baroque pompousness and theatrical illusionism, for an enthusiastic

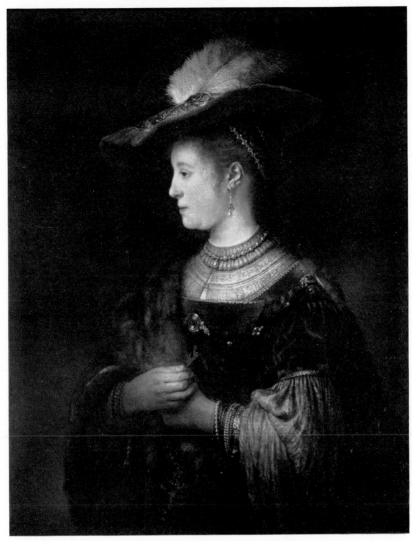

62. SASKIA. Kassel, Museum. Oil on panel (98 × 77)

temperament such as his easily led to extremes. But there are other portraits of Saskia, like the one in Kassel (fig. 62) in which we may share the artist's delight in her delicate features and the exquisite ornamentation of her rich costume. The profile view is somewhat unusual in Baroque portraiture and was perhaps suggested to Rembrandt by some Renaissance painting. The large flat hat and the style of the dress could have been derived from decorative sixteenth-century portraits in the manner of Cranach or Beham. This portrait shows Rembrandt's gentler side, where intimate and refined qualities prevail over the vulgarities of the Baroque which often carried him away in this period of material success.

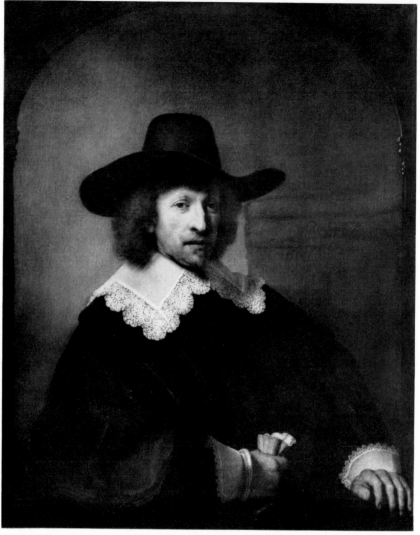

63. PORTRAIT OF NICOLAAS VAN BAMBEEK. 1641. Brussels, Museum. Oil on canvas (105 × 83)

The portraits dating from the beginning of Rembrandt's middle period frequently show an extraordinary sensitiveness, both psychologically and pictorially. We reproduce as examples the companion pictures of 1641 of a *Gentleman with Gloves* in Brussels (fig. 63) and a *Lady with a Fan* in Buckingham Palace (fig. 64) which have recently been identified as Nicolaas van Bambeek and his wife Agatha Bas.[8a] It seems that in this middle period sensitiveness became the dominating feature and the artist refrained intentionally from more forceful accents. There are exceptions, such as the *Night Watch* in particular, for Rembrandt's rich and vital nature demanded a wide range of expression. But most of his single portraits, as well as his

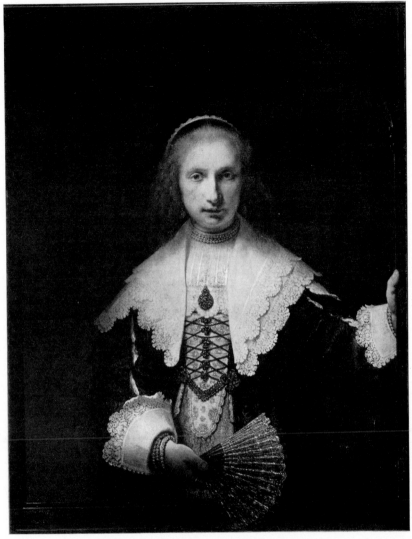

64. PORTRAIT OF AGATHA BAS. 1641. London, Buckingham Palace. Oil on canvas (104·5 × 85).
Reproduced by gracious permission of Her Majesty The Queen.

fine landscape drawings and etchings, in this period exhibit primarily a quality of sensitiveness along with a remarkable sincerity and truth to life. A transparent blond tonality and a chiaroscuro which is enriched in its middle values by more subtle gradations, form adequate means of expressing this new tendency. The effect of spaciousness is increased, not only through the placing of the figures within a window frame—a favourite device of Baroque illusionism—but even more through the fine atmospheric quality which is now displayed. The architectural framing also adds a new feeling for the significance of the surface plane and imbues the composition with a higher degree of stability and balance.

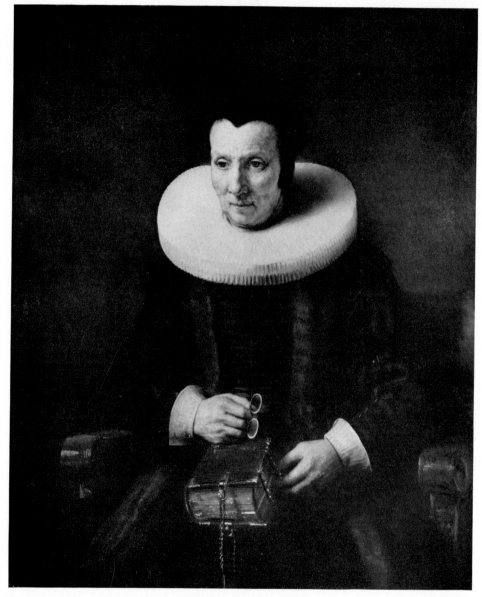

65. AN OLD LADY WITH A BOOK. 164(7). Washington, National Gallery of Art (Mellon Collection). Oil on canvas (109 × 91)

Among Rembrandt's pupils Ferdinand Bol was particularly inspired by his master's style of the late thirties and early forties. His portraits at times come deceptively close to those of Rembrandt in the tonality, the meditative mood of the sitter, and in a certain tenderness of characterization. But closer scrutiny reveals that even this gifted pupil could not attain his master's level. The individuality of Bol's sitter is only vaguely expressed. His chiaroscuro is less articulate and does not sufficiently

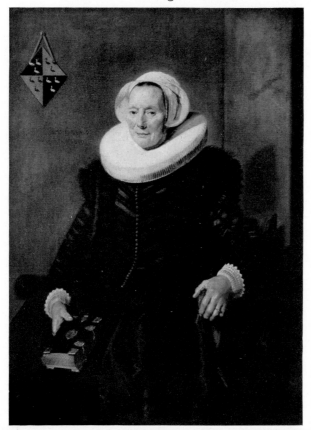

66. Frans Hals: PORTRAIT OF MARITGE VOOGT. 1639. Amsterdam, Rijksmuseum.
Oil on canvas (126·5 × 93)

clarify the solidity of the form or the relationship of figure and space. While Rembrandt achieves a complex balance between the two- and three-dimensional aspects of the composition, with every form in its proper place, Bol's figure lacks that sureness of position and runs into flatness at the contours.

The portrait of an old lady in an armchair, with a Bible on her lap, dated 164[7] and now in Washington (fig. 65), confirms the growth of a tectonic tendency in Rembrandt's compositions of the forties. This tendency remains subdued, however, in relation to the chiaroscuro which organizes the whole with a higher economy than before. There is also an increased emphasis on character, mood, and expression. In this case the comparison with a portrait by Frans Hals of a similar subject may be of interest. Frans Hals's portrait of Maritge Voogt in Amsterdam (fig. 66) clearly shows a more extrovert attitude. The composition has little of Rembrandt's quiet stability but exhibits a daring movement that darts over the surface with swift diagonal accents. Frans Hals thus creates a high degree of momentary animation and produces a brilliant surface life in the salient passages.

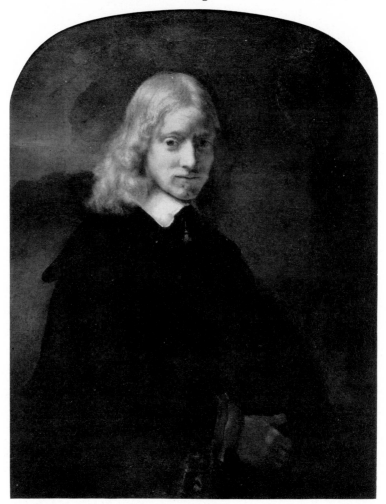

67. PORTRAIT OF A MAN (Clement de Jonghe?). Buscot Park, Lord Faringdon.
Oil on canvas (92·5 × 73·5)

Rembrandt, as we have said, is less interested in such momentary impressions or such vivid surface animation. With his figure he creates a centre of physical and spiritual gravity, while the surrounding space and atmosphere play an important part in the full suggestion of his sitter's existence. Rembrandt's portraits of this decade demonstrate the manner in which the atmosphere gains a double function and a double meaning. It fills the space with light and air but it also contributes essentially to the suggestion of inner mood and thought, and thus has a symbolic as well as a visual significance.

The commissioned portraits of the early fifties include some of Rembrandt's greatest works, such as the portrait of a young gentleman (Clement de Jonghe?) at Buscot Park (fig. 67), that of Nicolaes Bruyningh in Kassel, 1652 (fig. 68), and the

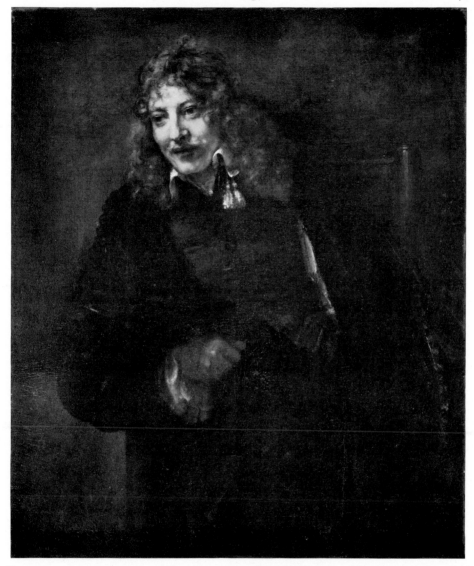

68. PORTRAIT OF NICOLAES BRUYNINGH. 1652. Kassel, Museum. Oil on canvas (92·5 × 73·5)

famous Jan Six portrait of 1654, in the Six Collection in Amsterdam (fig. 69). Rembrandt at this phase has deepened the tonality of his chiaroscuro. He has intensified the whites and the blacks, while the browns, reds, and yellows have gained in warmth. In the portrait of Jan Six the colouristic splendour dominates over the chiaroscuro effect. The patrician wears a grey coat with gold buttons. A scarlet, gold-braided mantle is casually thrown over his shoulder. The greys form a beautiful contrast with this bright red, and the touches of golden yellow enliven the pictorial harmony. In all three paintings, but particularly in the Jan Six, we observe a new

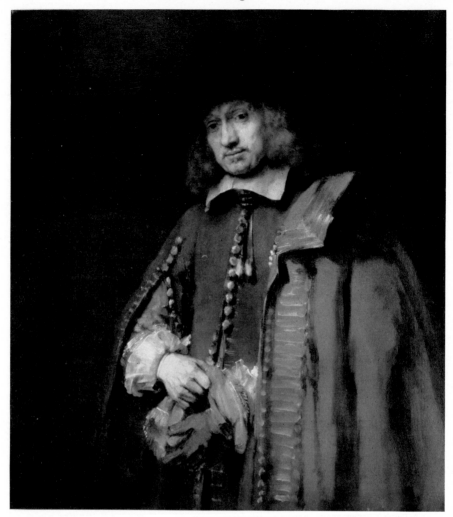

69. PORTRAIT OF JAN SIX. 1654. Amsterdam, Six Foundation.
Oil on canvas (112 × 102)

charm of texture which is due to Rembrandt's forceful and expressive brushwork, with bold impasto in the highlights and a rich play of values surrounding them.

Although these portraits vary considerably in attitude and composition, they have in common the meditative mood and spiritual flavour which distinguish Rembrandt's mature works. All three sitters are wrapped in their own thoughts, from which they do not fully emerge even when their glance is directed to the spectator or to some person nearby. The play of light around the faces is incredibly subtle and evocative, leading imperceptibly from the tangible to the intangible, and stirring our imagination as to the sitters' innermost thoughts and feelings. Neumann interprets Jan Six's expression as follows: 'This man's mind is full of thoughts. He is about to go

70. Bartholomeus van der Helst: PORTRAIT OF PAULUS POTTER. 1654.
The Hague, Mauritshuis. Oil on canvas (98·5 × 79·5)

out among the people, perhaps to the Town Hall; there pass before him, as in a dream, all those with whom he regularly deals. He listens to their words, and divines also their more secret thoughts and interests, of which they do not speak. And as all this crowds before him, a reflective, somewhat melancholy smile comes into his eyes; an other-worldly and penetrating look plays over his features. There is a trace, too, of the sympathetic kindness of the detached bystander, forming altogether a complexity of expression which seems inexhaustible, and is not met with in any other portrait in the world.'[9]

Whether or not we accept this biographer's spirited interpretation in detail, what he sees in the portrait of Six confirms the suggestive power of Rembrandt's characterization, completely lacking in the typical Dutch portrait of the day (fig. 70). The Bruyningh portrait has as much, if not more, of this same magic quality. The pensive smile of this young patrician is unforgettable; his face glows with human warmth and intellectual refinement. How different it is from Frans Hals's robust laughter

71. PORTRAIT OF A GENTLEMAN WITH A TALL HAT AND GLOVES. Washington, National Gallery
of Art (Widener Collection). Oil on canvas (99·5 × 82·5)

or from the inscrutable smile of Leonardo's Gioconda! Yet, like Leonardo's por-
trait, the Bruyningh retains the mystery of a great masterwork, together with an
unsurpassable perfection.

The portraits of Rembrandt's last ten years show a still further increase in power
of characterization, in breadth of composition, and pictorial treatment. Among
those which were obviously commissioned, the pair of portraits from the Yous-
soupoff Collection, now in Washington, is outstanding in quality and beauty (figs.
71, 72). The preservation seems good except for the lower right corner of the man's

72. PORTRAIT OF A LADY WITH AN OSTRICH-FEATHER FAN. Washington, National Gallery of Art (Widener Collection). Oil on canvas (99 × 82·5)

portrait, where his hand shows a roughness of surface that is not Rembrandt's work and may result from an early restoration. But this does not impair the general effect of the picture, which is overwhelmingly impressive.

Rembrandt has not deviated from the standard arrangement in companion portraits. There is the familiar three-quarter position of the husband as he turns toward his wife and makes a gesture with his right hand in her direction; her frontal attitude is the same as we have seen in earlier examples. But the figures here are given greater significance through an increase in size, further suppression of

73. Johannes Verspronck: PORTRAIT OF ANDRÉ DE VILLEPONTOUX. 1651.
The Hague, van Bruegel Douglas Collection

detail, and more powerful accent on the essentials. Directness of portrayal is combined with sensitive restraint; bold presentation with a suggestion of remoteness. The intensified chiaroscuro, with strong whites and blacks and warm brown shadows, the atmosphere which bathes all the forms, and the vibrating quality of the surfaces are responsible for this complex, almost miraculous effect.

The composition shows an architectonic power in the building up of the design. The placing of the forms in broad frontality and close to the spectator strengthens the front plane and heightens the monumental effect. The receding planes are artfully adjusted to parallel positions. Rembrandt may have learned this device from the Italian Renaissance, but we are not made conscious of the structure of the spatial composition, for the transitions from one plane to another are extraordinarily subtle and natural. The chiaroscuro creates a relationship of values which also serves to bind the different planes together. Another feature of these late portraits which recalls certain Renaissance figures is their grave dignity, although this differs rather

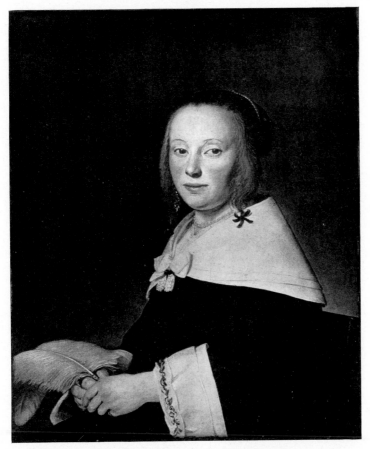

74. Johannes Verspronck: PORTRAIT OF MARIA HAMIEUX. 1651.
The Hague, van Bruegel Douglas Collection

from the classic ideal which the great Italian portraitists sought to express. In a portrait by Titian we feel that man relies fully upon his own resources, and derives his dignity from a consciousness of his own value. The dignity of Rembrandt's subjects, even persons like these, of high social standing, seems to emanate from a sense of humility rather than heroic self-assurance, from an inner disposition to accept life in a charitable and sympathetic spirit. This does not exclude the subtle differentiation to be found in this pair, between the virile and active nature of the man and the more passive and contemplative one of the woman.

Rembrandt's subjects often show a spirit that is akin to the ideals of Puritanism. But there is still a wide gulf between the all-embracing humanity of Rembrandt and that combination of moral integrity and outward cleanliness which many Dutch painters exhibit in their portraits and which seems a more typical expression of the Dutch Calvinism of Rembrandt's time. Two portraits by the competent Haarlem painter, Johannes Verspronck, may illustrate this point (figs. 73, 74). A comparison

75. PORTRAIT OF A MAN WITH A MAGNIFYING GLASS. New York, Metropolitan Museum.
Oil on canvas (93 × 73)

leaves no doubt that Rembrandt rose far above the pedantry, sobriety, and narrow-
ness of the average Dutch attitude. His freer and more universal nature embraced
not only daily life but the mystery of human existence as well.

The element of mystery is often enhanced in Rembrandt's portraits of his own
choice, or those in which the sitters allowed him to indulge his romantic and pic-
torial fancy. Such portraits are the *Man with a Magnifying Glass* and the *Woman*

76. PORTRAIT OF A LADY WITH A PINK. New York, Metropolitan Museum.
Oil on canvas (92 × 74)

with a Pink, both in the Metropolitan Museum (figs. 75, 76), and obviously dating from Rembrandt's latest period. Whether or not this pair represents the distinguished Portuguese Jew, Miguel de Barrios, and his wife, Abiguel de Piña, as J. Zwarts suggested,[10] is difficult to determine. There is some doubt about this identification, but from the facial types and the exotic costumes, it seems probable that here are represented Jewish people of the upper class, with whom Rembrandt was

in close contact, and who allowed the artist considerable freedom in portraying them. There is even more freedom shown in the other more famous double portrait of the same couple as a bridal pair, the so-called *Jewish Bride* in Amsterdam (fig. 112). In this picture both persons appear slightly younger, and their unusual attitudes can be properly explained only as an allusion to some Biblical story. Rembrandt had portrayed the man alone at an earlier date (1659) in the fine oil sketch (Br. 296) of the Bache Collection, now also in the Metropolitan Museum. There he wears the same large hat as in the *Jewish Bride* and his mantle is thrown over his shoulder in the fashion popular in the early Louis XIV period.

The companion portraits in the Metropolitan Museum show, in their relation to each other, some deviation from the standard type of companion portraits. The woman's figure is seen almost in profile, as she faces her husband, and her head is inclined in his direction. The position of the man's right hand might be interpreted as pointing to the woman in the traditional way, but its main function here is to hold a magnifying glass. Moreover, the hand is unusually inconspicuous by the absence of any light accent. The concentration upon facial expression is even stronger than in the Youssoupoff portraits. The heads emerge from the surrounding darkness with a mysterious glow, and the meditative gaze of the eyes expresses the limit of inner absorption. The luminous red and gold, particularly in the woman's costume and jewellery, adds to the exotic romanticism of these portraits. The emotional impact, never surpassed by Rembrandt, finds adequate expression in the richness and the subtlety of the pictorial performance.

Among the self-chosen portraits of Rembrandt's middle and late periods, the group representing the members of his family and household is again very large, as it had been during his early years. Like the self-portraits, these studies are not only striking works of art, but also documents of the artist's life and surroundings. Because of the interest these family portraits hold for us, however, it is easy to overestimate their significance as authentic records of the appearance and character of Rembrandt's closest associates. This we must guard against, in view of the complex and profound aims in the mature Rembrandt's art. Since this group of pictures imposed few restrictions upon the artist's pictorial fancy, it is doubtful whether all of them can be classified strictly within the category of portraiture. Often they slip into the representation of genre subjects or serve as Biblical or mythological figures with the portrait character subdued. We shall limit our considerations here to those cases in which the portrait qualities predominate.

From 1645–7 we find a group of genre-like portraits and studies, all representing the same model, a young girl who obviously belonged at that time to Rembrandt's household. Valentiner's identification of this girl as the youthful Hendrickje[11] has not met with general acceptance. Her features show some similarity to those in later, unquestioned portraits of Hendrickje, but she seems hardly more than a child, while

77. YOUNG GIRL LEANING ON A WINDOW-SILL. 1645. London, Dulwich College Gallery.
Oil on canvas (77·5 × 62·5)

Hendrickje was at this time about twenty years of age.[12] A picture in Edinburgh
representing Hendrickje in bed, drawing aside the curtain (fig. 83), shows how she
looked at the end of the 1640's, a fully matured young woman. But the young girl so
frequently represented in 1645–7, even though not Hendrickje, interests us as one
of the models Rembrandt chose from his immediate surroundings. In the charming
picture at Dulwich College, dated 1645 (fig. 77), she leans out of a window and looks
at the spectator with shy naïveté. Rembrandt has here transformed an ordinary genre
motif of Dutch art into a portrait with deep psychological content. A comparison
with similar subjects by Gerard Dou, Nicolaes Maes, or other Dutch genre painters
immediately brings out Rembrandt's greater naturalness of conception. One again
realizes his unique ability to focus interest upon the inner life of his subjects, even

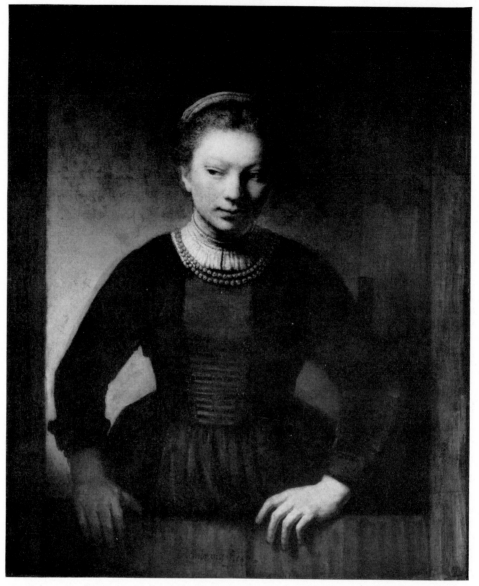

78. YOUNG GIRL AT A HALF DOOR. 1645. Chicago, Art Institute. Oil on canvas (100 × 84)

in as young a model as this girl. Both composition and chiaroscuro serve this pur-
pose, affording a natural yet forceful concentration on the girl's face. While the
window-sill guides the eye into the depth of space, the left arm leads, in the second
plane, to the girl's head which is slightly subdued beside the brightly illuminated
left shoulder and upper arm in the front plane. We have repeatedly observed how
Rembrandt reserved the most subtle play of half tones for the revelation of inner life
in the faces.

79. HEAD OF A YOUNG GIRL. New York, Sydney J. Lamon Collection.
Oil on panel (26 × 21)

The same girl is represented in another genre-like portrait in Chicago, also dated 1645 (fig. 78). Here she looks out through the opened upper half of a door, with her hands resting on the lower part. In this picture Rembrandt has created an interesting chiaroscuro pattern by silhouetting the figure against a lighter background. Through the openings under the girl's slightly bent arms, this silhouette gains an ornate Baroque quality. But again it is the mood of the girl that dominates, and light and dark accents are primarily organized for this purpose.

Rembrandt frequently used the features of this girl for figures in his religious pictures. There is the study for the head of the Madonna in the *Holy Family* of the Hermitage, 1645 (fig. 163), where the girl is shown bending forward and looking toward the lower left corner. There is another lively and charming study of this girl seen from the side, as she turns suddenly toward the spectator without losing that genuine introspective quality that is common to most of Rembrandt's heads (fig. 79). This forceful and, at the same time, subtle study gives a foretaste of Rembrandt's later bold technique in its broad brush strokes and the delicate glazing of its half tones. It served as a model for one of the figures in Rembrandt's lost *Circumcision* of 1646, which we know only from an old copy in the Museum in Brunswick. The

80. GIRL WITH A BROOM. 165(1). Washington, National Gallery of Art (Mellon Collection).
Oil on canvas (107 × 91)

original was painted for Prince Frederick Henry of the Netherlands, along with the *Adoration of the Shepherds* (Br. 574) of the same year, now in Munich.

There is finally the half-figure of a nude girl in Bayonne (Br. 372) which served as model for the *Susanna and the Elders* of 1647 in Berlin. All these studies are done on small panels, not over ten inches in height. Rembrandt seems to have preferred panels for preliminary oil studies of heads, and since Frans Hals did the same, we may assume that it was a workshop habit of the period.

81. YOUNG GIRL AT A WINDOW. 1651. Stockholm, National Museum. Oil on canvas (78 × 63)

The *Girl with a Broom* in Washington, 165[1] (fig. 80), and the *Girl at a Window* in Stockholm, 1651 (fig. 81), also show a resemblance to Hendrickje but cannot be so identified, since Hendrickje was at this time twenty-five years old. The model in these pictures is hardly older than fifteen. She was, in all probability, another young helper in Rembrandt's household, as the girl of the Dulwich picture had been six years before. In the meantime Hendrickje had advanced to the role of a *huisfrouw* and could claim such help for her housekeeping.[13] In the Washington painting the girl with a broom in her arms leans heavily on a wooden fence by a well, while the empty bucket lies overturned in the lower right corner. Its slanting position forms a contrast to the vigorous diagonal of the broomstick, with both these accents contributing to the spatial articulation and bringing an element of balanced movement into the composition. The red of the girl's bodice and the gold tones in her hair and in the bucket add to the harmony of the pictorial performance. One wonders

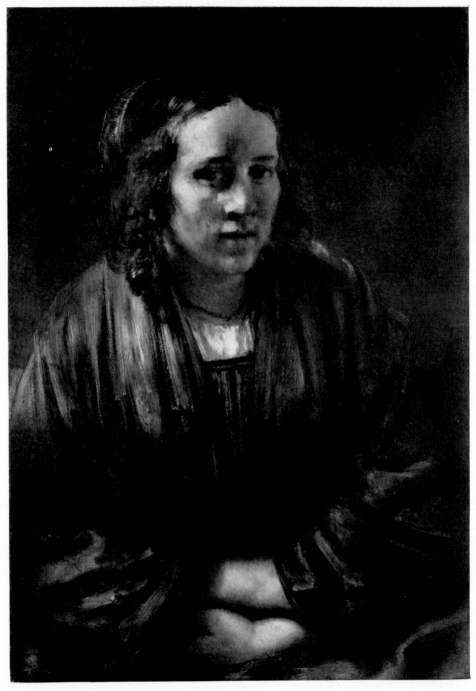

82. HENDRICKJE STOFFELS. Bundesrepublik Deutschland, Bundesschatzministerium.
Exhibited in Munich, Alte Pinakothek. Oil on panel (72·5 × 51·5)

how Rembrandt was able to weave so much mystery about so trivial a motif from daily life. But to him life was significant and mysterious in all its spheres. Again it is the human content that speaks to us first through the girl's large and deeply shadowed eyes. They betray the slightly sorrowful mood of a child who bears the burden of heavy daily duties. In the Stockholm picture the same girl appears a little less downcast as she looks meditatively out at the spectator. The scarlet of her dress is strikingly set against the warm brown darkness of the background, and the impasto white at her neck separates the rosy flesh tones from the intense red of her garment. The painting has all the freshness of an immediate study from life. Were it not that the date of 1651 excludes Hendrickje as the subject, one might accept this identification on the basis of a close facial resemblance to Hendrickje's later, unquestioned portraits.

The series of portraits of Hendrickje Stoffels begins in 164[9] with the Edinburgh painting of her in bed, already mentioned (fig. 83). The motif recalls the *Danaë* of 1636 (fig. 237) where, however, the woman (in that case Saskia) appeared as a full nude, and showed a more unrestrained joy and vivacity. Here the composition seems too compact to allow a freer and more graceful movement. Even though the picture does not belong among the most spirited representations of Hendrickje, it shows an admirable fullness of form and considerable success in mastering her difficult posture. Her head comes forward into the centre of the picture, and all else seems to be arranged in order to heighten the interest in this focal point.

The portraits of Hendrickje in the Louvre, in Munich (formerly von Mendelssohn Collection), and in Berlin represent Rembrandt's second wife, as we may call her, more impressively. In these paintings the artist has lent dignity and womanly charm to her appearance. If she was of humble origin, as Houbraken reports, and as we must assume of one who served as a housemaid, these pictures betray nothing vulgar about her. Of course Hendrickje is less elegant and animated than Saskia, but her portraits reveal the warmheartedness and human sympathy that meant so much to Rembrandt's ardent and often temperamental nature.

A document of 1652[14] records the burial of a child of Rembrandt's. This was probably Hendrickje's first child, and the date is approximately that of her portrait in the Louvre (fig. 28), in which a slight sadness may be detected in her expressive dark eyes. The painter has adorned Hendrickje with precious jewellery and a glittering brocade garment, but all this material splendour remains subordinate to the impression of the woman's humanity and tenderness of feeling. Rembrandt's advanced style begins to manifest itself in the broad frontality of the representation, in the fullness of form and simplicity of composition.

In the Munich portrait, of about 1658, and the one in Berlin, of 1659, Hendrickje appears in full maturity, aged about thirty-two. The former portrait (fig. 82)

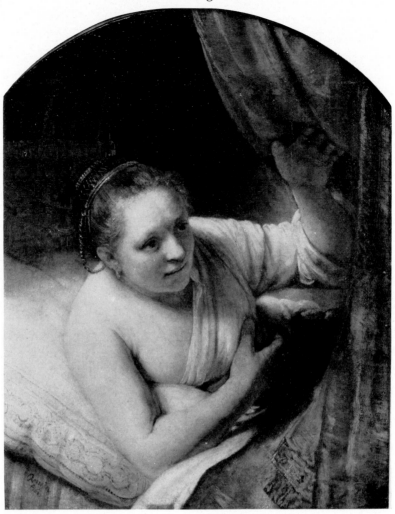

83. HENDRICKJE STOFFELS IN BED. 164(9). Edinburgh, National Gallery.
Oil on canvas (81 × 67)

is distinguished by a subdued tonality,[15] and a highly sensitive mood is reflected in Hendrickje's half-shadowed face. In the Berlin portrait (fig. 84) the paint is more vigorously applied and the colours are deeper. Here is the mature Rembrandt's favourite harmony—red, gold, black, and white—set against a dark brown background. The composition presents a most fortunate combination of architectural firmness—introduced by the window frame and strengthened by the position of Hendrickje's arms—and easy naturalness, conveyed by the convincing relaxation of the woman's body and the rather strong inclination of her head. The graceful black necklace forms a corresponding curve and at the same time heightens by contrast the luminosity of the flesh tones.

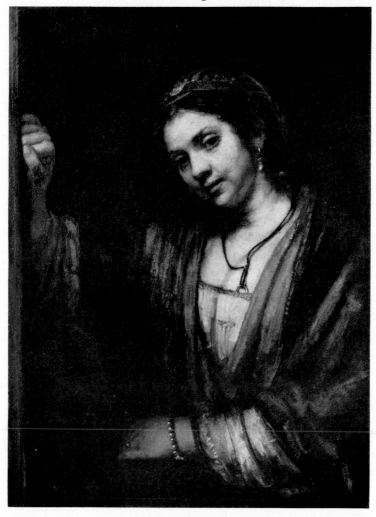

84. HENDRICKJE STOFFELS AT A WINDOW. Berlin-Dahlem, Staatliche Museen.
Oil on canvas (86 × 65)

The remarkable pictures of Hendrickje as *Flora,* in the Metropolitan, as *Bath-sheba,* in the Louvre, and as *Woman Bathing,* in the London National Gallery, do not fall strictly within the category of portraiture. But something of Hendrickje's personality is always revealed, whether she is represented as a nude or in allegorical disguise. The *Venus Embracing Cupid,* in the Louvre, has more of the portrait about it (fig. 85). The date of 1662 has been suggested by most authorities, but if the Cupid bears the features of Rembrandt's daughter Cornelia, it must be an earlier likeness of the child, for in that year she was eight years old. The painting has all the breadth of Rembrandt's late style; a detail such as the placing of the hands is characteristic.[16] The problem of combining portraiture with a mythological subject is not, in this

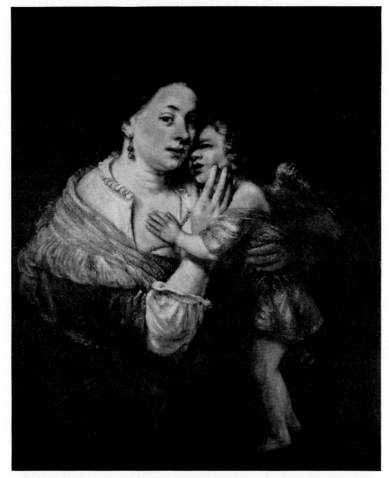

85. HENDRICKJE STOFFELS AS VENUS. Paris, Louvre.
Oil on canvas (110 × 88)

case, very successfully solved, although the picture holds our attention as a work of
the mature Rembrandt's brush.

Far more moving is Hendrickje's portrait of 1660 in the Metropolitan Museum
(fig. 86). It is possible that this picture was intended as a companion piece to Rem-
brandt's self-portrait of the same year, also in the Metropolitan (Br. 54). The
measurements are approximately the same. The portrait of Hendrickje shows her
leaning forward and to the side, her head bowed in deep contemplation. A brown
mantle trimmed with reddish fur is thrown over her shoulders and glitters here and
there with golden lights. This thinly painted portrait, with its luminous flesh tones
and the deep, dark accents of the eyes has the freshness of a study. It has been said
that Hendrickje's expression here betrays a presentiment of her approaching end.[17]
Such an interpretation may go too far, but something of the corporeal quality in

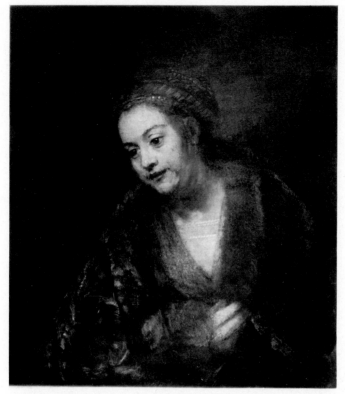

86. HENDRICKJE STOFFELS. 1660. New York, Metropolitan Museum.
Oil on canvas (76 × 67)

Hendrickje's earlier portraits has disappeared in this last study of her. More than all the others, it shows Rembrandt's unsurpassed ability to express a profound mood.

Next to Hendrickje, the most frequently portrayed subject of Rembrandt's later years was his son Titus. As the only surviving child of Saskia, Titus had a natural claim upon his father's affection, and the portraits of him seem to represent a boy of lovable nature. He had inherited something of Rembrandt's artistic disposition and sensitiveness,[18] enabling him to carry on the family art business for the support of his ageing father. His death at the early age of twenty-seven supports the assumption that Titus suffered the fate that has befallen many great men's sons, who often seem to lack the vitality to lead full lives of their own. However, there is no sign of morbidity in Rembrandt's portraits of Titus, except in the latest one, where he appears to be about twenty.

Titus' identity is fairly well established by a continuous series of painted portraits dating from 1655 to 1660, in which the boy's resemblance to his father is striking. Unmistakably related to these paintings is the etching of Titus (H. 261, fig. 27) which must be the one described as *Titus conterfeytsel*[19] in Clement de Jonghe's

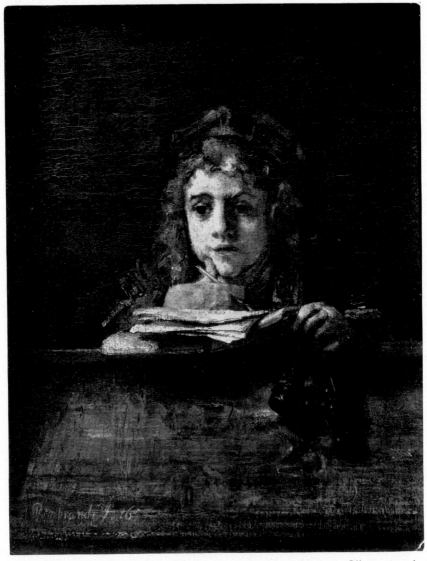

87. TITUS AT A DESK. 1655. Rotterdam, Boymans-van Beuningen Museum. Oil on canvas (77 × 63)

inventory. Since Clement de Jonghe was Rembrandt's publisher, his titles for the individual etchings may be accepted as fairly reliable. If we concentrate upon the clearly identifiable portraits and avoid doubtful ones,[20] we may gain a very distinct impression of Titus' features and of his character. His face was proportioned like his father's. He also inherited Rembrandt's broad nose, while his expressive dark eyes and his clearly marked eyebrows were his own. His hair was chestnut brown, falling in heavy locks; it shines in the portraits with a golden tint in the highlights. At times he seems to resemble Hendrickje rather than Saskia.

88. TITUS DRAWING. Dresden, Print Room. Drawing (18·2 × 14)

The portrait belonging to the Boymans-van Beuningen Museum in Rotterdam (fig. 87), dated 1655, is the earliest of the clearly identifiable ones.[21] The thirteen-year-old Titus faces the spectator here as he sits behind a high desk and gazes out at something he is drawing. He is still a child, but his glance shows a contemplative mood that seems beyond his years. The light centres in the middle of the picture, on the boy's face, his right hand, and the papers before him. Attention is particularly drawn to his large dreamy eyes. The golden brown of his hair, the dull red of cap and sleeves, and the green in his coat build up a pleasing harmony of colours, with an accent of black in the ink-container that dangles from his left hand. A remarkable pictorial performance is the subdued play of cool and warm tones in the broad side of the desk, adding to the charm of this painting.

Titus as a young draughtsman is also the subject of a drawing in Dresden (fig. 88),

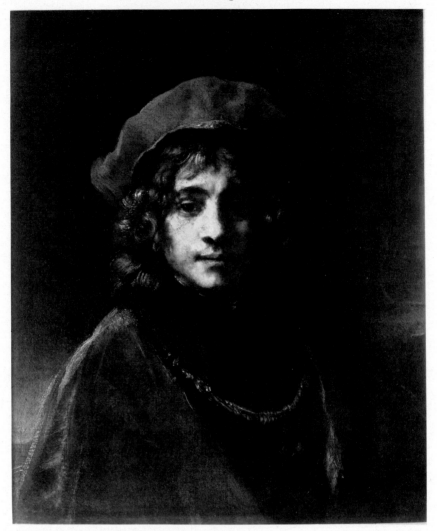

89. TITUS. London, Wallace Collection. Oil on canvas (67·5 × 61)

which Valentiner dates in the same year as the Rotterdam Museum painting. The boy is seated on a thick cushion, at the same high desk, but this time in profile and full-figure. He is deeply absorbed in his work. His broad-brimmed hat seems somewhat over-large, but this was the Dutch fashion. The drawing is done in the broad and swift manner of Rembrandt's advanced penmanship, and catches the momentary life of the subject while forming a composition of great clarity and expressiveness.

The portraits in the Wallace Collection (fig. 89) and in Vienna (fig. 90) follow at intervals of about two years. The Wallace painting shows Titus at about fifteen, in a frontal view with a yellow-brown mantle, a gold chain, and red beret; in the Vienna

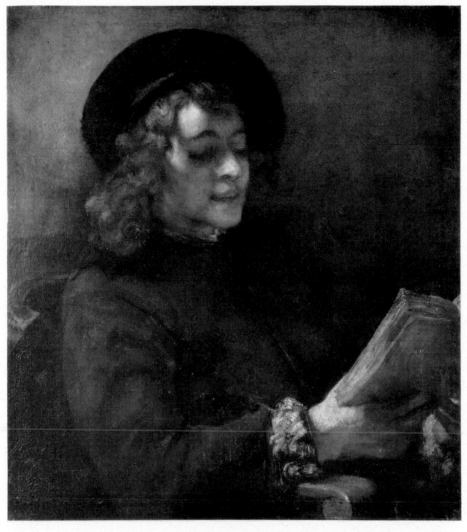

90. TITUS READING. Vienna, Museum. Oil on canvas (70·5 × 64)

portrait, where he is seen seated and reading, in a three-quarter profile position, he may be seventeen. Both give a very attractive impression of Titus' appearance and character at this age. The earlier of the two reflects the boy's keen good nature in his open gaze and sensitive mouth; the other, through the charm of Rembrandt's pictorial interpretation, suggests his absorption and pleasure in his reading.

In the Baltimore portrait of 1660 (fig. 91), the nineteen-year-old Titus appears in a relaxed and very informal attitude, leaning on his elbow in an ample armchair and supporting his chin in his right hand. The angle of his large, dark velvet beret repeats the diagonal direction of the supporting arm. Attention is again focused on the illuminated centre of the picture, on Titus' face and hand, but the subdued light

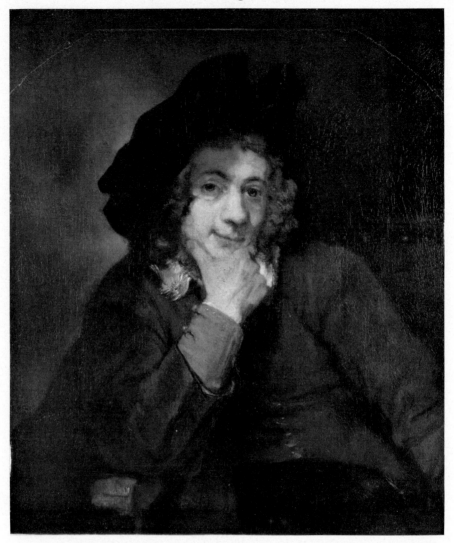

91. TITUS. 1660. Baltimore, Museum of Art (Mary Frick Jacobs Collection). Oil on canvas (71·5 × 67)

behind his dark silhouette is needed for the full spatial articulation, and adds also to the richness of the chiaroscuro pattern. This portrait has a remarkably lifelike quality; Titus seems to respond vividly and sympathetically to the presence of his father.[22]

All the more surprising, therefore, is the portrait in the Rijksmuseum, Amsterdam (on loan from the Louvre) (fig. 92), which Valentiner and Hofstede de Groot place also in the year 1660. Titus almost frightens us here by his ghostlike appearance. His face is pale and emaciated, and the melancholy of his great dark eyes lends to the picture an impression of overpowering tragedy. Although Titus lived

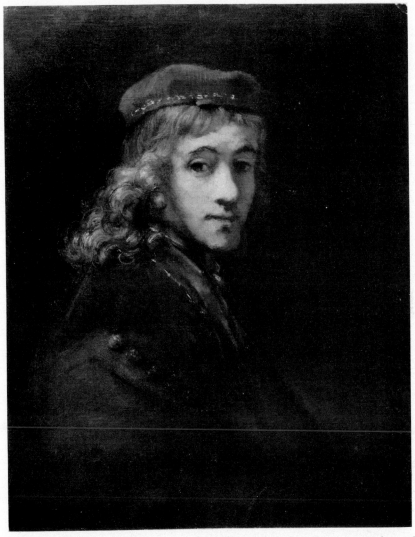

92. TITUS. Amsterdam, Rijksmuseum (on loan from the Louvre). Oil on canvas (72 × 56)

until 1668, this may well be the last portrait we have of him; none later has been identified with certainty.

There are two more models who were repeatedly represented from 1650–4. They have been called Rembrandt's older brother Adriaen and his wife, Elisabeth Simonsdr. van Leeuwen.[23] Some doubt has been cast upon this identification, however, by the arguments that Rembrandt's brother Adriaen was a poor shoemaker in Leyden while the artist was working in Amsterdam, and that he died in 1652 whereas one of the portraits is dated 1654.[24] Without further documentary evidence no definite answer can be given to these questions. But the fact remains that these two

models were frequently used by Rembrandt (and by his pupils)[25] and must have been as easily available as members of his family or his household. The man seems close to sixty, the woman not much younger. The virile and weather-beaten features of the so-called Adriaen appear in one of Rembrandt's most famous paintings, the *Man with the Gilt Helmet* (fig. 93). The old warrior of this portrait might almost be taken for the pious Roman captain of the Crucifixion scene. And the thoughtful and devout expression of the woman as Rembrandt portrayed her suggests that he associated her with some Biblical prophetess or matriarch.

The *Man with the Gilt Helmet*, in Berlin, rightly deserves its fame. A few words cannot do justice to this masterpiece, which modern critics have especially praised for the boldness of Rembrandt's technique in the powerful impasto of the helmet. It would be difficult to find anywhere a more emphatic glorification of the beauty of gold and of old craftsmanship in this precious metal. But Rembrandt's aim was not a still-life effect for its own sake. This phenomenon of pictorial beauty is placed in a mysterious and even tragic setting. One can hardly imagine a laughing face of the Frans Hals type under this helmet. The spiritual content dominates in spite of the brilliance of the upper part of the composition. This contrast between the splendour of the helmet and the subdued tonality of the face makes one deeply conscious of both the tangible and the intangible forces in Rembrandt's world, and of their inseparable inner relationship. As in all his greatest works, one feels here a fusion of the real with the visionary, and this painting, through its inner glow and its deep harmonies, comes closer to the effect of music than to that of the plastic arts.

The *Woman Seated in an Armchair* (fig. 94), in the Hermitage, dated 1654, is also outstanding among Rembrandt portraits, and supreme in conveying the mood of the sitter. The old woman, with her completely relaxed pose, expresses the kind of meditation which Rembrandt valued so highly, in which emotion and thought are equally involved. The hands are an essential part of the characterization. The highlighted scarf which links face and hands as the two centres of attraction marks the slight inclination of her body. This portrait was later enlarged to become the companion piece to the portrait of the *Old Jew in an Armchair* (fig. 102) also in the Hermitage, but the model is without doubt the woman who appears so often as the pendant to the so-called Adriaen, brother of Rembrandt.

Among the self-chosen portraits of Rembrandt's early maturity the Jewish subjects have been mentioned as occupying an important place. The artist took a keen pleasure in making quick sketches in pen or chalk of the Jews on the street, catching a vivid impression of their strange attire and bearing (fig. 208). But even more closely he studied their physiognomies, representing them in small oil sketches and also in half- and three-quarter-length portraits in life size (figs. 95–102). The large number and variety of Jewish subjects, as well as the unconventionality of such representations in seventeenth-century painting, merit further consideration as to

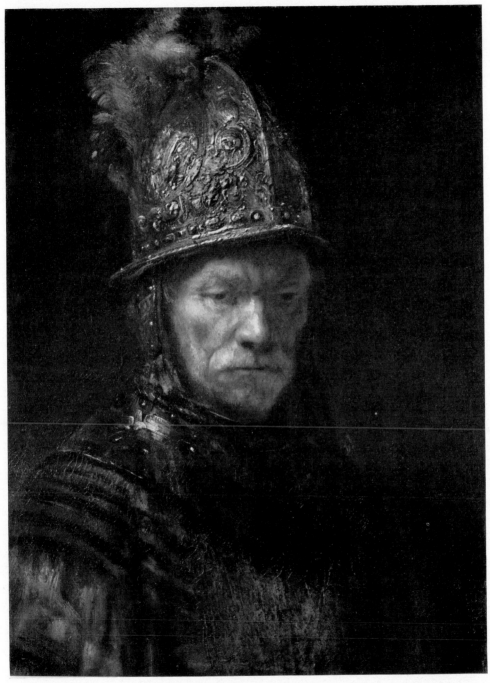

93. MAN WITH A GILT HELMET (Rembrandt's brother?). Berlin-Dahlem, Staatliche Museen.
Oil on canvas ($67 \times 51 \cdot 5$)

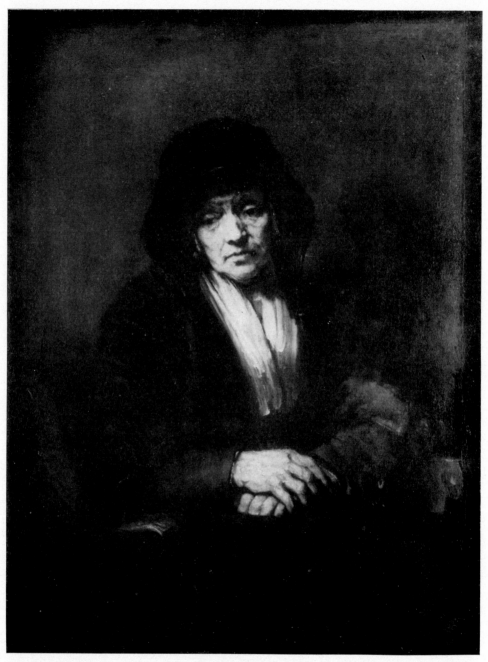

94. PORTRAIT OF AN OLD WOMAN (wife of Rembrandt's brother ?). 1654. Leningrad, Hermitage.
Oil on canvas (109 × 84)

95. PORTRAIT OF A JEW. 1647. Beetsterzwaag, Bieruma-Oosting Collection. Oil on panel (23·5 × 20·5)
96. PORTRAIT OF A JEW. Berlin-Dahlem, Staatliche Museen. Oil on panel (24·5 × 20·5)

why Rembrandt took such an interest in these people at this phase of his career. The fact that he lived at the edge of the Jewish quarter in Amsterdam was surely one of the reasons for this developing interest. His romantic tendencies, already referred to, would also account, to some degree, for the attraction which he found in the picturesque Jewish types. We recall that Pieter Lastman had first stimulated Rembrandt's taste for Oriental costumes and characters. But this interest remained rather general in his early period; not until later did he show a particular predilection for the Jewish physiognomy. The full explanation of this phenomenon can be found only in relating it to Rembrandt's spiritual development. With this broader perspective it becomes clear that the artist's deepening religious attitude was primarily responsible for his intense interest in the Jews as the authentic people of the Bible. And this growing interest coincided with the general tendency on Rembrandt's part to replace the theatricalism of the Baroque by a greater simplicity and sincerity in everything he represented, whether portraits, subjects of daily life, landscapes, or Biblical scenes.

While Rembrandt was thus the first European painter to devote much attention to the appearance and characterization of the Jewish people, it is fair to state that the historical moment and the place in which the artist lived were unusually favourable for such an innovation. In the Amsterdam of Rembrandt's day the Jews were permitted to live without degrading restrictions or interference, and in comparatively free contact with their gentile neighbours. As early as 1593 the Spanish Jews (the so-called Sephardim) had found a haven in Holland, and by the early years of the seventeenth century had formed a flourishing community in Amsterdam. They were

97. PORTRAIT OF AN OLD JEW. Formerly Detroit, Julius H. Haass Collection.
Oil on panel (23·5 × 18·5)

descendants of the Jews who had for many centuries taken an active part in the distinguished Arabian-Spanish culture; they brought with them to Holland not only wealth and skill, but a fairly high standard of living. It was different with the Eastern Jews (the Ashkenazim) who followed later, in the course of the seventeenth century. They came as refugees from Germany and Poland, and made a somewhat different impression in their new environment. They brought little wealth, but a

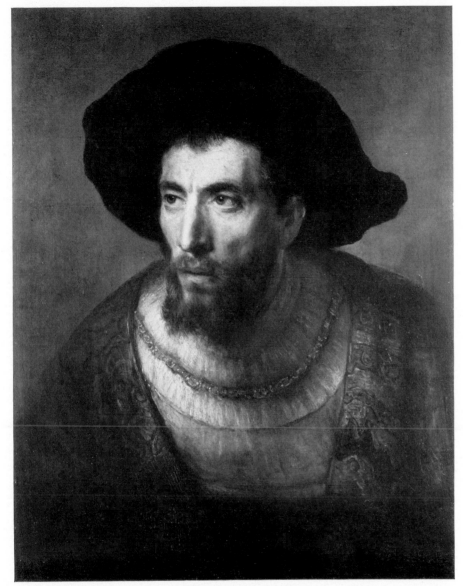

98. A JEWISH PHILOSOPHER. Washington, National Gallery of Art (Widener Collection).
Oil on panel (61·5 × 49·5)

long, unbroken tradition of intense Talmudic studies. Both the Western and the Eastern Jews clung to the Messianic hope as God's chosen people. It was this hope and this tenacity to their faith which had given them an almost mystical strength to endure hardships through centuries of persecution.

Christian dogmatism of the Middle Ages had prevented any broad perspective on the Jewish people;[26] more than that, it had insured their isolation and debasement

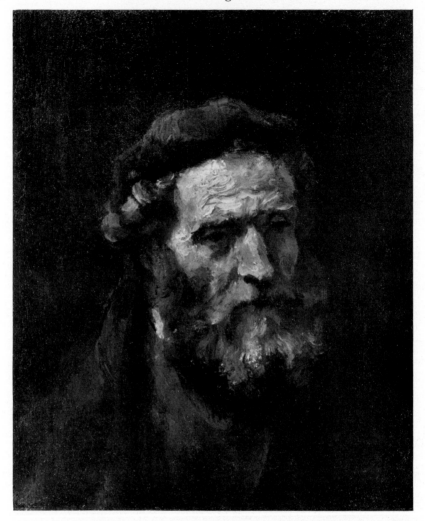

99. HEAD OF AN OLD MAN. Paris, Etienne Nicolas Collection.
Oil on panel (24·5 × 20)

for centuries to follow. The Renaissance and the Reformation brought some change through a new interest in the Old Testament, in the Hebrew language and history. It was Calvinism in particular which drew attention to the Old Testament and opened up a more just consideration of the Jews as the original Biblical people. But in addition to all the historical circumstances which fostered Rembrandt's interest, there remains the indisputable fact that the artist's attitude toward the Jewish people was an unusually sympathetic one.

Rembrandt's portraits of Jews show a great variety, although it is not always possible to distinguish between the Ashkenazic and the Sephardic types. It seems that the Eastern type occurs most frequently in the small oil sketches, and this im-

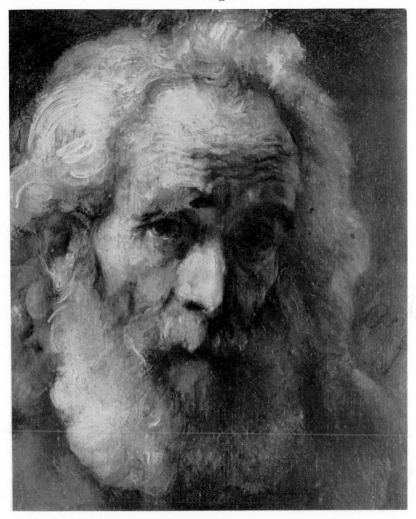

100. HEAD OF AN OLD MAN. Detail. 1659. Formerly New York, Mrs. A. W. Erickson Collection.
Oil on panel (37·5 × 26·5)

pression is substantiated by the few indications there are of differences in costume, headdress, and other external features.[27] We are struck, in the first place, by the sensitive objectivity of Rembrandt's characterizations. He avoided caricature as well as idealization. His intention, in his physiognomical studies, was clearly not to give a cross-section of Jewish types. He selected those that appealed to him and concentrated upon the ones he could most appropriately use in his Biblical scenes. He was especially attracted by the faces of old Jews, embodying patriarchal dignity, but he took an interest also in what we may call the pharisaic type. Here he expressed a stubborn tenacity of character, along with an intellectual gift for casuistic argumentation. Jews of a pronounced sensual cast of features (and who therefore furnished

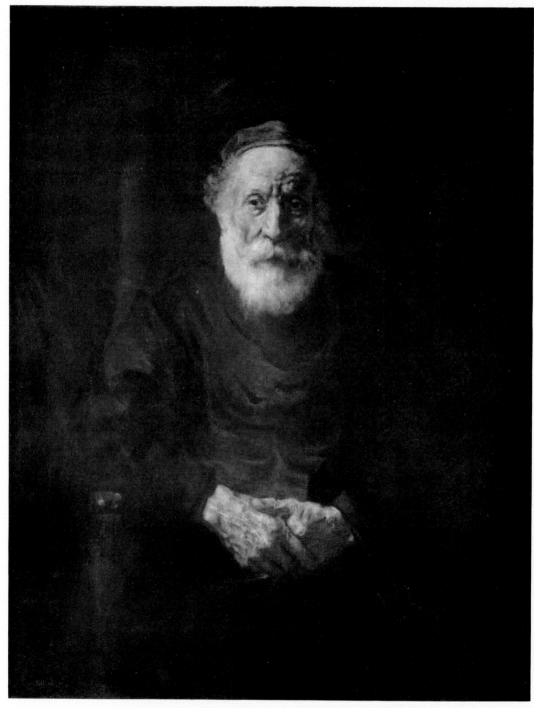

101. PORTRAIT OF AN OLD JEW, SEATED. Leningrad, Hermitage.
Oil on canvas (108 × 86)

102. PORTRAIT OF AN OLD JEW IN AN ARMCHAIR. 1654. Leningrad, Hermitage.
Oil on canvas (109 × 84)

103. STUDY FOR THE HEAD OF CHRIST. Berlin-Dahlem, Staatliche Museen.
Oil on panel (25 × 20)

suitable models for the elders in the story of Susanna) are also to be found. But more frequently met with is the gentle and meek type which Rembrandt seems to have discovered among the young Talmudic students, and which he used in his representations of Christ.

It was Rembrandt's desire for authenticity, and his close adherence to the Bible, that made him go so far as to derive his Christ-type from Jewish models, for this was contrary to all tradition. In the *Head of a Young Jew* in Berlin (fig. 103) the painter obviously used a model, although the arrangement of the hair is idealized, to conform to the traditional Christ-type. The facial expression seems closely observed

104. STUDY FOR THE HEAD OF CHRIST. Formerly Amsterdam, P. de Boer Galleries.
Oil on panel (25·5 × 20)

from nature, rather than imagined; the complex foreshortening in the attitude of the head also gives the impression of a direct study from life. The *Head of Christ*, formerly in the P. de Boer Galleries, Amsterdam (fig. 104), moves a step farther from reality toward a more idealized expression of mildness and humility. But Rembrandt's transition from the realistic to the imaginary is so subtle that it is almost impossible to draw a borderline between the two. We are on firmer ground in the case of the two following examples: the *Portrait of a Young Jew* of 1661, in the van Horne Collection in Montreal (fig. 105), and the half-figure of the *Risen Christ*, of the same year, in Munich (fig. 106). There can be no doubt that the first is an

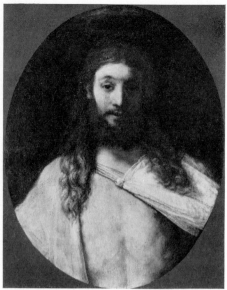

105. PORTRAIT OF A YOUNG JEW. 1661. Montreal, van Horne Collection. Oil on canvas (64 × 57)
106. CHRIST. 1661. Munich, Alte Pinakothek. Oil on canvas (81 × 64)

actual portrait from life and that it served as model for the second. The facial similarity of the two is striking, and the attitude of the head is the same in both cases. But through the most subtle adjustment in composition and expression—not so much through the idealization of costume and hair—Rembrandt has created a Christ of convincingly divine character. The light is raised to the forehead, thus enhancing the loftiness and spirituality of the Saviour's appearance. The glance has lost its physical directness and reflects an infinite remoteness. The young Jew of Amsterdam is transformed into a vision of Christ that emanates divine wisdom and compassion.

Among the portraits of old men less easily identifiable as Jewish types are a number dating about 1660 which assuredly seem to be close studies from life.[28] Yet at the same time they are among the most moving and profound visualizations of devoutness to be found in European art. At this late phase in Rembrandt's career he also portrayed some Slavic types which, according to Bode,[29] he found among the Russian pilgrims who passed through Amsterdam. The *Old Man Praying* (fig. 107), in the C. Barreiss Collection, Zürich, seems to be derived from such a model. The *Portrait of a Bearded Man* in Berlin (Br. 284) represents another such type and was, in all probability, the model for Rembrandt's *St. Bartholomew* of 1657, formerly in the Goldman Collection (Br. 613).

The deepened humanity of Rembrandt in his late years, as well as his tremendous realistic power, is nowhere more amply demonstrated than in the portrait of *Two*

107. OLD MAN PRAYING (an Apostle ?). 1661. Zürich, C. Barreiss Collection.
Oil on canvas (83 × 67)

Negroes of 1661, from the Bredius Collection, now in the Mauritshuis in The Hague (fig. 108). The picture has all the monumentality of Rembrandt's late compositions along with pictorial richness and subtlety. The first negro is represented in broad frontality. His armour and his bearing indicate noble rank. The light upon his face reveals a frank and manly character, and slightly softens the pronounced racial features. In contrast, the head of the second, who leans forward and looks over the shoulder of his companion, remains in shadow and thus suggests more of the

108. TWO NEGROES. 1661. The Hague, Mauritshuis. Oil on canvas (77 × 63)

darkness and mystery of his race. In Rembrandt's inventory of 1656 there is listed a picture of two 'Moors,' and the assumption has been that this painting was already begun at that time and changed to its present form in 1661, the date which appears on the picture. But since both the composition and pictorial execution are entirely consistent with this late date, it seems more reasonable to assume that the inventory refers to an earlier study of negro heads, which served as a model for this masterpiece.

GROUP PORTRAITS

I. DOUBLE AND FAMILY PORTRAITS

Only six double portraits and one family portrait by Rembrandt are known to us. This type of portraiture was never greatly in demand in Holland for the reason that double or group portraits in life size did not fit easily into the narrow houses of the Dutch burghers. Even the most prominent portraitists, Frans Hals, van der Helst,

109. PORTRAIT OF A MAN AND HIS WIFE. 1633. Boston, Isabella Stewart Gardner Museum.
Oil on canvas (131 × 107)

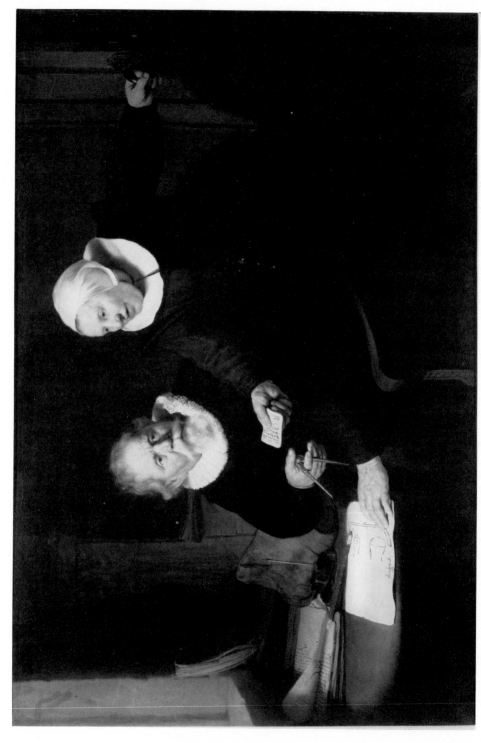

110. PORTRAIT OF A SHIPBUILDER AND HIS WIFE. 1633. London, Buckingham Palace. Oil on canvas (115 × 165).
Reproduced by gracious permission of Her Majesty The Queen.

Nicolaes Maes, and others, received few such commissions. There was a preference for single portraits of family members, related, in the case of husband and wife, by gestures and other corresponding features, and thus forming companion pieces. However, Rembrandt has left enough to show his treatment of family portraits in his different periods, and in almost every case has solved a difficult problem in a new, interesting manner.

The problem consisted in relating two or more figures, both psychologically and formally, without departing from the requirements of portraiture for a complete exhibition of the individual sitter in a characteristic attitude. Considering Rembrandt's tendency to isolate his subjects within their own world of contemplation, one might expect him to find difficulty in combining two portraits or more in a single picture. But Rembrandt was flexible enough to master this task with competence and originality. His wide experience in Biblical painting taught him how to relate figures through a common spiritual or emotional bond. But group portraiture calls for a somewhat different treatment. The action can be only slight, for otherwise it destroys the portrait character; and a common spiritual bond is not immediately offered by the subject but has to be suggested in an understandable fashion by the artist. It is altogether a much more complex undertaking than the painting of a single portrait, and one which requires both extraordinary power of composition and psychological insight.

In the *Portrait of a Man and His Wife*, of 1633 (fig. 109), in the Gardner Museum, Boston, still reflecting the cool colours and the minute touch of his Leyden work, Rembrandt has placed his figures in an interior such as Thomas de Keyser had favoured for his double portraits. Our interest in the two sitters is nicely balanced by spatial and pictorial accents. The man, although put into the second plane, is the more focal figure, with his striking Baroque silhouette set off against the light grey background. The chair has no small function within this composition. It serves as a *repoussoir* for the two figures; it balances the seated woman, strengthens the frame, and leads the eye toward the man in the centre of the picture.

The *Portrait of the Shipbuilder and His Wife* in Buckingham Palace (fig. 110) shows a remarkable advance, although it bears the same date of 1633. The figures here are fuller and more dominating, and Rembrandt has created a dramatic moment by having the woman deliver a letter to her husband. The instantaneous nature of the action is stressed by the manner in which she holds the door open with her left hand, while leaning forward to give him the note. The man's attitude also reveals that the interruption is unexpected. As he looks up his thoughts are still upon the work in which he was absorbed. The strong diagonal brought into the composition by the woman's outstretched arms marks out the spatial range in which the action takes place, and helps to focus and to balance our interest. Although the attraction is somewhat divided between the letter and the two heads, the man's full face holds

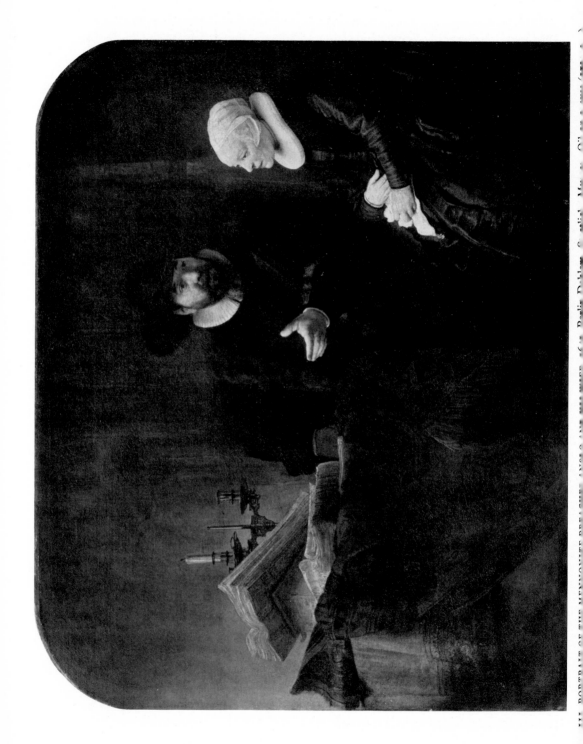

III. PORTRAIT OF THE MENNONITE PREACHER ANSLO AND HIS WIFE. Painted 1641. Berlin, Deahlem, Staatliche Museen. Canvas, 6′ 10¾″ × 8′ 11 nn½″ (176 × 210)

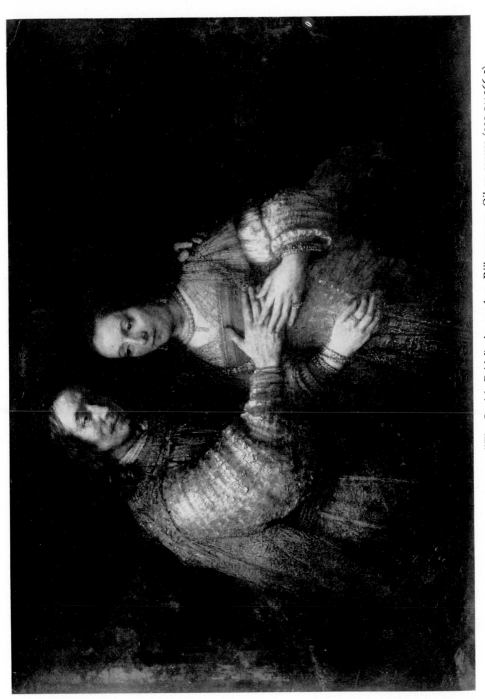

112. PORTRAIT OF A BRIDAL PAIR ('The Jewish Bride'). Amsterdam, Rijksmuseum. Oil on canvas (121·5 × 166·5)

113. Hans Holbein the Younger: JACOB AND RACHEL.
Basel, Museum. Drawing.

114. ISAAC AND REBECCA. New York, S. Kramarsky Collection. Drawing (14·5 × 18·5)

our primary attention. The picture is a strong example of Rembrandt's dramatic realism in his first period in Amsterdam.[30]

The double portrait of the *Mennonite Preacher Anslo and His Wife* in Berlin, 1641, also shows some action but of a more subtle and spiritual sort (fig. 111). Although Anslo is represented frontally, in the centre of the picture, his figure is more remote

115. Hugo van der Goes: JACOB AND RACHEL. Oxford, Christ Church. Drawing (33·8 × 57)

116. Dirck Santvoort: JACOB AND RACHEL. Formerly Mandl & Co., Berlin

from the spectator than was that of the shipbuilder, and his features are enveloped in shadowy atmosphere. Yet the effect of his personality is very marked. He turns to the woman to expound some religious doctrine and she reacts visibly under the impact of his words. Her handkerchief lies forgotten in her lap, as she raises her head with increasing attention. Her relaxed right hand also indicates her complete

absorption. The composition hinges upon Anslo's extended left hand, which establishes the relationship, both pictorially and psychologically, between the two halves of the picture, the woman on one side and the marvellously painted books on the other. The red of the tablecloth lends a warm colouristic note to the smoky chiaroscuro of the interior. The painting has the golden transparent quality of Rembrandt's middle period, as well as the fine restraint of those years.[31]

With the so-called *Jewish Bride* in Amsterdam we come to Rembrandt's last period. This magnificent painting (fig. 112), dating from the early or middle sixties, reveals all the colouristic power and profound humanity of the mature Rembrandt. The title of *Jewish Bride* was attached to the picture about 1825 while it belonged to the Vaillant Collection in Amsterdam. Since that time a countless number of suggestions have been offered to explain the meaning of the representation, with most interpretations assuming a Biblical source. Rembrandt has obviously painted a bridal pair from life, but he has endowed the figures with a symbolic character as if he wished to express through this portrait the meaning of marital relationship in general. He has suggested this meaning in profound human terms that are both emotional and spiritual, both intimate and monumental.

As in all Rembrandt's late works the figures are broadly displayed, the woman almost frontally, the man turned slightly toward her. Following the Venetian precedent they are represented in three-quarter length, within an oblong frame. They seem to float rather than to stand in a world of mysterious dimness. One gains the impression that the light comes from within the picture as much as from an outside source. It strikes the forms with conscious selection, stressing their frontality and causing the colour to flare up with unusual intensity in the woman's scarlet skirt and the man's golden olive sleeve. The inner relationship between the two figures is brought out in their postures, their facial expression and, above all, in their gestures, which are as unusual in Dutch portraiture as they are significant. Although the sensual implications are unmistakable, it is the solemnity and tenderness that speak to us first. There is reflected what might be called a patriarchal conception of bridal relationship in which the man becomes the responsible owner of the woman and cherishes her as his possession.

If Rembrandt intended to represent a bridal pair in Biblical disguise, this was not without precedent in contemporary Dutch art.[32] Accordingly the figures have been variously identified as Ruth and Boaz, Esther and Ahasuerus, Tobias and Sarah, or Isaac and Rebecca. Who, then, might be the Biblical characters to whom Rembrandt alluded here, with the consent of his patrons?[33] As an aid in solving this problem we must first refer to a drawing which obviously bears a close relationship to this composition (fig. 114). At first glance it looks like a direct study for the *Jewish Bride*, and so it was labelled by Valentiner (Val. 243). The style of draughtsmanship, however, places it in the early fifties rather than the middle sixties, as Benesch has rightly

117. FAMILY PORTRAIT. Brunswick, Museum. Oil on canvas (126 × 167)

observed,[34] and closer investigation shows that there are significant differences which loosen the connexion between drawing and painting. As for the subject of the drawing, it now seems certain that Rembrandt followed, with some variation, Raphael's composition in the Loggia of the Vatican representing *Isaac and Rebecca Spied upon by King Abimelech*.[35] In Rembrandt's painting this subject is no longer indicated, since Abimelech has disappeared. The two figures, moreover, are no longer seated, their costumes reflect the contemporary fashion (most obvious in the headdress), and the man's position is changed from a profile to a three-quarter view. The pair now nearly fill the picture plane, in the manner of a portrait, and the spirit of the scene is transformed from an amorous to a more solemn one.[35a]

While granting some plausibility to the 'Isaac and Rebecca' theory, through this relationship of painting and drawing, we cannot overlook another possibility, namely, that Rembrandt was alluding to 'Jacob and Rachel'. There is a painting of this subject by Rembrandt's contemporary, Dirck Santvoort, which shows a striking similarity in the attitude of the couple and in the gesture of the man (fig. 116). This picture bears no date but is obviously earlier than Rembrandt's *Jewish Bride*, probably about 1640. Santvoort was an artist of little inventive power, primarily a portraitist, and here in this case Jacob and Rachel, as well as the other figures, show unmistakably portrait-like features. Our interest in Santvoort's *Jacob and Rachel* composition as a possible source for Rembrandt's motif is heightened by the fact that Santvoort followed a very old iconographical tradition that goes back to the fifteenth century. A drawing by Hugo van der Goes in Oxford had treated the same subject in a very similar arrangement (fig. 115). The tradition lived on in the sixteenth century as we find in Holbein's little drawing of *Jacob and Rachel* in Basel (fig. 113),[36] where the gestures are even closer to those in the Rembrandt composition. It may be that Rembrandt saw Santvoort's painting or a similar representation of the Jacob and Rachel subject after he had done the drawing of *Isaac and Rebecca*, and that this new impression had some bearing on the final version of the *Jewish Bride*. All we can say with certainty is that the gestures are most unusual for an ordinary Dutch portrait. This fact makes it very probable that Rembrandt intended here to represent his patrons as a Biblical pair, and it was natural also for him to rely upon a tradition which would justify the symbolical treatment.[37]

The equally famous *Family Portrait* in Brunswick belongs to the very end of Rembrandt's career, dating 1667–9 (figs. 117, 118). It is the most glorious colouristic performance in his entire work—a symphony in red, harmonized with green-blue and silvery white, golden yellow and olive green. The reds are intensified by the contrasting darkness of the man's coat on the opposite side of the canvas. Like the *Jewish Bride*, this picture contradicts the popular notion that Rembrandt the chiaroscurist left little room for Rembrandt the colourist.[38] There is no doubt that some influence of the decorative and colouristic splendour of the Louis XIV style touched

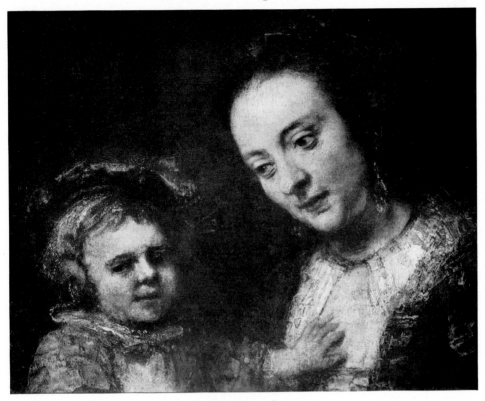

118. Detail from fig. 117

Rembrandt in this picture. Perhaps he wished to compete with his former pupil, Nicolaes Maes, who had gained a leading position among Dutch portraitists working in the French manner. Or he may simply have wanted to please his patrons by an unusual display of colour. But Rembrandt has transformed the superficial splendour of the Louis XIV fashion into something less definable; the fluctuating tones take on an almost immaterial glow, and the surfaces never seem to reach the point of tangibility. A highly personal technique and an inimitable, spontaneous brushwork have wrought this miracle of painterly performance. The only parallels to be found are in the late works of the greatest European painters, such as Titian, Velazquez, or Goya.

Through this colouristic beauty Rembrandt's humanity again speaks clearly. The vigorous crescendo of the reds on the right side of the picture culminates in the fiery scarlet of the mother's robe, and lends emotional warmth to her affectionate embrace of the youngest child. Here is the focus of the composition, and in the child's little figure the cool and the warm tones of the colour arrangement interpenetrate.

Neither in the *Jewish Bride* nor in the *Family Portrait* has Rembrandt allowed the tragic mood of many of his late works to come to the fore. Bridal love and parental

devotion are expressed with the most warmhearted sympathy, but the mystery and the gloomy undertone of human existence are not entirely eliminated. Even here, in the darkness of the rear planes, in the unusual depth of the shadows, is sounded a note of foreboding, and we realize that Rembrandt was exercising a conscious restraint in his expression of human happiness.

2. CORPORATION PORTRAITS

Any exhibition of Rembrandt's paintings which does not include the large corporation portraits of the *Anatomy Lesson of Dr. Tulp* (1632), the *Night Watch* (1642), and the *Syndics* (1661–2) can give but a fragmentary impression of the extraordinary force and range of the artist's pictorial achievements. Each of these large-scale productions represents a landmark in Rembrandt's work, and shows that, whenever the Dutch public called upon him for a major task, he did not fail to respond with all his power, imagination, and ability. Rembrandt did not adopt a lofty and inflexible attitude toward his patrons; in fact, he seems to have shown a sincere sympathy for the corporative spirit to be characterized in these group portraits. Even in the much-discussed case of the *Night Watch* he acted in agreement at least with the captain of the company, who must have approved the artist's plan for the composition. It was perhaps unfortunate that the result could not fully satisfy every member of the company, but in stressing the group spirit by representing a unified action under a single leader, Rembrandt had to subordinate some of the individual figures. The persistent assumption that the loss of Rembrandt's popularity was a direct outcome of his wilful execution of the *Night Watch* cannot be substantiated. His reputation declined gradually, due to the increasing opposition to his chiaroscuro manner. In the *Syndics* he showed that he was able to compromise with tradition without sacrificing his originality, but this came too late to restore his former popularity.

A few words should first be said about the peculiar character of the official group portrait in Dutch painting. No other country in Europe developed this type of portraiture and this fact makes it a strong national manifestation of Holland's culture.[39] Owing to the prevalence of Calvinism the Church had long since ceased to be a patron of the arts. Moreover, there was in Holland no absolute sovereign or great court to provide artists with large commissions for monumental projects.[40] Apart from occasional decorations for town halls, the only large official commissions open to Dutch painters were these corporation portraits. Here was an opportunity to glorify the civic spirit of the Dutch burghers. The members of shooting companies (originally formed for national defence), the boards of the guilds, and the regents of charitable institutions had themselves portrayed as a body. The artist's obligation to give equal prominence to each individual portrait resulted in a certain dullness of composition which even Frans Hals did not always overcome. It was in meeting this

problem that Rembrandt surpassed all his forerunners and contemporaries alike, whether he dealt with a 'regent' portrait or with the more difficult task of portraying a large shooting company.

The *Anatomy Lessons* belong in the category of 'regent' portraits, inasmuch as the entire Guild of Surgeons was usually not represented, but only a small group of doctors—mostly the foremen of the Guild—as they attended a lecture and demonstration by one of their members.[41] One may wonder why, in the representations of this subject by de Keyser and Rembrandt, the audience receiving instruction in anatomy is made up of mature men rather than young students. The answer is that at that time the demonstration of the dissection of a human corpse was a very unusual event, occurring only once or twice a year.[42] In de Keyser's *Anatomy Lesson of Dr. Sebastiaen Egbertsz* of 1619 the lecturer demonstrates before a skeleton (fig. 119). The youthful Rembrandt had the rare opportunity of portraying an actual dissection and thus was able to display his ability both as portraitist and as historical painter.[42a]

It is not hard to believe that Rembrandt's *Anatomy Lesson of Dr. Nicolaes Tulp* (fig. 120), appearing after de Keyser's picture, had the effect of a bombshell upon his contemporaries. The younger artist has brought an unusual tension into the group and raised the act of lecturing to a dramatic event. He has related the speaker and the subject of his demonstration most intensely to the audience of seven listeners, while the older master remained content with a loose co-ordination of the individual portraits. Within Rembrandt's closely knit group the corpse exerts the strongest attraction as the broadest area of intense light. The lecturer provides a strong accent through the darkness of his costume, which contrasts powerfully with the brightness of the corpse and more sharply with the bright spots in his own figure, the highlighted hands, face, and collar. Dr. Tulp alone wears a hat—a formality which marks the official nature of his demonstration—while the seven listeners are bareheaded. They form an area with lighter value contrasts within the group. Each of the faces is set off against a large white collar, and the greyish atmosphere of the room softens the outlines. The colour is cool and almost monochrome, with the main accents left to the chiaroscuro. The tones vary from grey to brown and from white to black. The subdued greenish shadows in the corpse form a startling contrast to the red touches in the dissected arm.

One of the most fascinating features in this group portrait is the subtle variation in the attentiveness of the listeners. The three directly behind the corpse are leaning forward in their eagerness to follow the demonstration closely. But each reacts in a different way to Dr. Tulp's words. The two doctors seated at the extreme left attend less closely. One of them looks at Dr. Tulp's face rather than at his action; the other turns his eyes out of the picture. The rear figure, who occupies the highest position in the group, is the only one whose gaze establishes a definite contact with the spectator, as he points to the scene in front of him. His colleague to the right, who

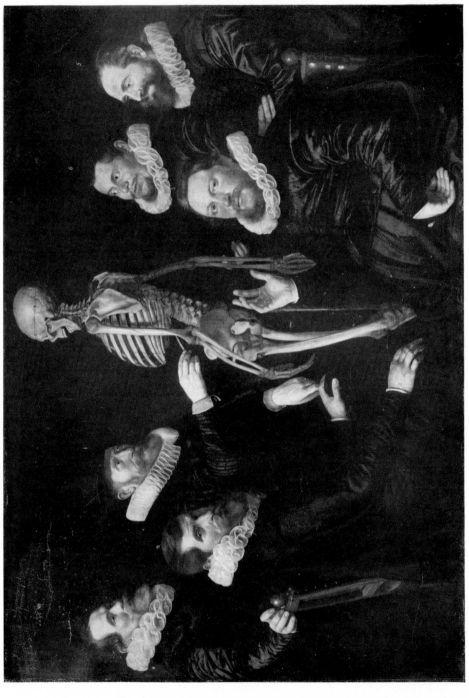

119. Thomas de Keyser: ANATOMY LESSON OF DR. SEBASTIAEN EGBERTSZ. 1619. Amsterdam, Rijksmuseum. Oil on canvas (135 × 186)

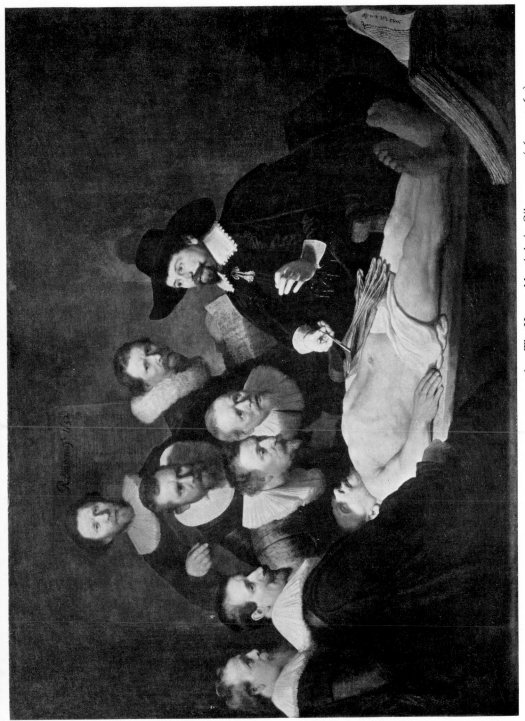

120. ANATOMY LESSON OF DR. NICOLAES TULP. 1632. The Hague, Mauritshuis. Oil on canvas (162·5 × 216·5)

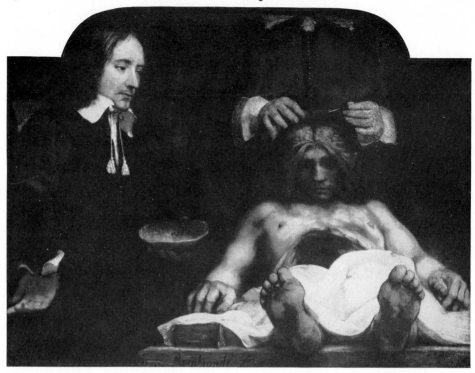

121. ANATOMY LESSON OF DR. JOAN DEIJMAN. 1656. Amsterdam, Rijksmuseum.
Fragment, oil on canvas (100 × 132)

holds a sheet of paper inscribed with all the names, likewise looks out toward the spectator, but with a less direct appeal. Varying degrees of interest are thus recorded and the tenseness of the moment is relieved by elements of relaxation.

The pyramidal form of the composition helps to knit the individual figures into a coherent group, both in depth and on the surface. One can distinguish roughly three planes, but only within the two front planes would it be possible to draw a ground plan. The three figures surmounting the group are somewhat ambiguously placed in space, although they are closely drawn into the surface arrangement. Later in Rembrandt's work such ambiguities disappeared. In this case they are of little consequence in relation to the intense dramatic effect of the group, which is largely the result of its strong compositional, pictorial, and psychological unification.

Almost a quarter of a century later, in 1656, Rembrandt was again faced with the task of representing an 'Anatomy Lesson'. This time Dr. Joan Deijman was the lecturer. Only a fragment of the original painting has survived, in the Rijksmuseum in Amsterdam (fig. 121). It shows the corpse with the figure of the operating doctor behind it; the canvas is torn off at his shoulders. The only other remaining figure is the assistant who stands at the left, holding the upper dome of the skull, which the doctor has just removed. There is an authentic pen sketch of the whole composition,

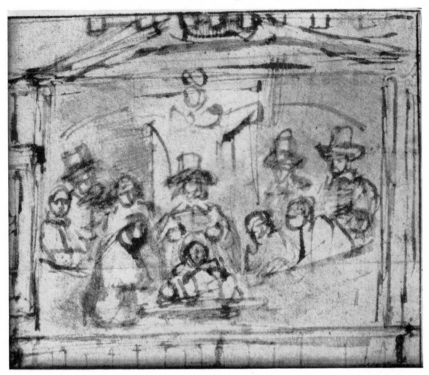

122. ANATOMY LESSON OF DR. JOAN DEIJMAN. Amsterdam, Print Room.
Drawing (11 × 13·3)

also in Amsterdam, which, in connexion with this fragment, allows certain con-
clusions as to the differences between Rembrandt's early and later interpretations of
an 'Anatomy Lesson'.

As the drawing shows (fig. 122), the composition has become more formal, with a
pronounced symmetry that is stressed by an architectural background but relieved
of any rigidity through the free distribution of figures on either side. This back-
ground divides the group clearly into three sections. Small groups of spectators sit
or stand in loge-like niches at left and right, while the doctor and the corpse are
placed on the central axis. The corpse is boldly foreshortened, recalling Mantegna's
famous *Dead Christ* in the Brera, Milan; the doctor is in a frontal position as he
performs an operation on the exposed brain.

The preserved fragment of the painting is too small and its condition too un-
satisfactory to allow any far-reaching conclusions on the pictorial organization and
execution of the whole work. The figures that remain, however, give some suggestion
of the mystery and the psychological interpretation which the mature Rembrandt
conveyed with this scene. The greater breadth and boldness of his painterly treat-
ment is still to be seen in the representation of the corpse. The foreshortened view
of this body, as one's eye travels from the upright soles of the feet over the white

loincloth and the cavernous torso to the deeply shadowed, lifeless face, is of a breath-taking directness.

The so-called *Night Watch* of 1642 (fig. 124) will always impress the world as a thunderbolt of genius, in spite of all the criticism that has been levelled against it. Its fame rivals that of Beethoven's *Eroica* or Michelangelo's Sistine Chapel. Perhaps there is more than coincidence in the fact that all three masterpieces were created by men in their middle thirties, an age in which youthful fire is often happily blended with virile force and mastery.

The subject of the *Night Watch* was a simple one—the marching out of a burgher company to a parade or a shooting contest.[43] The title is a misnomer.[44] The theme itself offered little opportunity for the display of dramatic action in the grand Baroque style which Rembrandt had favoured during his first period in Amsterdam. Yet his extraordinary treatment has raised this rather trivial occasion to a spectacle of unforgettable pictorial glamour. A comparison with Thomas de Keyser's *Shooting Company* of 1632, the closest parallel to be found among Rembrandt's fore-runners, will show at once the changes introduced by the younger artist. Instead of placing a pedantic emphasis upon each individual portrait, Rembrandt has boldly subordinated this traditional feature in the interest of a more unified action. He has chosen the moment of the call to arms, when the drum sounds and the crowd pours from all sides to gather behind its leaders. Arms are hastily examined, loaded, or shouldered while the men are already on the move. The group includes many more than the actual number of members of the company.[45] Children are running about, a dog barks at the drummer, a boy fires off his gun in the midst of the crowd, to heighten the general commotion. The company advances into position, but an orderly formation is not yet reached and the effect is one of surging movement.

To appreciate the composition in its completeness one must study the contemporary copy of the *Night Watch* by Gerrit Lundens, showing the scene as Rembrandt conceived it (fig. 123).[46] In 1715 the original painting was transferred from its place in the Guildhall of the Shooting Companies (*Kloveniersdoelen*) to the Town Hall in Amsterdam and on this occasion it was cut down on all four sides to fit into its new position between two doors. The loss was greatest on the left side and along the lower edge. This reduction now mars the general effect, and only the Lundens copy gives an idea of the composition in its unmutilated state.[47]

There is another contemporary copy of the *Night Watch* in the form of a water-colour drawing preserved in the family album of the leader of the company, Captain Cocq.[48] This drawing confirms the correctness of the Lundens copy and tells us, by its inscription, the exact meaning of the representation: the young *Heer van Purmerlandt* (Frans Banning Cocq) as the captain, gives orders to his lieutenant, the *Heer van Vlaerdingen* (Willem van Ruytenburch), to have his company of burghers march out. In the original painting the names of these two officers are recorded, along with

those of the sixteen other members, on the shield which is fastened to the wall above
the central group. But since neither of the two contemporary copies reproduces this
inscribed shield, the assumption has been that it was a later addition.[49]

Rembrandt's bold innovation in transforming a group portrait into a dramatically
animated crowd stems from truly Baroque impulses. He has created a tremendous
burst of movement of utmost complexity, brushing aside all remnants of the more
static order which the Renaissance tradition had continued to impose upon his fore-
runners. The Baroque favoured both complexity and unification of movement, and
Rembrandt has succeeded in expressing both here, subtly subordinating the diversity
of action to a concentric trend within the whole.

The advancing movement of the two foremost officers is the decisive factor in the
general battle of directions. Its dominating influence in the composition is based
first of all upon the prominence and striking realism of these two figures, but it re-
ceives no small support from accents in other parts of the composition. Thus the
diagonal of the lieutenant's pike, marking the direction of the forward movement
from the right rear corner, is repeated in the parallel diagonals of the rifle and the
lance, above and behind. And the contrasting diagonal in the captain's staff gains
added strength from two parallel oblique accents on the left side, in the gun of the
rifleman in the second plane, and the banner in the third. The variety of movement,
both in space and on the surface of the picture, is carried as far as it can be without
seriously interrupting the dominating forward trend. A lively differentiation of levels
contributes to this effect, as does the activity of the individual figures. Heads appear
at many different heights as children dart through the crowd, or as men lean over to
load their guns. Rembrandt has also introduced steps in the background to elevate
the rear group. As for the movement of the individual figures, it is clear that the
artist has used contrasting directions both to diversify and to unify the action within
the whole composition. A few examples may illustrate this important point. The
contrasting directions in the figure of the standard-bearer link the rear group with
that on the left, and the diagonal of his banner gives additional accent to the advan-
cing stride of the two leaders. The sergeant on the extreme right, with outstretched
right arm and halberd pointing forward over his left shoulder, serves to connect the
figures around and behind him with the central group. A similar function is assigned
to the sergeant on the left, seated on the wall bordering the canal. His upright form
and his vertically poised halberd help also to check the movement of the crowd
which pours in from the rear. This restraining vertical accent allows the diagonal
coming from the other side to dominate. By giving to these three figures, the stan-
dard-bearer and the two sergeants,[50] key positions in their respective groups, the
artist has integrated the ranks with the general order of the composition.

This complex display of movement gains additional clarity from the background
architecture, more easily discernible in the Lundens copy than in the original. The

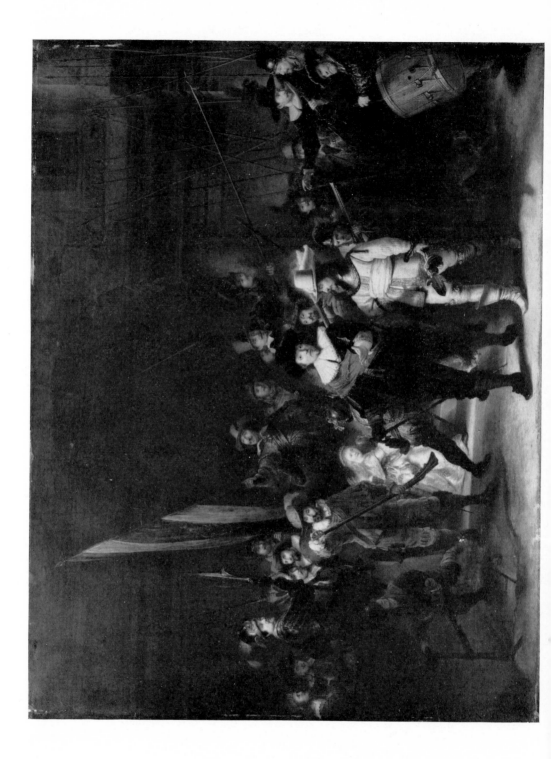

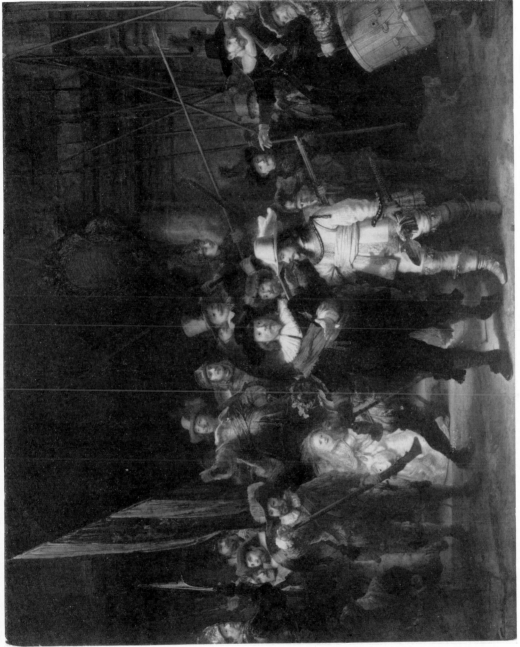

124. THE SHOOTING COMPANY OF CAPTAIN FRANS BANNING COCQ. 1642. ('The Night Watch'). Amsterdam, Rijksmuseum.
Oil on canvas (387 × 502)

threefold division of the background sets off the group on either side from the advancing stream of figures in the centre. Although this central current is interrupted by the sidelong dash of the children in the middle distance, the large portal with its arched top secures the coherence of this section and gives due emphasis to the forward movement.

A subtle though clear and comprehensive spatial order underlies this dramatic spectacle. The ground plan reveals a zigzag formation, a familiar Baroque device to lead the eye forward and back into the depth of a picture. A succession of four planes constitutes in this case the framework of the spatial set-up, and is most clearly distinguishable in the area where the composition opens up toward the brightly illuminated figure of the little girl. The first plane is marked by the glove that dangles from the captain's right hand, the second by the gun of the rifleman and the foot of the boy running to the right. The third plane is accentuated by the girl and the fourth by the standardbearer, above and behind her. Rembrandt has left no doubt about the extension of these four planes to either side, or their relation to one another; there is hardly a point in this vast space that is not clearly related to all others with a minimum of accents. It may be the glint of a lance or the barrel of a gun, an outstretched hand or a lighted face which performs the task of defining the space in proper relation to the whole composition.

The dominating impression produced by the *Night Watch*, however, is neither one of organized movement nor of spatial order. It is the drama of light and dark which provides the strongest pictorial sensation, and with it the intensity of the colouristic effect in the two leading figures. Critics have never been able to agree as to whether Rembrandt is here primarily a chiaroscurist or a colourist. This picture represents a phase of his development in which the artist introduced intense colour into the foreground of his chiaroscuro organization, thus co-ordinating the two devices in a way that is both personal and striking. The *Sacrifice of Manoah* (fig. 160), dated a year earlier, shows the same tendency. In Rembrandt's later work, to be sure, there is often a softer harmony and a more complete integration of these two pictorial devices. But the relative hardness and intensity of both chiaroscuro and colour in the *Night Watch* are largely responsible for its powerful dramatic effect.

The strongest accents of light and colour coincide in the figure of the lieutenant, who is clad in a brilliant lemon-yellow uniform. The contrast with the black uniform of the captain intensifies the brightness of this yellow which reappears, slightly paler and cooler but still intense, in the figure of the little girl at the left. These yellows are linked with larger areas of orange-red into a predominantly warm harmony. The red in the captain's scarf is the most intense; that of the two riflemen, on either side of the central group, appears slightly duller, as does the red of the drum which is laced with gold. The cooler tones of blue and green play a secondary role, in the lieutenant's uniform, the drummer's sleeve, etc. Intensities are considerably

lowered in the rear planes where the colour is very much broken up into smaller areas. Here a greenish-gold tonality prevails in the costumes and armour, not only adding to the colouristic harmony but also filling the dimness of the space with a suggestive glitter and lending a glow to the chiaroscuro.

The powerful accord of yellow and red by which Rembrandt has centred the attraction on the two foremost figures reappears in later work as his favourite harmony. We may be sure, therefore, that this choice of colours as well as the selective lighting was dictated by the artist's personal taste rather than by outward circumstances.[51] And the flavour of mystery which the picture gains through its chiaroscuro is, of course, Rembrandt's own. By his sensitive interrelating of lights and darks, of the clearly defined with the indistinct, Rembrandt has brought to the subject a broader and deeper significance than the actual event called for. Opinions have differed widely as to whether this can be interpreted as a transgression of artistic subjectivity or an expression of Rembrandt's powerful genius. In any case, his pictorial imagination here reached an extraordinary height. The occasion certainly challenged all his forces.[52]

To those who criticize the *Night Watch* for its lack of portrait character one may say that from the psychological standpoint Rembrandt made no mistake in subordinating the individual characterization to the expression of general agitation and tension in such a mass scene. While the pictorial style of the *Night Watch* still reflects his Baroque trend and brings it to a definite culmination, the independence and deepening sincerity of Rembrandt's later years are already anticipated.

The wide range of Rembrandt's genius does not allow narrow classifications in the interpretation of his work and development. In his portraiture we have seen the pendulum swing between such contrasting tendencies as the subjective and the objective, the extrovert and the introvert, the realistic and the romantic. All these tendencies are implicit in Rembrandt's work, varying only in degree and intensity. If, in this chapter, we have emphasized certain characteristics which prevail in the various phases and types of Rembrandt's portraiture, it is with the conscious realization that such an interpretation can never reach full comprehensiveness.[52a]

In approaching Rembrandt's greatest group portrait, the *Syndics* (fig. 126), a work done twenty years after the *Night Watch*, we feel even more strongly the difficulty of doing justice to a masterpiece by merely emphasizing some of its outstanding qualities. Is it the amazing suggestion of life in this picture which deserves our greatest admiration, or is it the penetrating interpretation of character in the sitters? Is it the subtle balance of the composition or the colouristic harmony? Is it the serenity of the general impression—so unlike the wilful dramatization of the *Night Watch*—or Rembrandt's deeply sympathetic attitude toward his subjects?

Whatever one may stress in the first place, there is something particularly felicitous about this painting, which has aroused the highest enthusiasm among

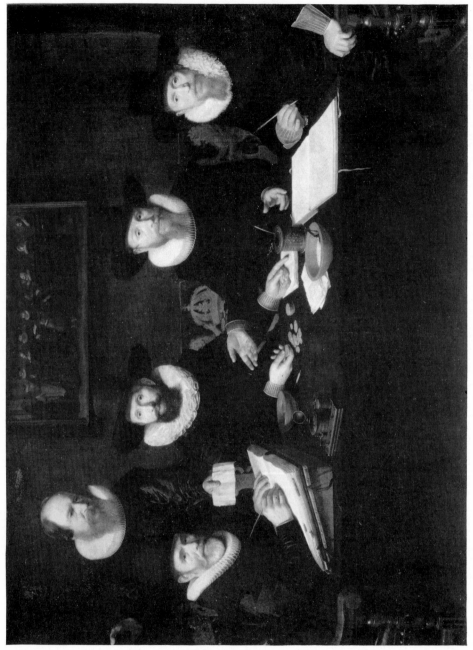

125. Nicolaes Elias: REGENTS OF THE 'SPINHUIS'. 162(8). Amsterdam, Rijksmuseum. Oil on canvas (178 × 233)

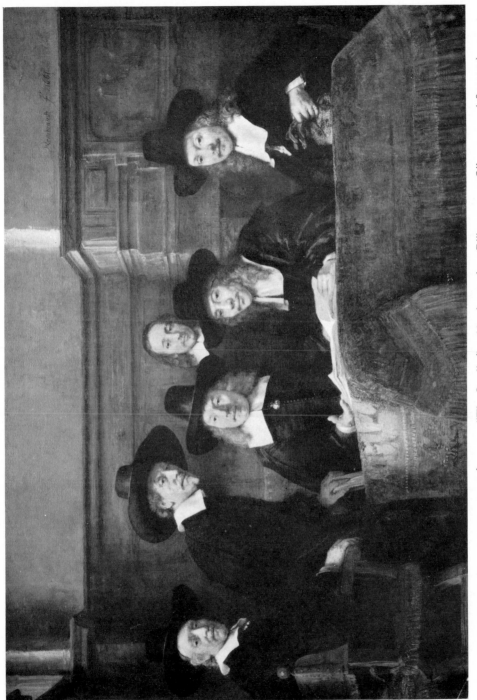

126. THE BOARD OF THE DRAPERS' GUILD ('The Syndics'). 1662. Amsterdam, Rijksmuseum. Oil on canvas (185 × 274)

Rembrandt critics since the time of Thoré-Bürger, Charles Blanc, and Fromentin.[53] The *Syndics* breathes a tranquillity that is rare in Rembrandt's late works. The artist here appears to have been completely at ease with his subjects and with the world. He has refrained from eccentric and fanciful treatment, showing his patrons and the Dutch public that he could adhere to tradition and be as true to life and as decorative as any of his more popular contemporaries, yet surpass them all in conveying the humanity of his subjects by his sympathetic understanding. In this painting Rembrandt has reached a perfect solution of the crucial problem in group portraiture, that of preserving the character of the individual portrait within a unifying action and coherent composition.

In full conformity with tradition Rembrandt has represented members of the Board of the Guild (here it is the Drapers' Guild) as in conference but momentarily turning to the spectator. A glance at Nicolaes Elias' group portrait of the *Regents of the Spinhuis* of 162[8] (fig. 125), and other earlier examples proves that Rembrandt has here followed a well-established convention. His changes were only slight, but yet essential in creating a higher form of unity in the composition. The figures in the group by Elias show a great diversity of gesture and accent, and the numerous inanimate objects, such as books, inkstands, and money, as well as details of costume, are as prominent as the regents' faces and hands. The Rembrandt painting at once attracts us by the personalities to which all other details are subordinated, and by the manner in which attention is focused upon a definite moment.

The traditional interpretation of the *Syndics* has been that the men are seated before the assembly of the Drapers' Guild, whose regents they are, and giving to this unseen assembly an account of the year's business. H. van de Waal[53a] has shown, however, that such annual gatherings for the rendering of accounts were not usual in the Guild; and that therefore the often repeated interpretation that the syndic on the left is rising to deal with someone making a disturbance in the audience must be wrong. But even if this assumption is discarded, the fact remains that the rising man's posture is a very momentary one and adds substantially to the illusion that the group reacts spontaneously to someone in front of them. And since no assembly can be assumed, this must be the spectator himself at the moment of his entrance. Thus Rembrandt dramatizes the scene more than his forerunners had, by aiming at the very instant of the onlooker's appearance which causes an interruption. Such pointed illusionism would have been dangerous for a lesser master. Not so with Rembrandt. He always endowed his group portraits with a certain dramatic tension, and here the mature artist successfully combined it with the general impression of tranquillity.

The regent seated in the centre is the presiding officer. With the account books before him, he alone is represented in full frontality; the gesture of his right hand and its focal position leave no doubt about his role. Closer observation reveals how

the artist has given both psychological and formal support to this man's central position. The movements of each of the other figures lead subtly to him and so also do the pictorial accents coming from the front plane. The area of brilliant red in the tablecloth directly below his hand serves as a foil to his dark costume, and the white pages of the book relate his figure to the edge of the table in the foreground.

There is no undue emphasis on the centre, however; Rembrandt has allowed almost equal importance to the other regents by their participation in a moment of psychological tension. The strong emphasis upon horizontal accents seems to be a conscious means to create both unity and co-ordination in this group. Three horizontals run through the picture at almost equal intervals. The lowest is formed by the edge of the table and carried on by the arm of the chair at the left; the middle one is established by the prevailing level of the heads; and the upper one runs along the edge of the wainscoting. Any rigidity in these repeated horizontals is broken by sharp deviations on all three levels. The sharpest occurs in the group itself, in the rising curve of the heads on the left. With a kind of contrapuntal effect this movement is echoed by the slight rise in the upper horizontal on the right, and at the same time counteracted by the firmness of the lower horizontal on that side.[53b]

Rembrandt never introduced such formal features without integrating them closely with the psychological content. Thus the almost upright attitude of the regent at the left as he rises from his chair suggests that, as we observed above, some interruption has distracted him. Each of the other regents shows his individual reaction to this incident. The president has momentarily looked up from his report, to give his attention to the interruption, while his colleague to the right, whose hand is also on the account book, shows a quietly observant neutrality. The old regent at the extreme left looks down on the unseen spectator with an air of sceptical detachment; the younger man on the right, also intently watching, expresses a slight impatience in taking up his gloves as if to leave. In spite of these subtle variations, the general mood of the regents is one of good will, and they give the impression of well-established security. The servant standing in the rear has the patient look of one accustomed to remaining in the background.

Even in Rembrandt's youth—if we turn back to the *Anatomy Lesson of Dr. Tulp*—he had shown extraordinary ability in differentiating the expressions of a group of sitters while focusing their interest on a common object. Here, in this late work, the atmosphere is less tense and the accents are distributed more sparsely, yet tellingly. Rembrandt has exploited the tectonic qualities inherent in the picture plane for the monumental effect of the composition. He has built up a relief-like arrangement which allows a broad display of forms with few disturbing foreshortenings. A smooth transition of planes provides spatial clarity without any conspicuous recessions.

The light is softer than before, and less manifestly naturalistic. It flows not only

from an outside source (here an upper window on the left) but seems also to issue independently from within the picture, freely emphasizing the frontal aspect of the group and creating an organization of values which fully serves the artist's expressive purposes. The colour, which in the early work was subordinated to the chiaroscuro, has now become a more integral part of the composition. The glowing orange-red in the tablecloth, interwoven with gold, and the sunny brown of the background form a striking contrast to the deep blacks and intense whites in the sober costumes of the regents. The warm flesh tones are well set off in this colouristic harmony. The faces, although subdued in intensity, are enlivened by the richest modulation of values and by an extraordinary textural charm. Here, as in other passages, the breadth and flexibility of the brushwork is an important factor in heightening the pictorial life of the picture.

With the *Syndics* Rembrandt has created his greatest monument to Dutch character. He has not overlooked the sober, calculating spirit of these merchants who helped to build up Holland's leadership in world trade while maintaining their own wealth and social position. But beyond that Rembrandt has expressed a broader humanity in these figures. We are led to believe that tolerance and human dignity prevailed in their community, and that religion was still a guiding force in their lives. Rembrandt has endowed them with an honest pride that is far more impressive than the vanity shown by the Dutch aristocrats of the succeeding Louis XIV period.

The artist's sympathetic attitude reflects his own humanity as well as that of his subjects. While the ageing Rembrandt had reason to be resentful toward the society of his day, no hint of this is felt in the picture. Neither does he show any flattery of these wealthy patrons. Rembrandt was great enough to forget his own humiliations and personal interests and devote all his power to a true and comprehensive human evaluation of his sitters.[54]

LANDSCAPE

L ANDSCAPE was one of the most popular subjects in Dutch art. The naïveté and unpretentiousness, the pictorial sensitiveness and fidelity to nature of Holland's landscape painters have gained for them many friends in the course of the centuries; their reputation has risen to new heights whenever pictorial realism has been the prevailing trend. During the Baroque period in the Catholic countries religious painting retained a dominant role. The royal courts of the day provided artists with countless commissions for the glorification of kings and princes. In Calvinistic and democratic Holland, however, both Church and Court had ceased to be influential patrons of the arts, and the innate love of the Dutch burghers for the intimate depiction of their surroundings gained free expression. Landscape subjects became increasingly popular, and the Dutch painters and etchers revelled in a detailed description of Holland's countryside.

One is tempted to relate this imposing pictorial appreciation of nature in Dutch landscape painting to the broader trends in contemporary philosophy and science. The seventeenth century was the period in which human thought focused with extraordinary intensity upon the investigation of the laws of nature; it was the time when the advance of empiricism and rationalism began to challenge the traditional conceptions of the world.

It is a sign of Rembrandt's keenness and universality that he participated so actively in Dutch landscape art. But this he did in a very individual manner, for which no exact parallel can be found among his contemporaries. Landscape makes its first appearance in Rembrandt's work in the second half of the 1630's; it is no longer found after the mid-fifties. Thus we can say that it was largely during Rembrandt's middle period that he was intensely productive in this category as a draughtsman, etcher and painter. We know altogether about twenty-four landscape etchings, more than two hundred and fifty drawings,[1] and seventeen landscape paintings.[2] In proportion to Rembrandt's entire work and to his output in portraiture or Biblical painting, this is a small number. Yet, when valued for their own merits and their significance within the artist's development, his landscapes deserve close attention.

Rembrandt's studies in nature brought him new experiences which had a bearing upon both his pictorial and psychological outlook. He gained a conception of space in its most comprehensive aspect and learned in landscape work how to subordinate the individual form to a larger whole. In addition to this widening and balancing of his visual perception, he found, in the phenomenon of outdoor light, new and more subtle devices for the distinction and the interrelating of planes within a broad spatial

concept. This phenomenon of daylight in the open air Rembrandt expressed most fully in his drawings and etchings. In them is found an all-over brightness with shadows reduced to a minimum, the play of values becoming most delicate and the tonality highly transparent. Another important feature is the suggestion of air and atmosphere, which gains added significance as an element of pictorial animation. This Rembrandt achieved by his vibrant lines and tones, and by a subtly graded aerial perspective penetrating every corner of his compositions.

The effect of Rembrandt's occupation with landscape is to be seen in all his work. It was the calming, clarifying, and balancing influence which the contemplation of nature often brings to man, making him see his own individual problems in more normal proportion, with a widened perspective. We have already observed that during Rembrandt's middle period the qualities of sincerity and inwardness became most outstanding. His contact with nature must have helped to promote such development. It certainly helped the artist to overcome the Baroque theatricality of his youthful period and to express himself with greater directness, simplicity, and sensitiveness.

Rembrandt differs from the familiar type of Dutch landscapist in that he avoided a specialistic approach and sought a more universal understanding and characterization of the Dutch scene. This did not exclude intimate and individual features—Rembrandt was, in point of observation, often more acute and penetrating than all the others—but it did prevent limitation to one or two aspects of Dutch landscape. There were specialists for marine views (Jan van de Cappelle, Willem van de Velde) and flat landscapes (Philips de Koninck, Joris van der Hagen), for dunes and canal scenes (Jan van Goyen, Salomon van Ruysdael), for woody landscapes (Jacob van Ruisdael, Hobbema), and even for winter scenes (Beerstraaten, C. Molenaer) and moonlight views (Aert van der Neer). But Rembrandt's interest did not follow such restricted considerations. The way in which he approached and interpreted nature shows some parallel to his interpretation of man in portraiture. In both cases we observe a romantic as well as a realistic trend.

In his landscapes Rembrandt reserved the realistic trend largely for his drawings and etchings, while his romanticism found powerful expression in his landscape paintings. Realism and romanticism, as we know, were nothing new to Dutch landscape; both were found in the work of Rembrandt's predecessors and contemporaries. There were even some artists, such as Hercules Seghers and Jacob van Ruisdael, who combined the two trends. Ruisdael's panoramic views of Haarlem, including even such minute details as fences and laundry in the bleaching yards, alternate with imaginative compositions such as his Jewish cemeteries or spectacular waterfalls. And Seghers, somewhat earlier, excelled in realistic flat landscapes as well as fantastic mountain scenes. But Rembrandt alone seems to have felt that different techniques sometimes ask for different methods of approach. This may have

been his reason for reserving the realistic rendering of nature to his draughtsmanship and etching, and the romantic interpretation to his painting. Perhaps also it was the procedure in painting, in which the artist works from the darks up to the lights, that led Rembrandt to more abstract and imaginary conceptions of landscape, with full play for the chiaroscuro, and all its implication of mystery. Rembrandt's genius was flexible enough to handle both types of landscape with equal facility: the objective view of nature and the imaginary vision.

Particularly in the drawings and etchings we may observe how Rembrandt rapidly developed a shorthand style, through the graphic media of the pen, the brush, and the etching needle. With these simple means he attained a directness, a spontaneity and brevity of expression which the more intricate process of oil painting did not allow. In his rendering of landscape, he avoided the obvious features and stressed the inconspicuous ones which often breathe the true spirit of the Dutch countryside in its simplicity and modest charm. He brought out the spaciousness, the luminosity, the breezy atmosphere, and the broad horizontality; he often centred on such homely motifs as a few old cottages among scattered trees, a stretch of canal with a boat hidden in the reeds, a small bridge with a windswept tree on one side and a sailing boat on the other. These were motifs which Rembrandt thought worth while, because they reflected the essence of Holland's landscape. Other Dutch artists, such as van Goyen, Ruisdael, Molyn, also chose these subjects but, on the whole, they clung to more conventional motifs, showing less independence in their selection, and less flexibility in their graphic treatment. None of them carried their draughtsmanship to the point of expressive shorthand that Rembrandt did. The magic of Rembrandt's shorthand is perhaps too easily taken for granted after so many generations have continued to admire this feature of his graphic art. But we must not forget that shorthand in itself is not an admirable quality unless it combines brevity with suggestiveness, unless the brevity is the result of sensitive selection, with an emphasis upon significant features and an appeal to the spectator's imagination. Rembrandt's shorthand meets this test; it often recalls the achievement of Far Eastern draughtsmen, and it foreshadows nineteenth-century Impressionism. It also proves the point that artistic economy and power of expression are interdependent qualities.

We finally raise the question as to why Rembrandt's main activity as a landscapist remained limited to the period of about 1640–55. The answer leads once more to the problem of Rembrandt's humanity. The enjoyment of nature for its own sake was able to offer him only temporary satisfaction. He derived from it as much as he needed for the clarification and the broadening of his vision. But after a time he reached the point where human subjects again became more important to him than the aspect of nature, however appealing. It is highly significant that for all Rembrandt's impressionistic tendencies in his landscape drawings and etchings, he

127. TWO THATCHED COTTAGES. Chatsworth, Devonshire Collection. Drawing (13·7 × 20)

differed widely from the modern Impressionists in the conclusions he drew from his experiences in nature. Ultimately he found that for him the appreciation of the visual world was incomplete without a substantial human content as its essence.

From the group of Rembrandt's landscape drawings we shall select a few examples illustrating his three phases. The study in pen and ink of *Two Cottages* in the Devonshire Collection at Chatsworth belongs to the end of the thirties (fig. 127).[2a] Characteristic features of this comparatively early period are the artist's interest in and insistence upon detail, together with a strong diagonal movement into the distance. The scratchy stroke of his pen shows the same Baroque love of ornateness that his etching needle does at this time. The full vigour of Rembrandt's draughtsmanship is already felt in the directness of his touch. There is a powerful expression of bulk in these cottages and a richness of texture in his treatment of their surfaces.

The *Farm among Trees near a Canal* (fig. 128) in the British Museum leads into the late forties, when the breadth and sensitiveness of Rembrandt's rendering of landscape increases. Delicate brushwork is now combined with subtle penmanship. An effect of atmosphere and spaciousness is the dominating feature, and a horizontal trend begins to assert itself in the composition. Rembrandt's shorthand stroke has gained not only in delicacy of touch but in flexibility as well. The artist has now discovered the poetic beauty of the Dutch country in its intimacy and modesty. This composition could hardly be simpler and yet, through the diaphanous character of the drawing, it allows a broad display of spatial and pictorial life.

128. FARM AMONG TREES NEAR A CANAL. London, British Museum. Drawing (15·6 × 23·3)

Another drawing of the middle period which we reproduce (fig. 129) is also in the Devonshire Collection. It represents a typical Dutch scene in which water and sky prevail, and which Lugt has identified as the 'Omval'.[3] A flat neck of land appears in the middle distance, with windmills, houses, and trees sparsely set along the water's edge. A sailing boat approaches from the right rear. The atmosphere is even more transparent and vaporous here, and the flatness of the country is carried to an even more distant horizon. Rembrandt has attained complete spatial clarity over an incredibly wide area by means of a very few, sensitively placed accents. The delicate reflections in the motionless water, spreading toward the foreground, and the subtle indications of aerial perspective in the drawing of the houses, trees, and windmills help to suggest a continuous recession into the distance. All this wide expanse of water and land, and the vast sky overhead, filling more than three-quarters of the composition, vibrate with atmospheric life. It is easy to understand how this kind of sensitive drawing impressed and inspired Turner; he has left us many equally suggestive sketches in this manner.

Rembrandt's landscape drawings in his late style show an increase in the power of accents, for the sake of a greater structural quality and pictorial richness. This is clearly indicated in the *Landscape with Windmills* representing a view of the western outskirts of Amsterdam (fig. 130).[4] The drawing can be dated about 1655, when Rembrandt's etchings and also his paintings display similar features. The atmospheric effect which Rembrandt had developed during his middle period is by no

129. VIEW ON THE AMSTEL, AT THE OMVAL. Chatsworth, Devonshire Collection.
Drawing (10·8 × 19·7)

means sacrificed to the new structural quality, nor is the transparency lost with his broader touch. Rembrandt's progress from the sensitive to the monumental, from a delicate and hazy effect to greater pictorial richness and luminosity, is well brought out by a comparison of this drawing with the previous one, whether one looks at details, such as the largest windmill in each, or at the whole composition. He now employs the reed pen, with its broader stroke, combining it with vigorous touches of the brush. By such breadth of treatment he comes close to the effect of the brush-work in his late oil paintings.

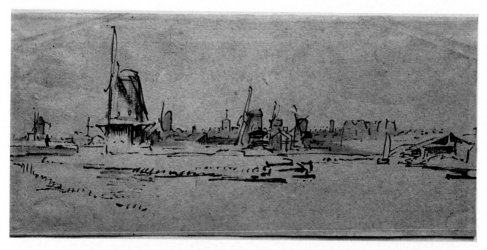

130. WINDMILLS ON THE WEST SIDE OF AMSTERDAM. Copenhagen, Print Room.
Drawing (12 × 26·3)

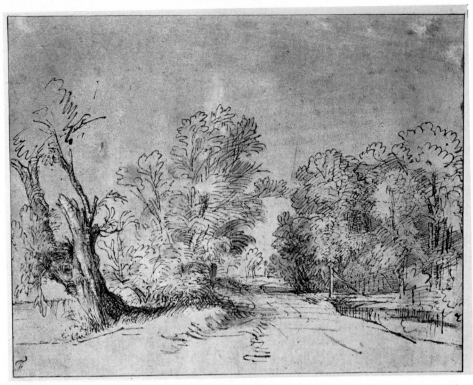

131. ROAD THROUGH THE TREES. Chatsworth, Devonshire Collection. Drawing (15·6 × 20)

There are, of course, many intermediary steps between the two phases last described. Rembrandt's landscape studies include numerous sketches of trees or woodland scenes along country roads. Such a motif is represented in another drawing in the collection at Chatsworth (fig. 131) which may be dated in the late forties.[4a] In his treatment of foliage Rembrandt never loses himself in a characterization of the individual tree, as Ruisdael liked to do. He remains rather general, yet gives sufficient variety to form and structure to express the organic life of the tree and the movement of the leaves. Much of his attention is centred upon the play of light and shade, in the interest of clear spatial distinctions and a coherent organization of values. Rembrandt's formula for foliage is brief but never monotonous. Flexible variations in scale and direction are maintained throughout and parallel shading contributes to the sensitive gradation from full daylight into shadow. Thus in his rendering of trees and woody scenes he conveys richness without fussiness of detail and combines breadth of vision with intimate animation.

The study in pen and brush of a village road, leading in a wide curve to cottages among trees in the middle distance, belongs to the Print Room in Berlin (fig. 132).[4b] Here, as in the landscape drawing with the many windmills, the artist uses the reed pen to gain more breadth and power in his stroke, and adds a few touches of wash

with the brush. Now in the mid 1650's, Rembrandt has the ability to sum up larger areas with a minimum of vigorous touches. In his approach to nature he seems to have passed the phase of intimate observation; he now gives the impression of boldly superimposing his temperament upon nature's forms with a complete mastery of means and a compositional force that is truly monumental. From drawings like these one realizes why the artist could go no further in his landscape studies. With their directness, breadth, and pictorial power they represent the climax of Rembrandt's shorthand style.

Rembrandt's landscape etchings, which first appear about 1640, clearly show his previous experience with the etching needle. In the charming little *View of Amsterdam* (H. 176, fig. 133)[5] the artist exploits the vibrating quality of the etched line for the creation of an all-over atmospheric effect. The open meshwork of lines, which maintains a transparency even in the most dense passages, adds to this impression as does the delicate and consistent indication of the aerial perspective. The etched line in Rembrandt's hands never becomes monotonous or mannered, but retains a spontaneous and descriptive quality. Structure and texture of forms are expressed and only slightly subordinated to the general impression of airiness and expansive space. As an etcher Rembrandt at this phase has learned to exploit the whiteness of the paper for the creation of a bright daylight effect. The composition is firmly knit by diagonals and horizontals, with smaller vertical accents. The subtle organization of values plays an important part. A delicate focal point seems to exist in the middle distance in the two tiny figures who appear just below the large storehouses of the

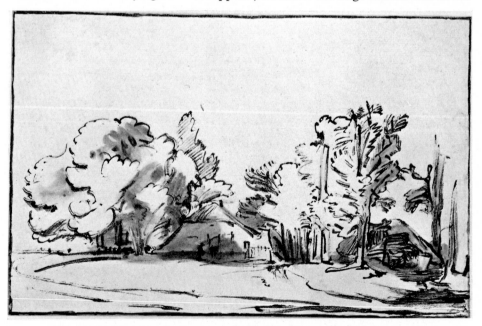

132. COTTAGES AMONG THE TREES. Berlin, Print Room. Drawing (19·5 × 31)

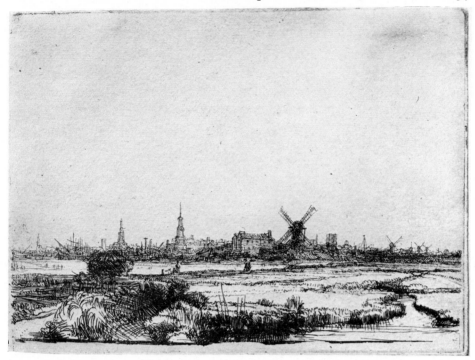

133. VIEW OF AMSTERDAM. Etching (H.176). (11·2 × 15·3)

East and West India companies. The skyline exerts a strong attraction with its
lively and characteristic silhouette. But even in this hazy distance there is no flatness
of form; the remotest buildings retain their three-dimensional existence. The un-
conventional freshness of Rembrandt's vision lends a timeless charm to this little
view of the Dutch capital. In this etching, as in many others, the artist did not hesi-
tate to have the directions reversed in the print; topographical correctness was never
his first concern.

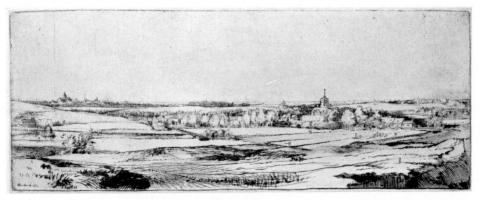

134. THE GOLDWEIGHER'S FIELD. 1651. Etching (H.249). (12 × 31·9)

The large flat landscape of 1651, traditionally called the *Goldweigher's Field*, from the assumption that it represents the country seat of the Receiver General, Jan Uytenbogaert,[6] is done chiefly in drypoint (H. 249, fig. 134). The composition shows a more striking emphasis upon the horizontal character of the landscape, with the sky less dominant (there is here a one-to-one relationship between earth and sky) and the formations of the earth richer and more luminous in graphic effect. The scribbling stroke of the etched line, which Rembrandt had so cleverly exploited during his middle period for the impression of atmospheric vibration, has given way to the simplified stroke of the drypoint needle. In Rembrandt's mature period the drypoint surpasses the etched line in power of accent and in directness and breadth of touch. The artist now avoids too sudden a dash into the distance. While the interpenetration of diagonals and horizontals is richer than before, the diagonals are here subdued, indicating a very gradual recession into an incredibly remote background. The general character of the country with its flatness ever so slightly enlivened by low rolling hills, its alternation of land and water, of meadows and woods, is beautifully brought out. The cloudless sky and the sharply contrasting light and shadow suggest the sunny quality of a hot summer day. There is no strong focus of attraction in this composition; Rembrandt has created a rather even distribution of accents, leaving the main emphasis to the general features. Many enthusiastic pages have been written about this etching, which may be called one of the most impressive characterizations of Dutch landscape in graphic art.

The two following examples belong to the intermediary phase between 1640 and 1650, and are chosen to demonstrate the previously mentioned coexistence of two opposite tendencies in Rembrandt's treatment of landscape. The *Three Trees* of 1643 (H. 205, fig. 135), with its pronounced chiaroscuro, is full of a Baroque romanticism which is quite exceptional in Rembrandt's etched work. Both in scale and in pictorial brilliance the artist here rivals his own paintings. The striking vision of the three trees, with massed foliage darkly silhouetted against a brightening sky, belongs among Rembrandt's most unforgettable creations. For this grandiose motif he has explored nature's wide repertoire, its brilliance and darkness, sunshine and thunderstorm, the contrast of flat, expansive plain and low hilly formation. The sky is full of drama, and the earth stirs with activity of every sort. There is a draughtsman seated on the top of the hill at the right, a carriage full of people approaching him, a pair of lovers hidden in the dark bushes of the foreground, and on the other side of the pond a man fishing and a woman seated beside him. In the middle distance animals are grazing and men are busy at their labour. The range of Rembrandt's graphic expression is extraordinarily wide in this print. The addition of fine drypoint work in the sky enlivens the atmospheric effect through soft transitions. The meaning of the scene is clear: as the storm clouds are scattered the darkness recedes and daylight breaks through, gradually revealing the true character of the Dutch plain.

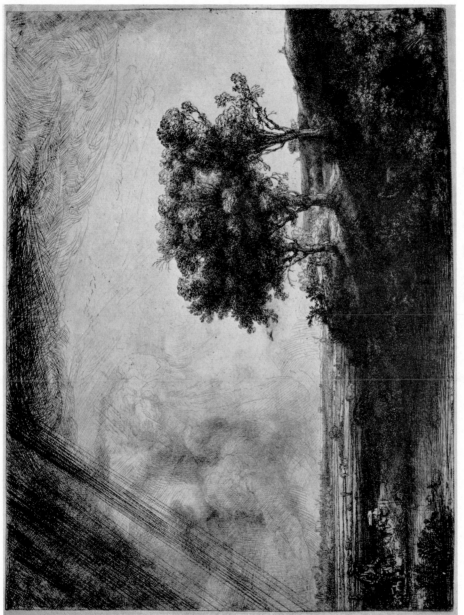

135. THE THREE TREES. 1643. Etching (H.205). (21·1 × 28)

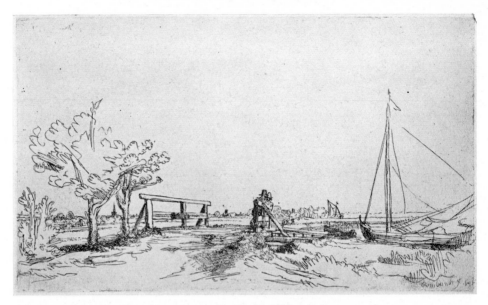

136. SIX'S BRIDGE. 1645. Etching (H.209). (12·9 × 22·3)

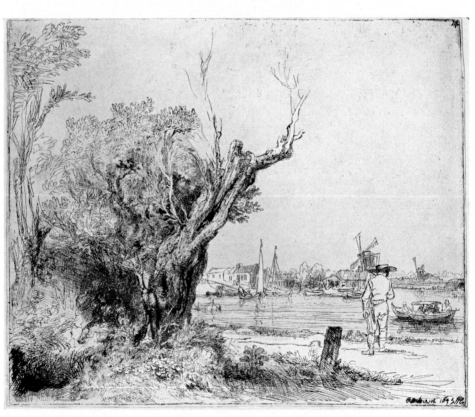

137. THE OMVAL. 1645. Etching (H.210). (18·5 × 22·5)

In comprehensiveness of effort and richness of pictorial effect this small etching of the *Three Trees* is, in a way, comparable to the great *Night Watch* of one year earlier. As in the case of the *Night Watch* there might be critical objections from a purist point of view. The crowded network of lines in this print gives the impression of working from dark into light, contrary to the demands of the graphic medium for a light-to-dark procedure. The resulting power, however, is undeniable.

In contrast to the romantic treatment of the *Three Trees*, the *Six's Bridge* of 1645 (H. 209, fig. 136) represents a climax of Rembrandt's realistic tendencies in land-scape etching. It also marks a high point in his shorthand style in this technique. The title goes back to Gersaint, who relates the traditional story that Rembrandt etched this plate 'against time for a wager at the country house of his friend, Jan Six, while the servant was fetching the mustard, that had been forgotten for a meal, from the neighbouring village'.[7] This sounds like a nice legend that owes its origin to an early appreciation of the amazing sketchiness in this etching. The composition is marked by a strong emphasis on the middle distance, which accounts for the con-tinuity of the recession and convincingly links the foreground with the far distance. A focal point is established in the figures of the two men leaning against the railing of the bridge. They add a human touch to the general impression of an open land-scape that breathes the bright and windy seaside atmosphere of Holland. There was a time when pure etchings like this were held in higher esteem than the drypoint effects of Rembrandt's later work. Whatever our judgement on this point may be, Rembrandt here comes closest to the sketchiness of the nineteenth-century Impressionists, but without losing, as they often do, the fundamental quality of structural clarity.

Two more landscape etchings may finally be added to indicate the richness of Rembrandt's production in this field during these years. The *Omval* of 1645 (H. 210, fig. 137) represents a specific view of the little hamlet near Amsterdam, situated at the bend of the Amstel.[8] In this case, as in the *View of Amsterdam*, the scene is reversed in the print. In his workshop Rembrandt later combined this view with a group of trees to fill the left foreground. The study of an old willow, now in the Louvre (HdG. 769), may have served him as model. This contrasting of a powerful tree motif in the foreground with flat country in the distance recalls the composition of the *Three Trees*. But Rembrandt's more open manner here, with the resulting effect of diffused daylight, lends a different character to the *Omval* print and alters the general impression from the dramatic to the familiar. Here, too, as in the *Three Trees*, Rembrandt has concealed a pair of lovers in the shadow of the foreground bushes, while everyday life goes on about them. The figure of the man at the right, who turns toward the boat filled with passengers, has an important function within the composition, in relating foreground to distance, and in contributing a rather bright spot to the prevailing higher value on this side of the picture. Rembrandt has

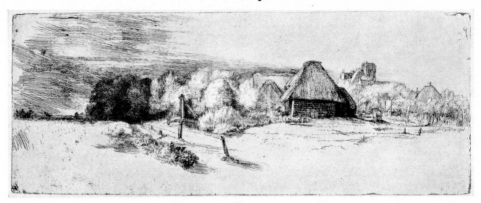

138. LANDSCAPE WITH TREES, FARM BUILDINGS, AND A TOWER.
Etching (H.244). (12·3 × 31·8)

again handled the needle with a delightful ease and sketchiness, maintaining a transparency even in the most dense passages of the undergrowth and opening its foliage toward the sky and the foremost plane with the freest of light touches.

If ever an artist put his whole heart into a simple representation of nature, this was the case in Rembrandt's etching of a *Landscape with Trees, Farm Buildings, and a Tower*, of 1650 (H. 244, fig. 138). Cast shadows indicate the time of day when the sun turns toward the horizon. The motif, in its utter simplicity, recalls similar subjects among Bruegel's drawings, and shows an equally plastic and airy treatment. But the richness and breadth of pictorial accent in this print lends the landscape both a deeper brilliance and a firmer structural power than Bruegrel could attain. The eye is drawn to the left, where the sun's rays cause a rich play of tones in the sky. The right side of the composition balances this attraction by the strong accent on the central cottage standing between brightly shining trees. The open foreground heightens, by contrast, the compactness in the middle distance, where the landscape fuses into a stretch of trees and buildings. Conspicuous as these forms are, they are subordinated to the larger aspects of nature—its horizontality, its fullness, its luminosity. Rembrandt in this print is free from any influence of the classic Italian landscape, often found in his late paintings. He needed no accessories symbolizing a heroic past in order to enhance the monumental character of the composition. The true grandeur which he achieved here is derived solely from the impression of nature itself.

The visionary type of landscape, as pointed out in the beginning of this chapter, is found primarily in Rembrandt's paintings. His technical habits were probably partly responsible for this. His procedure in painting was to work from the dark into the light (basically the 'Venetian' mode). This device enforces upon an artist a departure from visual reality, both in pictorial conception and execution. To Rembrandt darkness was not an indispensable attribute of nature, but it played an

important part in the expression of his own feelings. He found a temporary delight in the bright, outdoor daylight which almost completely absorbs the darkness, as we have seen in his various graphic studies. But his paintings prove that he tended to infuse a quality of mystery even into landscape subjects. For this purpose darkness was essentially correlated with light, and usually predominated in his rich chiaroscuro patterns.

In his landscape painting Rembrandt was fairly consistent in maintaining the romantic attitude (which represents nature not as it is, but as the artist's imagination visualizes it). His progress was from the fantastic to the ideal; from entertaining and dramatic representations he turned to scenes of idyllic and sombre calm. In his first group of landscapes, dating from the late thirties to the early forties, Rembrandt was influenced by the northern painters of romantic landscapes, particularly Hercules Seghers, and also by Mannerists like Roelant Savery and Govaert Jansz. All these artists were represented by paintings in Rembrandt's own collection. From Seghers he derived the fantastic type of rocky landscape with half-bare pine trees clinging to steep slopes, while from the Mannerists he borrowed the luxuriant tree with full foliage and oddly twisted trunk. Later he showed some affinity for the Italian type of landscape created by Giorgione and Titian and developed by the Carracci and Elsheimer. The recurrence of such motifs as arched stone bridges, obelisks, and ancient ruins, set among gently sloping hills and bathed in soft light, is proof of this classic trend. Elements of the classic influence which had come to Rembrandt early in his career, through his teacher Lastman, found a congenial response only in his later work.

The *Landscape with the Baptism of the Eunuch* of 1636 (fig. 139) represents a hybrid form combining Biblical painting and landscape and shows a strong influence of Seghers in its curious mountain formations. The chiaroscuro has not yet reached its full power, nor is the atmospheric life developed. The sky thus remains rather insignificant and plays little part in furthering the spatial effect. The dimness of the dark tones is still reminiscent of interior scenes.

In the later thirties and early forties Rembrandt deliberately chose the moments when nature presents strong and unexpected contrasts—gloomy, threatening weather, with the light dramatically breaking through dark clouds to strike a few spots with intense brilliance. Many other features heighten the visionary and exotic character. Mountainous terrain is arbitrarily combined with flat country. Mills turn and waterfalls splash in a very improbable manner. Ghostly cities are revealed by the sudden flashes of light, high on a hill or deep in a remote valley. Strange Romanesque-Baroque churches, lone columns and arches add to this romantic miscellany of motifs, but all is fused into a convincing unity through the fire of Rembrandt's imagination and the power of his chiaroscuro (figs. 140–142). The colouristic effect is still rather monochrome, with a subdued contrast of browns and

142. LANDSCAPE WITH A BRIDGE. Berlin-Dahlem, Staatliche Museen. Oil on panel (28×40)

141. LANDSCAPE WITH AN OBELISK. 1638. Boston, Isabella Stewart Gardner Museum. Oil on panel (55 × 71·5)

139. LANDSCAPE WITH THE BAPTISM OF THE EUNUCH. 1636. Hanover, Landesgalerie.
Oil on canvas (71·2 × 103·7)

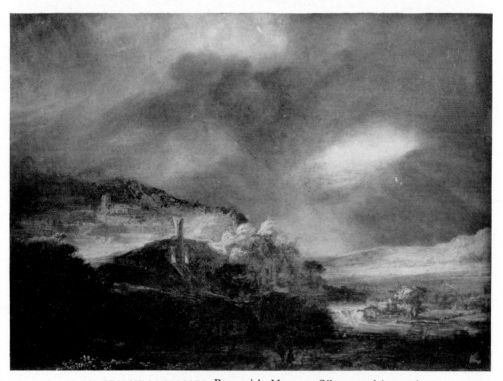

140. STORMY LANDSCAPE. Brunswick, Museum. Oil on panel (52 × 72)

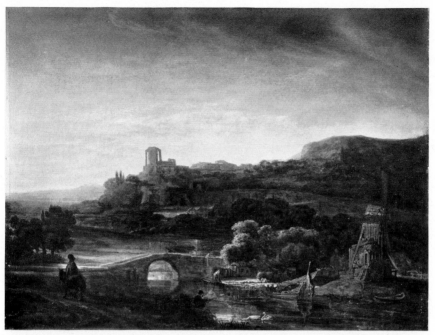

143. RIVER VALLEY WITH RUINS. Kassel, Museum. Oil on panel (66 × 86)

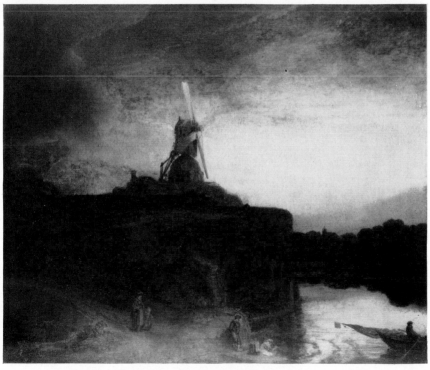

144. THE MILL. Washington, National Gallery of Art (Widener Collection).
Oil on canvas (87·5 × 105·5)

greens, of pinks and greys, reaching its strongest point in the golden yellows of the highlighted passages. The constant blending of the tones and the fluidity of the treatment heighten both the dynamic quality and the pictorial unity. 'Man glaubt Beethoven am Klavier sitzen zu sehen und phantasieren zu hören. Akkorden-folgen ergiessen sich ohne Melodie und Solo.'[9]

The *River Valley with Ruins*, in Kassel (fig. 143), and the *Mill*, formerly in the Widener Collection and now in Washington (fig. 144), are landscape paintings of the early fifties. Both are still conceived in the romantic vein, with the most varied elements in nature combined into an imaginative whole. But there is greater breadth and simplification than before, and even more monumentality. Lights and darks are less scattered; the shadows are massed in the upper sky and in the foreground, leaving the horizon to glow with a golden light and send soft reflections over the darkening earth. Against this luminous distance the silhouettes of the main motifs stand out impressively. In the Washington picture it is a mill set high upon a bastion beside a broad moat, its arms catching the last rays of the setting sun. In the Kassel landscape it is the cadence of a broad hilly formation with a lofty cathedral marking the point where it slopes down into the valley. Here, too, the bright horizon casts its glow over the edge of the hill and the tower is bathed in a clear light. In these two late landscapes the tonality shows an increased warmth. The chiaroscuro effect still predominates over any local colour, but it is a chiaroscuro full of colouristic glow. The warm brown of the earth is deepened by golden yellow highlights and blackish shadows, by touches of red in the *staffage* and olive green in the vegetation; the luminous white of the sky is intensified by streaks of yellow, grey, and dark blue.

One cannot deny that in these late paintings Rembrandt came close to the ideal character, the calm, and the grandeur of classic landscapes. There is a hint of Elsheimer in the dark silhouettes set off against glowing horizons and reflected in quiet waters. But Rembrandt went beyond Elsheimer in pictorial richness and suggestive power. His landscapes express far more than nostalgia for the glory of nature and for the heroic past; they reveal a humanity of great complexity and depth, comprehending both mystery and clarity, tragedy and beauty, drama and lyric calm. It is the reconcilement of opposite forces that lends to Rembrandt's work a greater mellowness and emotional appeal.

IV

BIBLICAL SUBJECTS

I N seventeenth-century Holland religious subjects had ceased to form an important category in painting. Portraiture and landscape, genre and still life, marine views, street scenes, and animals—all had their specialists. Hardly an aspect of the Dutch burgher's daily life escaped the painters' interest and attention. Religious art, however, was so little in demand that it had no specialists other than Rembrandt and his immediate pupils. And even these pupils, in most cases, turned away from Biblical subjects to the more profitable fields of portraiture, genre, or landscape just as soon as they became independent painters.

This taste of the Dutch for the realistic depiction of everyday life, as well as their indifference toward religious art, can be explained by the Calvinist background of their culture. According to Calvin the art of painting should be concerned only with the rendering of the visible world and its purpose should be the decoration of private houses and civic buildings. He denied to the fine arts any right to serve religion. It was his conviction that figural representations of God or of Christ degrade the Divine through humanization.[1] The severe simplicity of Holland's churches, with their complete lack of decoration, still reflects Calvinistic austerity in its original form.

Against this background it is all the more surprising that Rembrandt's work centred so strongly on religious art. His teacher, Pieter Lastman, it is true, had devoted no small portion of his work to Biblical subjects. But Lastman represents the initial phase of the Dutch Baroque, which was dependent upon its Italian sources and still favoured historical or Biblical subject matter. In the following generation, Rembrandt stood almost alone in his large-scale production of Biblical works. The significance of this fact as a manifestation of his strong personal inclination toward religious art cannot be overestimated.

Let us first see how large a place this category occupies in Rembrandt's work in comparison to portraiture, his other major field of production. If we count all the Biblical subjects, in painting, etching, and drawing, they surpass the portraits in number. In the field of portraiture we know more than four hundred paintings, about seventy-five etchings, and only a few drawings, bringing the total number of portraits to about five hundred. Of Biblical subjects there have survived about one hundred and sixty paintings, about eighty etchings, and more than six hundred drawings, which means a total of approximately eight hundred and fifty in this field. But in order to give this statistical account more meaning, we must consider the sizes of the single items—in other words, the amount of work invested in them.

Large group portraits like the *Syndics* (fig. 126) or the *Night Watch* (fig. 124) balance, of course, a great many drawings in the religious category; on the other hand, Biblical paintings of the dimensions and importance of the *Blinding of Samson* (fig. 158), *Jacob blessing the Sons of Joseph* (fig. 188), or the *Return of the Prodigal Son* (fig. 193), outweigh many a painted portrait of the early period, done in a more or less routine manner. Also, large-scale etchings of Biblical subjects such as the *Hundred Guilder Print* (H. 236, fig. 169) and the *Three Crosses* (H. 270, fig. 176) must be counted against a number of lightly etched portraits of the earlier period.

One significant fact stands out immediately from the above statistics: the extraordinary preponderance of Bible subjects among the drawings. Most of these were obviously done not as preparatory sketches for paintings or etchings but as independent and complete works. And since the market value of drawings was negligible,[2] they clearly manifest the artist's inner urge to deal constantly and intensely with religious subjects of the most varied sort.

In the case of Rembrandt's paintings of Biblical scenes we do not know how large a percentage was commissioned work, since records of such commissions are few.[3] The fact, however, that religious painting was very little in demand allows the assumption that in painting as well as in drawing it was Rembrandt's own choice to deal so largely with Biblical subject matter. As for his etchings, we learn from Houbraken that Rembrandt could count upon a large group of collectors to purchase every print that came from his press, even to all the different states.[4] These enthusiastic amateurs seem to have been pleased with any subject etched by Rembrandt's hand,[5] and the artist made ample use of this freedom by producing an unusual number of Bible illustrations. Thus, from whatever angle we regard the above statistics, there can be little doubt that Rembrandt's prodigious activity in the field of religious art was mainly due to his own inclination and not to the demands of patrons or the art market.

In considering Rembrandt's attitude toward the Bible we may ask whether his artistic or his religious interest was uppermost. Did the Scriptures serve primarily to provide the artist with appropriate motifs for narrative subjects of an historical or dramatic character? Or is the purely religious content sufficiently predominant to warrant the investigation of Rembrandt's religious attitude? It is not surprising to find the two elements closely interwoven, but we observe that in the course of Rembrandt's development the religious content gains in significance and depth, becoming more and more distinct and personal. For Pieter Lastman the Bible had been chiefly a source for narrative scenes. Lastman was a professional historical painter who sought to entertain and impress his public by presenting Biblical subjects with a lively naturalism and a certain archaeological precision. Rembrandt at first adopted this approach, but for him the Bible stories soon came to mean more than mere source material of a dramatic nature.

Also in the selection of subjects from the Bible the young Rembrandt began by following his teacher and the current tradition of Biblical painting. He later added some new topics, but few that can be called discoveries of his own. His innovation consisted more in the new depth of interpretation than in the originality of subject matter. There was a certain group of favourite themes, such as the 'Expulsion of Hagar', the stories of Tobias and Susanna, and 'Christ at Emmaus', to which Rembrandt clung throughout his life, creating ever new solutions and constantly trying to improve both the representation and the interpretation. He generally preferred such stories as allowed him to focus on the reaction of the individual human being. He avoided those mass scenes which had been the favourites of the late Renaissance and Mannerist Bible painters and illustrators—subjects such as the 'Deluge', the 'Gathering of the Manna', the 'Worship of the Brazen Serpent', or the 'Massacre of the Innocents'. He never dealt with apocalyptic themes or those of a purely theological significance, such as the 'Holy Trinity'. Neither did he attempt to represent God's actions. We might search in vain for the scenes of the Creation, which Michelangelo so grandly described. The reason for this is not hard to find. For Rembrandt it was essential to humanize his subjects and to endow them with profound psychological content. Whether out of religious motives or out of deference to his Calvinistic environment, Rembrandt, with a very few exceptions, did not give form to God the Almighty. In the representations of his favourite characters of the Old Testament in moments of contact with the Divine, God's angel messengers appear though He does not.[6] When Rembrandt turned to the New Testament, on the other hand, he dealt largely with the figure of Christ Himself, and here he endeavoured to combine the human and the divine in his characterization.

Rembrandt's choice of Biblical subjects, however, as well as his interpretation, underwent certain changes in the course of his career. Throughout the 1630's the conspicuous Orientalism of Lastman was still to be felt, and the Baroque taste for the heroic and the bombastic led Rembrandt to prefer such subjects as the story of Samson, which figures quite prominently at this time. During the forties and early fifties he turned to more tranquil themes of an almost lyric character. The figures of the young Tobias, Joseph, and Daniel, and in particular the youthful Jesus now appear frequently. They all reflect the artist's deepened religious perception, but also his delight in his son Titus, who served as model for these figures.

Finally, during Rembrandt's last years, while his material circumstances were deteriorating and his private life was stricken by further disaster, the Bible subjects show another shift of interest and accent. This time it is Christ's Passion which we find represented with unprecedented power. The gloom of tragedy is likewise cast on the great Bible figures which the old Rembrandt selected to represent man in his hour of trial or innermost conflict. The *Return of the Prodigal Son* is the last, and perhaps the most profound manifestation of Rembrandt's religious

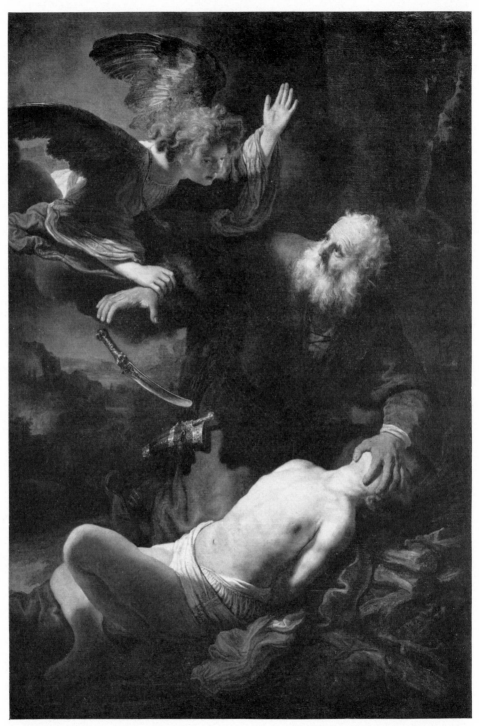

145. THE SACRIFICE OF ABRAHAM. 1635. Leningrad, Hermitage. Oil on canvas (193 × 133)

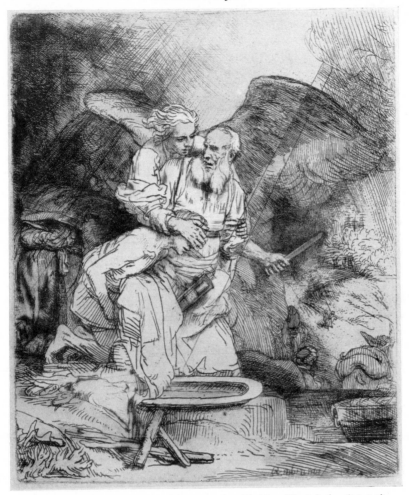

146. THE SACRIFICE OF ABRAHAM. 1655. Etching (H.283). (15·6 × 13·1)

attitude, symbolizing the forgiveness of God the Father toward weary and repent-
ant man. Thus in choice as well as interpretation Rembrandt's Biblical subjects
reflect throughout his life his own experience and spiritual growth.

What, then, are the new and original features in Rembrandt's religious represen-
tations, by which he is distinguished from contemporary Baroque art and from the
art of earlier periods ? Rembrandt is original in his expression of man's inward re-
action in the specifically religious situations which arise whenever human contact
with the Divine is sought or takes place. Pieter Lastman and the typical Baroque
painters stressed the outward, physical manifestations of religious emotion, through
gestures and facial expression. But Rembrandt, with his insight into the nature of
true experience, found the means to express the inward response in its full range
and intensity. As an adequate setting for his Biblical scenes Rembrandt created an

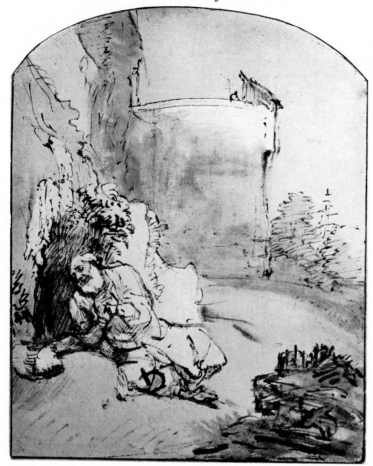

147. JONAH AT THE WALLS OF NINEVEH. Vienna, Albertina. Drawing (21·7 × 17·3)

atmosphere of stillness and mystery, and in this respect, too, he is unusual. The showy and theatrical manner of his predecessors and contemporaries was irreconcilable with the spirit of introspection that characterizes Rembrandt's religious scenes.

In thus throwing the accent upon the spiritual, Rembrandt was faced with the problem of expressing the invisible within the visible world. He solved this problem with no distortion of one at the expense of the other, and with full awareness of human nature in all its dimensions. While the spiritual content dominates, the physical world remains its indispensable, though flexible, frame. This may be called a most natural consideration. But where else, we may ask, in Baroque or modern art, do we find this basic relationship explored with the same psychological insight, the same sure and sensitive grasp of essential features, and expressed with equal subtlety and power?

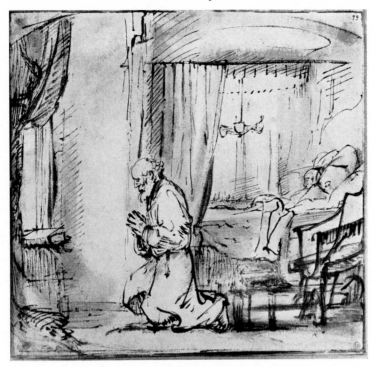

148. ST. PETER PRAYING FOR THE RESURRECTION OF TABITHA.
Bayonne, Musée Bonnat. Drawing (19 × 20)

In his search for full expression in religious art, as he understood it, Rembrandt gained two basic artistic realizations, which we have seen applied in his portraiture. He learned first that spiritual content can only be suggested, but never fully described with plastic distinctness. His second discovery was that the most flexible and intangible elements of the visual world, such as light, shade, and atmosphere, are best suited for the suggestion of this spiritual content. Rembrandt follows what one may call the principle of analogy for the expression of the intangible. In poetry this same principle is employed to evoke the idea of immaterial things. Christ's use of parables shows a most profound application of this formula. In philosophy, too, analogy is the ultimate resort for the expression of the true nature of things, and of spiritual content in particular.[7]

It must be remembered that those features which we have described as innovations in Rembrandt's religious art did not fully materialize until his later period. Up to the end of the 1630's his work still shows much of the characteristic Baroque spirit in the Lastman or Rubens manner. But from about 1640 on the new features become more and more prominent. A juxtaposition of the *Sacrifice of Abraham* of 1635, in Leningrad (fig. 145), with the etching of the same subject, dated 1655 (H. 283, fig. 146), may illustrate this point. In the painting, which is based upon a

Lastman composition,[8] the main emphasis is still laid on the physical manifestation of the miracle, with a typical Baroque love of ostentatious movement. In accordance with the Biblical text Isaac is bound and laid upon the altar, to be slaughtered like an ordinary burnt offering. The father's broad grip on the boy's face, pressing back his head to stretch his throat for the fatal cut, is a touch of the most brutal realism. The angel descends upon Abraham from the upper left with a whirlwind movement, his left hand conspicuously raised to the sky, his right grasping Abraham's wrist with such sudden force that the knife slips from the old man's fingers. This over-emphasis on the momentary aspect gives the impression that the knife is suspended in mid-air, a theatrical feature which attracts attention fully as much as Abraham's look of surprise at the angel's appearance.

In contrast to this scene, the etching of 1655 lays all emphasis upon Abraham's inward reaction. In his willingness to sacrifice his own flesh, the venerable patriarch passes the supreme test of man's obedience to God. This inner conflict of Abraham's is now the focal point of Rembrandt's representation, and all outward action he subordinates to its expression. He interprets the Biblical text with greater independence of descriptive details and with a deeper human insight. Isaac is no longer stretched out like any sacrificial victim. He kneels with an innocent submissiveness[9] beside his father, who presses the son's head to his own body. It is a gesture infinitely more human than the one in the earlier version. The angel appears from behind Abraham, grasping both his arms with an embrace that is powerful and highly symbolic. Although his face is close to Abraham's, and his mighty grip instantly suspends the action, the angel remains unseen by the patriarch. Diagonal beams of light pierce the cloudy atmosphere which surrounds the group, symbolizing, like the angel's appearance, the divine grace that descends upon Abraham at this sacred moment. The father himself has not yet fully grasped the significance of this blessed visitation. As he listens, inwardly, to the unknown voice, the stamp of suffering still marks his features. By thus linking the past moments in Abraham's inner experience with the present advent of the miracle, the artist deepens the spiritual significance of the scene and relieves it of the instantaneous quality.

Rembrandt, in his later period, shows the same basic features whether he chooses episodes from the Old or the New Testament. But we can go further and try to define the specifically Christian tenor of his Biblical representations, beyond their general religious content. Rembrandt's Christianity was broad and evangelical. Certain fundamental notions such as 'humility' and 'suffering' he suggests with unparalleled depth of vision and power of expression. In his representations there is fully expressed the Biblical humility which throws man wholly upon God's mercy. This is completely at variance with the classic emphasis upon human strength and self-reliance, never quite abandoned by the typical Baroque painter. Rembrandt's interpretation of God conforms to the Biblical concept of an all-embracing Power,

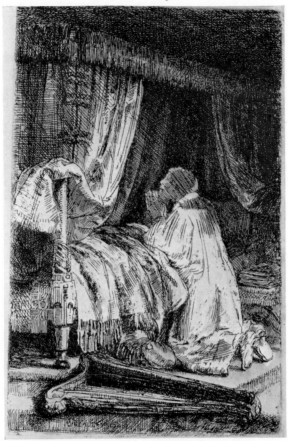

149. DAVID IN PRAYER. 1652. Etching (H.258). (14 × 9·5)

of a mysterious and unfathomable character. But the indisputable centre of his religious world is the figure of Christ as the bearer of divine compassion and mercy (fig. 169). The statement has often been made that in Rembrandt's work Christ appears primarily as the helper of the poor and the destitute. This alone is too narrow an interpretation, however, savouring of nineteenth-century conceptions of humanitarianism. Christ, as Rembrandt conceives Him, is first of all the Teacher and the Bringer of Salvation.

While Rembrandt saw Christ so clearly as the centre of his religious world, he looked upon the Old Testament as the Sacred Book on man's fate and God's will. He did not regard the Old Testament period as the 'dark age of humanity,' before the advent of Christ, or 'history in the shade'—in the words of Calvin—sparsely illumined by a few acts of revelation.[10] Neither did he treat the stories of the Old Testament as prefigurations of the life of Christ, as the *Biblia Pauperum* did. To Rembrandt they were significant in themselves, symbolizing man's fallibility and

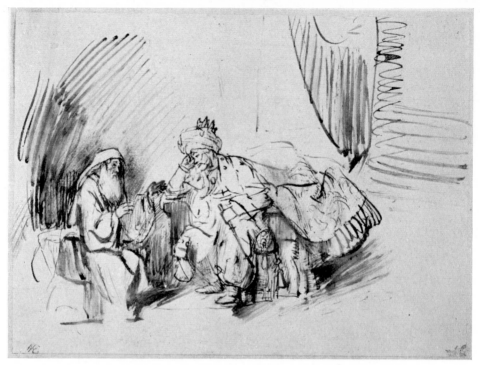

150. NATHAN ADMONISHING DAVID. New York, Metropolitan Museum. Drawing (18·3 × 24·2)

man's humility, and never without the implication of God's supreme power and ultimate judgement.

Our consideration of the character and the import of Rembrandt's religious art finally raises the questions whether the artist was an adherent of any of the contemporary religious movements in Holland and whether his work reflects such a connexion. To answer these questions we must first make a general distinction between Protestant and Catholic art in the Baroque period, with Rembrandt an outstanding representative of the Protestant group; then we shall deal with the relationship of Rembrandt's religious art to Calvinism, and in the third place, with its relation to Mennonism.

Rembrandt has always been taken as the exponent of the Protestant spirit as opposed to that of Catholicism in Baroque art, and for the illustration of this point the contrast between Rembrandt and Rubens offers itself readily. In any such comparison the basic differences are at once apparent. Rubens' art gives expression to the power and the splendour of the Church, to its saints and martyrs, and particularly to the ideals of the Counter-reformation. In accordance with the Jesuit demand for an appeal to the masses in the interest of religious propaganda, his art stresses the outward physical manifestation of the supernatural in a rather ostentatious manner. This type of Catholic altar painting, full of pictorial glamour and

bursting with action, is diametrically opposed to Rembrandt's quiet representations, which are designed not to stir up a congregation, but to appeal to the individual who is ready for intimate and searching contemplation. While granting that Rembrandt can be regarded as an outstanding representative of the Protestant spirit, we hesitate to identify his art with the Protestant movement as a whole. Its main trends, Calvinism and Lutheranism, either rejected religious art or remained indifferent to the pictorial expression of religious themes. Rembrandt is therefore exceptional, almost unique, in giving expression to Protestant piety; Rubens, for his part, in line with Van Dyck, Murillo, and a host of famous Italian painters and sculptors, is a typical exponent of the Catholic approach toward religious art in the seventeenth century.

Rembrandt's religious concepts had much in common with Calvinism, the official religion of the Dutch republic from the time of the liberation from Spain. Only in the early decades of the seventeenth century had Calvinism shown a severe and unbending attitude toward other sects, particularly the more liberal one (Remonstrants) which developed within its own camp. After the Synod of Dort (1618–19), when the orthodox branch became firmly established, an atmosphere of tolerance prevailed. Related creeds and mystical groups were allowed to spread, and Catholic services were tolerated in private houses. Rembrandt seems to have shared with Calvinism the idea that religion, with the central belief in the sanctity of the Bible, is the primary concept of life and permeates all its spheres. His art often reflects the belief, so crucial in Calvin's theology, that man is powerless before God. Furthermore, Calvinism had encouraged a renewed and intensified interest in the Old Testament as the story of the chosen people, and this also was a feature which appealed to Rembrandt. He represented the world of the Patriarchs, the Judges, and the Kings as no painter had ever done before. As we know, he even lived in close contact with the remnants of this chosen people to whom Calvinist sympathy had offered a refuge in the Dutch community.

But there were essential points in Calvin's doctrine, emphasized by his strict followers, with which Rembrandt's art was less in accord. Rembrandt did not regard the Old Testament so exclusively through the perspective of God's selection and damnation. For him, as we have seen, it was a rich source for the stories of man's life and destiny which he treated with a strong humanization and emphasis upon individual psychological reaction. These features meant little to Calvin, who enforced a rather strict interpretation of the Bible by his dogma of predestination. Under his rigorously organized system human thought was centred exclusively upon the idea of the 'absolute sovereignty of God in all natural and moral spheres', leaving no room for an artist's imagination. Thus Calvin's thinking moved from heaven down to earth, rigidly ordering every sphere of life according to an assumed divine plan, with heavy emphasis upon will, duty, and calling. Rembrandt's art gives the impression that he was neither as rational nor as abstract as the 'Aristotle of the Reformation'

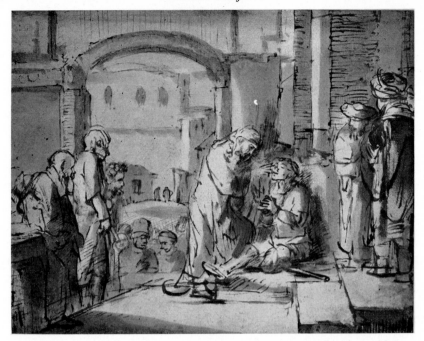

151. CHRIST HEALING A BLIND MAN. Rotterdam, Boymans-van Beuningen Museum.
Drawing (18 × 22·6)

(as Melanchthon called Calvin). Rembrandt's attitude was primarily an intuitive one.
And with all his profound devoutness, he was thirsty for life and for freedom. Thus,
unlike Calvin, in his religious conceptions he moved from the earth up to heaven,
maintaining the firmest possible foundation for his visions in the real world around
him.[11]

Comparatively little emphasis has been given, in the literature on Rembrandt, to
the artist's relationship to the Mennonites. Some theologians have discussed this
problem, but too exclusively from the theological angle.[12] Among the biographers
only Neumann devotes to it a more explicit investigation.[13] A study of the Men-
nonite literature, and Menno's own writings in particular, will reveal how close
Rembrandt came in his Biblical representations to the spiritual attitude of this sect.
The documentary evidence for his adherence to the Mennonite creed is fairly
positive. Baldinucci provides the following information, which he received from
Rembrandt's pupil, the Danish painter Bernhardt Keil: 'This artist [Rembrandt]
professed in those days the religion of the Menists [Mennonites], which, though false
too, is yet opposed to that of Calvin, inasmuch as they do not practise the rite of
baptism before the age of thirty. They do not elect educated preachers, but employ
for such posts men of humble condition as long as they are esteemed by them
honourable and just people, and for the rest they live following their caprice.'[14] This
statement is supported by the fact that Rembrandt came into close contact with

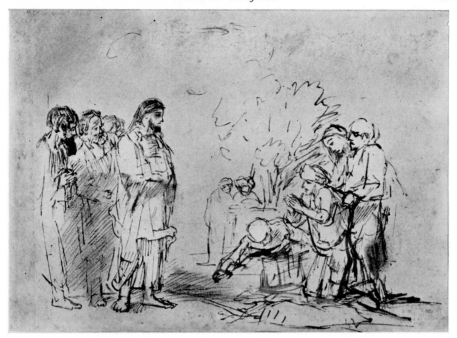

152. CHRIST HEALING A SICK PERSON. Berlin, Print Room.
Drawing (18 × 24·7)

Anslo, the leading liberal Mennonite preacher of Amsterdam, at the very time when
his art began to reflect a decisive turn toward Mennonism.[15]

Whether Rembrandt really became a member of the Mennonite community[16] or
was only closely attached to it does not greatly matter for the understanding of his
work. Neumann's explicit argumentation leads to the conclusion that the artist
belonged to the liberal wing of the Mennonite community at Amsterdam, the so-
called 'Waterlander' group (to which Anslo also belonged), and this seems con-
vincing. But what really counts is Rembrandt's spiritual affinity to this sect, with
which he shared many basic beliefs, far more than with Calvinism.

The Mennonite creed goes back to the original and literal content of the Bible,
excluding all dogmas, sacraments, and ceremonies that were not instituted by Christ
Himself or by the apostles at His command. It grants neither to the church nor the
state the right to interfere with or supplement these original commands of Christ.
Thus, in strict adherence to Christ's words, the Mennonites refuse to bear arms or
to take an oath, and for this they have had to suffer much persecution in the course
of their history.

The religious activities of the Mennonites consisted mainly in Bible reading
and in doing charitable works. The original creed of Menno Simons, their founder,
was in several respects more severe than that of the liberal group of the 'Water-
landers' in Rembrandt's time. But Menno's principal ideas remained a spiritual

guide and the backbone of the whole movement. Certain of Menno's admonishments, such as 'Be of Christian disposition, long suffering, peaceable, merciful, affectionate, and truly humble, and be obedient to the word of the Lord,'[17] still constituted the basic programme of seventeenth-century Mennonism, even in its most liberal form. Following Menno, the Mennonites always preferred the 'poor in spirit' to the 'worldly wise and learned' ('for it is hidden from them'),[18] and accepted their brethren in Christ 'without any respect to person'. With Menno they laid all emphasis upon man's heart and conscience. It was the inward reaction alone which signified at church ceremonies. These ceremonies, such as adult baptism and the Lord's Supper, had no meaning save as outward manifestations of man's inner experience. For the same reason silence at prayer was often the practice. Ministers were lay preachers selected from the ranks of the community—just as Baldinucci describes—with no regard for any academic standards, but only for 'Christian' qualities, as understood by the Mennonites. Community life was modelled after apostolic conditions, before the church hierarchy came into existence, and the state was respected only so long as it did not interfere with the word of God.

Such freedom from any church cult, such disregard for social distinctions, such directness and sincerity in the interpretation of the Bible, and above all, the 'simple and warm spirituality' of Menno and his followers must have attracted a nature like Rembrandt's. With him, too, Christ the Teacher and the Healer of human suffering was the centre of the religious world, not the formidable idea of God which Calvin had derived from the Old Testament.[19] Rembrandt shared with the Mennonites an indifference to all dogmatic notions and institutions, seeking, as they did, to go back to the simple truth of the Bible.

The writings of Calvin were concerned with the construction and validity of his theological system as based on a reinterpretation of the holy sources—not with the individual Biblical episodes as such. It was different with the Mennonites; to them every Bible story was of moment and was looked upon without any dogmatic preconceptions. It is interesting, in going through Menno's writings, to find almost all of Rembrandt's favourite Biblical subjects mentioned and commented upon in the same spirit. St. Paul, of course, whom Rembrandt represented so frequently, is common ground for all denominations. But Menno devotes, for instance, to 'Saul and David' and to the 'Denial of St. Peter' long and lucid passages[20] which bring clearly to mind Rembrandt's famous paintings of these subjects (figs. 189, 190). Menno deals explicitly with the scene of David admonished by Nathan,[21] treated in a number of masterly late drawings by Rembrandt (fig. 150). The story of 'Christ and the Adulteress' is referred to by Menno, as well as the significant stories of the chaste Susanna, the pious Esther, Jacob and Esau, and Hagar[22]—all favourite subjects of Rembrandt. Finally, the rarely represented central scene of Rembrandt's *Hundred Guilder Print* (fig. 169), showing the blessing of the children ('Suffer little

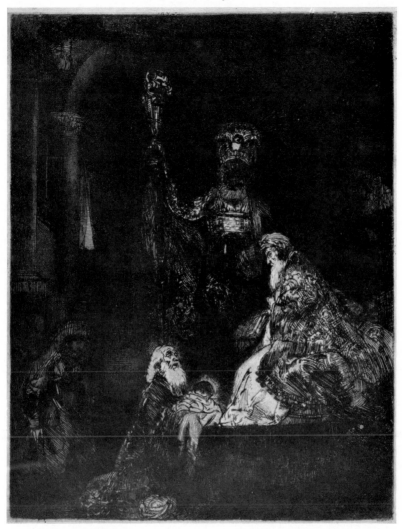

153. THE PRESENTATION IN THE TEMPLE. Etching (H.279). (20·7 × 16·2)

children, and forbid them not, to come unto me: for of such is the Kingdom of Heaven') is also a salient theme in Menno's writings. Upon these words of Christ he bases his conviction that children can enter into heaven without being baptized; this is his argument for adult baptism as opposed to infant baptism.[23] All in all, one gains the impression that the truly evangelical simplicity of the Mennonites, their sobriety, sincerity, and humility are reflected in Rembrandt's religious art much more than in Calvinism, with its highly abstract and dialectic theology.

With all the evidence, outward and implied, that can be brought together to prove Rembrandt's sympathy toward the Mennonites,[24] it would be a false assumption to consider his religious art as based exclusively upon their creed. Rembrandt was too

much of an individualist to conform completely to any given pattern; one may speak
of a spiritual affinity with the Mennonites, but should guard against identifying
him too closely with them. The painter's powerful artistic impulses and keen imagina-
tion, his romantic taste for armour and jewellery, his delight in the dramatic as well
as the lyric aspects of the Biblical stories—these are features which have little in
common with the Mennonite attitude. Rembrandt's closeness to reality, his vivid
response to the visual and the psychological, colour even his religious art and lend it,
in addition to its basic Mennonite features, a strongly individual flavour.

It has been contended that Rembrandt's art became more and more mystic in
character, and came to show a close affinity with the mysticism of the seventeenth-
century German, Jacob Boehme. Neumann, who advanced this thesis, stresses in
particular Boehme's symbolic interpretation of light and dark as powers of Good and
Evil, of God and Satan, relating it to Rembrandt's use of chiaroscuro. But this
feature alone is not enough to link Rembrandt's entire religious approach with
Boehme's obscure and eclectic mysticism, which embraces the most varied trends,
such as theosophy, pantheism, and alchemy. Rembrandt's chiaroscuro and its sym-
bolical meaning can be as easily related to the words of many other religious writers,
and first of all to the New Testament itself. On the whole, Rembrandt's Biblical
figures reveal an introspection fused with sobriety, and this again links him with the
Mennonites.[25]

These considerations as to the religious concepts behind the Biblical art of Rem-
brandt ought to reassert themselves whenever we turn to the individual works. Only
a closer analysis can prove the validity of our assumptions.

OUR survey of Rembrandt's religious subjects may begin with a juxtaposition of
two examples of the *Presentation in the Temple*. The earlier one, belonging to the
Museum in Hamburg (fig. 154), is dated about 1628, and is still close to Lastman's
style; the other, in The Hague, dated 1631 (fig. 155), represents Rembrandt's work
in Leyden, when he broke away from his teacher's influence.

In any study of Rembrandt's Biblical subjects one ought first to read the pertinent
passages in the Bible in order to realize how closely the artist follows the text and
where he departs from it. The deviations are usually slight, but not without purpose.
Rembrandt's freedom in this respect increased as he grew older. In these early
scenes of the 'Presentation' he adheres closely to the text and describes the scene
fairly completely, bringing in the two episodes of the story as told in Luke 2: 22-38.
We see Simeon, who has just taken the Child, thanking God for this sacred moment,
and we see the prophetess Hannah, who also recognizes the significance of the event.
The Hamburg picture already contracts the two episodes into one scene, with
Hannah given a dominating position and Simeon represented at the moment when
he turns to the Virgin, as she and Joseph 'marvel at those things which were spoken'.

Rembrandt's dependence upon Lastman is obvious in the vigorous physical appearance of the figures and their conspicuous gestures. Hannah's attitude is unmistakably derived from Lastman. The triangular scheme of the composition also comes from this source, as does the dark silhouetting of the group against a light background. Finally, the rather glossy paint, with distinct patches of local colour, and the heavy brushwork remind one of Rembrandt's teacher. Yet no one would confuse this picture with a work by Lastman. Beyond the fact that we recognize the features of Rembrandt's mother in the prophetess, we see the young artist's individual style beginning to assert itself. The chiaroscuro is already his own. In the strong concentration of lights and darks for the sake of dramatic expression Rembrandt surpasses his teacher. The intensity of the colour, although relatively high, is subordinated to a subtle organization of values. Daylight effects are realistically rendered, especially in the brightly illuminated wall behind the group. A thin veil of atmosphere relates the figures to the surrounding space, softening the edges of the forms and the sharpness of the colours. While the gestures are still forced and somewhat theatrical, a new quality begins to be felt, a slight element of mystery unknown to the prosy realism of Lastman. On the whole, however, Rembrandt has not yet fully freed himself from his teacher's influence. His figures do not express true depth of feeling. The Christ child, in spite of His halo, is not yet the real centre of interest; the main accent is given to the prophetess Hannah.

In the painting done in Leyden about three years later, reminiscences of Lastman have almost disappeared. The figures are no longer so overpowering in their closeness to the spectator. A lofty, dimly lighted temple interior with fantastic columns dominates the scene and heightens the impression of mystery. But the small figures of the main group gain distinctness by the sparkling sunlight which strikes them. The golden halo of the Christ child makes Him a source of light within the sunlight.

The figure of the prophetess Hannah is again an important one in the composition,[26] although no longer as prominent as in the Hamburg picture. She has approached the group from the left foreground and is seen from the rear, as she makes a gesture with her high-lighted right hand toward the Christ child. Her figure thus serves to relate the main actors spatially with other parts of the composition, even to the seated Jews at the extreme right. Another powerful accent leading to the Child is the massive vertical of the clustered column that rises just behind the kneeling Simeon and glows in subdued gold tones. Many additional figures are drawn into this representation—interested spectators and thronging crowds on the flight of steps leading up to the high altar. While Rembrandt thus expands the scene and enlivens it by many accessories, he does not fail to concentrate the interest in the central group of figures. This group is clearly articulated by the variety of postures and by accents in light and colour. A subdued coolness and delicacy characterizes

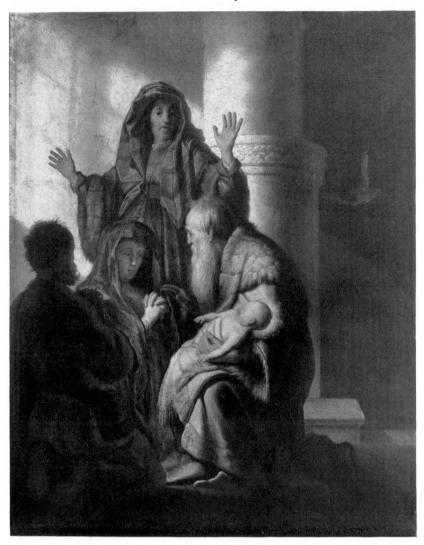

154. THE PRESENTATION IN THE TEMPLE. Hamburg, Kunsthalle. Oil on panel (55·5 × 44)

the colour harmony. Mary's pale blue is sensitively contrasted with the gold and pink in Simeon's mantle and the purple robe and silvery head-dress of Hannah. The blue becomes neutralized into grey in the two standing spectators. Throughout the whole is woven the pleasing contrast of greyish and brownish tones brightened by the warm glitter of gold.

The minuteness of execution brings an element of preciousness into the picture, but there is no loss of crispness or freedom of touch, as is often the case in the work of Rembrandt's Leyden pupil, Gerard Dou. Rembrandt is now unlike Lastman in stressing the intimate quality, yet a feeling for the monumental remains implied.

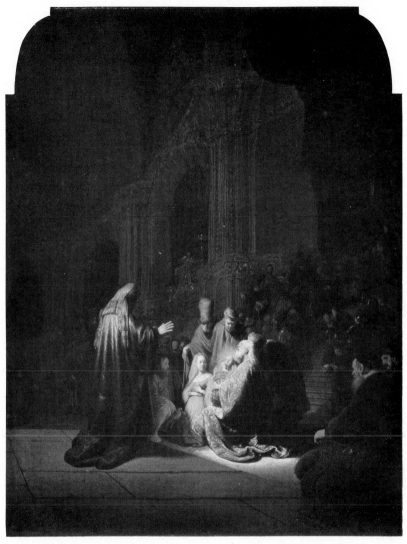

155. THE PRESENTATION IN THE TEMPLE. 1631. The Hague, Mauritshuis. Oil on panel (61 × 48)

The figures are relieved of over-emphasis and more significance is given to the intangible elements of space, light, and atmosphere.

Among Rembrandt's Biblical paintings of the thirties the 'Passion' series, done for the Stadholder, Prince Frederick Henry of Orange, is most outstanding. Several of the artist's letters to Constantyn Huygens, secretary to the Prince and agent for this commission, are preserved.[27] They are mainly of a business nature, but Rembrandt makes an interesting remark on his own work and we find him giving advice on the hanging of the pictures.[28] In 1639 he writes that he feels sure of pleasing the Prince with his paintings of the *Entombment* and the *Resurrection* because in them

156. Lucas Vorsterman after Rubens: THE DESCENT FROM THE CROSS.
Engraving.

he has observed 'the greatest and the most natural movement' (*die meeste ende die naetuereelste beweechgelickheyt*). This formula fully expresses the current Baroque tendency, which found its most powerful representative in Rubens.[29] In fact, in the *Descent from the Cross* from this 'Passion' series, now in Munich (fig. 157), Rembrandt is obviously dependent upon Rubens' treatment of the same subject in Antwerp. The Dutch painter must surely have known the engraving by Lucas Vorsterman (fig. 156) in which Rubens' composition appears reversed. In Rembrandt's *Descent* the body of Christ and the position of the three men holding it are clearly taken over. However, Rembrandt makes significant changes. He heightens the dramatic effect by slightly different means and his realism is more incisive since he feels free from any classical requirements of dignity, beauty, or heroism. He separates the three holy women from the main group and gives them a more subordinate position in the darkened left foreground. The place they occupied in the Rubens composition is now taken by a single standing Oriental—Joseph of Arimathea—who supervises the

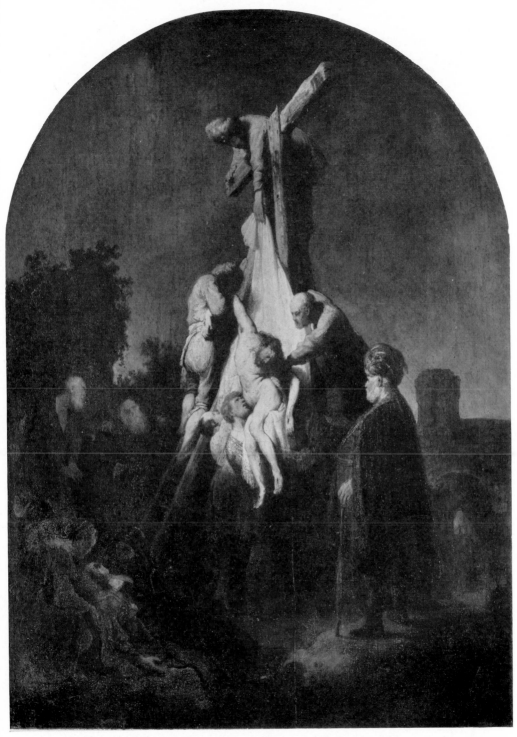

157. THE DESCENT FROM THE CROSS. Munich, Alte Pinakothek. Oil on panel (93 × 68)

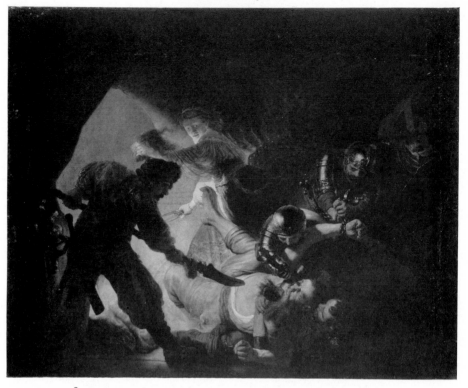

158. THE BLINDING OF SAMSON. 1636. Frankfurt, Staedel Institute.
Oil on canvas (238 × 287)

action but is prevented by his dark tonality from becoming too conspicuous. Furthermore, Rubens' two men leaning over the cross are reduced to a single figure, in the interest of a more dramatic concentration. This figure is placed higher and holds a winding sheet which is more broadly displayed, thus increasing the area of dramatic lighting on and around the corpse. Rembrandt's realism is particularly noticeable in Christ's body, a really dead mass, sagging in ugly distortion; this is no Raphaelesque nude exhibiting a beautiful contour. The care and devotion of the men who take down the corpse reflect an intense inner participation utterly different from Rubens' effort to maintain a certain classical dignity, even in scenes of violent emotion. The pale, cool blues, yellows, and greys of the Munich *Descent* still recall Rembrandt's Leyden period, and show a subordination of colour to chiaroscuro. While in this picture the Baroque tendencies dominate through the dramatic stressing of the outward action, Rembrandt's *Descent from the Cross* of the following year, 1634, now in the Hermitage (fig. 184), deepens the expression of religious feeling by showing even more intimately the participation of the men who hold Christ's body, and by giving greater emphasis to the Virgin's tragic role.

From the second half of the thirties to the beginning of the forties Rembrandt

159. Rubens: THE CAPTURE OF SAMSON. Munich, Alte Pinakothek.
Oil on canvas (118 × 133)

produced four large paintings dealing with the story of Samson, the liberator from Philistine oppression. There is *Samson Threatening His Father-in-Law* (fig. 22) of 163[5], in Berlin, the *Blinding of Samson*, 1636, in Frankfurt (fig. 158), *Samson's Wedding Feast*, 1638 and the *Sacrifice of Manoah*, 1641 (fig. 160), both in Dresden. The particular favour which the Baroque period showed for this Biblical story was due to its heroic, dramatic, and sensual aspects. (In the medieval period its popularity had derived from the parallelism seen between the figures of Samson and Christ.) The Thirty Years War fostered a taste for the horrible (*Kult des Grässlichen*)[30] both in literature and painting. Rembrandt, although his contact with this trend was of brief duration, shows, in the *Blinding of Samson*, that he could surpass his contemporaries, and even Rubens, in the interpretation of extreme horror. There is a *Capture of Samson* by Rubens (fig. 159) in Munich[31] in which the moment represented is the seizure of the hero as he rises from the couch. Delilah, leaning on a pillow, watches the success of her treachery with undisguised joy. The composition centres on Samson's herculean shoulder, which suggests terrific muscular exertion and powerful resistance. Rembrandt goes far beyond Rubens in his effort to depict the brutal climax of the story. Rembrandt's Samson gives no display of

heroic strength; he has fallen to the ground in the iron grip of a Philistine while another plunges a sword into his eye. The giant's blood gushes forth and his whole frame writhes in sudden agony.

The composition, with all its spontaneity, is clearly thought out along Baroque lines.[31a] Diagonals from the sides and background point to the central act of blinding, the one from the rear running along Samson's convulsive right leg and linking Delilah's escape with the torture of the betrayed hero in the foreground. The chiaroscuro is highly important for the spatial and pictorial organization as well as for the psychological accentuation. This may be realized first in the profile figure of the Philistine warrior on the left, who stands ready with his halberd. His picturesque dark silhouette in subdued colours of dull red and yellow-brown is contrasted with the light blue opening behind. We notice first his readiness to counteract any resistance on Samson's part, and second, his horror-struck expression; both features contribute to the psychological tension of the drama. On the right the steel armour of the Philistines glitters with a few strong reflections which follow a diagonal pattern on this side. The main shaft of light, however, leads along Samson's contorted body to the dim opening in the rear which Delilah has reached. Grasping Samson's shorn locks in one hand, the shears in the other, she glances back at the victim with an expression of mingled triumph and horror. In its masterly delineation of the heroine's feelings, this figure recalls Shakespeare's most vivid and crisp passages. The colour is sensitively integrated with the chiaroscuro. The eye is attracted by the bright atmospheric blue in the rear, which gains in intensity through the juxtaposition of Samson's lemon-yellow trousers. On the right the contrast is not so much one of colour as of value.

As in the case of the *Descent from the Cross*, Rembrandt is again more remote from any classic conception than Rubens ever was. He puts ruthless realism before beauty and heroism, as we see in Samson's ugly attitude, and he puts psychological depth before any idealizing trend, as in the head of Delilah. His pictorial organization is altogether more complex and subtle than Rubens', and certainly highly original.

This scene from the Samson story, more than any other work, shows Rembrandt exploiting the Bible for dramatic and sensational motifs that would appeal to the contemporary taste. On the surface the picture offers little promise of the artist's inward-turning nature. But closer appreciation makes one feel the extraordinary psychological and pictorial sensibilities which, within a few years, lead to a deeper and truly religious trend.

By 1641 this change is already manifested in the *Sacrifice of Manoah* (figs. 160, 161). The subject comes from the beginning of the Samson narrative, and illustrates the moment when the aged Manoah and his wife offer a thanksgiving to the stranger who has foretold the birth of a male child, the future hero Samson. As the

160. THE SACRIFICE OF MANOAH. 1641. Dresden, Museum. Oil on canvas (242 × 283)

sacrifice flames up, the stranger vanishes, rising like an angel above the fire, while the old people kneel with lowered eyes and clasped hands. It is a moment of sacred stillness and exaltation such as Rembrandt has never before attempted. Here, for the first time, the inner reaction dominates over the outward manifestation of a miracle. In the similar subject of *The Angel Leaving Tobias, and His Family* of 1637, in the Louvre (Br. 503), the artist's primary concern was clearly the physical and visible aspect of the miracle, the angel's whirling ascent and its sensational effect upon the spectators, including the little dog. But here, in the *Sacrifice of Manoah*, the scene is interpreted in the new spirit of 'inwardness' characterized in the introductory remarks of this chapter. Nothing loud, nothing visibly sensational interferes now with the truly religious experience of the kneeling figures and the surrounding atmosphere of silence and mystery which allows its fullest expression.

The composition shows a new simplicity and even monumentality in its relief-like arrangement with a parallel order of planes. It seems almost classicistic, but Rembrandt's flexible and expressive chiaroscuro always prevents the freezing of any

161. Detail from fig. 160

form or of the surrounding space to a mere shell. For those who like to define Rembrandt's development as a rigid sequence of styles, it may be disturbing to find such simplicity and solemnity in a work done simultaneously with one of his most Baroque creations, the *Night Watch* (fig. 124). But Rembrandt did not advance with mechanical precision from one phase to the next, from Baroque dynamism and intricacy to classic simplicity and calm. There were vivid reactions in both directions during this transitional period, and it was some time before solemnity became the prevailing mood in Rembrandt's work.[32]

For all their apparent differences, there are strong similarities between the *Night Watch* and the *Sacrifice of Manoah*. In both compositions the most intense light and colour is given to a group in the right foreground, while the major part of the picture is kept in comparative darkness. And the dominating colour in both cases is an accord of red and yellow; Manoah's wife is clad in a lemon-yellow robe with an

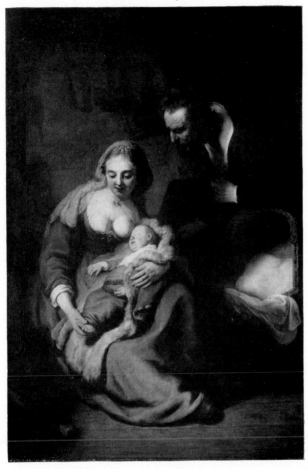

162. THE HOLY FAMILY. 1631. Munich, Alte Pinakothek. Oil on canvas (195 × 132)

intense orange-red cloak, Manoah in a deep purplish red. The paint in the high-lighted areas shows the same quality of opaqueness.

Saxl has pointed out that Rembrandt made several alterations in the picture at a later date.[33] The left side does, in fact, show a freer and more advanced treatment. The omission of the angel's wings—which heightens the accent on the principal figures—seems also in line with Rembrandt's later tendency to simplification.[34] The figures of Manoah and his wife, however, are clearly painted in the detailed impasto manner which we find in the highlighted lieutenant of the *Night Watch*, and lack the vibrancy of tones that distinguishes the left side and the immediate foreground.

While the *Sacrifice of Manoah* signalizes the beginning of a new attitude in Rembrandt's religious art, it cannot be said that the Biblical subjects of the middle period show such a pronounced religious character in every case. But one feels a change going on in Rembrandt's humanity which may be connected with the artist's

163. STUDY FOR HEAD OF THE MADONNA.
Formerly Boizenburg, Duensing Collection.
Oil on panel (20·6 × 17·3)

164. STUDY FOR THE HOLY FAMILY.
Bayonne, Musée Bonnat.
Drawing (16·1 × 15·8)

new perception of Christ in a truly evangelical (and Mennonite) sense. We now see
Rembrandt interpreting the Holy Family in a spirit of human intimacy and tender-
ness, or taking a special delight in such figures as the young Tobias, the young
Joseph, Daniel, Susanna, and Jonathan. All these characters, like Jesus in his boy-
hood, manifest extraordinary qualities of youthful integrity. Rembrandt's new per-
ception of Christ finds its most comprehensive expression in the *Hundred Guilder
Print* (H. 236, fig. 169), on which the artist must have worked for many years,
perhaps during the entire decade from 1640–50.

The *Holy Family* of 1645, in Leningrad (fig. 165), when compared to the *Holy
Family* of 1631, in Munich (fig. 162), shows the characteristic features of the middle
period. The date of the Munich picture places it between the Leyden and the first
Amsterdam period; in character it is closer to the latter. Its life-sized figures reflect
Rembrandt's trend toward the monumental and sensual naturalism of Rubens
which often marks his early Amsterdam style. Rembrandt has chosen the moment
when the Child has fallen asleep after the nursing, as in Rubens' painting in the
Cook Collection.[35] The mother's breast is still unveiled and Joseph leans over the
cradle, watching the scene with fatherly interest. The colours are subdued and tend
toward a monochrome effect. The fox fur on which the Christ child lies is a brilliant
piece of illusionistic painting. It contrasts with the purple in the Madonna's gown
and the dull green in Joseph's coat.

In the Leningrad picture the figures are less overpowering in size and less obvious
in their physical description. Space and atmosphere now play a greater part in the
general impression. The mood is one of intimacy and the interpretation of the scene

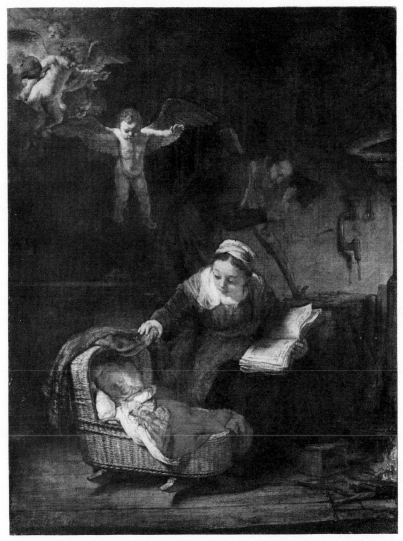

165. THE HOLY FAMILY WITH ANGELS. 1645. Leningrad, Hermitage.
Oil on canvas (117 × 91)

is more on the spiritual side. The young mother interrupts her Bible reading for a moment and lifts the curtain over the top of the cradle to look at the sleeping Child. The Child is made the centre of pictorial attraction through the subtle grading of light and dark on its face and the colours on and about the cradle (the green and intense cherry red of fur-lined coverlets, the yellow-brown of the wickerwork). Mary is distinguished by a deep red that contrasts with her dark blue skirt. Infant angels invade the chamber, flying down from the left upper corner, while Joseph works undisturbed with his hatchet in the background. These details are subdued by the dim atmosphere of the room, except for the upper corner where the super-

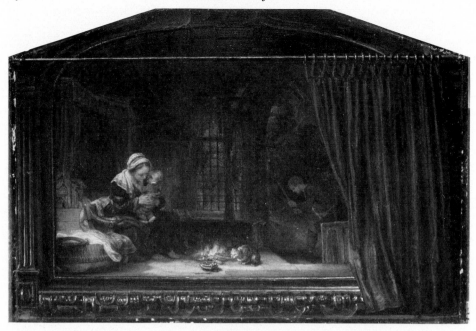

166. THE HOLY FAMILY. 1646. Kassel, Museum. Oil on panel (45 × 67)

natural light comes in. The small fire at the right provides material warmth for the group, while the tenderness of the young mother's movement, and the deep colours, produce a warmth of a more spiritual sort.

Any comparison with Nicolaes Maes, who left Rembrandt's studio about this time, and who exploited such religious subjects for their genre character, will show his master's greater naturalness and inimitable sensitiveness. Maes's *Mother at the Cradle*, formerly in the Huldschinsky Collection,[36] varies the motif of the Leningrad *Holy Family* without reaching the subtle psychological understanding or the pictorial refinement of Rembrandt. The pupil's chiaroscuro is heavier, his colour more on the purely decorative side. With Rembrandt the genre character is not an end in itself, but only a means of humanizing the Biblical scenes. He fuses convincingly the natural and the supernatural, while the human content dominates with an engaging tenderness of feeling. A preliminary pen sketch of the Leningrad composition is known (fig. 164), also an oil study for the head of the Virgin (fig. 163).[37]

The *Holy Family* in Kassel (fig. 166) follows a year later, in 1646, and exhibits a similar intimacy and tenderness. The composition, however, is considerably varied. Picture frame and curtain are painted here, an unusually illusionistic feature which may have impressed Rembrandt's patrons. The golden tones of the Baroque frame and the deep red of the heavy curtain form a warm colouristic accord which ties in harmoniously with the colours of the interior scene. Mary is seen seated before her

bed and warming her bare feet near a little fire that burns in the centre of the room. She has just taken up the Child and caresses it affectionately. On the other side of the fire crouches the cat, ready to snatch what remains in the little terracotta bowl that marks the front plane in the centre. At the right is Joseph, working in the court-yard at a slightly lower level. The warm glow of peaceful family life fills the whole room, emanating from the fond mother-and-child group as well as from the jewel-like colour that is fused with a deep, soft chiaroscuro.

The theme of Susanna, like many another Biblical subject, Rembrandt first took over from his teacher Lastman. He copied Lastman's painting, now in Berlin, in a drawing of about 1633–5 (Val. 632 B). Rembrandt's painting of 1647, also in Berlin (fig. 167), reinterprets the scene quite independently and only in the landscape back-ground shows any resemblance to Lastman's composition. Rembrandt's teacher dealt with this subject in a characteristic Baroque fashion, stressing the sensual appeal to the spectator by an obvious exhibition of Susanna's nude beauty and the lasciviousness of the old men. Rubens, Domenichino, and Guercino had interpreted the scene with more vigour but in the same spirit, as had also Tintoretto and Veronese.

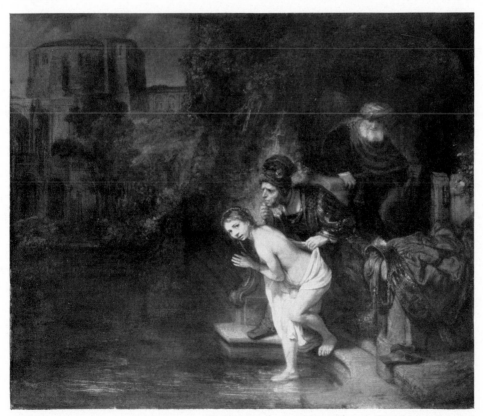

167. SUSANNA AND THE ELDERS. 1647. Berlin-Dahlem, Staatliche Museen. Oil on panel (76 × 91)

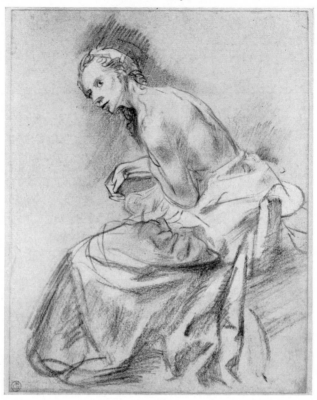

168. STUDY FOR SUSANNA. Berlin, Print Room. Drawing (20·3 × 16·4)

The maturing Rembrandt makes very significant changes that reflect his new attitude toward the Bible. He does not soften the dramatic quality; he rather intensifies it by a more concentrated chiaroscuro which heightens the psychological tension. The main accent now lies in Susanna's inner anguish, rather than on her tempting beauty. Both innocence and despair are expressed in the nervous movement of her shining body, set against the dark landscape background. The whole pictorial composition centres upon her face, which turns appealingly to the spectator. She sees no escape. One of the two elders has already come dangerously close, with an evil, threatening gesture. The dramatic emphasis upon Susanna's dilemma brings out the religious meaning of the story, which Menno had repeatedly quoted in his references to the 'virtuous Susanna.' In reading the Biblical account of this very moment, one is struck by Rembrandt's close adherence to the text:

> Then Susanna sighed, and said: 'I am straitened on every side: for if I do this thing, it is death unto me; and if I do it not, I cannot escape your hands.
> 'It is better for me to fall into your hands, and not do it, than to sin in the sight of the Lord.'[38]

As for colouristic charm, the picture rivals the two representations of the

Holy Family just mentioned in the jewel-like glow of colour set in a warm, soft chiaroscuro of mysterious depth. The principal accent of a brilliant cherry red is given to Susanna's garment in the right foreground. It contrasts harmoniously with the dark green tones of the landscape and with the touches of gold, blue, and purple in the figures nearby.[39]

The so-called *Hundred Guilder Print* (H. 236, fig. 169) is the most representative religious work from the end of Rembrandt's middle, or the beginning of his mature period—however one chooses to classify the years 1648–50. The title *Hundred Guilder Print* may well go back to the seventeenth century. It was apparently derived from the price this etching once fetched at an auction. We know from a document of 1711[40] that it was already at that time the popularly recognized title.[41]

The subject is taken from Matthew 19,[42] with the various episodes mentioned in the chapter combined in a single scene. Christ has come from Galilee to the border of Judæa, with a great multitude following Him. He preaches and heals the sick (verses 1 and 2). We see in the print a large group of people gathered on either side of Christ, before a massive wall. The sick and destitute are still streaming in through the gate at the right and waiting with pious expectation to be healed. The text goes on to say that the Pharisees tempted Christ by a question on the lawfulness of divorce. Rembrandt has omitted a direct reference to this instance, but has included the group of Pharisees arguing among themselves in the left upper corner. The next episode, however, mentioned in verses 13 and 14, occupies a central position in the print:

> Then were there brought unto him little children, that he should put his hands on
> them, and pray: and the disciples rebuked them.
> But Jesus said, 'Suffer little children, and forbid them not, to come unto me: for
> of such is the kingdom of heaven.'

We see St. Peter, recognizable by his bald profile,[43] holding back the young mother who advances toward the Lord. Another woman follows, drawn forward by her boy. The gesture of Christ's right hand unmistakably counteracts that of St. Peter, and opens the path for the mothers. Also included is the rich youth who could not make up his mind to give his possessions to the poor, in order to follow Christ wholeheartedly (verses 16ff.). This young man is seated at the left, pondering Christ's words, his figure slightly in shadow but distinguished by his elegant attire.

Thus we see that Rembrandt has followed the text with considerable fidelity. He has taken only such liberties as seemed to him necessary to fuse the successive instances into one coherent scene. The figure of Christ dominates the composition as its spiritual and formal centre; yet He is not set apart from the multitude but intimately tied up with it by various devices. Even such remote and apparently indifferent figures as the Oriental standing in the left foreground and seen from the rear, the Pharisees above, or the camel driver on the extreme right, help through

contrast as well as formal relationships to underline the significance of Christ and the intimate bond between Him and the attending crowd.

Each individual in this large group remains distinct in character and emotional participation. A tremendous variety of human reactions is brought out, both in the more prosperous figures at Christ's right, and in the sick and the destitute at His left. Middleton describes the latter group as follows: 'Every figure and every face is a study; we hear the piteous accents of entreaty which come from the poor creature who lifts her wasted arms; we listen to the tale of misery told by the woman who leads forward the infirm old man [fig. 170]; nay, we could almost tell of what malady each has to complain; and every sorrowful face and figure speaks as much of suffering and of hoped-for relief as do those of the most afflicted who crowd our hospitals.'[44]

Regarded from the point of view of formal composition this mass scene shows some advance over similar ones of the early forties. It has both a horizontal and a diagonal trend such as we find in the *Presentation* of about 1640 (H. 162).[45] But the spatial articulation has gained through a more open and concentric grouping and through richer accentuation.[46] Baroque features are still implied in the movement that surges from the outer edges to the centre. But here the calm figure of Christ dominates, forming the anchor of the composition and bringing it into a subtle balance.

Not the least of the factors in the unity and expressiveness of the design is the distribution of light and dark. The major darks belong to the right side, where human misery huddles on a lower level, but this area is enlivened by the most delicate treatment of luminous half tones. The other side is in full sunshine and the graphic execution is more open and sketchy. The figure of Christ is distinguished by a broad light and dark contrast of its own. He stands slightly elevated against the background shadows and surrounded by a subtle gleam of supernatural light.

In the general device of the chiaroscuro the finely graded half tones play an important role. They spread over the whole a filmy atmospheric vibration, they heighten the expression of inner life and bind the figure of Christ more closely to the multitude, both in a physical and a spiritual sense. Notice, for example, the faint shadow cast upon Christ's robe by the hands and profile of the kneeling woman— perhaps the mother of the paralytic in front. This is not only a naturalistic feature. In its infinite delicacy this shadow represents more than a mere physical linking of Christ with the people nearby. In maintaining a fluid borderline between the lights and the darks, between the visible and the invisible, these fine half tones contribute to the suggestion of an all-pervading spiritual atmosphere.

The painting of the *Vision of Daniel* in Berlin (fig. 173), which is generally dated about 1650, is close to the *Hundred Guilder Print* in style and spirit. There is a similar tenderness of feeling expressed, a religious conception which lays all accent

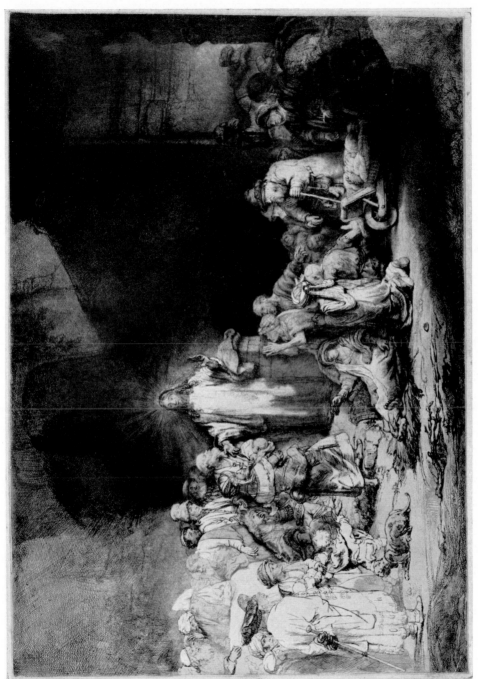

169. CHRIST HEALING THE SICK (The 'Hundred Guilder Print'). Etching (H.236). (27·8 × 39·6)

170. BLIND MAN GUIDED BY A WOMAN.
Study for the 'Hundred Guilder Print'.
Paris, Louvre. Drawing (12·2 × 9·8)

on the inward reaction. As in the *Hundred Guilder Print*, the atmosphere surrounding the figures—here the angel and the young Daniel—contributes to the suggestion of the transcendental nature of the event. The Book of Daniel had a particular meaning for the sixteenth and seventeenth centuries. Its prophecies brought comfort to people familiar with religious persecution or the tyranny of kings. It was as widely read and illustrated as many stories of the New Testament. Rembrandt's painting illustrates the prophet's vision near the river Ulai, as described in chapter eight. The youthful Daniel sees the successive evil kingdoms which are to bring oppression to God's people. Each of the kingdoms is symbolized by a horned beast. 'And behold there stood before the river a ram which had two horns . . . I saw the ram pushing westward and northward and southward . . . he did according to his will and became great.' The combat of the beasts and the final overcoming of the mighty ram by an even more terrible goat 'casting down the truth to the ground' is not represented, but we see the Angel Gabriel, who afterward appears to explain the vision to Daniel and point to final deliverance. 'I was afraid and fell upon my face, but he said unto me: "Understand, O son of man" . . . he touched me and set me upright. And he said: "Behold, I will make thee know what shall be in the last end of the indignation, for at the time appointed, the end shall be." '[47]

Rembrandt's artistic means of representing the scene are again highly personal. He does not allow the young prophet to stare into the face of the celestial messenger.

Daniel seems to be rising under the angel's gentle touch, as he becomes aware of the vision's meaning. The light accents on the heads and the two right hands of the figures are highly evocative. The same is true of the tender blond tonality of the painting, with precious touches of green and gold on Daniel and the lighter colours on the angel which enhance his unearthly appearance.

These accents of light and colour are not yet suggested in the preliminary pen sketch in the Louvre (fig. 172), although the composition is outlined distinctly. It is interesting to see how Rembrandt has restrained the movement of the angel in the painting in order to increase the loftiness of his figure. The emphasis on the long white sleeve creates the impression that the angel is enveloping the figure of the young Daniel as he touches his shoulder protectingly.

The youthful Joseph is another Biblical favourite in Rembrandt's work of this period, along with the young Christ and Tobias. All these characters bear the features and appearance of Titus, who served as his father's model. The drawing of *Joseph in Prison, Interpreting the Dreams of Pharaoh's Butler and Baker* (fig. 175) has all the characteristics of Rembrandt's draughtsmanship of the early fifties. The setting is much simpler than that of the *Hundred Guilder Print*, which still shows strong Baroque elements in composition. With Rembrandt the new simplicity does not serve formal, classicistic ideals, but opens the way to a new concentration on the psychological content, on the close spiritual interrelationship of the figures. In this

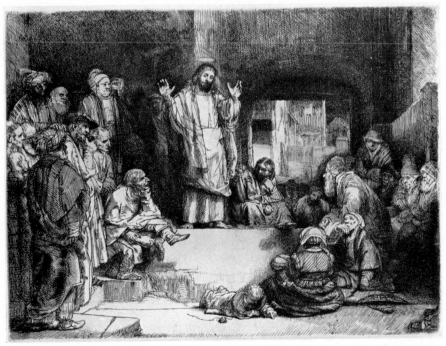

171. CHRIST PREACHING ('La Petite Tombe'). Etching (H.256). (15·5 × 20·7)

172. STUDY FOR THE VISION OF DANIEL. Paris, Louvre (Bonnat Collection). Drawing ($16 \cdot 5 \times 24 \cdot 3$)

173. THE VISION OF DANIEL. Berlin-Dahlem, Staatliche Museen. Oil on canvas (96 × 116)

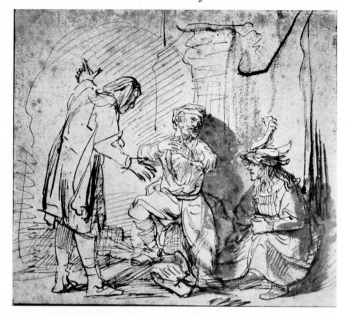

174. JOSEPH INTERPRETING DREAMS IN THE PRISON. Providence, Rhode Island,
John Nicholas Brown Collection. Drawing (15·5 × 18)

drawing Joseph, hardly more than a boy, is seated erect at the right, opposite the
two men, who listen with complete absorption to his explanation of their dreams.
The inner contact between the three figures could not be stronger, nor could the
characterization of the young Joseph be more lucid.

A comparison with a drawing of the same subject (fig. 174) done almost twenty
years earlier, about 1633, shows the great change from Rembrandt's Baroque phase
to his mature style. In the early sketch the picturesque aspect of the scene is
dominant, with a dramatic emphasis upon gestures. But this fails to convey as much
inner life as the quiet penetration of the later drawing. In the thirties Rembrandt
chose the moment when Joseph addresses the baker, foretelling his execution by
hanging, while the man reacts with a gesture of violent despair. In the later drawing
Joseph addresses the butler, who is to be freed, while the baker listens in deep
thought. This slight shift of content allows a general mood of stillness and gravity to
predominate over any outward display of emotion. The sensitive brevity of Rem-
brandt's mature draughtsmanship, the emphasis on atmosphere rather than on florid
lineament, heightens the expression of spiritual elements.

From about 1653 Rembrandt's religious art begins to show a more gloomy cast
and still greater depth and power of expression. There is no basic change in his
Christian attitude, but we observe a new concentration on the suffering of Christ,
on the drama of Golgotha, and the mystery of His sacrifice. Scenes from the youth
of Christ, His miracles and the events following the Resurrection continue to appear

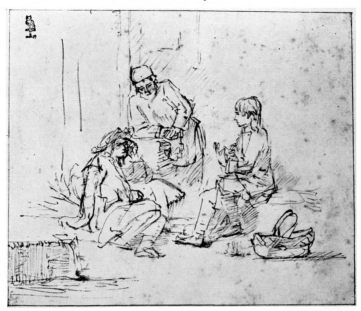

175. JOSEPH INTERPRETING DREAMS IN THE PRISON. Amsterdam, Rijksmuseum.
Drawing (15·7 × 18·9)

in Rembrandt's etchings and drawings (figs. 151, 152). But all of these subjects now seem imbued with a sombre undertone.

If the *Hundred Guilder Print* can be said to impart the artist's faith, this impression is even stronger in the case of the *Three Crosses* (H. 270, figs. 176, 177). Rembrandt's vision of Calvary stresses in an unprecedented fashion the transcendental meaning of Christ's death. The supernatural breaks into the natural with an elementary and irresistible force such as only profound belief can visualize. Here, as in Bach's *St. Matthew Passion*, religious and artistic fervour fuse to express the sublime.

Rembrandt has treated an age-old traditional subject with an overwhelming originality which draws its strength and its character from the account in Luke 23:

And it was about the sixth hour, and there was a darkness over all the earth until the ninth hour.
And the sun was darkened, and the veil of the temple was rent in the midst.
And when Jesus had cried with a loud voice, he said, 'Father, into thy hands I commend my spirit': and having said thus, he gave up the ghost.
Now, when the centurion saw what was done, he glorified God, saying, 'Certainly, this was a righteous man.'
And all the people that came together to that sight, beholding the things which were done, smote their breasts, and returned.

In close adherence to the Biblical text Rembrandt gives to the atmospheric drama the leading role in his composition. Light and dark are here the most powerful

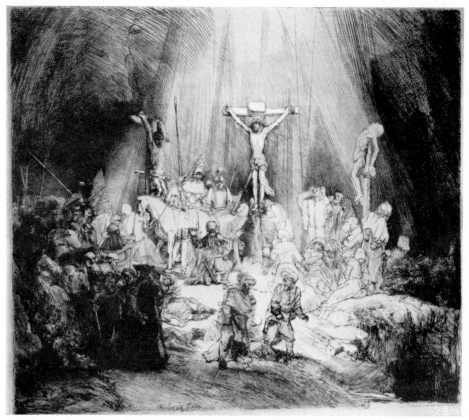

176. CHRIST CRUCIFIED BETWEEN THE TWO THIEVES (The 'Three Crosses'). 1653.
Etching, third state (H.270). (38·7 × 45)

agents in creating the general mood and they raise the event, in the full sense of the Bible, to cosmic dimensions, to a most comprehensive and truly universal significance. There is 'darkness over all the earth,' with a supernatural light breaking through from heaven in a broad stream that bathes the cross in the centre. Adored by the kneeling centurion who opens wide his arms to the great revelation,[47a] the Crucifix soars triumphantly into the light like the 'Hallelujah' at the end of a great Baroque oratorio. There is richly accentuated shading in the group of 'rulers' in the foreground who are returning after having derided Christ (verse 35). In contrast, the large crowd immediately under the cross seems almost flat, exposed to the full intensity of the celestial lighting. At first glance one is aware only of the general agitation in the group. Closer observation shows the mounted Roman soldiers on the left and the holy women on the right, with the fainting Virgin in their midst and St. John standing behind in an attitude of utter despair.

Compared to the *Hundred Guilder Print* the technique of the *Three Crosses* shows a tremendous advance in breadth and spontaneity of draughtsmanship. Rembrandt

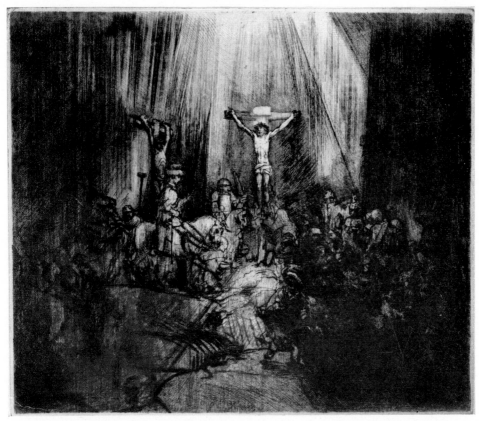

177. CHRIST CRUCIFIED BETWEEN THE TWO THIEVES (The 'Three Crosses'). 1653.
Etching, fourth state (H.270).

exploits the drypoint needle for this effect, increasing as well the power and pictorial richness of the black and white, at least in the early state. No longer is there any sign of the painstaking elaboration of detail which marks large portions of the *Hundred Guilder Print*.

We know altogether five states of the *Three Crosses*. The decisive change occurred with the fourth state, after the main accents of the drypoint work had worn away. Rembrandt then polished down several passages on the plate and altered the entire composition by adding new motifs such as the horseman in profile (copied from a Pisanello medal) and the prancing horse behind him. But the principal change was the transformation of the scene into one of nocturnal gloom, pierced only by the beams of supernatural light. Some critics believe that in this late transformation of the print Rembrandt reaches the ultimate in mystery and tragedy. Others give preference to the first state, in which the drypoint work shows its full force. Still others value the third state, in which the central portion has gained a uniform brightness through the fading of the drypoint work, while the foreground groups show

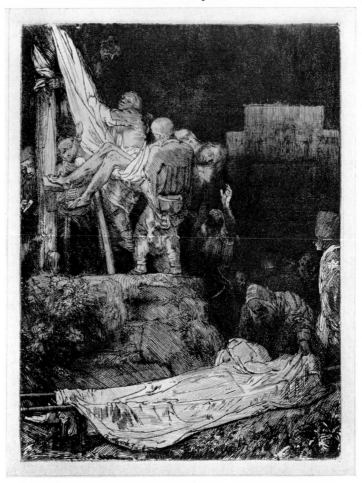

178. THE DESCENT FROM THE CROSS. 1654. Etching (H.280). (21 × 16·1)

more elaboration. Yet the second state, after the burr of the drypoint has lost something of its first harshness, presents a harmonious and coherent general effect. The transformation in the fourth state—ingenious as it is—represents an enforced solution, where Rembrandt made the best of a worn-out plate. It is true, the extended darkness creates a new and tragic mood of formidable power, but it does not sufficiently cover the holes in the original composition, or equal the earlier states in spatial clarity and articulateness.[47b]

Throughout the fifties Rembrandt was occupied with the theme of the Passion. He seems to have planned two series in etching, one on a large and one on a smaller scale.[48] Of large Passion scenes he finished only the *Ecce Homo* (H. 271) as a companion piece to the *Three Crosses*. It is equally monumental but less moving as a religious representation. The large-scale architectural setting absorbs too much

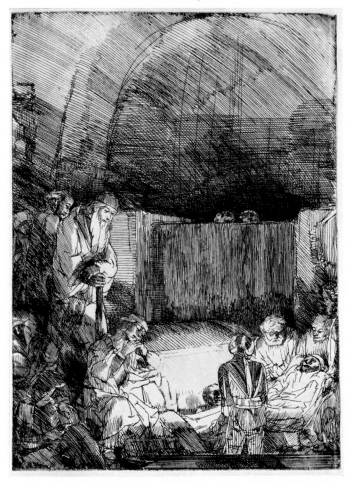

179. THE ENTOMBMENT. Etching (H.281). (21·1 × 16·1)

attraction, and Christ fails to become the centre of interest. The composition is a
temporary concession, on Rembrandt's part, to the current wave of classicism.
There is also a remote derivation from Lucas van Leyden's famous engraving of the
Ecce Homo.

From the series of small Passion scenes the *Descent from the Cross* (H. 280, fig.
178) and the *Entombment* (H. 281, fig. 179), both of 1654, are most expressive and
original compositions. In both of them Rembrandt has compressed the figures into
smaller compass, leaving room for the echo of their mood in the unfathomable dark
space surrounding them. Large, comparatively empty passages become highly
evocative through vibrant shadowing or transparent lighting. This is the case in the
Deposition scene, with the long, linen-covered bier stretched across the bottom; and
in the high rear wall of the *Entombment*, where two lone skulls on a horizontal ledge

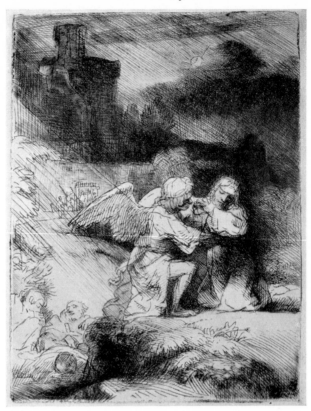

180. THE AGONY IN THE GARDEN. Etching (H.293). (11·8 × 8·3)

are the only interruption in a vast area. In both compositions the action is subdued
to allow a tragic stillness to prevail.

Fully as moving, in spite of its very small dimensions, is the tiny etching of the
Agony in the Garden of 1657 (H. 293, figs. 180, 181). Blanc praises it with true
French temperament: 'Quelle profondeur de sentiment! Quelle poésie dans la mise
en scène de ce drame auguste, et quelle grandeur dans un si petit cadre! La nature
entière est en deuil, le ciel va se couvrir de nuées sinistres.'[49] Here, as in the *Three
Crosses*, the gloomy aspect of nature reflects the tragic content of the drama. The
two figures are extraordinarily expressive in their interaction: Christ in the agony of
His effort to submit to God's will; the angel kneeling and 'strengthening' Him,
while keeping a slight distance. In the preliminary drawing in Hamburg (Val. 454)
Christ kneels in profile while the angel, approaching from the rear, appears almost
in front view. The reversal of this scheme in the etching gives to Christ, by His
frontal position, a more direct appeal to the spectator. The angel's comforting
gesture also becomes more effective through the full display of his figure within the
front plane.

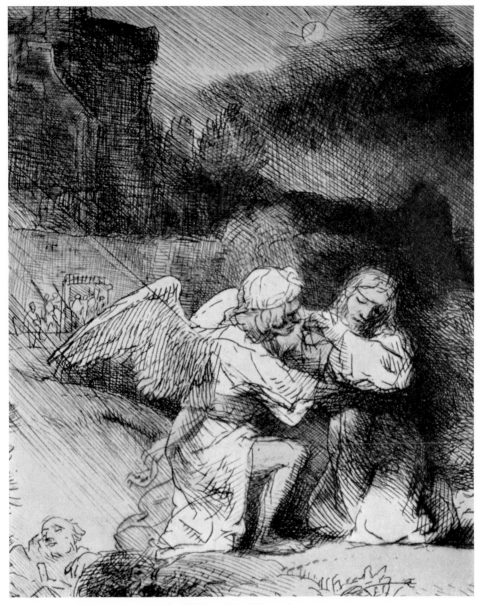

181. Enlarged detail from fig. 180

Among the etchings of the fifties representing scenes after the Resurrection are the *Incredulity of St. Thomas* (H. 237) and *Christ at Emmaus* (H. 282, fig. 183). In the Louvre painting of the Emmaus scene (fig. 182), dated 1648, Rembrandt's mature conception of Christ is already apparent. All earlier Baroque representations of this subject—best-known are those by Caravaggio and Rubens—seem by comparison unconvincing in the revelation of Christ's unearthly nature. Rembrandt

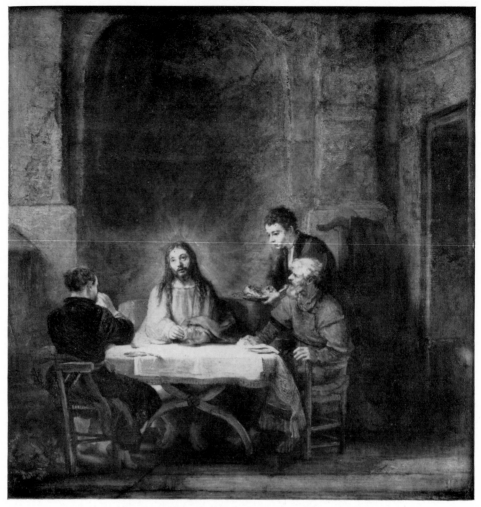

182. CHRIST AT EMMAUS. 1648. Paris, Louvre. Oil on panel (68 × 65)

no longer relies upon the vivid gestures of the disciples to emphasize the significance of the moment. Christ's divine person imposes itself quietly upon His companions, and His mildness and inner glory radiate throughout the room. The twilight of the interior fuses with the supernatural light, preventing the forms from becoming prosaically distinct. Restrained touches of red animate the warm, golden brown tonality of the painting. In its architectural background a lofty niche echoes the exaltation of the Redeemer, while His features and His attitude reveal the utmost meekness.

The etching of 1654 (fig. 183) carries further the impression of Christ's spiritual nature. The slight note of sentimentality in the upward glance of the Louvre Christ has disappeared. In the etching Christ seems more manly, a dignified rabbi and a

183. CHRIST AT EMMAUS. 1654. Etching (H.282). (20·9 × 15·9)

visionary in one. He has broken the bread (in the Louvre painting He is about to break it) and holds the two pieces wide apart, presenting them to the disciples.[50] This gesture provides a firm basis for the triangle of the upper part of Christ's body, which asserts itself in this composition with considerable force. Also the light emanating from Christ has gained intensity and supernatural power. The reactions of the two disciples are stronger than in the Louvre painting, more like those of Caravaggio and Rubens, but the light, sketchy treatment of their figures, and their distance from Christ, serve to subordinate them. His majestic and dominating figure in its glorious light is effectively contrasted with the earthly, shadowed form of the innkeeper in the foreground. Pausing for a moment on his way to the cellar, this man notices the excitement of the disciple on the left but remains unaware of the revelation.

Thus Rembrandt indicates most subtly, through the figure of the innkeeper and the axis of vision which he introduces into the picture, the limitation of the natural

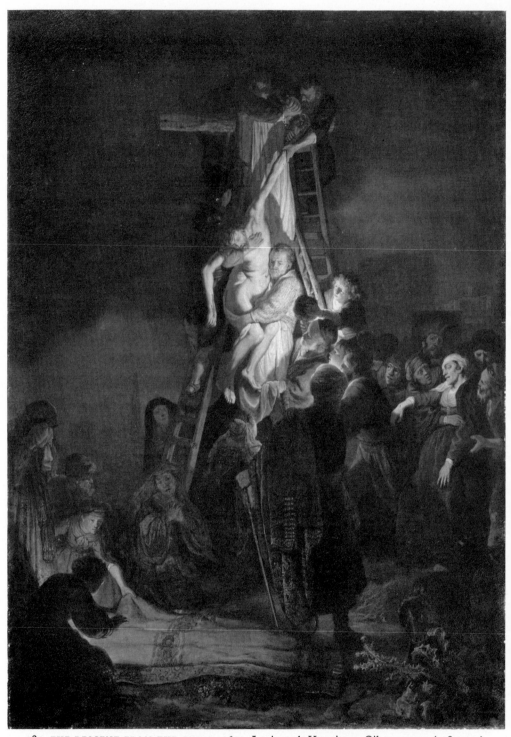

184. THE DESCENT FROM THE CROSS. 1634. Leningrad, Hermitage. Oil on canvas (158 × 117)

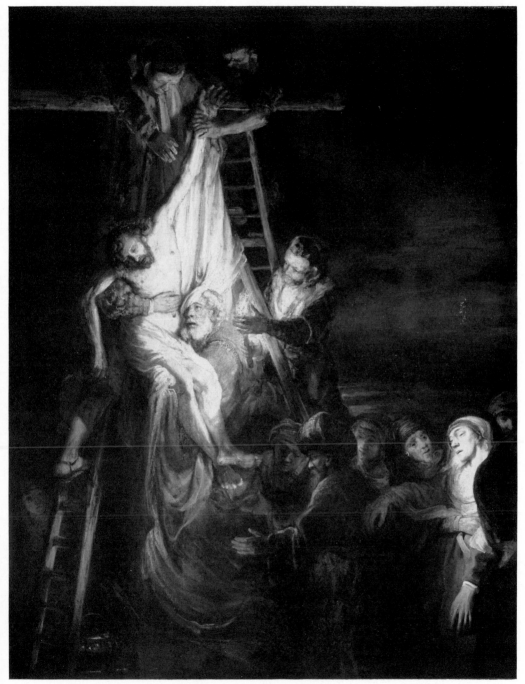

185. THE DESCENT FROM THE CROSS. 165(3). Washington, National Gallery of Art
(Widener Collection). Oil on canvas (143 × 111)

before the supernatural world. It is probably also significant that neither the land-
lord nor his dog, which turns away from the scene, are touched by the divine rays
bathing the two disciples. This light glows and spreads into the upper part of the
picture. And here, on the broad curtain which backs the composition, the interplay
of light and shadow symbolizes further the meaning of this representation: the
entrance of the transcendent into the natural world.

A number of paintings of the middle fifties confirm Rembrandt's profound
interest in the scenes of the Passion at this time. These include a highly important
Descent from the Cross dated 165[3], probably the work mentioned in Rembrandt's
inventory of July 25, 1656. This *Descent*, formerly in the Widener Collection, now
in the National Gallery in Washington (fig. 185), may owe its origin to a patron's
desire for a replica of the *Descent from the Cross* in Leningrad, painted twenty years
before (fig. 184).[51] Whatever his reasons, Rembrandt shows how, with a few
significant changes, he can transform an old composition into something completely
new in its emotional content and pictorial expression. By reducing the composition
to include only the right upper part of the earlier one, while maintaining approxi-
mately the same dimensions for the canvas, Rembrandt has heightened the power
of the figures and allowed a stronger concentration on the main theme. The leaving
out of a second light behind Joseph of Arimathea also contributes to this end.

The head of the aged Nicodemus, closest to the body of Christ, is made a
powerful centre of emotional content. Various compositional devices lead to him.
He receives the most intense light from the nearby candle (according to the
Biblical text the Descent took place at night). His figure is also the most brilliant
colour accent of red and gold. The horizontally placed forearms of the two attending
men point to Nicodemus, as does the vertical accent in the linen cloth coming from
above. Finally, the head of the fainting Virgin, which forms the second light spot
in this nocturnal scene, leads up to him, repeating the angle of inclination but
reflecting an even more poignant reaction—the agony of the mother.

While emotion now dominates, the action is softened and simplified, in the
interest of a more solemn, lofty mood. This is obvious, for example, in the altered
attitudes of the two men at the top of the cross. No longer are they occupied with
the removal of a nail on which Christ's arm still hangs, causing an ugly distortion in
the sagging body; the corpse is now freed and the men are gently lowering Christ's
arm with complete absorption in their task. The Baroque tendency in the earlier
configuration, which exploited the curvatures and the cast shadows of Christ's
contorted body for a picturesque effect, is now replaced by a relatively simple
arrangement of horizontals and verticals, producing a clearer order and greater
stability. The painterly treatment also deserves mention, for the breadth and vigour
of its handling. The colouristic warmth is extraordinary when compared to the
rather monochrome character of the earlier work. If this *Descent* were the only

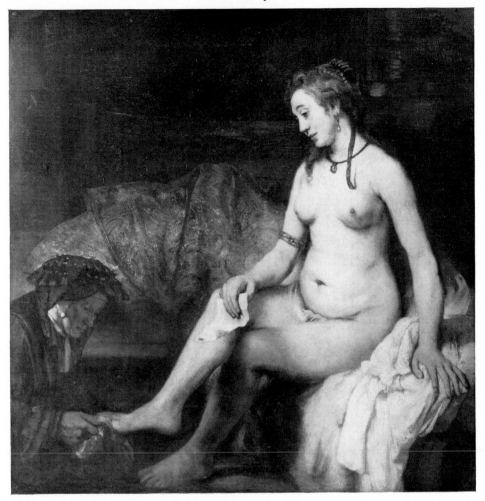

186. BATHSHEBA. 1654. Paris, Louvre. Oil on canvas (142 × 142)

known example of Rembrandt's religious painting, it would leave a deep impression upon us. The head of the old Nicodemus, seen within the context of this remarkable composition, is not easily forgotten.

The *Bathsheba* of 1654 in the Louvre (fig. 186) has often been praised by painters and critics alike.[52] This is chiefly because of the masterly painting of the nude, with the breadth of a Courbet yet greater tonal softness and compositional strength. Rembrandt had already treated the subject several times in the early thirties and the early forties.[53] But only now is Bathsheba characterized with the deep human implications that belong to this Biblical figure. She holds David's letter in her hand, and both her facial expression and her relaxed attitude reflect her mind's preoccupation with the unusual message.[54] It was Hendrickje who served here as the model,

in the very year in which her daughter Cornelia was born and Hendrickje herself admonished by the Church Council.[55]

For sheer beauty of painting the *Bathsheba* has few equals among the nudes of the Baroque period. Rubens' *Bathsheba* in Dresden, done about 1635, shows greater fluidity, both in composition and treatment, and a bright silvery tonality. It contrasts with the more static character and tectonic construction of Rembrandt's nude and with the glowing warmth of his tonality. Rubens used this Biblical motif primarily for the display of feminine charm and painterly brilliance. Rembrandt, however, not only arouses admiration of the nude but also makes one aware of Bathsheba's feelings.

The second plane is reserved for the almost frontal display of the figure, vigorously modelled with soft half tones in broad strokes. Between the white areas of the letter and towel in the foreground and the glittering gold of the brocaded garment in the rear, the warm and cool tones of the flesh are well set off. The kneeling servant in dark tones of a dull red heightens the luminosity of Bathsheba's body, as do the brownish shadows on all sides. Thus chiaroscuro and colour co-operate in bringing about a glowing, warm harmony. The red pillow in the right front corner and the coral chain in Bathsheba's hair lead the colour up to its highest pitch.

The composition is constructed with architectural simplicity. As so often in Rembrandt's work of the fifties one is tempted to speak of a classicistic touch, but there is no constrained formality in the arrangement, and the woman's attitude remains completely natural. Atmosphere and tonal softness, too, prevent any rigidity of the plastic form, powerful as this is.

In 1655 Rembrandt painted two very similar versions of *Potiphar's Wife Accusing Joseph*. The picture in Berlin (fig. 187) seems superior to the one in Washington, its general effect being both richer and more striking. This is one of Rembrandt's most sparkling colouristic performances, with its various red, gold, and olive tones; an intense white is found in the centre of the composition, with bluish tones at the outer edges, in Joseph's coat, the curtain, and the cloak spread on the floor in the foreground.

The dominant figure is Potiphar's wife, with her sumptuous dress of rose and gold, trimmed with ermine. She glows with a diabolical beauty, while Potiphar stands motionless in half shadow and Joseph, at the left, makes a despairing gesture with his eyes turned upward. Rembrandt has painted the triumph of the evil woman with an obvious enthusiasm for Oriental splendour. One has only to think of such costume painters as Frans van Mieris or Eglon van der Neer to realize the vast difference between their brilliant depiction of mere textures and Rembrandt's spirited performance. With Rembrandt preciousness of drapery was not an end in itself, but it was often an aid in the expression of his theme. Thus here, the magic of the colours, their vibration and glow, lend an indefinable element to the material

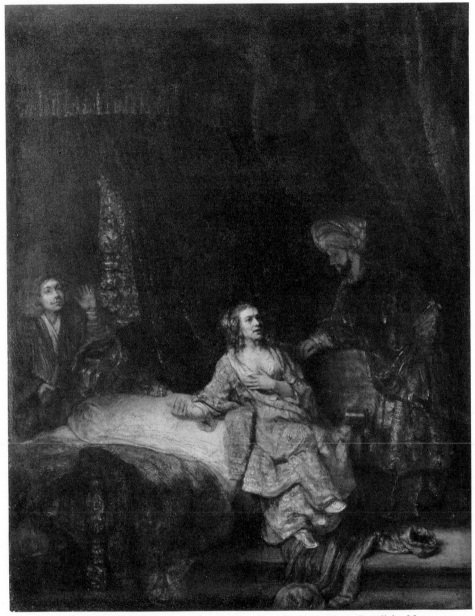

187. POTIPHAR'S WIFE ACCUSING JOSEPH. 1655. Berlin-Dahlem, Staatliche Museen.
Oil on canvas (110 × 87)

beauty of the picture. Rembrandt's aim was to represent the Biblical story in its full significance rather than to paint a genre scene in the characteristic Dutch style.

One of Rembrandt's most impressive religious paintings, *Jacob Blessing the Sons of Joseph*, in Kassel (fig. 188), was produced in the very year of his financial collapse,

1656—a fact which proves that the outer circumstances of his life could not upset the inner balance of the mature artist's work. On the contrary, his sensibilities seem heightened in the expression of this lofty theme from the Old Testament.

That Rembrandt well understood the sacred significance of the Biblical act of blessing is clearly indicated by the extraordinary solemnity with which he endows this scene. In the Bible the person blessing is, for the moment, an instrument of God's will, and therefore his pronouncements have the awe-inspiring finality of a divine message. The text in Genesis 48 describes how Joseph brings to his aged father's bedside his two sons, Manasseh and Ephraim. He places them so that the almost blind Jacob may first touch Manasseh, the elder. But Jacob, contrary to all expectation, blesses the younger one first. When Joseph interferes to correct this apparent mistake ('not so, my father, for this is the first-born; put thy right hand upon his head'), Jacob, spiritually enlightened at this sacred moment, refuses to do so ('I know it, my son, I know it'), announcing prophetically that the younger brother shall be greater than the elder. 'And he set Ephraim before Manasseh.'

Rembrandt throws the main emphasis upon the act of blessing and the participation of each individual. Joseph's interference is reduced to a gentle gesture. As is usually the case in Rembrandt's later works, the figures appear in half to three-quarter length, with their facial expressions and their hands brought into considerable prominence. The brightly illumined right arm of the patriarch attracts us first. His hand touches Ephraim, the fair-haired boy, who leans forward with a child-like devoutness to receive the benediction. Jacob's left hand, barely visible, gently pushes the head of the other boy aside with the back of his fingers.[55a] The gesture of Joseph's left hand can be interpreted as a cautious effort to guide his father's right toward the head of Manasseh, the dark-haired boy. Joseph's right arm supports his father's back, with four fingers faintly seen between the white pillow and Jacob's fur mantle. This complicated play of hands accompanies like a soft human melody the theme of divine selection, which operates independently of tradition. But it is done very inconspicuously and is clearly subordinated to the main theme of the blessing of the chosen child.

In adding Asenath, Joseph's wife, who is not mentioned in the text, Rembrandt has enlarged the scene to a full family picture. Asenath's figure balances the composition and adds an attractive element of maternal happiness and devotion. She forms a contrast to the mighty figure of the old Jacob, whose features remain slightly shaded. Rembrandt never painted a grander type of patriarch.[56]

The group is framed by dark curtains and the dull red of the coverlet in the foreground. In this heavy setting the forms appear in the warm light of the second plane with an added luminosity and plastic quality. But the plasticity is modified by a fine veil of atmosphere and by the vibration of tones and colours which seem to blend into each other in the interest of a heightened spiritual and pictorial unification.

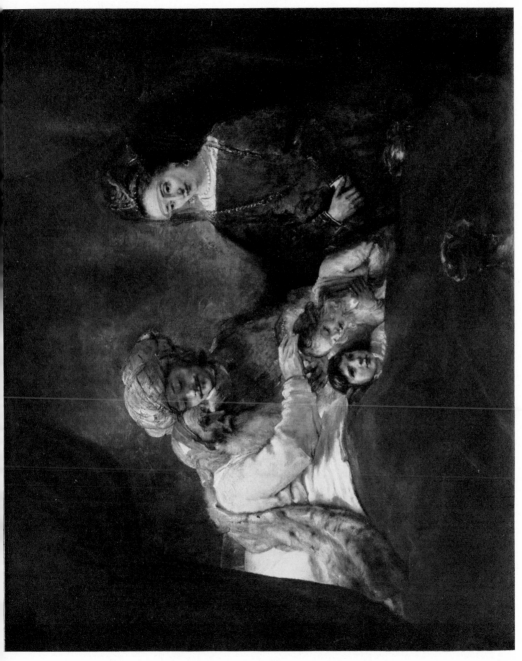

188. JACOB BLESSING THE SONS OF JOSEPH. 1656. Kassel, Museum. Oil on canvas (174 × 209)

The colours are Rembrandt's favourite ones of the fifties, predominantly yellows and reds, but with the reds more subdued than usual. Against the cold white of the pillow Jacob's figure appears in delicate warm tints. His cap is yellowish, his sleeve more whitish, shaded with grey and violet. A fox fur is thrown over his shoulder, the most brightly illumined passage in the picture. Joseph's turban glitters with gold. A pure lemon yellow is found in the fair boy's cloak, while Asenath, behind him, wears a dark olive-brown dress, rich with jewels. Her bluish headdress also glitters with golden spots of embroidery.[57]

Some changes in the construction of the bed must have come about in the course of the pictorial execution, since the head and foot of the bedstead are not properly related, either to each other or to the angle of Jacob's body.[58] But these deficiencies are inconspicuous and obviously did not concern Rembrandt at the more advanced stage of his work when he darkened the foreground to gain more prominence for the group in the lighted second plane.

The *Denial of St. Peter* in Amsterdam (fig. 189) and *Saul and David* in The Hague (fig. 190) must next be named as important Biblical paintings dating from the turn of the fifties to the sixties. Both can be compared to Rembrandt's late portraits, not only in breadth of style but also in the powerful exhibition of inner life and character. These religious paintings, however, deal more specifically with the expression of the dramatic inner conflict which the Bible story suggested to the artist.

St. Peter is exposed to the crucial test whether he shall deny his Lord out of fear for his own life. He fails, as Christ had foretold. King Saul is struggling with an overmastering jealousy and hatred toward young David, 'because the Lord was with him and was departed from Saul' (I Samuel 18:12). In both cases sinners are represented, but of different types: Peter is the repentant sinner who will be saved; Saul is the confirmed, the inveterate sinner who is doomed to fall. There is accordingly a milder atmosphere in the painting of St. Peter and a note of sinister gloom in the *Saul and David*. The dominating impression in each scene is the profound human aspect: Rembrandt's sympathetic and powerful exposition of the chief actor's inner conflict in his hour of trial.

In the composition of the *Denial* everything hinges upon the expression of Peter, from whom an answer is expected. There is a troubled face, but there is also great dignity and poise; this is the disciple who first addressed the Master as the 'Son of the living God' (Matthew 16:16). These broad shoulders and erect posture belong to one whose very name signifies 'rock'. 'And upon this rock I will build my church, and the gates of hell shall not prevail against it' (Matthew 16:18). Rembrandt personifies all the loyalty and valour of Christ's foremost follower in the towering figure which fills one-third of the picture, gaining added prominence through its brightness and frontality. But Rembrandt teaches also the Christian paradox of the fallibility of all flesh, however loyal. The faithful Peter is yielding and speaking

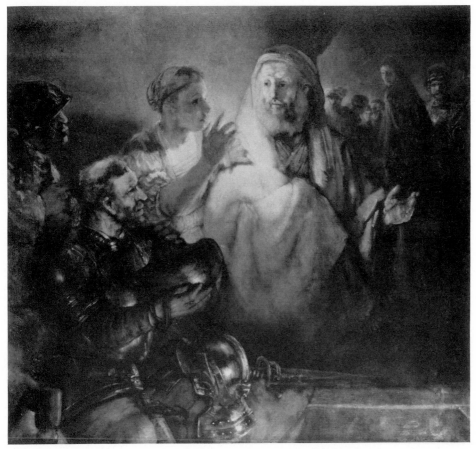

189. THE DENIAL OF ST. PETER. 1660. Amsterdam, Rijksmuseum. Oil on canvas (153 × 168)

falsely, denying the One to whom he had said: 'Lord, I am ready to go with thee, both into prison and to death' (Luke 22:33).

As for the arrangement of the individual figures, we find the most intense relationship established between the apostle and the questioning maid. She focuses the light of her candle upon St. Peter's face and looks into his eyes with a searching attention. Her features show decision in contrast to the apostle's embarrassment, and she is also marked by the strongest colour accent, a bright orange-red in her bodice. The faces of the two grim warriors on the left are equally searching. These three figures form a wedge directed at St. Peter and symbolizing a powerful challenge to the steadfastness of his faith. Furthermore, the maid's forearm links the nearer warrior's face with that of the apostle, and leads the eye to Christ in the rear, who turns back at this moment ('and the Lord turned and looked upon Peter,' Luke 22:61). This diagonal may be called the axis of the composition. Through it Christ's figure, comparatively small and only slightly indicated in the dim light of the rear

guardroom, gains due significance. Peter's left hand, with its gesture of denial, also serves to direct attention to Christ, who appears just above it in the background.

A striking feature in the pictorial composition is the yellowish white of Peter's mantle, vividly reflecting the candlelight, with gradual transitions to the darker shades in the lower section. The white-clad apostle is sharply contrasted with the dark and heavily armoured warrior in the foreground.

A preliminary drawing of this subject in the Ecole des Beaux-Arts in Paris (Val. 465) does not give to Peter such a dominating place nor does it relate Christ so significantly to the apostle. It stresses more the general agitation in the guardroom at night. The motif of the maid holding up a candle as she questions St. Peter, Rembrandt may have derived from a composition of Gerhart Seghers, a Flemish follower of Caravaggio.[59] But only in Rembrandt's composition does this motif gain central importance. Closer to the finished painting is another drawing, in the Biblioteca Nacional in Madrid.[60] This shows the St. Peter-maid motif in the centre, but the maid is here seen from the rear and the figures on the left are not yet brought into such a direct relationship with the apostle as they are in the painting.

No visitor to the Mauritshuis will easily forget the large painting of *Saul and David* (fig. 190). He may be haunted by the expression of fear and despair in the eye of a mighty king, seated opposite a young harpist who is wholly absorbed in his playing. Rembrandt has shown in all regal splendour the first anointed king: 'there was not among the children of Israel a goodlier person than he: from his shoulders and upward he was higher than any of the people' (I Samuel 9:2). But Saul, so fervently welcomed, so victorious against the enemy, because he 'rejected the word of the Lord,' was 'rejected from being king' (15:23). Thus, in the midst of his underlords, Saul felt abandoned and shaken. The story of David playing before the king to relieve his melancholy is told three times in the book and describes those extremes of passion which characterize the nature of Saul. The music of his young rival can at last no longer overcome the evil spirit upon him, and he wants to smite the one whom 'he loved so greatly'. Rage and jealousy seize the heart of Saul, fallen from grace, to end in suicide.

In Rembrandt's painting we see the king seated high above the youthful David who appears only in half-length in the opposite lower corner. The large dark curtain between the two suggests Saul's inner solitude, while the flow of the music from one side to the other across this dark area is indicated by the curves of the harp and the curtain's edge leading up to his head. Saul has grasped the curtain with his left hand to wipe away a tear from his eye, showing that the music has indeed reached his soul. But another, more sinister feeling is stirring within him. His uncovered eye, wide open and darkly brooding, betrays his inner torment;[61] so does the slightly suggested movement of his right hand on the javelin.

Although the turban forms the most colourful spot in the picture, it does not

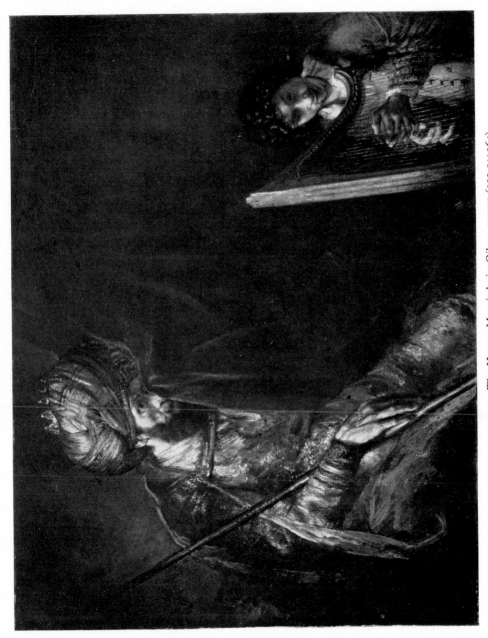

190. SAUL AND DAVID. The Hague, Mauritshuis. Oil on canvas (130·5 × 164)

interfere with the primary attraction of Saul's facial expression. Here, as often, Rembrandt has separated the strongest psychological and pictorial accents, yet kept them closely related. The material splendour belongs to the colourful red and blue turban, while the main chiaroscuro accents are reserved for the face. A secondary light accent falls on the king's hand and correspondingly, on the other side, on David's white shirt at his neck and wrist. The glow and the vibration of the colours add tremendously to the moving power of this picture, particularly the deep purplish red and golden-yellow lining of Saul's cloak and the gold embroidery of his robe. Here the colour is laid on with a Tintoretto-like boldness and sketchiness, while the variegated turban, surmounted by a pointed crown, is executed in a more detailed manner. This flexibility in technical treatment lends the picture an unusual richness. To place its date toward the end of the fifties seems most plausible, on the basis of style. The repeated occurrence of the Saul type in other Rembrandt paintings at that time is another argument in favour of this dating.

A glance back to the *Saul and David* of about 1630, in Frankfurt (fig. 191), shows the extraordinary progress from Rembrandt's Leyden period to his fully developed style. In the small Frankfurt painting a theatrical spotlight is thrown on the scene. The king is an actor with conspicuous gestures, and his suspicious glance is aggressively directed at his hated young rival playing the harp before him. In the very centre of the picture Saul's fist grips the javelin with an unmistakable obvious-ness. In contrast to this the late work has a weighty stillness and inner glow. The drama of the king's soul is laid open before the spectator. No longer are surfaces and materials rendered solely for the sake of pictorial refinement. Everything, colour and brushwork, light and shade, spatial composition and pictorial design, serves primarily to express the meaning of the story. And for this purpose the artist's language has taken on a symbolical significance.

In his last and most monumental religious painting, the *Return of the Prodigal Son* in Leningrad (fig. 193), the aged Rembrandt interprets the Christian idea of mercy with the deepest solemnity, as though this were his spiritual testament to the world. The parable is Jesus' answer to the Pharisees who said 'This man receiveth sinners and eateth with them' (Luke 15:2); it is summed up in the words: 'I say unto you, that likewise joy shall be in heaven over one sinner that repenteth, more than over ninety-and-nine just persons, which need no repentance.'

In 1636 Rembrandt treated this subject in an etching (H. 147, fig. 192) with a very literal interpretation of the Biblical text.[62] Here the repentance of the son who had 'wasted his substance with riotous living' is given fully as much emphasis as the forgiveness of the father who 'had compassion and fell on his neck and kissed him.' In fact, this closeness to the text allowed the young Rembrandt to express to the utmost degree his fondness for Baroque motion and emotion, and to elaborate on narrative details such as the servant bringing the best robe and shoes.

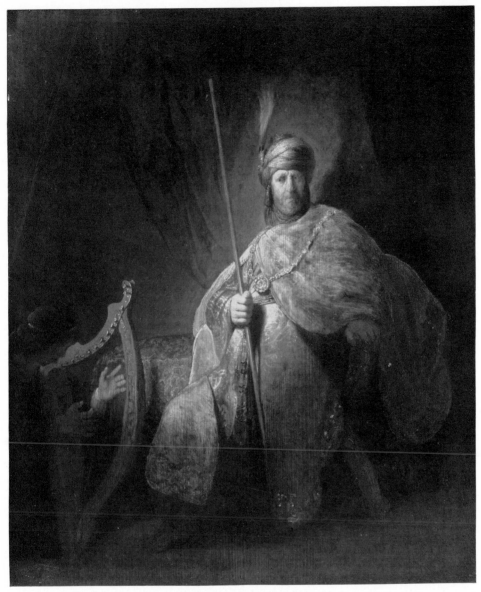

191. SAUL AND DAVID. Frankfurt, Staedel Institute. Oil on panel (62 × 50)

The late painting of this subject does not attempt any such literal rendering. It concentrates upon the act of forgiveness by the old father; his parental love and compassion dominate everything. The group of father and son is outwardly almost motionless, but inwardly all the more deeply moved. The two figures stand out in brilliant colours in a mild foreground light, while the rest of the picture remains comparatively dark. The gold-tinged ochre in the son's ragged garment and the bright scarlet in the father's cloak form an unforgettable harmony.

192. THE RETURN OF THE PRODIGAL SON. 1636. Etching (H.147). (15·6 × 13·6)

The father bends in a frontal attitude over his kneeling son. Though his eyes are closed, his features glow with an august kindness. His hands, stiffened with old age, are broadly yet gently laid on the son's shoulders. The prodigal has indeed the appearance of a swineherd. His clothes and sandals are torn, his head is bald. With utter humility he presses his shadowed face against his father's breast. Of the attendant figures the old man on the right, standing erect and solemn, wears a dull red coat and a yellowish robe. Next to him, a little farther back, sits a bearded man with a

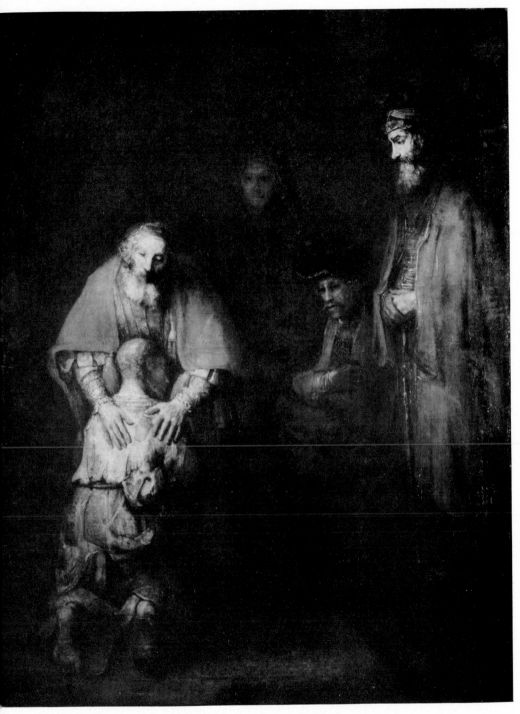

193. THE RETURN OF THE PRODIGAL SON. Leningrad, Hermitage. Oil on canvas (262 × 205)

broad black hat. Two others appear dimly in the background. All these accessory figures show an almost rigid immobility. They look on silently and reflect the deep emotion of the main group.

Here, even more than in the previous paintings, all formal features, and the colours in particular, have taken on a symbolical significance, just as the parable itself gains full meaning only through its deeply symbolic character. The story deals not with the human love of an earthly father, as grasped by the limited comprehension of the elder son, who rebukes his father's action. What is meant and represented here is the divine love and mercy in its power to transform Death into Life. 'For this my son was dead and is alive again; he was lost and is found.' The luminous red in the father's cloak is the colour of love, and is raised to a spiritual symbol like the robes of Mary or St. John in a fifteenth-century altarpiece. It suggests a jubilant voice that vibrates in close harmony with the other tones of the picture and glows with an ineffable power out of the dark shadows of this huge canvas. The profoundly religious character of this late masterwork, and its great solemnity, seem to require a medieval cathedral rather than a Baroque building as a proper setting.

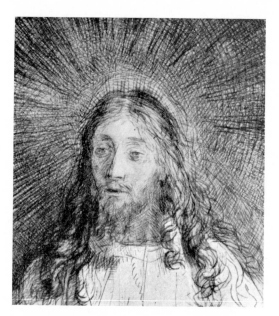

194. HEAD OF CHRIST. Enlarged detail from
the 'Hundred Guilder Print' (fig. 169)

V

GENRE · MYTHOLOGY · HISTORY

ALL the miscellaneous subjects which fall outside the broad categories of portraiture, landscape, and religious art are combined, for reasons of economy, in this chapter. Although occupying a smaller place in Rembrandt's production, this group includes some of his important works. The foregoing discussion of the basic tendencies found in his portraits, landscapes, and Biblical subjects leads us to expect the same personal and often most unusual treatment in the minor fields of genre, still life, mythology and history.

Rembrandt's absorbing interest in motifs from daily life differed considerably from the attitude of the typical Dutch genre painters, with their fondness for young ladies in neat interiors, musical parties, gallant officers and cavaliers, or humorous, anecdotal scenes. None of these artists, neither Vermeer nor Pieter de Hooch, Terborch, Metsu, nor Jan Steen, seem to have spent much time on drawing. Only rarely do we meet with their sketches of single figures done in preparation for a painting. Rembrandt, on the other hand, was extremely productive in drawing motifs from daily life, although he painted very few such subjects. The charm of these sketches lies, in no small measure, in the artist's free and spontaneous reaction to the varied impressions he received at home or on the streets.[1] Picturesque figures, characteristic gestures, all sorts of simple incidents caught his interest and he speedily set them down on paper in his suggestive shorthand. Thus this group of 'daily life' drawings is an impressive proof of the breadth and the vividness of Rembrandt's realism. It also reveals his unusual ability to absorb a vast amount of visual and artistic experience. Great artists like Rembrandt and Shakespeare seem, at times, to turn out their production with the luxuriant expenditure and apparent aimlessness of nature itself. But after some penetration, one discovers in this abundance both a purpose and a higher economy. Rembrandt needed such rich visual experience and such intimate contact with the living world around him in order to fulfil his artistic programme. Most of his sketches were done in the early years when his expansion was rapid. The later drawings are not as numerous, although still covering a variety of subjects; less sharply detailed than before, they are distinguished by a more summarizing pictorial treatment.

Among the individual motifs that stand out in this group we mention first the 'mother and child'. Rembrandt's interest in this subject is very different from that of Pieter de Hooch, Metsu, or Maes, who stress its homely and sentimental appeal. Rembrandt introduces us to a more vital atmosphere: his babies are often naughty, his mothers shown as tired from their exhausting maternal duties or quick-tempered

195. MOTHER NURSING A CHILD. Stockholm, National Museum. Drawing (17·5 × 15·3)

in dealing with their problems (fig. 196). Even the happy moments recorded by Rembrandt reflect the artist's feeling for vital reactions, as when the mother devotes all her attention to nursing (fig. 195), forgetting herself in her contact with the child. In another case we see a mother encouraging her baby's first steps (fig. 197) or a young woman and an old one—probably mother and grandmother—doing the same, and vividly showing their participation (fig. 198). Childbed scenes are not uncommon. Sometimes Rembrandt expresses the young mother's anxiety (fig.

196. THE UNRULY CHILD. Berlin, Print Room. Drawing (20·6 × 14·3)

197. BABY LEARNING TO WALK. London, British Museum.
Drawing (7·8 × 7·5)

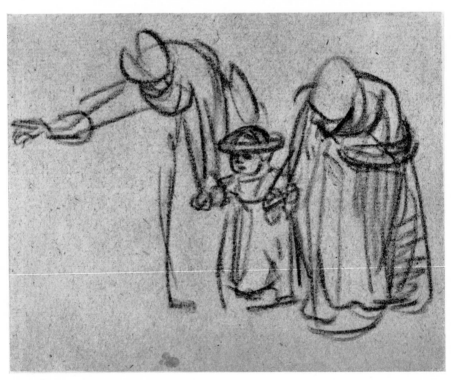

198. BABY LEARNING TO WALK. London, British Museum. Drawing (10·3 × 12·8)

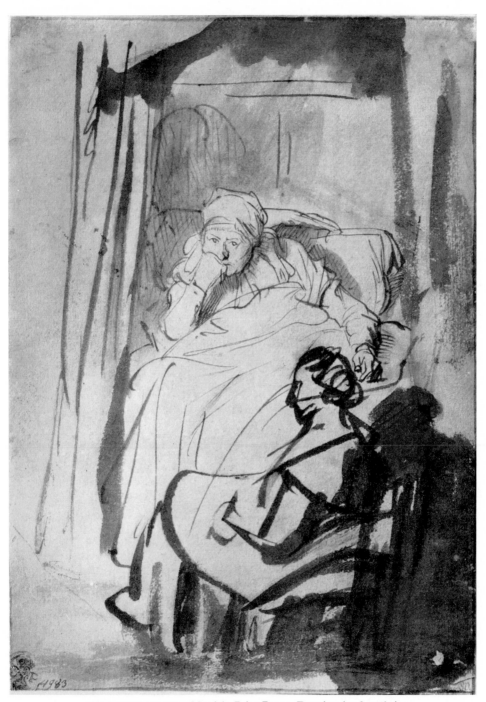

199. SASKIA IN BED. Munich, Print Room. Drawing (22·8 × 16·5)

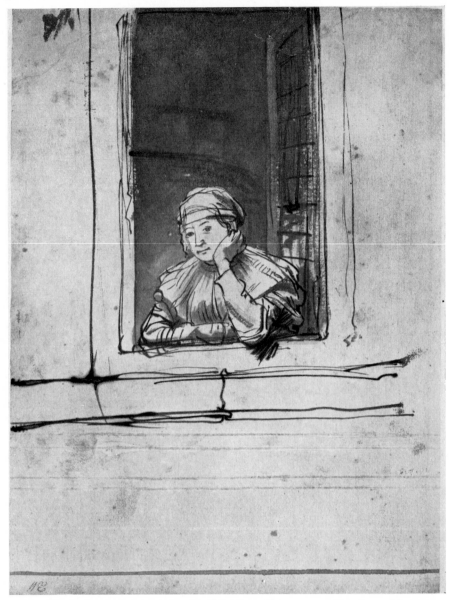

200. SASKIA AT AN OPEN WINDOW. Rotterdam, Boymans-van Beuningen Museum.
Drawing (23 × 17)

199). In this case it is Saskia, and we recall that she lost three children before the birth of Titus. In this drawing in Munich the nurse, sitting in the foreground, adds a dramatic note by increasing the spatial depth and by heightening the focal interest on the brooding Saskia in the centre.

There are also numerous sketches of Saskia, and later Hendrickje, by themselves, in various attitudes, such as leaning out of a window (figs. 200, 201), meditating

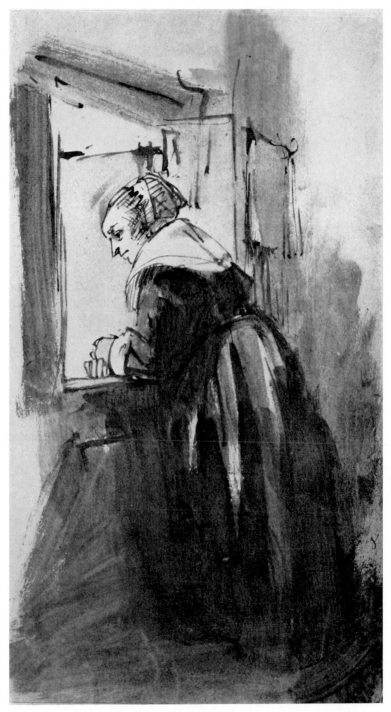

201. YOUNG WOMAN AT A WINDOW (Hendrickje?). Paris, Louvre
(Edmond de Rothschild Collection). Drawing (29·2 × 16·2)

202. WOMAN SEATED, IN MEDITATION (Saskia ?). London, British Museum.
Drawing (21·7 × 15·3)

203. SLEEPING GIRL (Hendrickje ?). London, British Museum. Drawing (24·5 × 20·3)

while seated in an armchair (fig. 202),[1a] asleep (fig. 203), and so on. In all these cases the likeness is less important than the characteristic position or the mood of the person represented. Here again the contrast between early and late drawings is fairly strong. The early ones, however, have their own vividness and striking power. From the beginning Rembrandt's line possesses an electric quality, giving form, life, and atmosphere with every stroke.

Of more than usual interest are those sketches representing persons engaged in

204. TITIA, SISTER OF SASKIA, SEWING. 1639. Stockholm, National Museum.
Drawing (17·8 × 14·6)

some occupation. These figures never seem to pose for the spectator as they do in
the genre paintings of Dou and others. Rembrandt is able to penetrate to the core
of their activity and catch them in moments of complete unselfconsciousness.
Examples are the *Young Man Sharpening his Pen by Candlelight*, in Weimar (fig.
205), and the *Woman Sewing* (fig. 204), identified by Rembrandt's own inscription
as Saskia's elder sister, Titia. The two etchings of the *Cardplayer* (H. 190) and the

Young Man Drawing from a Cast (H. 191) may also be mentioned in this connexion, because of their sketchy character. Titus is often represented in some occupation—writing, reading, or sketching (fig. 88). The painting in the Metropolitan Museum of the *Old Woman Cutting Her Fingernails* (fig. 261) is a well-known but rare example of a genre subject by Rembrandt in the oil technique. A small pen sketch for it is preserved in Stockholm.[2] Recent cleaning of the painting has revealed that the date, instead of 1658, should be read as 1648, and this is far more in keeping with the character of the painting.[2a] Nicolaes Maes was at that time Rembrandt's pupil, and it was from works like this one that he derived his popular category of genre paintings, transforming his master's chiaroscuro and colourism into a plainer yet more decorative style.

As for street scenes, we encounter the most varied motifs in Rembrandt's work.

205. MAN SHARPENING A PEN. Slightly enlarged. Weimar, Museum. Drawing (12·5 × 12·3)

206. THE PANCAKE WOMAN. Paris, Louvre. Drawing (14·9 × 17)

One is that of the 'pancake woman,' known to us in drawings (fig. 206) and in an etching (H. 141). Such old women, frying pancakes in the open air and selling them to the passers-by, Rembrandt must have seen on many a street corner. Judging by his humorous representations of this subject, the customers were mostly children. In the drawing reproduced here a mother restrains her baby from touching the hot pan, while a little boy on the left eagerly digs for the penny in his pocket. The etching of the same subject is also animated by such entertaining touches, in particular the baby in the foreground, defending his cake against an aggressive little dog. Another favourite motif of Rembrandt's, which he sketched repeatedly and also etched (H. 254), was the procession of children carrying a star-shaped lantern through the streets on the Feast of the Epiphany. Then there are the studies of quacksalvers. In Rembrandt's etching of that subject (H. 139) he has represented the quack as a single figure, amusingly picturesque in his fanciful attire. One of the drawings (fig. 207) shows the quack on a stage, equipped with all the paraphernalia of his dubious profession and haranguing a crowd of potential customers. An advertising poster stands behind him. The large flat umbrella, which shades his

207. THE QUACK. Berlin, Print Room. Drawing (20 × 14·7)

208. JEWS IN THE STREET. Haarlem, Teyler Museum. Drawing (17·5 × 23·7)

209. THE SYNAGOGUE. Enlarged. 1648. Etching (H.234). (7·1 × 12·9)

210. BEGGAR SEATED ON A BANK. 1630. Etching (H.11). (11·6 × 6·9)
211. BEGGAR WOMAN AND CHILD. Fogg Art Museum, Paul J. Sachs Collection.
Drawing (12·1 × 7·4)

little platform becomes in Rembrandt's sketch a daring compositional means to link the actor with his audience and to emphasize the agitation of the scene.

From the group of numerous studies of Jews we reproduce two examples (figs. 208, 209). The artist's particular interest in the Jewish people has already been dealt with in the chapter on portraiture. The pen or chalk sketches represent them in full figure, as Rembrandt saw them walking on the street or standing in groups, and he never failed to render vividly their exotic appearance and characteristic gestures.

Beggar subjects are found frequently in Rembrandt's earliest etchings and drawings done in Leyden (figs. 210–212).[2b] At that time Callot's etchings of beggars had gained widespread popularity throughout Europe, and it is possible that the youthful Rembrandt wished to compete with the famous French artist. The subject was not at all far-fetched during this period of the Thirty Years War, when misery and suffering were to be seen on almost every side. Callot's representations of beggars show little of Rembrandt's human interest in the subject. They reflect the same burlesque flavour found in the Frenchman's figures of comedians and grotesque

212. THREE STUDIES OF A BEGGAR. London, British Museum.
Drawing (15·2 × 18·5)

dwarfs; they belong in the atmosphere of the stage and were made for the entertainment of a pleasure-seeking public. Rembrandt, from the beginning, sounds a much deeper note. He, too, has an eye for the picturesque and the comical side of the beggars' appearance. But his emphasis lies on their deplorable condition, on their loneliness, exhaustion, and tragic degradation to an animal-like state. It is interesting to compare the early etching of the *Rat-killer*, 1632 (H. 97, fig. 213), representing a poor pedlar selling rat poison, with a later subject of this type, the *Beggars Receiving Alms at the Door of a House*, of 1648 (H. 233, fig. 214). In the later work the picturesque note has disappeared in the interest of a simple and human interpretation. All surface accessories of the attire have been eliminated to give powerful emphasis to the humble mood of the beggars as they accept the charity of a benevolent old householder.

Whether the so-called *Polish Rider* of the Frick Collection in New York (fig. 215) can be considered a genre motif, or belongs in the category of portraiture, still remains an open question. To this handsome painting, generally dated about 1655, Julius S. Held has devoted an interesting study,[3] providing an answer to some of its

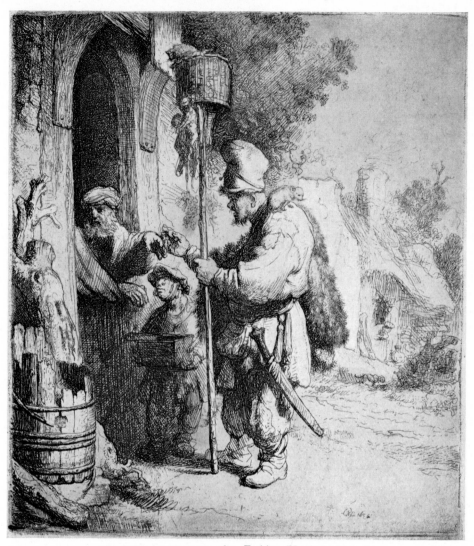

213. THE RAT-KILLER. 1632. Etching (H.97). (14 × 12·4)

varied problems and throwing new light on its rather mysterious character. The young horseman's uniform is not specifically Polish. His armour and dress suggest, in a more general way, the east European light cavalry which at that time was often engaged in the fight against the Turks and the Tartars. Thus Rembrandt's painting may represent an idealized type of that military group which the seventeenth century connected with the defence of Christianity against the infidels. If this interpretation is true, Rembrandt's *Polish Rider* has a significance similar to that of Dürer's *Knight, Death, and Devil*, representing the *miles Christianus*. The monsters which, with Dürer, symbolize the knight's spiritual and physical danger are

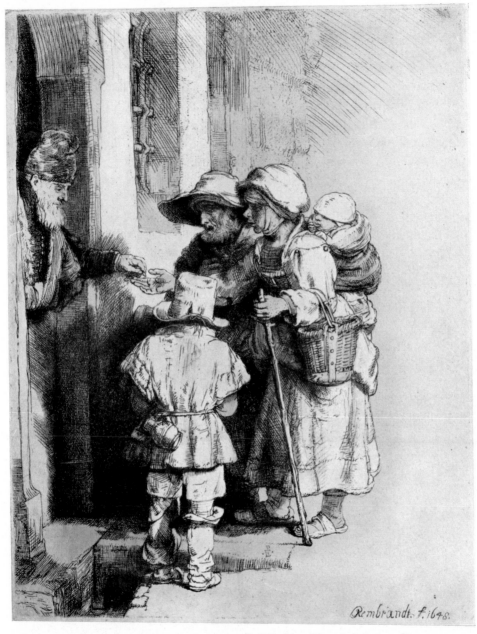

214. BEGGARS RECEIVING ALMS. 1648. Etching (H.233). (16·4 × 12·8)

omitted in the Rembrandt painting, but the composition of the *Polish Rider*, even though reversed, reflects something of Dürer's famous print, in the position of the horseman as well as in the landscape rising so close and steep behind him.

Another genre subject more definitely derived from Dürer at the very time of the

Polish Rider is the drawing now in the Museum in Groningen, representing a well-dressed pair, the cavalier inviting the lady to take a walk (fig. 217).[4] By Rembrandt's reversal of the composition and his free translation into a seventeenth-century scene, the close relationship to Dürer's engraving of the *Promenade* has been overlooked. There exists, as it happens, an engraved copy of the Dürer, in reverse, by Marcantonio (fig. 216), and this might have been in Rembrandt's possession. As for the motif and the position of the figures Rembrandt has followed Dürer fairly closely, yet he has retained his own style of draughtsmanship and represented the figures completely in the spirit and the costume of his own time. The most striking change is the cavalier's taking off of his plumed cap—a feature which enhances the significance of his gesture but also balances the composition and adds to the spatial distinctions on this side. A detail which makes it certain that Rembrandt depended upon Dürer's engraving can be seen in the cavalier's right hand appearing behind the lady's waist. This is very discreetly indicated in the Dürer, where only the fingertips are visible. It becomes a little more distinct in the Rembrandt drawing. We are here faced with a case of derivation by a great master who so completely

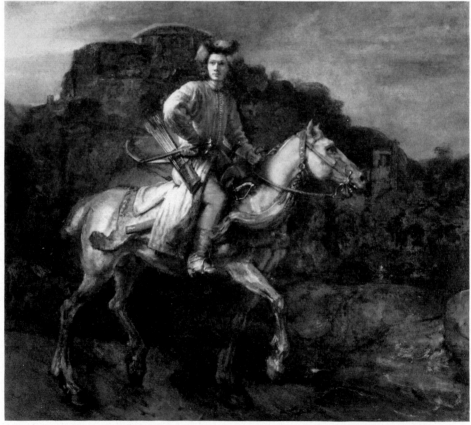

215. THE POLISH RIDER. New York, Frick Collection. Oil on canvas (115 × 133.5)

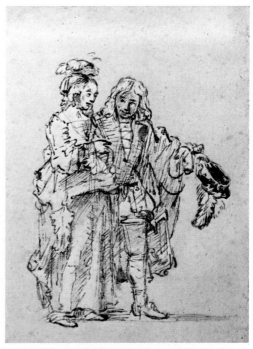

216. Marcantonio, after Dürer: THE PROMENADE. Engraving (19·5 × 12·1)
217. Rembrandt (Copy ?): THE PROMENADE. Groningen, Museum. Drawing (16·5 × 12)

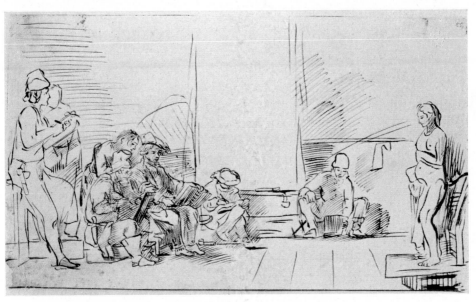

218. Rembrandt School: REMBRANDT GIVING INSTRUCTION IN HIS STUDIO.
Weimar, Museum. Drawing

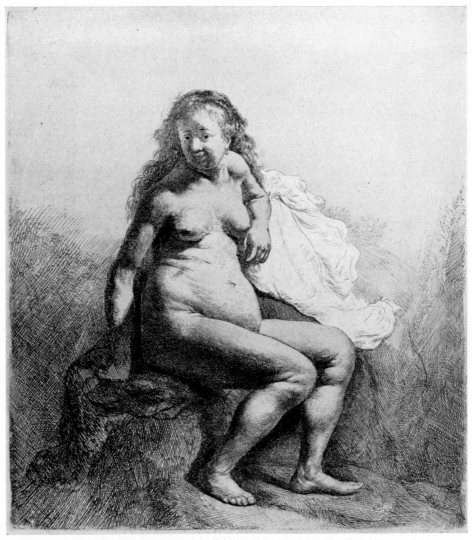

219. NUDE WOMAN SEATED ON A MOUND. Etching (H.43). (17·7 × 16)

transforms the old motif that hardly any obvious traces of his source remain. It is a rare spectacle to see Rembrandt react to Dürer as we do here, and in so intimate and spirited a manner.

Rembrandt did not neglect the study of the nude, which, as we know, formed a definite part of his teaching programme.[5] Two drawings by pupils represent the master giving instruction to a life class. In one the model is reclining on a couch, in the other she stands on a little platform in an attitude not unlike that of the Medici Venus (fig. 218). In Rembrandt's own work we find large numbers of nude studies only at certain phases of his career; the subject did not occupy him constantly. It

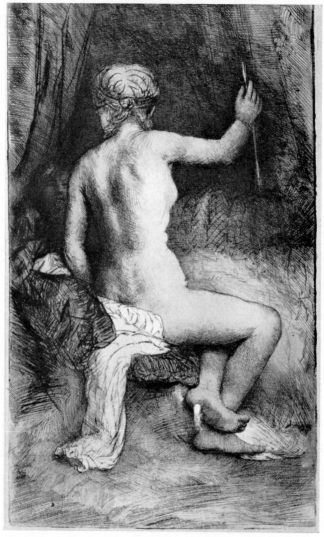

220. WOMAN WITH AN ARROW. 1661. Etching (H. 303). (20·3 × 12·3)

goes without saying that his treatment of the nude was quite unacademic from the beginning. He used these studies for his Biblical and mythological representations—for Bathsheba, Susanna, Danaë, and others. The male nudes figured in the themes of *Christ at the Column* and the *Crucifixion*. Rembrandt did very few painted nudes, however, and not many more in etching. And none of them show the glorification of the human body called for by the classical tradition. For him the beauty of his figures seems to have been unimportant. Many we find rather ugly, though always full of vitality. In the later studies the artist often devotes as much emphasis to the pictorial animation of the space and atmosphere as to the nudes themselves. Thus

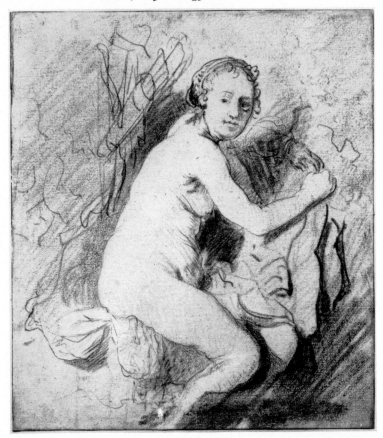

221. WOMAN BATHING. Study for the etching of Diana (H.42). London, British Museum.
Drawing (18·1 × 16·4)

our interest extends from the figures to their surroundings, and we become aware of them as part of a larger whole. The contemplative mood of Rembrandt's models often adds to this impression.

These qualities are strongly brought out in Rembrandt's late etchings of female nudes. We reproduce here the so-called *Woman with an Arrow* of 1661 (H. 303, fig. 220), which was done largely with the drypoint needle and the burin. A softly glowing light caresses the figure in its upright, slightly formal attitude, setting it off against the dark of the background. The atmospheric effect and the mysterious character of the chiaroscuro dominate over the plastic appearance of the body, although the figure has all the breadth characteristic of Rembrandt's late works. An early etching like the *Nude Woman Seated on a Mound*, of 1631 (H. 43, fig. 219), shows a more detailed plasticity and a fresh and pointed realism. The surface of the body has been painstakingly described and the lighting is more naturalistic. Every wrinkle, every bulge has been recorded, and an almost scientific interest in the nude

222. STUDY OF A NUDE WOMAN. Chicago, Art Institute. Drawing (21·3 × 17·7)

for itself obviously absorbed the artist here. He has not yet undertaken to integrate the figure with its surroundings or imbue it with a deeper significance.

It is not surprising that Rembrandt's drawings of nudes show even more swiftness and breadth of treatment than do his etchings. At first he preferred chalk for such studies (fig. 221), but soon turned to the pen and the brush, for their greater flexibility. In a group of late studies of female nudes (fig. 222) pen strokes and brushwork are integrated with the utmost lightness and perfection. The pen stresses the structural features with crisp accents, the brush provides a transparent atmospheric tone that links figure and space.

223. STUDIES OF MALE NUDES. Etching (H.222). (19·4 × 22·8)

The drawings and etchings of male nudes can all be placed about 1646. This date is found on two of the etchings, and the whole group belongs to the same stylistic phase (figs. 223, 224). Moreover, the model in every case is the same: a lanky, undernourished young man who appears also in drawings by Rembrandt's pupils. The ones which are unquestionably by the master's own hand, like the example reproduced here,[6] are far more sensitive in the treatment of light and in the expression of form and mood than are those of his followers.[7]

Rembrandt's all-embracing interest in nature and his rare genius for draughtsmanship are nowhere more strikingly manifested than in his studies of animals.[8] Not a few great masters have been attracted by animals and have excelled in representing them: Pisanello and Leonardo, Dürer, Rubens, and Delacroix, not to mention the Far Eastern draughtsmen. Rembrandt was unsurpassed in

224. STUDY OF A MALE NUDE. Vienna, Albertina. Drawing (19·8 × 13·3)

his ability to catch the essential characteristics of every creature, at rest or in motion, whether the ponderous elephant (fig. 226), the rapacious lioness (fig. 228), or the exotic bird of paradise (fig. 227). This last drawing may have been done after the stuffed specimen in Rembrandt's collection, mentioned in his inventory, yet the birds look very much alive. The numerous sketches of lions indicate that he was particularly fascinated by the king of beasts (fig. 225). One result of these studies can be seen in the drawing of *Daniel in the Lions' Den* (Val. 210), where the animal is superbly characterized in a number of different attitudes, ranging from a fiercely threatening to a majestically relaxed pose.

Paintings of still life by Rembrandt are very rare. When they do occur, the addition of a human figure places them rather in the category of genre; they show a complete disregard for the common type of Dutch still-life painting as it flourished

225. LION. Paris, Louvre (Bonnat Collection). Drawing (13·8 × 20·7)

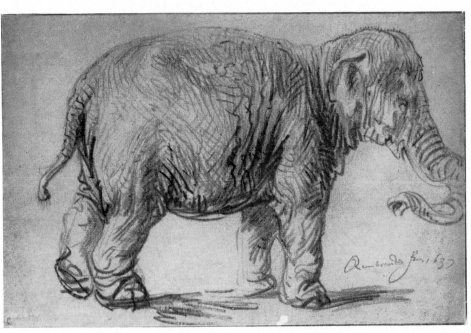

226. ELEPHANT. 1637. Vienna, Albertina. Drawing (23·3 × 35·6)

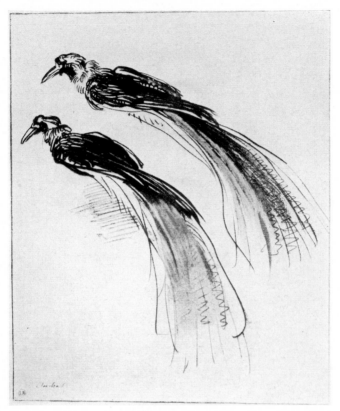

227. STUDIES OF A BIRD OF PARADISE. Paris, Louvre (Bonnat Collection).
Drawing (18·1 × 15·4)

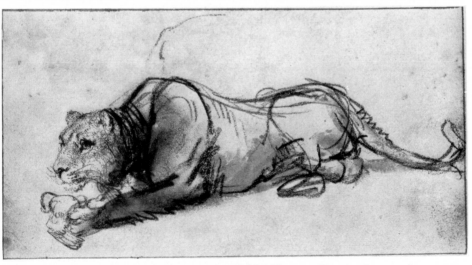

228. LIONESS WITH PREY. London, British Museum. Drawing (12·7 × 24)

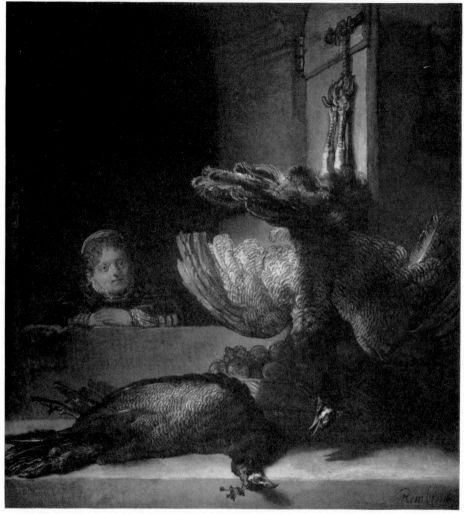

229. STILL LIFE WITH DEAD PEACOCKS. Amsterdam, Rijksmuseum. Oil on canvas (137·5 × 129)

in Rembrandt's time. In his work we find none of the neat arrangements of flowers or fruits with china, glass, silverware, and luxurious tablecloths. In the late thirties Rembrandt painted three pictures with dead birds. We reproduce the *Still Life with Two Dead Peacocks* now in Amsterdam (fig. 229). It may represent the display of a poultry shop. One bird lies on a stone shelf under a large window, the other is hung by the legs on the open shutter, its head dangling in front of a basket of fruit. In the opening appears a young girl leaning on both arms. It is a curious and very unconventional arrangement, full of Baroque charm in the curvilinear pattern of the birds' bodies and in the fantastic play of light and shadow. The subdued colours of the plumage—the blue and yellow-ochre, the fine greys and browns—contrast

230. THE SLAUGHTERED OX. 1655. Paris, Louvre. Oil on panel (94 × 67)

discreetly with the neutral tones of the architecture and the dull red in the fruits. Both Neumann[9] and Schmidt-Degener[10] see in this colour scheme a relationship to the *Night Watch*, but this may be less evident now that the latter has been cleaned. The so-called *Self-Portrait with a Dead Bittern* in Dresden (Br. 31) and the *Still Life with a Gun, a Dead Bittern, and a Girl in the Background*, in the Kunsthaus, Zürich (Bührle Collection) (Br. 455) are quite similar in the wilful originality of arrangement and in the fine pictorial treatment of plumage.

Years later, in 1655, Rembrandt painted the *Slaughtered Ox*, now in the Louvre (fig. 230). He has represented the disembowelled carcass hanging on a wooden frame in a butcher's cellar. A woman is visible in the background, leaning on a closed half-door. She looks minute beside the mighty carcass, which is hit by a beam of sunlight and sparkles in a brilliant red, with touches of ochre and silvery blue. The picture was acquired by the Louvre in 1857 for the modest sum of five thousand francs. Since the subject was generally considered shocking, the painting

231. SCHOLAR IN HIS STUDY. London, National Gallery. Oil on panel (55·5 × 46·5)

found no higher bidders at the sale. There were two men in Paris at that time, however, who recognized its extraordinary qualities: Delacroix and Daumier. Delacroix copied the picture carefully and Daumier was stimulated to do a whole series of butcher-shop scenes.[11] The *Slaughtered Ox* demonstrates that there were no limits to Rembrandt's genius in his exploration of reality and in the boldness of his pictorial and colouristic expression. In spite of its modern appeal, the picture is a true Rembrandt in its peculiar colour harmony and in the feeling of mystery with which the artist has endowed even this commonplace subject.

Finally, in the traditional category of genre representations, there remains to be mentioned one motif which seems particularly close to Rembrandt and can be called one of his most personal choices: the 'scholar in his study'. Similar subjects are fairly common in contemporary Dutch genre painting, where we find the geographer, the physician, the alchemist, or the hermit reading, but in every case

the outward attributes of scholarly activity are primarily stressed, and in a way to attract public curiosity. Most successful in this respect was Gerard Dou, Rembrandt's pupil of his earlier years, who turned out innumerable variations on this favourite theme. Dou delighted in displaying old books, globes, musical instruments, or writing materials, piled in profusion against a background of Oriental rugs or velvet curtains. In Rembrandt's representations, it is the old philosopher enjoying the privilege of meditating in complete seclusion in his search for truth. Light and shade, a penumbral atmosphere, which Rembrandt found essential for the expression of the intangible, gain a particular importance in connexion with this subject.

Only among his earliest paintings do we find two scholars in conversation (Br. 423, 424). After that, Rembrandt concentrates on the theme of the single philosopher in his studio, pondering over his problems. The most striking examples among those done in the Leyden manner, like the pictures now in London (fig. 231) and in Paris (fig. 232), show the figure rather small in relation to the vast interior, with heavy vaulting, spiral staircases, and a generally medieval aspect. The shadowy

232. SCHOLAR IN HIS STUDY. 1633. Paris, Louvre. Oil on panel (29 × 33)

233. SCHOLAR IN HIS STUDY. Paris, Louvre. Drawing (18·1 × 18·8)

atmosphere dominates in the total impression, yet the figure, tiny as it is, retains the focal attention and the artist has succeeded in making the surrounding space reflect the scholar's contemplative mood.

In his middle period Rembrandt takes up this subject in etching (H. 201, 202) and drawing (fig. 233). The figure now becomes more prominent. The artist again tries to represent man's lonely search and his spiritual striving by varying the attitudes and chiaroscuro effect. But it is only in the next decade that another step is taken, and Rembrandt attempts to reveal an answer to this questioning of the human mind.

The so-called *Faust* etching of 1652 (H. 260, fig. 234) has long been a puzzle to interpreters of Rembrandt. The title has often been contested. It originated in the middle of the eighteenth century, when Gersaint listed the etching in his catalogue[12]

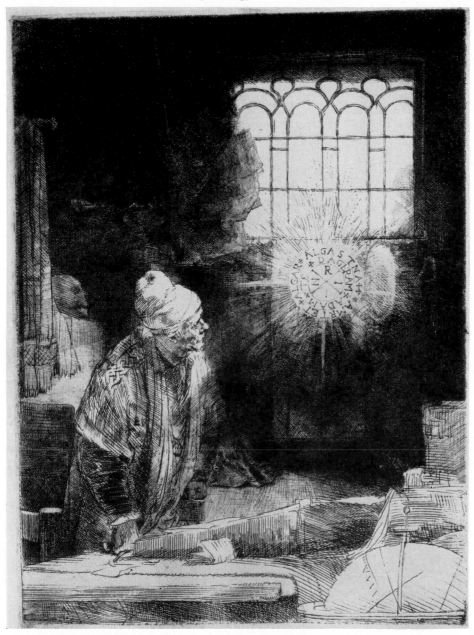

234. SCHOLAR IN HIS STUDY (so-called 'Faust'). Etching (H.260). (20·9 × 16·1)

of 1751 as 'Dr. Fautrieus', whereupon Yver, in his supplement catalogue[13] of 1756, corrected the name to 'Dr. Faustus'. Since then this title has stuck to the etching, one reason being that Goethe's first edition of *Faust*, in 1790, was illustrated with a print by J. H. Lips which was a free copy of the Rembrandt. Besides the 'Faust'

hypothesis[13a] there is a document of 1679,[14] which deserves serious consideration. This is the list of Rembrandt's etchings in the possession of Clement de Jonghe, the dealer who had been in close contact with the artist and who had been portrayed by him in an etching of 1651 (H. 251). Number 33 of de Jonghe's inventory is entitled *practiserende alchimist* and obviously refers to our etching. Weisbach has rightly pointed out[15] that the term 'alchemist' should not be taken in too narrow a sense. In Rembrandt's time various scholarly and pseudo-scholarly activities such as astrology, medicine, cabalistic art, and theurgy were connected with alchemy and often practised by one and the same person. Thus the suggestion is permissible that such a higher type of 'spiritual' alchemist is represented here at the moment when he experiences a religious vision. The disc, object of that vision, has a general resemblance to the magic circles found in contemporary conjuring books, and its religious character is indicated by the clearly defined monogram of Christ in its centre.

As for the representation, we see a scholar who has risen from his desk at the appearance of an extraordinary phenomenon in his window. He had been deep in his work, as the pen in his right hand indicates—yet the interruption has not startled the man. He looks intently at the miraculous appearance as if trying to absorb its full significance. A skull is seen in the half shadow behind him, like a macabre echo of the scholar's own face. A globe in the foreground, books and papers on every side, fill the room.

The eye travels from the bright and sketchily indicated globe in the right corner to the brilliantly lighted head of the scholar and on to the disc which finally holds our attention as the focal point in the pictorial organization. Adjacent to this disc, on the right, is seen another circle of similar size, this one foreshortened. It appears to be a mirror, with a ghostly pair of hands holding and pointing to it. In the disc, it seems, lies the real source of the unusual illumination, in spite of the large window above. It was no easy task for the etcher to display this phenomenon against the brightness of the window. But Rembrandt knew how to create a supernatural light effect within a natural one, producing intensity wherever he needed it, through contrast with the immediate surroundings, yet not losing sight of the broad disposition of light and shade in his composition. Thus it is not the largest areas of white which exert the strongest attraction—neither the sphere in front nor the window behind—but the scholar's head and the disc.

The attempt to decipher the lettering on this disc has not yet found a final solution. Bojanowski's[16] reading of it as a definite anagram—which was accepted in the first edition of this book—has been effectively contested by H. M. Rotermund.[17] He was able to show that the inscription is identical with that of an amulet no longer extant but described in an inventory of 1672, and that it resembles other inscriptions on dies for stamping amulets still to be found in the coin collection in Vienna. These amulets invoke the name of God in different languages (Latin,

Hebrew, Greek) and were believed to give protection to those wearing them. Rotermund found also a close resemblance to the inscriptions on 'magic' circles—as Weisbach had previously done—but he could not decipher the text more than tentatively, and did not come to a conclusion on the original meaning of the print. As long as such uncertainty prevails, it seems best to stay with the meaning which Rembrandt's representation impresses upon us: that here is a scholar seen experiencing a supernatural vision while working at his desk, and that in this vision the monogram of Christ is of central importance. These features alone, and their extraordinary graphic expression, make the etching a powerful testimony to the mature Rembrandt's spirituality, whatever may have been the original title of the print.

Rembrandt took little interest in allegorical subjects, and in this he was no different from the other Dutch painters of his time. In contrast with the international Baroque style, which abounded in allegories, both religious and courtly, Dutch art was reluctant to make metaphorical statements that were not based upon direct visual experience. Dutch literature, on the other hand, conformed more readily to this contemporary fashion, and thus the task of book illustration led a few Dutch artists to allegorical subjects. Even Rembrandt, for this purpose, was twice induced to create allegories, but none of his book illustrations (H. 106 and H. 284, 1–4) can be numbered among his striking graphic works. His only noteworthy example of a painted allegory, the so-called *Concord of the State* of 1641 (Br. 476) shows a composition which gathers the miscellaneous motifs of this subject into a florid Baroque design. The title in this case is found in Rembrandt's inventory of 1656, where the item described under No. 106 as *De Eendracht van't lant* obviously refers to this painting.[18]

Rembrandt's interest in mythological subjects was also limited. Only in his earlier work do they occur at all frequently. The influence of Lastman, the humanistic atmosphere of Leyden, and Rembrandt's contact with the art of Rubens and the international High Baroque during his first years in Amsterdam may be responsible for this early fondness for classical subjects. After the middle of the thirties they appear only occasionally, and of the few outstanding works produced in the artist's maturity, the greater number were done on commission rather than by choice. These late mythological paintings, impressive as they are, show little sympathy toward the classical world. Even here the interpretation bears the stamp of Rembrandt's personal religious spirit.

Among the early mythological subjects the *Rape of Proserpina* (fig. 235) and the *Rape of Europa* of 1632 (fig. 12) are noteworthy. The *Rape of Proserpina* in particular shows a powerful Baroque dramatization of the subject, with a miniaturist's refinement of execution—a combination of features which characterizes Rembrandt's Leyden style.[19] The artist has chosen the most breath-taking moment of

235. THE RAPE OF PROSERPINA. Berlin-Dahlem, Staatliche Museen. Oil on panel (83 × 78)

the drama, when the violently resisting daughter of Ceres is already in Pluto's clutches, while her two companions still cling to her garment. The chariot, drawn by fiery dark horses, will in the next moment plunge into the shades of the underworld, which already engulf the right foreground. But the group is still sharply illuminated by the sunlight which strikes Proserpina and her maidens, with the long diagonal of her robe between them. This bright accent forms the vital nerve of the composition; without it the picture would lose its dramatic intensity. The delicacy of the colours—the cool sky blue and the pale golden yellow, the silvery white, light purple, and apple green—is well suited to the refined execution, which shows a crisp, fluid touch.

236. THE RAPE OF GANYMEDE. 1635. Dresden, Museum. Oil on canvas (171·5 × 130)

In the *Rape of Ganymede* of 1635 (fig. 236) we see Rembrandt striving for the monumentality and the full realism of the High Baroque style. But he does this by radical means. He departs from the traditional charm of the ancient myth by neglecting its main point, namely, the youth's beauty, which induced the Father of the Gods to take the form of an eagle and carry Ganymede off to Olympus. Correggio and Rubens told this story with a much more congenial feeling. Rembrandt represents the great bird clutching a crying child in his talons and cruel beak and soaring up into sinister clouds. The chubby form of the little prince, with his kicking feet, stands out brightly lighted and in full plasticity against the dark trees, and the most drastic result of the sudden shock is not concealed. This is one of the boldest strokes of anticlassic naturalism, and is found also in other works of Rembrandt's early period such as the large *Blinding of Samson* (fig. 158). Like the *Samson*, the *Ganymede* has an unforgettable dramatic quality and a most vigorous chiaroscuro design, with the eagle's powerful dark silhouette as its crowning accent. A preparatory drawing in Dresden (Val. 609) shows Ganymede's parents below, the mother raising her arms in despair, the father aiming with bow and arrow at the abductor. The omission of these figures in the painting has heightened the force of the main motif.

One year later, in 1636, Rembrandt created his undisputed masterwork among the mythological subjects of the thirties, if not his most beautiful painting of this entire period: the *Danaë* now in Leningrad (fig. 237). Among the many darkish Rembrandts in the Hermitage this picture's sunny quality is an immediate attraction. It strikes a chord of youthfulness and sensuous delight that is rare in Rembrandt's work, and it does not lack the human warmth and air of mystery characteristic of Rembrandt's best creations.

There has been much discussion about the meaning of the painting, and various Biblical and mythological subjects have been suggested. These, to mention only a few, include 'Rachel Awaiting Jacob,'[20] 'Venus Awaiting Mars,'[21] 'Hagar Awaiting Abraham,'[22] 'Leah Awaiting Jacob,'[22a] and 'Danaë';[23] this last interpretation means a return to the traditional title with a new and more convincing explanation. It has always been clear, however, to every interpreter, that the focus of the scene lies in the young woman's happy expectation of the approaching lover, who is still unseen but for whom the old maidservant lifts the curtain. The crying cupid, with hands bound—in obvious allusion to the heroine's story—symbolizes some obstacle to her happiness. Former objections to the title 'Danaë' were based upon this unusual attribute of the fettered cupid and the absence of the golden shower. Panofsky has succeeded in disposing of these objections in his learned investigation of the literary and pictorial sources of Rembrandt's painting. He informs us that the bound cupid, a symbol of chastity since the Middle Ages, alludes to the rigid seclusion to which Danaë was condemned by her father, the Argive king Akrisios.

237. DANAË. 1636. Leningrad, Hermitage. Oil on canvas (185 × 203)

Warned by an oracle that the son of this daughter would kill him, he kept the princess in strictest isolation. To explain the omission of the golden rain, Panofsky points to precedents in which the celestial light which heralds the arrival of Zeus becomes as important as the gold coins contained in it. Rembrandt, then, went only one step further in eliminating the gold entirely, in favour of a completely luminaristic symbol of the god's advent.

Neumann had already returned to the 'Danaë' interpretation because of the discovery of a document of 1660[24] that mentions a large painting of *Danaë* by Rembrandt in the estate of a certain widow. The appraisers of this estate were two of Rembrandt's pupils, Juriaen Ovens and Ferdinand Bol, who may be considered fairly reliable in their description of the subject. The large *Danaë* listed in Rembrandt's inventory, although without the artist's name, may also be the picture now in Leningrad. A little drawing in Brunswick (Val. 605)[24a] shows a preliminary phase of the composition in which the 'Danaë' theme is indisputably clear. In spite of its brevity there can be no doubt about the falling shower of gold, while the

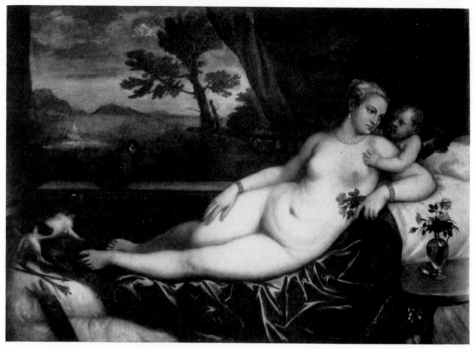

238. Titian: VENUS AND CUPID. Florence, Uffizi. Oil on canvas (139 × 195)

gesture of the maid indicates, unmistakably, an effort to catch it, just as we find in Titian's representation in Madrid. By altering the shape of his composition from an upright to an oblong one, Rembrandt has given much less emphasis in the painting to the downward slant of the light, but here, too, as Panofsky has rightly stressed, it falls from above. This is indicated in the background opening and by the highlights on the maid's face, on Danaë's face and body, and particularly on her outstretched hand. Her glance also is directed slightly upward, while the maid stares fixedly toward the left as if she expects an earthly visitor and is not yet aware of the miracle. Such fine distinctions are not uncommon in Rembrandt's work, as we have seen in other cases.[25]

The composition hangs upon Danaë's extended right hand. Her movement, so free and natural in contrast to the cupid's painful constriction, has an extraordinary charm and expressiveness. More instinctive than conscious, it can be interpreted as a gesture of invitation as well as of slight defence against the blinding light. But it is even more than this. The hand serves not only to focus our attention but also to bring clarity into a complex spatial and pictorial organization by defining the intermediary plane between the nude and the background and by relating the various light accents to a coherent design. The idea of light as a bringer of happiness—which seems to be a major point in Rembrandt's interpretation of

Danaë—relieves the scene of any oppressive voluptuousness. Such symbolical use of light was quite in accord with Rembrandt's general artistic attitude. Yet the picture's sensuous appeal remains strong.

Rembrandt never painted a female nude with greater delight and with a more searching pictorial realism. The flesh tone takes on a sunny warmth through contrast with the cool whites of the linen pillows and coverlets. Soft bluish shadows play over the form, animating and partly veiling it. A pale red and a glittering gold-green are contrasted in the outer setting. The gilded and richly carved bedstead is hung with heavy olive-green silk curtains, while the lower part of the bed holds to a more bluish green tone. A fairly large area of subdued red is found in the table cover at the right. Tiny vermilion accents in Danaë's bracelets and headdress bring the red up to its highest pitch and add a piquant touch.

Rembrandt's *Danaë*, as a painting of a nude, has a very distinct place in the history of European painting and more specifically in that of the Baroque period. While the reclining posture is ultimately derived from Titian's Venus-type[26] (fig. 238), little remains of the plastic grandeur and the Olympian detachment of the goddess in the Renaissance master's interpretation. Like Velazquez' famous Venus in London, the *Danaë* is a creature of flesh and blood, whose nudeness is rendered with the sensuous naturalism of the Baroque. Light and atmosphere have softened the plastic and linear sharpness and brought to life an expressive play of tonal values. The Spaniard, we admit, has retained something of the classic sense of beauty. Rembrandt, on the other hand, has endowed his figure with an incomparable directness, human intimacy, and vivid dramatic quality.

In Leyden and in his early years in Amsterdam Rembrandt created a number of single mythological figures, usually goddesses like Diana, Minerva, Bellona, or Flora. The humanistic tradition which favoured such subjects was then still alive. These early representations are often overburdened with pompous Baroque accessories, and seem posed and artificial. Even in the artist's later years, he did not always overcome this tendency, which was perhaps more a national than an individual one. It is interesting to compare the painting of Hendrickje as 'Flora,' in the Metropolitan Museum (fig. 240) with the same motif done in 1635 when Saskia was the model (fig. 239). In the late version Rembrandt has adopted from the Venetians a greater breadth and monumentality. It is possible to assume here, with Bode, an influence of Titian's *Flora*. Rembrandt's picture is a beautiful piece of painting, with the richness of its white and the velvety quality of the pigment. But a comparison with its prototype makes one conscious of the overdressing of the figure and too close a dependence upon the model. Titian, like other Renaissance masters, followed Boccaccio in representing the goddess as a courtesan,[27] but his Flora, nevertheless, retained the lofty character of a deity.

During the fifties and early sixties, Rembrandt painted three idealized portraits

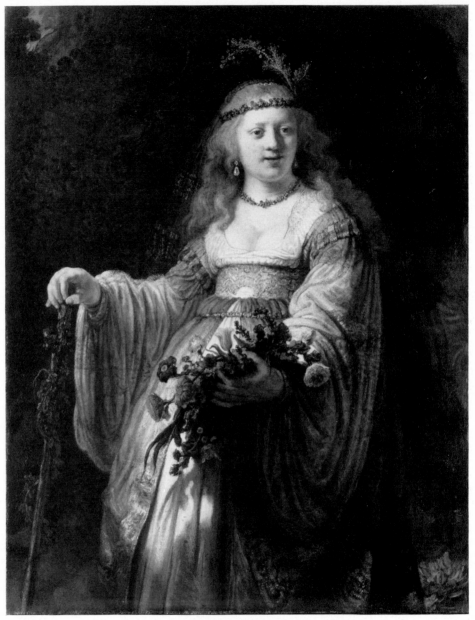

239. SASKIA AS FLORA. 1635. London, National Gallery. Oil on canvas (121·5 × 96·5)

of famous personalities of classical antiquity: an Aristotle, an Alexander the Great, and a Homer. These were the commissions of a Sicilian nobleman, Don Antonio Ruffo, who resided in Messina and had formed an important collection of paintings by old and contemporary masters. The documents from the Ruffo archives, published in 1916 by the Marchese Vincenzo Ruffo,[28] a descendant of Don Antonio,

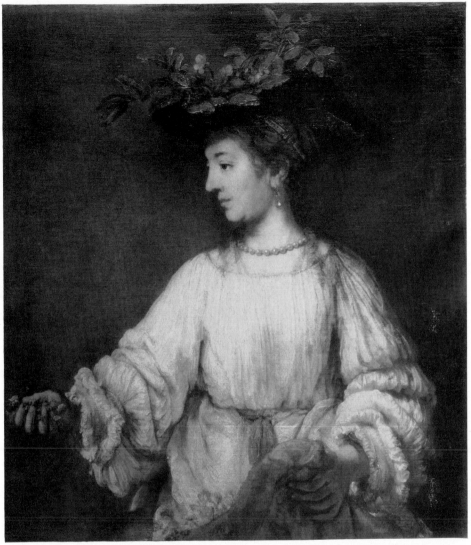

240. HENDRICKJE AS FLORA. New York, Metropolitan Museum. Oil on canvas (104 × 91)

have revealed the fact that the Dutch master's reputation had spread to the southern-most tip of Europe during a period when, at home, his popularity was on the decline. It was in 1652 that Don Antonio ordered from Rembrandt a 'philosopher'. The painting was finished in 1653 and delivered the following year; this is the *Aristotle with the Bust of Homer* now in the Metropolitan Museum (fig. 242). In 1661 Ruffo acquired a half-figure in life size of *Alexander the Great*, of the same dimensions as the *Aristotle*, but he complained that the picture had been enlarged on all four sides in order to change it from a mere head to a half-length figure. Rembrandt thereupon offered to paint the subject a second time if Ruffo would pay

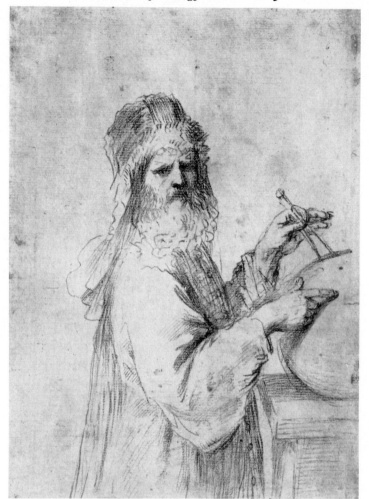

241. Guercino: THE COSMOGRAPHER. Princeton University, Museum of Art.
Drawing.

once more the full price of five hundred guilders. As for the outcome of this matter, documents furnish no further details. About the same time Ruffo was corresponding with Rembrandt about a third picture, a *Homer*. When this painting arrived in Messina, Ruffo found it too large and, in his opinion, unfinished. Rembrandt seems to have made some changes, since it was accepted in 1663.

After the acquisition of the *Aristotle* but before giving further commissions to Rembrandt, Don Antonio decided to add companion pictures by prominent Italian masters. In 1660 he turned with this request to Guercino and, a year later, to Mattia Preti; both of these artists responded readily to the Sicilian nobleman's wishes. In the case of Guercino, who was then a man of nearly seventy, the commission was explicitly for a painting in the master's early manner. Ruffo apparently

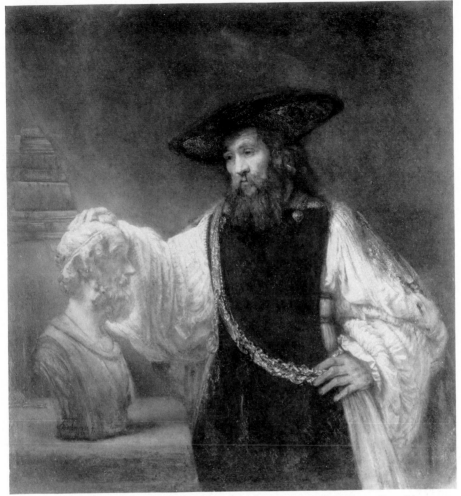

242. ARISTOTLE WITH THE BUST OF HOMER. 1653. New York, Metropolitan Museum.
Oil on canvas (139 × 133)

thought that this would form a better pendant to the chiaroscuro of Rembrandt's
work. Guercino, far from being offended by such a demand, replied to Ruffo in a
letter full of praise for Rembrandt's art. This letter is so memorable a document
that we give it here in translation:

As for the half-figure of Rembrandt which has come into your hands, it can-
not be other than complete perfection, because I have seen various works of his
in prints which have come to our region. They are very beautiful in execution,
engraved with good taste and done in a fine manner, so that one can assume that
his work in colour is likewise of complete exquisiteness and perfection. I sincerely
esteem him as a great artist.

Then as to the half-figure which you desire from me as a companion piece to that of Rembrandt, but to be done in my first broad manner, I am quite ready to agree, and to carry it out according to your orders. Will you, therefore, kindly send me the measurements, both the height and the breadth of the painting, so that I, on my part, shall not fail to use the same dimensions, and as much as my poor ability will allow, you yourself will see expressed in this picture.

If you would also, on the occasion of sending me the measurements, be willing to honour me with a little sketch of Rembrandt's picture, done by some artist, so that I could see the disposition of the half-figure, I should consider it the greatest favour, and should be better able to make a counterpart, as well as to place the light in the right place. I shall wait also for the subject which I am to represent, in order to be able to conform more closely to your wishes . . .[29]

Bologna, June 13, 1660

Guercino, upon receiving the sketch of Rembrandt's *Aristotle with the Bust of Homer*, understood the subject to be a 'physiognomist,' running his hand over a head in order to determine its type (an interesting misinterpretation). For his companion piece he wrote to Ruffo that he had chosen to paint a 'cosmographer'. The description of this lost picture in the Ruffo inventory has given a clue for the rediscovery of Guercino's original drawing for this commission (fig. 241).[30] From the drawing we see that Guercino adapted his composition closely to the *Aristotle* in the position of the figure, the lighting, the gesture, and also the pseudo-Oriental attire. Furthermore, the Ruffo inventory reveals that the two paintings were originally of the same shape and size (8×6 palms, i.e., about 192×144 cm.), whereas now the *Aristotle* is almost square (139×133 cm.).

In spite of all the adaptation on the part of the Italian master, the two representations differ widely in spirit, as might be expected. Guercino's scholar announces his profession by gestures and attributes, and looks out directly at the spectator. Rembrandt's figure, in contrast, is completely absorbed in its own world of deep meditation and mystery. Aristotle's gaze is turned inward; his right hand touches the bust gently, as in a dream, and this gesture symbolizes a spiritual union between the philosopher and the most venerable of ancient poets. Rembrandt owned a cast of a bust of Homer and he portrayed it here fairly closely.[31] From Aristotle's long golden chain hangs a medallion with an image of Alexander the Great, the philosopher's most famous pupil, to whom he passed on his knowledge of Homer. Colour and chiaroscuro in this picture are instrumental in expressing its deep mood and meaning: the solemnity of the black and white in the philosopher's costume; the richly painted white, and the beauty of the gold chain against the velvety black; the warm brownish shadows playing over Aristotle's features and over the bust, and spreading into the background.[31a]

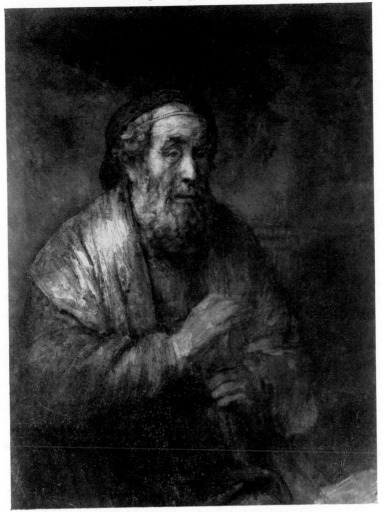

243. HOMER. 1663. The Hague, Mauritshuis. Oil on canvas (108 × 82·7)

For the second of Rembrandt's paintings for Don Antonio Ruffo—the *Alexander the Great*—no convincing identification has so far been offered. The so-called *Athena* (Br. 479), formerly in the Hermitage and now in the Gulbenkian Collection, does not quite fit into the documentary aspect of this case. Yet it must be said that the Gulbenkian painting as well as the similar one of a *Mars* in Glasgow (Br. 480), are surprisingly close to the image of Alexander on the medallion worn by *Aristotle*. Therefore we may assume that the lost *Alexander* resembled these paintings in its general character.

The *Homer* painted for Ruffo has been most convincingly identified as the picture now in The Hague (fig. 243). The Ruffo inventory describes the subject as 'Homer, seated, giving instruction to two pupils.' That the painting in The Hague is cut down

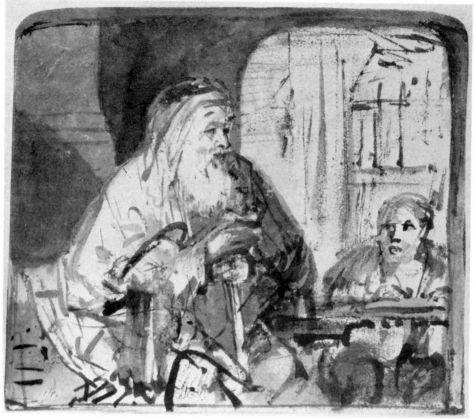

244. HOMER DICTATING TO A YOUNG SCRIBE. Stockholm, National Museum.
Drawing (14·5 × 16·7)

is noticeable in the right lower corner where the tips of two fingers may be seen, holding a pen to a sheet of paper. A preliminary drawing in Stockholm for this composition (fig. 244) shows the figure of a young scribe on the right, recording the poet's words. The painting may once have included a third figure, as mentioned in the inventory. In addition to being cut down, this picture in The Hague shows slight damage by fire, and this is further evidence for identifying it with the Ruffo *Homer*. We know that the entire Ruffo collection was endangered in 1848 by a fire in which many paintings seem to have been lost.

The subject of Homer was not uncommon in Italian Baroque painting. Pier Francesco Mola, in an arrangement similar to Rembrandt's, painted the poet in half-figure, with the young scribe at the right.[32] In Rembrandt's representation the old bard is seated in an armchair and raises his right hand slightly in accompaniment to his words. His face, which here shows less resemblance to the traditional portraits, is alight with inner animation. To characterize blindness is a most subtle undertaking for a painter. Rembrandt has expressed the helplessness of a blind person

with remarkable success, both in Homer's features and in the slightly groping gesture of his hand. But one feels that the old poet's mind is full of its own visions. A mildly radiating glow seems to emanate from his face and from his shoulder, which is covered with a golden-yellow silk scarf. The bold impasto and the lively touch in these passages both help to add to the impression of extraordinary inner vitality.

Rembrandt's *Homer* conveys fully the humility implied in the painter's late work. This could as well be the image of a Biblical patriarch. The dignity and the spiritual enlightenment of old age are represented as coming from many years of suffering and patience, and from a rich accumulation of life's experiences.

Don Antonio Ruffo must have appreciated Rembrandt's individual qualities, for otherwise he would not have favoured the Dutch master with repeated commissions, paying higher prices than those asked by the Italian artists. Ruffo's agent and adviser in Rome was the Italianized Fleming, Abraham Brueghel. This mediocre still-life painter did not share his patron's enthusiasm for Rembrandt and tried to exert some influence upon him. He wrote from Rome on May 22, 1665: 'As far as paintings of Rembrandt are concerned, they are not very highly thought of here. It is true that they are somewhat beautiful as mere heads. But here in Rome one can invest his money much better.' And on January 24, 1670, he made a much stronger attack against Rembrandt, in a letter which proves that Don Antonio's high opinion of the Dutch master had remained unchanged by Brueghel's previous criticism:

> By your letter of December 29, I see that you have had made various half-figures by the best painters of Italy, and that none of them approach those of Rembrandt. It is true that I agree with this. But one must consider that great painters, like those by whom you have had your half-figures made, are not usually willing to lower themselves for a trifling draped half-figure in which the light shows only the tip of the nose, and in which one does not know where the light comes from, since all the rest is dark. The great painters try to show a beautiful nude body, in which one can also see their knowledge of drawing. But an incompetent person, on the contrary, tries to cover his figure with dark, clumsy garments; and this kind of painter does the contours so that one does not know what to make out of it . . . What I merely want to say is, this is no business of great men, to occupy themselves with such trifles, which almost anyone can do. But I beg you to forgive me for speaking so freely. My love of painting leads me to do so . . .[33]

Ruffo's lasting admiration for Rembrandt is confirmed by the fact that as late as 1669 he acquired a large group of Rembrandt's etchings, no less than 189 of them.

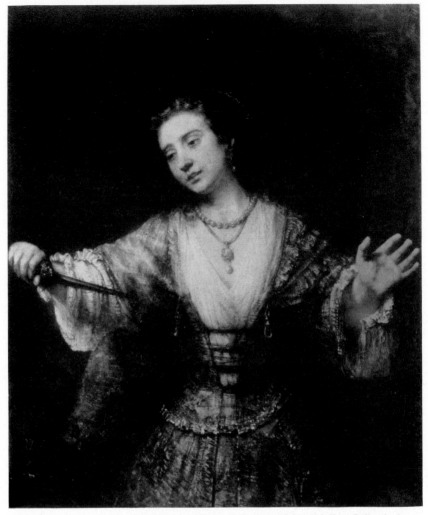

245. LUCRETIA. 1664. Washington, National Gallery of Art (Mellon Collection).
Oil on canvas (120 × 101)

These items were selected and shipped by the aged Rembrandt himself; they did not arrive in Messina, however, until after his death.

Our discussion of Rembrandt's classical subjects may conclude with the two late representations of *Lucretia*. The one in Washington, dated 1664 (fig. 245), combines broad frontality with a surprisingly open gesture, as if the artist wished the spectator to participate as closely as possible in the heroine's anguish. The brushwork in her splendid olive-golden garment shows magnificent passages.[33a]

In the later version of the subject in Minneapolis, dated 1666 (fig. 246), Rembrandt has suppressed the outward action in the interest of a still more powerful exhibition of the heroine's inner conflict. Lucretia, dishonoured but innocent,

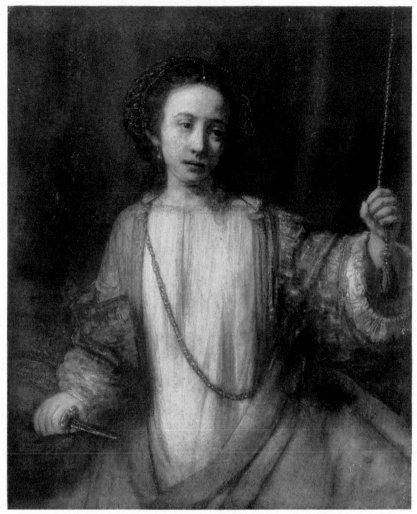

246. LUCRETIA. 1666. Minneapolis, Institute of Arts.
Oil on canvas (111 × 95)

maintains a touching dignity in her sadness at parting from life. Her outwardly calm attitude lends her figure the solemn grandeur so often characteristic of Rembrandt's very late works.

In 1661–2 Rembrandt received his only great opportunity to create a monumental historical painting on the largest scale. At that time the artist was at the height of his powers, as we know from the *Syndics* and other works. His self-portraits of this period, such as those in the Frick Collection (1658), the Louvre (1660), and the Rijksmuseum (1661), have already given us a full impression of Rembrandt at that phase of life which Plato evaluated highest.

The historical painting for which he received the commission was destined for

the new Town Hall of Amsterdam, a classicistic building of colossal proportions which still looms in the heart of the old city and now serves as the Royal Palace. In 1655, at the official dedication, the poet, Joost van den Vondel, had composed for the town fathers a rhymed description of the entire building,[34] giving the impression that everything was completed at that time. The structure had, in fact, risen only to the second storey, but Vondel was apparently familiar with the programme as it was to be carried out during the following years. The plan of decoration was in part derived from Veronese's famous murals for the Ducal Palace in Venice (the Amsterdamers fancied that their city had inherited the glory of the 'Queen of the Adriatic'); in part it followed northern types of town hall decoration, with subjects taken both from the Bible and ancient history, with allusion to the serious responsibilities of the town authorities and the civic virtues expected of them. Finally, there was a series of eight historical paintings dealing with the heroic beginnings of Holland's history. The subject was the uprising of the Batavians, under the leadership of Julius Civilis, against their Roman oppressors—a theme which obviously alluded to Holland's recent war of liberation from Spain.

The *Civilis* series was planned to fill the lunettes ($6 \times 5\frac{1}{2}$ metres) in the large gallery leading to the Civic Hall. The commission for the whole set had been given first to Govaert Flinck, but he died before his sketches could be executed.[35] The town fathers then decided to distribute this huge order among various painters. Jan Lievens and Jacob Jordaens were given commissions for single paintings early in the year 1661, and we may assume that this was also the date when Rembrandt was entrusted with his share in the series. To him fell the task of depicting the initial scene, for the southeast corner of the gallery—that of the banquet and the conspiracy of Julius Civilis. Rembrandt's painting was already in place in 1662, but was soon removed for some changes which the authorities may have requested.[36] For reasons unknown it was not returned to the Town Hall. By 1663 its place was taken by the work of Juriaen Ovens, who did a hasty job in painting over with oil colours the full-scale watercolour sketch by Flinck. Of Rembrandt's original canvas only a fragment has survived (fig. 248). It now belongs to the Museum in Stockholm and shows numerous changes by the master's own hand. The original draft for the whole composition has also come down to us in a drawing in Munich (Val. 588, fig. 247)—a most precious document, since, in connexion with the Stockholm fragment, it gives a clear idea of the grandeur of Rembrandt's conception and of its pictorial character.[37]

The subject is taken from Tacitus (*Historiae* IV, 13): Julius Civilis, a veteran warrior of royal blood who is marked by the loss of one eye, has invited his countrymen to a nocturnal banquet in a sacred grove where, by a passionate speech, he incites them to a solemn pledge of conspiracy against the conquerors. Rembrandt has given the central place to the barbaric ceremony of the taking of the oath. The

247. STUDY FOR THE CONSPIRACY OF JULIUS CIVILIS. Munich, Print Room.
Drawing (19·6 × 18)

drawing shows the group of figures in the middle ground before the mighty arch of a vaulted hall. A heavy curtain behind the conspirators covers the architecture to a point halfway up the piers; above, seen through the arches, is a suggestion of sky and trees. A broad staircase, flanked by two massive lions, leads from the foreground up to the banquet table.

This was perhaps the first time in the history of European monumental painting that true monumentality was achieved primarily by pictorial means—by a dramatic and colourful luminarism. The fragment in Stockholm gives this impression and the Munich drawing, by its completeness, adds the impression of structural clarity.

Here, in the drawing, the architecture lends the composition grandeur and spacious-ness, and helps to emphasize the drama of the main action. Even in this brief sketch the distribution of light and shade is of primary importance for the grand effect of the whole. The light is concentrated with great intensity in the centre of the scene; its actual source is covered by the dark figure of the man who offers a libation bowl to Civilis. The glow is reflected most brightly upon the group of conspirators who have risen from the table and gathered around the towering figure of their leader, raising their swords to his in a solemn oath. The light flaring with such vibrancy in the centre is in sharp contrast to the shadows cast by the figures upon the curtain behind them and to the larger areas of shade darkening the upper corners. It is altogether a powerful chiaroscuro animation of a vast space, and yet Rembrandt has avoided too gloomy a general impression in this nocturnal scene.

Turning to the painting we find the strong light accent in the centre somewhat weakened by the extension of the table to the left, in front of the conspirators, who here seem to be seated. Other changes have been made, without, however, adding to the clarity of the scene: one of the swords appears to hang in the air, while the arm of the beardless man next to Civilis has no convincing connexion with his body. The figure of the young man in the foreground raising his right hand is obviously a later addition. These were alterations by which Rembrandt tried to disguise the fragmentary character of the painting in order to make it more saleable.[38] With our knowledge of Rembrandt's preference for warm, deep colours, it is surprising to find the Stockholm fragment painted in a rather bright tonality with a beautiful greyish blue and pale yellow accord prominent in the main figure. The colours have an iridescent quality that lends the scene an air of unreality. By keeping the picture somewhat bright and colouristically attractive, Rembrandt may have hoped to disarm his adversaries who were criticizing, and even ridiculing, his 'dark manner'. At any rate, he proved with this work, as with the *Syndics* of this same time, that colouristic charm was not beyond his reach in a monumental painting, and that this quality could be combined with his conception of a painterly and dramatic treatment. Rembrandt, more than any of the other artists engaged in the Town Hall project, succeeded in bringing out the mythical grandeur of his subject and even its barbaric flavour, avoiding the over-distinctness of form and theatri-cality so characteristic of official Baroque painting, but giving solemn emphasis to the group spirit in this famous event in Holland's history.

It is all the more to be deplored that Rembrandt's contribution found no approval by the town authorities.[39] Vondel, the influential official poet, favoured the rhetorical pomp of the Rubens school, to which Rembrandt's own pupils and former followers (Flinck, Bol, Lievens, Ovens) had readily adapted themselves. It is not hard to understand why Rembrandt's unique achievement in this field of monumental painting did not meet with success. There was no yardstick available to measure the

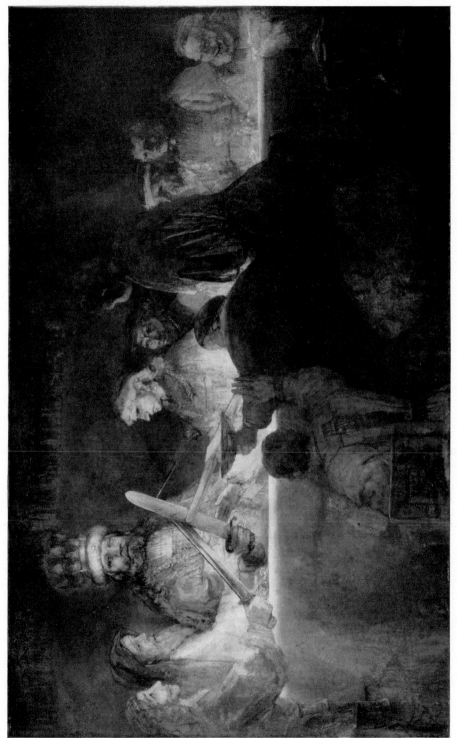

248. THE CONSPIRACY OF JULIUS CIVILIS. Stockholm, National Museum. Fragment, oil on canvas (196 × 309)

originality and the greatness of his work. He alone was able to combine pictorial richness with grandeur of conception, and he alone possessed a truly dramatic sense that grasped the human significance of a subject.

It is useless to contend what might have resulted if the town fathers had shown more understanding of Rembrandt's extraordinary creation, or to guess how it might have influenced the future course of monumental painting in Europe. Rembrandt's achievement was too personal and too inimitable to be carried on by scores of official wall decorators.

CUPID. Detail from fig. 237

REMBRANDT IN HIS CENTURY

I N attempting to understand Rembrandt's significance within his century we must extend our perspective beyond the frontiers of Holland and first find his position within the broad category of Baroque painting.[1] One of the signs of Rembrandt's greatness is the paradoxical fact that his art, while highly individual, repeatedly shows a close affinity to the international trends. It is easy to imagine some of Rembrandt's large-scale creations, such as the *Danaë*, the *Blinding of Samson*, or the *Night Watch*—even such late paintings as the *Conspiracy of Julius Civilis*—figuring prominently in a representative exhibition of Baroque art which includes works by Caravaggio and Rubens, Van Dyck and Bernini, Poussin and Velazquez. This would hardly be possible, to the same degree, with any of the other Dutch masters. None of Holland's artists approached so many sides of Baroque art, its imaginative power as well as its strong illusionism, its religious fervour as well as its pictorial breadth and splendour.[2] The majority of the Dutch painters fall into the category of 'Little Masters'—a type which grew out of certain national peculiarities and has no close parallel in other countries.

The development of Baroque painting may be traced according to generations, and its leading international representatives during the course of the century were Caravaggio (at the side of the Carracci), Rubens, and Poussin. This means that Italy's initial leadership in painting did not last throughout the century, but was succeeded by that of Flanders and France. However, both Rubens and Poussin still received decisive impulses from Italian sources. We may call the three successive phases which these masters represent the Early Baroque, the High Baroque, and the classicistic phase of the Baroque. A Late Baroque phase follows, in which the Louis XIV style makes itself felt, with the decorative lustre of French courtly taste. We have seen how Rembrandt responded to the main phases of this international development and how he adapted each one to his own ends. As for Caravaggio's influence, Rembrandt's grasp of the chiaroscuro device as a principal means of pictorial expression became a most decisive feature of his art from the very beginning. From Rubens he derived inspiration to treat dramatic themes on a large scale, full of High Baroque vigour and movement—this at least temporarily during the thirties.[3] There followed, in the forties and fifties, Rembrandt's contact with the international trend of classicism best represented by Poussin, which led the artist to greater simplicity, breadth, and solemnity, and to more tectonic and monumental compositions. Finally, at the end of Rembrandt's career, even a touch of the Louis XIV style may be detected in the colouristic brilliance and the allegorical flavour

of such works as the *Jewish Bride* in the Rijksmuseum or the *Family Portrait* in Brunswick.

While Rembrandt thus never lost contact with the broader trends of his period, it is always the powerful individual character of his art that outweighs its international aspects. Therefore, in the previous chapters, the distinctive, personal features have been stressed, rather than those which Rembrandt shared with his contemporaries. And these personal features, as we have observed, underwent certain changes from the first to the second half of Rembrandt's life. It was only later in his development that he departed more radically from the ideals of his time, and then only that his personality manifested its ultimate depth.

If we try to define some of the outstanding characteristics which distinguish Rembrandt from his contemporaries, we think perhaps first of his remarkable independence and his unusual urge to follow his own impulse in the choice of subject matter as well as in interpretation and treatment. Rembrandt was in this respect truly 'modern'—perhaps the first modern artist of this kind in history.[4] But Rembrandt's forceful individualism never took a completely arbitrary course; it maintained a firm foundation of universal significance. His spiritual tendency embraced all his subjects—portraiture, landscape, and Biblical painting alike—and since it was linked with an extraordinary human intimacy and empathy, Rembrandt's art comes closer to us than that of the international Baroque, with its more ostentatious character. It is true that the curious blend of the romantic with the realistic which often marks Rembrandt's work is a feature not uncommon in his time. But both these trends, with Rembrandt, were subject to his deep spiritual penetration and thus were relieved of undue theatricality or obviousness. As for his very spontaneous and highly personal technique, this never became an end in itself, but always served the expression of profound human content.

It would be interesting to know how far Rembrandt himself was conscious of his distinctive features, or what theory or opinions he might have formulated to express his own point of view, either in giving instruction to his pupils or in conversations with patrons, fellow artists, and others. Unfortunately we do not have in Rembrandt's case as revealing documents at our disposal as we do for Bernini,[5] Poussin,[6] or Rubens.[7] But there are a few records which, though meagre, are not without interest. These records show unmistakably that Rembrandt was opposed to the kind of theory which prevailed in the seventeenth century, particularly the latter half. Joachim von Sandrart complained (as others did also) that Rembrandt 'did not hesitate to oppose and contradict our rules of art, such as anatomy and the proportions of the human body, perspective and the usefulness of classical statues, Raphael's drawings and judicious pictorial disposition, and the academies which are so essential to our professions.' And he added, significantly, that Rembrandt, 'in doing so, alleged that one should be guided only by nature and by no other rules'.[8]

This principle of 'nature as the only guide' was obviously a basic point in Rembrandt's aesthetics, and by the term 'nature' he must have meant the totality of life as it appeared and appealed to him. (This same point had been the basic principle for Caravaggio, the greatest independent of the beginning of the century, in his defence against academic rules.)

Rembrandt seems to have demanded in addition, from his pupils, a love of nature. We derive this assumption from a conversation among three of Rembrandt's pupils, Carel Fabritius, Abraham Furnerius, and Samuel van Hoogstraten, reported by the last-named in his *Inleyding tot de Hooghe Schoole der Schilder Konst*.[9] Here we are told that the talent of a young artist depends not only upon his love of art but also upon his 'being in love with the task of representing the charms of nature.'[10] This emphasis upon an emotional approach, rather than a rational and aesthetic one such as contemporary art theories demanded, seems truly Rembrandtesque, if we extend the meaning of the term 'nature', as before, to the totality of life.

From the same conversation we learn that 'knowledge of the story' is characteristic of good historical painting. This, to be sure, was generally accepted, and no invention of Rembrandt's, but it sounds like a principle that he might have passed on to his pupils. His many religious subjects always show an intimate familiarity with the Biblical text as a basis for his profound interpretation.[11]

A final point in this recorded disputation among Rembrandt's pupils, is the question as to what is the first rule in good composition, and Carel Fabritius answers: 'to select and to organize the finest things in nature' (*de edelste natuerlijk-heden*). In both respects, selection as well as organization, Rembrandt's work always excelled. We cannot be so sure, however, that the term *edelste* was precisely the word used by Rembrandt. It has a classicistic connotation which Hoogstraten may have introduced in recording this conversation more than thirty years after his apprenticeship with Rembrandt, when he himself had become thoroughly imbued with the current classicistic aesthetics. He is probably again thinking of Rembrandt in another passage when he states that a good master ought to 'achieve unity in his composition', and subordinate the details to the whole. The passage goes on to mention the *Night Watch*, saying, 'Rembrandt, in his painting at the Doelen in Amsterdam, has brought this out very well, but many feel that he has gone too far.'[12]

A similar point is stressed by as authentic and direct a source as Sandrart, when he refers to Rembrandt's explicit demand for 'universal harmony' in his pictorial organization. Sandrart says that Rembrandt required of the dark accents, which partly obscured his outlines, 'nothing but the keeping together of the universal harmony'. And he adds, 'As regards this latter, he [Rembrandt] was excellent and knew not only how to depict the simplicity of nature accurately but also how to adorn it with natural vigour and powerful emphasis.'[13]

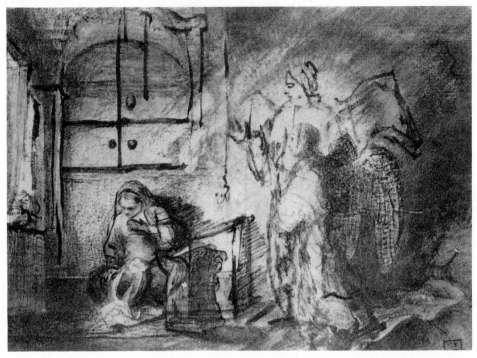

249. Rembrandt pupil (Constantyn à Renesse ?): Drawing corrected by Rembrandt.
THE ANNUNCIATION. Berlin, Print Room.

As for Rembrandt's method of teaching, we learn, from a number of drawings by his pupils, like the ones by Constantyn à Renesse reproduced here (figs. 249, 250), that the master often corrected their work by bringing in stronger accents, heightening the articulation as well as the coherence of their compositions—features which are in accord with the statements quoted above.[14]

Finally, there is evidence that Rembrandt demanded absolute independence for his artistic work, presumably for the whole process of creation from the choice of subject matter down to the finishing touches. When he was criticized for the bold and highly personal character of his technique, or his work was mistakenly considered careless or unfinished, he justified himself, according to Houbraken, by saying, 'A picture is completed when the master has achieved his intention by it.'[15]

These scattered contemporary records about Rembrandt's theoretical remarks do not, by any means, establish a full-fledged theory, but they show that he laid down certain basic points for himself and his pupils. These points reflect primarily the artist's defensive attitude against the current theories of academic classicism, as well as his strong desire to express himself fully and freely. But there is no insistence, in these records, upon a spiritual approach, so significant in Rembrandt's mature work, nor is there any demand for a spontaneous and personal form of artistic

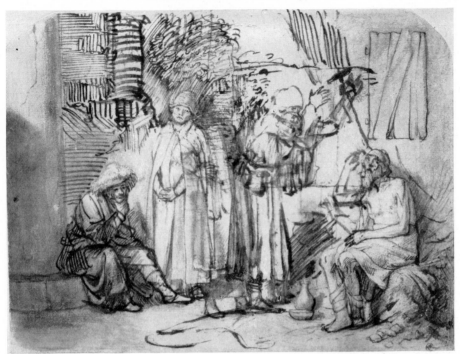

250. Rembrandt pupil (Constantyn à Renesse ?): Drawing corrected by Rembrandt.
JOB AND HIS FRIENDS. Stockholm, National Museum.

expression. These features were too much a part of his genius, too dependent upon his extraordinary sensibilities and creative powers to be transmitted to others by theories, or compressed into formulas.

In trying to reconstruct the judgement of his contemporaries on Rembrandt's art and personality, we are obliged to rely largely upon late seventeenth-century sources. These records reflect the decline of Rembrandt's reputation after an initial period of extreme popularity which lasted until the forties.[16] After the publication of van Mander's *Schilderboek* in Alkmaar in 1604, art criticism in Holland remained rather inactive until the later years of the century, when the theories of classicism began to overspread the Continent. By that time the Dutch, German, French, and Italian critics were expressing their opinions on Rembrandt's art in a fairly elaborate and professional form. Their source material was still authentic. Some of the writers, such as Sandrart, Hoogstraten, and de Lairesse, had known Rembrandt personally; others, like Baldinucci and Houbraken, had received direct information from Rembrandt's pupils, or, like Roger de Piles, had lived in Holland at a time when memories of the artist were still fresh. One feels something of a common judgement running through all their accounts, which vary only slightly in appreciation and criticism of Rembrandt's art. His extreme deviations from the standards

of classicism seem to have caused resentment, although his formidable genius commanded considerable respect.[17] Thus a curious mixture of admiration and sharp criticism resulted. We have seen this typical reaction in Sandrart's biography of Rembrandt. It is not very different with the others. The artist's extraordinary native gifts were admitted—his keen observation, his pictorial and colouristic power, the variety and vividness of expression in his figures, and last, but by no means least, his genius in graphic art. But equally strong was the censure for his outright 'naturalism', which did not shrink from ugly and vulgar types, from low-life motifs introduced even into the lofty realm of historical painting.[18] The rarity of classical subjects in Rembrandt's work was also criticized, and his neglect of clear draughtsmanship, which was thought to necessitate complete outlining. There was strong objection to the excessive darkness in his pictures. On the whole, the adverse criticism was directed at Rembrandt's violations of the classic ideals of linear and plastic clarity, of formal perfection and beauty, and nobility of taste. It is particularly interesting and revealing to realize how helpless Rembrandt's contemporaries were before the phenomenon of his introvert tendency—how they blamed him for his slow production and apparent indecision. Equally incomprehensible to them was Rembrandt's highly personal technique in his paintings, misinterpreted as unfinished and resulting from wilfulness and carelessness on his part. His drawings and etchings were to a certain degree exempted from this criticism, as we see from the appreciative remarks of Houbraken and others.[19]

What were the reasons that Rembrandt, from his early maturity, was so seriously misunderstood in his own century? Why did his contemporaries deplore his rebellious independence, which some believed was bound to lead to disaster?[20] Was this artist really such a lawbreaker, whose 'naturalism' was vulgar and indiscriminate, whose forceful and spontaneous individualism was irreconcilable with a spiritual discipline expressing an ideal of universal significance? Even in raising these questions we feel their absurdity. But seventeenth-century criticism was unable to furnish satisfactory answers, since a proper perspective on Rembrandt's art was barred by the prevailing classicistic views. The artist himself, with the exception of the few defensive formulas just mentioned, was averse to any more elaborate theorizing, which would have explained the very different spiritual basis of his art and shown the consistency of his attitude. This aversion to theorizing Rembrandt shared with the Dutch painters of his time. To all these artists nature was more important than rules, and none of them—Frans Hals, Vermeer, Ruisdael, Cuyp, nor Pieter de Hooch—have left any trace of a theoretical basis for their art. Neither do we find an adequate critical appreciation of their work in their own day. One may argue that their purely visual approach to nature was a quality peculiar to Dutch painting, and as such appreciated by their countrymen without the need of literary criticism. Huizinga points out in his fine study of Holland's seventeenth-

century culture[21] that the Dutch were comparatively inarticulate in their literary expression, while their visual perception and pictorial gift were on an extremely high level. In any case, the situation was such that Holland's writers and critics on art submitted readily to the rules of classicistic aesthetics as soon as these rules had become firmly established in Italy and France and began to sweep the Continent.

An understanding interpreter of the mature art of Rembrandt in his own day would have faced the difficult task of proving that here also a philosophy was implied—one which could compete with that of classicism but called for a very different artistic form. This philosophy put truth before beauty. But it was not only the obvious, visual truth of the physical world, but also, penetrating and conditioning it, the spiritual truth which had its roots in the Bible. Rembrandt dealt with man and nature. Both, in his conception, remain dependent upon the Supreme Force that brought them into being. Hence, even his landscapes are not self-sufficient pieces of nature separated from their source and reposing in their own beauty, as, for example, the classic *View of Delft* by Jan Vermeer. They are tied up with the creative process of all earthly life and subject to dynamic changes. There is no such thing, for him, as *nature morte*. Dead peacocks are combined in his still-life paintings with living persons. Rembrandt is unwilling to cut off anything from the continuous stream of creation—even a carcass, as we have seen in his *Slaughtered Ox*. In his figure subjects there is never a staged arrangement, of static finality, such as Poussin offers with great dignity and beauty. Rembrandt's people, wrapped in their own thoughts, are in communication, not with the outside world, like those of Rubens, Van Dyck, or Frans Hals, but with something within themselves that leads, at the same time, beyond themselves. Therefore, an introvert attitude, with Rembrandt, means the search for the spiritual force in man that conditions his life, its origin as well as its course. Man, so to speak, contemplates his state of dependence and accepts it in humility. Nature also is in this same state of dependence, but without knowing it. This puts man in a higher position, and makes him the most worthy subject for the painter. Rembrandt agrees here with Pascal's 'toute notre dignité consiste en la pensée'.

Since for Rembrandt the essence of truth about man and nature lies in the ultimate relationship of everything created to the Creator, he accepts all things, beautiful or not; their mere existence makes them worth while, as issuing from God. Forms, in his compositions, are not allowed to become too definite or to have any finality, since this would break their contact with the life process. If Rembrandt's chiaroscuro has any deeper purpose, it is this: to suggest, to keep alive these mysterious relationships, so true yet so impenetrable for the purely rational approach, so strongly felt by the artist's intuitive and religious mind, yet closed to the view of the aesthete and the classicist who insist upon beauty and a fully controlled

order. While Baroque 'naturalism' had nothing to oppose to the classical ideal save the imitation of nature, Rembrandt's art offered an interpretation of life and nature based upon religious concepts. In his art the classic and the Biblical worlds, in spite of a certain interpenetration, were no longer indiscriminately mixed, but the former became clearly subordinated to the latter. Thus, one of the oldest problems of Christian civilization was recognized again as a fundamental issue and answered with a new consistency and in a new form.

Small wonder that the consequences for Rembrandt's art were far-reaching. It was not only that he selected subjects of little interest to the classicists, if not excluded by them: namely, old, sick, or destitute people. In these subjects he discovered the spiritual substance for which the Bible cared most: the human soul in true humility or in sorest need of compassion and salvation. When, on the other hand, Rembrandt did deal with classical subjects, they were transplanted into a Christian world. His small scene of *Philemon and Baucis* (Br. 481), in the National Gallery in Washington, is bathed in a transcendent atmosphere not unlike that of a *Supper at Emmaus*.[22] His Homer, Aristotle, and Lucretia do not radiate the heroism and self-reliance, the grandeur and beauty, which the classic concept called for and Baroque naturalism had modified but not really transformed. In Rembrandt's hands the proud figures of the ancient world became humble human beings, bearing the stamp of suffering or old age but inwardly receptive and therefore open to divine mercy.

Just as Rembrandt's contemporaries did not fully comprehend the spiritual attitude implied in his art, they also failed to see the clear interdependence between his ideas and the form he chose for expressing them. Rembrandt was by no means totally opposed to classic art. We know from his inventory that he owned examples of ancient sculpture and that he admired the art of the great Renaissance masters. He derived motifs from Mantegna, Leonardo, Raphael, Dürer, and Lucas van Leyden. The Venetians exerted a considerable influence upon his style.[23] We have seen that for his own ends Rembrandt employed certain characteristic features of Renaissance art, such as simplicity, breadth, and solemnity, as well as its tectonic and monumental qualities. But other features fundamental to the classic conception were unacceptable to him.

'Clarity', to the classicist, meant a complete plastic representation of tangible objects, with no break in their contours, and set within a rationally constructed space. Rembrandt had little use for this kind of clarity, which brought the visible world under a firm control, but excluded any uncertainty and mystery—those intangible elements that were vital to his viewpoint. Rembrandt used both light and shadow in a far more subjective fashion, not primarily to define form, but for their suggestive and evocative qualities. Outlines are broken; they are only partly visible, partly obscured. Space takes on a less geometric character, with less tangible

limitations, but suggesting an imperceptible transition from the finite to the infinite. Along with light and dark, colour too gains a new symbolical significance, and a vibrating atmosphere pervades the whole picture, heightening the interdependence of all parts and preventing forms and surfaces from becoming isolated or over-distinct.

Rembrandt's concept of 'unity' also differed from that of the classicists. His was a more marked subordination of the individual forms and figures to the comprehensive elements of space, atmosphere, and chiaroscuro, and this symbolized a religious rather than a rational attitude. It replaced the anthropocentric point of view by the concept of man's submission to the spiritual forces of the universe. Compositional 'unity', as Rembrandt understood it, was therefore basically different from the concept of unity of a Poussin who demanded for each part its own separate and complete entity. It is true that in these respects (concept of clarity, concept of unity, departure from the anthropocentric viewpoint) Rembrandt was a Baroque master,[24] but he went beyond the typical Baroque attitude in deepening the function and the significance of these features. His pupils were able to follow him only to a certain degree. Their formal powers were limited and none of them could approach him in the expression of content.

But Rembrandt was not alone in his time in adopting a spiritual attitude that harked back to fundamental Biblical concepts. Two other independents and, like Rembrandt, two of the greatest men of the century, took this course in opposition to the dominating rational and humanistic trend: Milton and Pascal. Science as an unlimited field for man's searching mind is repudiated in *Paradise Lost*, when the Archangel Raphael and Adam discuss astronomical problems. 'Adam is exhorted to search rather things more worthy of knowledge', as the argument of Book VIII puts it.

> Whether the Sun predominant in Heav'n
> Rise on the Earth, or Earth rise on the Sun . . .
> Solicit not thy thoughts with matters hid,
> Leave them to God alone.

In *Paradise Regained*[25] the aged and lonely Milton, with all his background of classical studies, proceeded to characterize classic thought and culture as the most subtle weapon of Satan, the last resort, as it were, in Satan's attempts to corrupt the purity of Christ's ideas.

And out of his profound faith Blaise Pascal, the great mathematician and thinker, who had absorbed the wisdom of classic philosophy, reached a similar stand. In resisting the infringement of reason upon faith, Pascal put the realm of the heart into its own place at the side of the realm of the mind. 'Le coeur a ses raisons que la raison ne connaît point: on le sait en mille choses.' 'C'est le coeur qui sent Dieu, et non la raison.' These and many more passages in Pascal's *Pensées* strike a note

congenial to Rembrandt, although most of official France, and certainly Pascal's compatriot Poussin, took an opposite attitude.

> S'il n'y avait point d'obscurité, l'homme ne sentirait point sa corruption; s'il n'y avait point de lumière, l'homme n'espérerait point de remède. Ainsi, il est non seulement juste, mais utile pour nous, que Dieu soit caché en partie, et découvert en partie, puisqu'il est également dangereux à l'homme de connaître Dieu sans connaître sa misère, et de connaître sa misère sans connaître Dieu.[26]

With this comparison of Rembrandt, Milton, and Pascal we have touched only briefly upon the significant position of three great minds in this controversial century. Each of these men became more or less isolated in his own country, and what they stood for was swept aside by the leading intellectual and artistic trends which lined up with the newly consolidated forces of society, church, and state. Rembrandt's art left hardly a trace in Holland for generations to follow.

In trying to define more closely this much disputed place of Rembrandt in seventeenth-century Holland, it will be of particular interest to listen first to the opinions of two distinguished Dutch scholars: Frederik Schmidt-Degener, the art historian, and Johan Huizinga, the historian of culture. In a brilliant essay on 'Rembrandt and Vondel'[27] Schmidt-Degener contrasts the painter and the poet. Vondel is to him the typical representative of the Dutch Baroque which had its roots in Flanders rather than Holland and is characterized by a rhetorical and pictorial splendour. Official Holland, this author holds, always took the side of Flemish pompousness instead of recognizing the true representatives of Dutch character who were modest and reserved and tended to withdraw into themselves.[28] Schmidt-Degener's essay concludes with the statement that the mature Rembrandt not only resisted Baroque tendencies but was on the point of rescuing the great tradition of the Italian Cinquecento from the Baroque trend; that he therefore represents the last of the great Renaissance artists of universal significance, and that it was his official rejection as a monumental painter for the Town Hall of Amsterdam which robbed him of the opportunity to show himself as Raphael's true successor.[29]

Huizinga, in his penetrating study of the Dutch culture of the seventeenth century,[30] sees the best qualities of Dutch art in its unpretentious and sincere rendering of reality, but stresses its limitations both in style and form. According to him Rembrandt was a Romanticist who tried to depict an imaginary world in order to escape the narrowness of his actual surroundings. Thus the artist strove to rival the grandeur of the Baroque but was doomed to fail because of the general weakness of Dutch art on the formal side (*Schwäche des Formgefühls*). Only on a small scale, in graphic art, does he consider that Rembrandt was really successful.

It is clearly evident that these two authors contradict each other. Where, then, lies the truth? Huizinga we believe goes too far in assuming a continuous Baroque

tendency as the leading one in Rembrandt's art. We have seen that his work shows a decided change from a Baroque phase in the early part of his career to a style that was closer to classic art yet remained markedly divergent from it. While agreeing with Huizinga that Rembrandt strove to represent an imaginary world since the visual reality around him did not satisfy his creative fancy, we know that he turned from this to a deeper perception of man's inner life, in which the romantic aspect became subordinated to a spiritual tendency.

On the other hand, we feel that Schmidt-Degener, who is well aware of Rembrandt's development in all its phases and has high praise for his artistic achievement, relates the artist's mature style too closely to the Renaissance tradition. He could have reached this conclusion only by overlooking the fundamental difference which exists between Rembrandt's spiritual world and the classic one. It was this difference, as we have tried to show, which necessitated a very different artistic form, and which conditioned the unclassical features in Rembrandt's late work. Schmidt-Degener may not have admitted this difference as a fundamental one. In fact, he interprets Rembrandt's religious art in the tradition of nineteenth-century humanitarianism,[31] and sees the artist, accordingly, as a forerunner of Jean-Jacques Rousseau and Ernest Renan. One might argue that Rembrandt's art was broad enough to allow this interpretation, and that, by his strong humanization of the Biblical world, the great Dutch master paved the way for the purely humanitarian concept of later centuries. But such an assumption draws Rembrandt too far from the centre of his spiritual world and thus means a distortion of historical reality. It is true that Rembrandt was unique in his integration of the actual with the Biblical world, but with him this never deprived the Bible of its transcendental content.

We have seen that Rembrandt shared many features with his own countrymen. The Dutch painters in general showed a considerable independence of classicism up to the beginning of the Louis XIV period. Like Rembrandt, they accepted nature, rather than academic rules, as their principal guide. Pictorial intimacy and an individual touch characterized their art as well as his. But we know that the typical Dutch painters' notion of nature was limited to the external aspect of life. We have also referred to another limitation which set them apart from Rembrandt: the common Dutch practice of concentrating upon a single category, whether portraiture or genre, landscape, still life, or architectural scenes—not to mention even narrower subdivisions. To Rembrandt this kind of specialization was unthinkable. He brought to each category he dealt with the broader and deeper spirit which characterized his entire outlook, and which raised his art far above a national level.

STYLE AND TECHNIQUE[1]

PAINTING

THE general reader may be reluctant to follow into this last chapter, since the words 'style and technique', when taken apart from the whole context of works of art, may have a chilling sound. But the art historian cannot pass over considerations of this kind if he aims for full clarification of his subject. The investigation of artistic style has been practised now for several generations and has shown progress in surety of method—especially since the example of Wölfflin[1a]—though not always in competence of judgement. The strictly technical investigation on scientific grounds is a more recent approach. In the Rembrandt field we owe valuable findings to such experts as Doerner,[2] Laurie,[3] Hell,[4] and others.[5]

Style and technique are interdependent and as long as one of these factors is not clearly recognized in all its parts, something is missing in our knowledge. It is true that one can enjoy Rembrandt's art and respond to both its content and form, without possessing specific information on every technical detail. Even if we cannot tell definitely whether Rembrandt used for his impasto a white lead that was prepared with a thickened solution of dammar in turpentine or with a little egg added to the oil while grinding the pigments, we may still have access to the appreciation and understanding of his art. On the other hand, there is a meaning in the master's choice of materials. They were intended to fulfil a function in the whole artistic plan, and the more we know about these materials and their use, the more complete will be our understanding. Within the framework of this book it may be sufficient to touch upon only a few outstanding aspects of Rembrandt's style and technique, particularly those which the analysis of single works has brought to the fore. These aspects are, in painting, the chiaroscuro, the colouristic treatment, and the brushwork; in etching and drawing, again the chiaroscuro, but this time with a difference, and the technical means chosen.

The word 'chiaroscuro' is a composite of the Italian *chiaro* ('light' or 'bright') and *oscuro* ('dark'), and it means: primary emphasis on light and dark as a means of pictorial organization and expression. One may speak of a chiaroscuro effect even with van Eyck and his followers, later with Leonardo and Correggio. But only the Venetian School, under the leadership of Titian, raised this device to a dominating role. Titian's forerunners, Antonello da Messina and Giorgione, had already prepared this development through their emphasis on contrast of values in colouristic design. In the Early Baroque Caravaggio became the initiator and the banner-bearer of a powerful chiaroscuro movement which soon swept all of Europe. Even

251. Caravaggio (?): ST. JEROME. Rome, Borghese Gallery. Oil on canvas (112 × 157)

such outright colourists as Rubens and Poussin could not in their youth escape the influence of the great Lombard painter.

According to Bellori, Caravaggio 'invented a manner of putting his figures in the brown air of a closed room, putting a light up high which fell directly on the principal part of the body, leaving the rest in shadow so as to get strength from a violent opposition of light and shade'.[6] Such a naturalistic and dramatic chiaroscuro is seen in Caravaggio's *St. Jerome* of the Borghese Gallery (fig. 251).[7] This might be compared with an early Rembrandt of a similar subject, the *St. Paul in Prison*, 1627, in Stuttgart (fig. 252), in order to bring out Rembrandt's dependence upon the original Caravaggio style as well as his deviations from it. The young Leyden artist has not changed the basic principles. He, too, has tried to exploit the opposition of light and dark for naturalistic and dramatic purposes. But he differentiates and broadens the function of this pictorial device. To begin with, the light is more diffused and has lost something of its harsh intensity. In this case it is daylight. A sunbeam breaks into the prison cell and casts a vivid reflection on the wall against which the old apostle's head is effectively set. In contradistinction to the Caravaggio there is no sharp separation between the light and dark areas. They are interpenetrating, and show a fluctuating borderline. The light plays over all surfaces with subtle gradations, accentuating texture and form but also revealing the depth of space. The

252. ST. PAUL IN PRISON. 1627. Stuttgart, State Gallery. Oil on panel (72·8 × 60·3)

glossy surfaces remind one of Lastman, but the youthful Rembrandt surpasses his teacher in the rendering of atmosphere and reflected light.

Lastman was not the only source for the young Rembrandt's Caravaggiesque tendency. It may be traced also to his contacts with the School of Utrecht, particularly with the art of Gerard van Honthorst.[8] This painter (1590–1656) had spent his formative years in Italy, where he had early gained a reputation for his representations of nocturnal genre scenes with artificial lighting (fig. 253) and acquired the nickname of Gherardo della Notte. His stock device was a vivid contrast between a dark foreground form which covered the source of light, and the reflection of the candlelight on the surrounding figures and faces. These two features, the *repoussoir* effect of a dark form in the foreground and lively rendering of the light reflections,

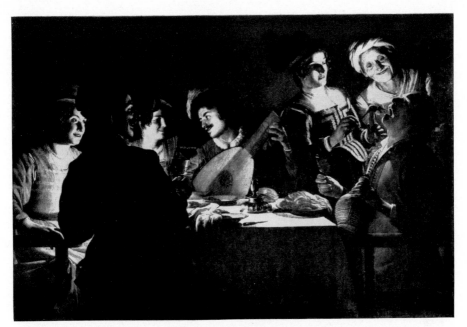

253. Gerard van Honthorst: A SUPPER PARTY. 1620. Florence, Uffizi.
Oil on canvas (138 × 204)

254. THE MONEY-CHANGER. 1627. Berlin-Dahlem, Staatliche Museen.
Oil on panel (32 × 42)

255. THE YOUNG REMBRANDT IN HIS STUDIO. Boston, Museum of Fine Arts.
Oil on panel (25 × 32)

Rembrandt took over, as one may see in his *Money-changer* of 1627, in Berlin (fig. 254). Here again the younger artist has expanded the function of the chiaroscuro by a richer and more intimate pictorial gradation. Through the indication of atmosphere he has made the spatial impression more coherent. The subordination of local colours to a more uniform tonality adds to this effect.[8a]

In the *Money-changer* as well as in the *St. Paul* one can already detect the new function of Rembrandt's chiaroscuro in the extension of the light and dark accents from tangible to intangible things. Voids as well as solids are emphasized; space gains an expressive life, and becomes an inseparable part of the figures' existence. It echoes their moods by the flexible and suggestive play of light and shade. Thus we may say that from the beginning Rembrandt's excitable imagination was stirred by the evocative qualities of shadows as well as by the revealing nature of light. For him, a cast shadow on the ground, a floating patch of darkness on a wall, a beam of daylight in a dim room, the glitter of metal within dusky half tones, were more than naturalistic phenomena. He seems to have felt that light and dark are magic elements which the painter can employ to veil or to reveal, to create drama and mood, to open the spectator's mind to unknown depths of vision and feeling.

We are not surprised, therefore, to find Rembrandt, even in his youth, marking

256. JEREMIAH LAMENTING THE DESTRUCTION OF JERUSALEM. 1630.
Amsterdam, Rijksmuseum. Oil on panel (58 × 46)

out an unusually wide range of pictorial and psychological expression by means of chiaroscuro. In the little painting in Boston showing the artist standing in his studio before an easel (fig. 255) we are struck by the boldness with which the mighty, dark form of the easel is placed in the immediate foreground as a dramatic *repoussoir* for the small figure of the painter. This daring accent almost throws the picture out of balance, yet the pictorial and psychological interest in the figure is maintained sufficiently to prevent the composition from tilting over. In contrast, a picture like the *Jeremiah Lamenting the Destruction of Jerusalem*, of 1630, now in Amsterdam (fig. 256), relies more on the refinement and subtlety of its chiaroscuro effect. The

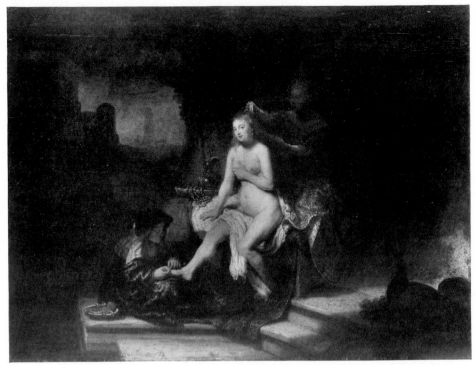

257. BATHSHEBA AT HER TOILET. 1643. New York, Metropolitan Museum.
Oil on panel (62 × 81)

old prophet's figure is placed between the dark and the light, and his brocaded tunic as well as the embroidered drapery and the silver vessels beside him glitter with precious highlights and a minuteness of touch that recalls van Eyck's paintings.

We have already seen the further development of Rembrandt's chiaroscuro in each of his main subjects. Therefore, a brief summing up may be sufficient here. While the *Night Watch*, with its powerful chiaroscuro display, is still related to the style of the thirties, it shows also a high degree of airiness and transparency in its articulate spaciousness. This latter feature is characteristic of the forties, and comes in as a result of Rembrandt's studies of landscape. As the charming *Bathsheba* of 1643, in the Metropolitan Museum (fig. 257), may illustrate, such airy transparency now extends to all parts of the picture. The contrasts are softened in the interest of a milder harmony and a blond luminous tonality prevails. Refinement and breadth of touch hold a pleasant balance. Rembrandt has avoided any dramatic intensification of contrasts for the sake of harmonious tonal unification.

Once this unity was established, Rembrandt progressed, in the later forties, to a new reinforcement of accents, while retaining the soft quality. *Christ and the Woman of Samaria* of 1655, in Berlin (fig. 258), may serve as an example of this enriched and colourful chiaroscuro in Rembrandt's mature work. The middle values no

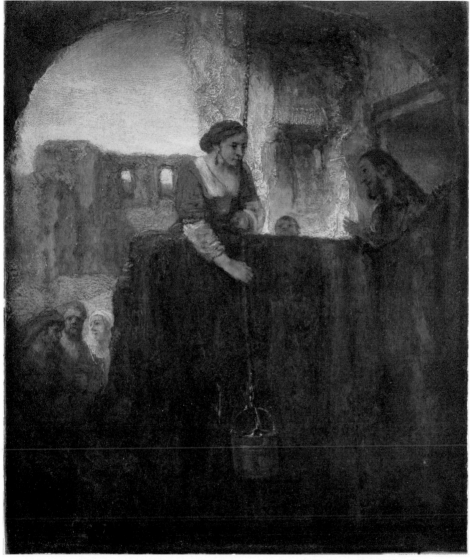

258. CHRIST AND THE WOMAN OF SAMARIA. 1655. Berlin-Dahlem, Staatliche Museen.
Oil on panel (46·5 × 39)

longer dominate. Deepened darks and intensified lights are vigorously set against
each other, but without any harsh transitions. The darks have gained a velvety
quality, the light a vibrating impasto, and the middle tones are given more life
through broader touches and greater variation. Rembrandt is now bolder and more
selective in his choice of light and dark accents and exploits to the utmost the
evocative power of the chiaroscuro device. The shadowed form of Christ, appearing
at the right upper corner behind the dark well, could hardly be less conspicuous.

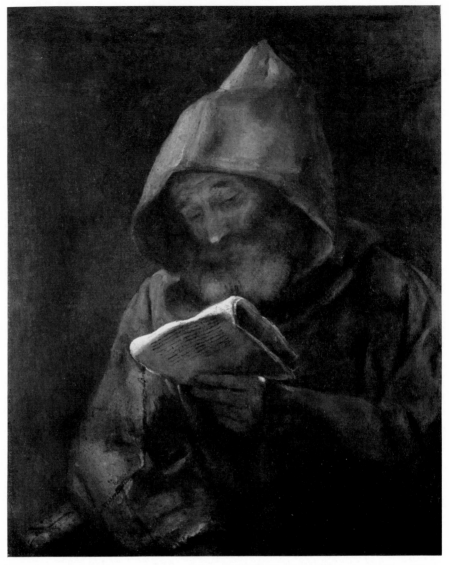

259. CAPUCHIN MONK READING. 1661. Helsinki, Museum. Oil on canvas (82 × 66)

And yet, due to the expressive distribution of light and dark, the spectator is made to feel the weight of His mystical power, as does the woman placed so dramatically, by both colour and value accents, at the focus of the composition.

While it is right to say that in many of Rembrandt's late paintings the chiaroscuro gains both in strength and richness, the artist has not always relied upon forceful value contrasts. He has sometimes given all emphasis to the luminous animation of the middle values, as seen in the *Capuchin Monk Reading*, of 1661, in the Museum in Helsinki (fig. 259). Here it is the monk's greyish brown garment and hood which

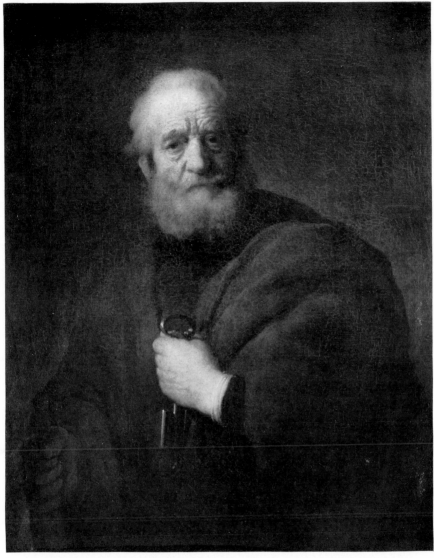

260. ST. PETER. 1632. Stockholm, National Museum. Oil on canvas (72 × 54)

come to life by subdued reflections. The narrow highlighted edge of the manuscript which he holds is needed to establish the whole gamut of values from the front plane to the more distant darks. The pictorial attraction here lies primarily in the phenomenon of reflected light and, in spite of its limited value range, the painting has a mysterious pictorial life in space. The Rembrandt of the thirties was not yet ready to exploit the chiaroscuro device for such magic effects. The *St. Peter* of 1632, in Stockholm (fig. 260), may illustrate how the young artist used the illumination of face and hand to emphasize the plasticity of form rather than to integrate

261. OLD WOMAN CUTTING HER FINGERNAILS. New York, Metropolitan Museum.
Oil on canvas (126 × 102)

it with an expressive general atmosphere. To be sure, form is not neglected in the later work; it even seems to have a more powerful existence, but it is built into a comprehensive pictorial concept.

Rembrandt rarely failed to exploit his chiaroscuro for the focusing of interest and for the clear spatial articulation of his compositions. The *Old Woman Cutting Her Fingernails*, 1648, in the Metropolitan Museum (fig. 261), is a striking work of Rembrandt's early maturity which brings out these qualities.[8b] Through the proper

262. Nicolaes Maes: GIRL PEELING APPLES. New York, Metropolitan Museum.
Oil on panel (54·6 × 45·7)

placing of value accents he has created a clear succession of planes in every part of the figure, and focuses our attention on the woman's action. A comparison of this painting with Nicolaes Maes's *Young Girl Peeling Apples*, hanging nearby in the Metropolitan Museum (fig. 262), makes it obvious how, in the pupil's picture, the three-dimensional aspect of the subject is full of weak spots. His value contrasts are harsh and sudden, lacking the finer transitions that guide the eye so smoothly in the Rembrandt from one plane to another. The placement of the hands and the spatial

relationship between head, hands, and knees in the two figures may be compared to show Rembrandt's superiority in adjusting each value to the adjacent areas in order to bring out a clear definition of forms as well as an expressive and coherent design. Such considerations as these can often help in distinguishing between work of the master's own hand and that of his followers who, as a rule, were unable to adapt his chiaroscuro in its full range and in all its functions.

The importance of colour in Rembrandt's painting is easily underestimated because of its close integration with the chiaroscuro. The Dutch master has been more often called a 'chiaroscurist' than a 'colourist'.[9] But once one has seen late works such as the *Jewish Bride*, the *Return of the Prodigal Son*, or the *Family Portrait* in Brunswick, with their fiery reds and the rich interplay of the accompanying tones, one hesitates to accept this classification. In these paintings Rembrandt is a colourist of extraordinary boldness and expressiveness, rivalling if not surpassing Rubens and Velazquez in their mature works. What is the reason for this late outburst after so long a development in which colour was usually subdued or, at the most, co-ordinated to the chiaroscuro effect? Was it Rembrandt's contact with Venetian painting, particularly that of Titian, which produced this surprising result? Or was it the artist's long restraint which accounts for the explosive character of his late colourism? If we look closer, and bring back to mind the whole of Rembrandt's work, we shall find that the colourism in his late paintings was not quite as sudden as it may appear under the first impact of the above-mentioned examples. In fact, Rembrandt's career repeatedly shows bold colouristic advances which prepared the ground for this glorious finale. The *Night Watch* was one of them. Here, as in the *Sacrifice of Manoah* of the same years, a vigorous colouristic effect first stood out from the general chiaroscuro, but with the two features, colour and chiaroscuro, not yet as softly integrated as in the late period. It was from this time on that a strong red-yellow accord became prominent, and the general tonality took a decisive turn from the cool to the warm side of the colour circle.

During the Leyden period a delicate cool tonality had prevailed, with discreet pale harmonies of yellow and light blue, pink or violet, apple green or light olive. The backgrounds were more greyish than brownish. In the course of the thirties the cool colours began to recede. Copper red, gold yellow, gold olive, and a warmer greyish brown appeared in larger quantities, often contrasted with fairly intense blue and blue-green (the *Blinding of Samson, Danaë*). While the warm tones slowly began to predominate, they did not all at once attain a higher intensity, and the colourism remained restrained and delicate.

The increasing harmony in the paintings of the forties was due as much to the warming up of the neutral tones, from grey and ochre to golden brown, as it was to the growing transparency and airiness which we have mentioned as resulting from Rembrandt's extensive landscape studies of that time. This attractive golden blond

tonality of his middle period coincided with the monochrome value painting in contemporary Dutch landscape, especially in the work of van Goyen and the early Cuyp, both of whom favoured a warm tonality. The intense red-yellow accord which made its first appearance in the *Night Watch* and the *Sacrifice of Manoah* occurred more frequently in the later forties (the *Holy Family* in Leningrad, *Susanna* in Berlin), accompanied by a deeper contrast of the neutrals. Blue, pink, and light olive are no longer found in any quantity but still enliven the play of colour in the middle values (landscapes).

There is no basic change to be seen in the colourism of the early fifties. The red-gold accord, however, is enriched and gains a softer harmony (*Self-portrait* from the Widener Collection); cool and warm tones interplay with more force. The neutrals also gain an added strength through the contrasts of white and black which are now well integrated with the colouristic harmony. A velvety depth develops in the shadows and a vibrating surface quality in the lights. Spots of interspersed black begin to heighten the colouristic intensity while linking it with the chiaroscuro. Sometimes a rich gold (the *Man with the Gilt Helmet*, *Aristotle*), set against a deep dark or a straight black, may be the principal attraction. In the landscapes small touches of red and blue, pink and olive green brighten the warm brown of the whole and add a colourful sparkle.

Once Rembrandt's palette had gained this warmth and intensity, in the later forties and during the early fifties, it seemed that for a time many Dutch painters were drawn into this course, so great was the impact of Rembrandt's personal style. Thus, during these years, Nicolaes Maes came out as a successful genre painter, ardently taking up Rembrandt's warm colourism, with a favoured red-yellow accord built into a forceful chiaroscuro. He, in turn, influenced Pieter de Hooch and the young Vermeer, until Carel Fabritius, another Rembrandt pupil of the forties and perhaps the most original one the master ever had, abandoned Rembrandt's chiaroscuro and warm harmonies for a silvery, cool daylight tonality with lightened backgrounds. By this move Fabritius set the stage for the classic phase of the Delft School of genre painting, in which Vermeer became most famous for his fine, cool harmonies of silvery blue and lemon yellow. Pieter de Hooch wavered for some time between the warm and dark glow of Rembrandt's colourism and Vermeer's cool brightness, often combining the two tendencies with extraordinary success. Metsu, too, seems to have been at times undecided, but had most fortunate moments. It is altogether remarkable how Rembrandt's colour and chiaroscuro during this decade impressed some of the most gifted younger artists, until the opposite tendency won out because of its greater appeal to contemporary taste. The bright, pleasing, and cool tonality of Van Dyck's English portraits came more and more into fashion, and a similar colouristic taste was brought in by the classicism coming from Italy and France.

In the late fifties and even more in the sixties, when Rembrandt had lost his in-fluential position in Dutch art, his warm harmonies still show a gain in intensity and power (*Hendrickje*, Berlin; *Self-portrait*, Frick Collection). Also the black and white contrast adds force to this accord (the *Syndics*). The deepening of both intensity and warmth is accompanied by an ever-increasing breadth and richness of treat-ment. The colour seems to emerge from the depth of space and to fluctuate, rather than to define surfaces. There are still a good many paintings of a more monochrome character, but the neutrals now seem to glow with colour value and, in spite of their limited range, reveal an unusual depth and richness.

We have seen how some of Rembrandt's latest and most important works bring his colouristic development to its absolute height, whether he sets a fiery scarlet against a gold olive (*Jewish Bride*) or against a yellowish ochre (the *Return of the Prodigal Son*), or adds as secondary colours a palette of salmon pink and pale blue, dull yellow and blue-green (*Family Portrait*). In these paintings he not only rivals the Louis XIV splendour, he surpasses it by the phosphorescent, almost magical quality of his colours. They seem to flare up, more than ever before, from an unfathomable depth, and to fluctuate before our eyes. The vibrancy and the blend-ing with neighbouring tones dematerialize their plastic function and suggest a world filled with intangible values.

As in his colourism, so in his brushwork Rembrandt reached rather late in life an extraordinary boldness and power such as few artists have attained. A certain wilful originality and flexibility characterize his technique from the beginning. But these features came to the fore only gradually, until finally the painter was able to combine an unprecedented spontaneity of touch with a highly complex pictorial organization.

Rembrandt's contemporaries were sometimes dismayed by the daring of his technique or ridiculed his unusual impasto as a wild smear. But there were also voices which spoke in appreciation of his technical genius. The only pupil of Rem-brandt's late years who could follow his master with considerable skill and under-standing was Aert de Gelder. Houbraken, in his description of de Gelder's life, makes some remarks on this artist's technique which could as well be taken for a characterization of Rembrandt's advanced method of painting. After mentioning how Aert de Gelder adopted his master's practice of surrounding himself with picturesque material such as costumes and draperies, weapons and armour, with which he decorated his workshop, Houbraken goes on to say: 'This rich store he used for his paintings, and he also had the habit of dressing up his jointed mannikin from head to toe, and in such a state to move it about as he needed, whereupon he would copy it with the brush or with his thumb and finger. Sometimes when, for example, he wanted to paint fringe or a brocaded border on a garment, he would also smear the colours on to his canvas or panel with a broad palette knife, and then

263. CHRIST AND THE WOMAN OF SAMARIA. Detail. 1655. New York, Metropolitan Museum. Oil on panel (61·5 × 49·5)

scrape out the pattern of the border or the threads of the fringe with the handle of his brush, and he rejected no means that could serve his purpose. And it is astonishing how natural and forceful this often looked, at some distance.'[10]

There can be no doubt that these technical peculiarities of de Gelder were derived from Rembrandt. A characteristic touch such as the scratching through the wet paint with a blunt point or the end of the brush occurs very early in Rembrandt's work. It is part of a general tendency to interrelate the various layers of paint and to mould the surface with all possible means, from the height of the impasto down to the ground of the canvas or panel. Thus Rembrandt creates an up-and-down movement in the relief of the paint, which steadily increases in richness, complexity and fluidity. His impasto is never put on evenly.[11] In his late period, when it is thickest, it also has a floating quality. The artist drags it across the dark colour

264. LUCRETIA. Minneapolis, Institute of Arts. Detail from fig. 246

below, he breaks its edges, or thins it out with the brush or spatula. Sometimes he spreads the impasto interruptedly over a darker area with a half-covering effect.[12] Like Titian in his late work, Rembrandt combines most flexibly a bold impasto with a subtle glazing technique. This technique provides the translucent shadows on top of the light passages or softens the edges of the dark shadows. The latter are often left uncovered. This open interplay of the various layers, as well as the richness and variety of touch are characteristic aspects of Rembrandt's late technique.

While the older Rembrandt shows in these many ways a close relationship to Titian, the early Rembrandt, with his use of fine glazes, frequently reminds us of the refinement of Flemish primitives. 'The painter,' says Laurie,[13] 'who was to become the greatest master of suggestion rather than of smooth and accurate representation, began by training himself to reproduce with minute and delicate finish the object before him' (the *Rape of Proserpina*, the *Money-changer*). Such reminiscences of early Flemish refinement are still noticeable in the early forties (*Bathsheba*, Metropolitan Museum), but they disappear with the artist's decisive broadening of his technique toward the end of that decade. Laurie has rightly observed that the vivid up-and-down movement in Rembrandt's painting surface serves the primary purpose of modelling the form. One might add that the steadily growing richness of tonal play and vibration on the surfaces does not lessen, but rather heightens, the suggestion of three-dimensionality. In other words, Rembrandt's technique progresses from the description to the suggestion of form with an increasing pictorial animation. Perhaps this evolution was comparatively slow because of the comprehensiveness and complexity of his formal aspirations.

A comparison with Frans Hals in this respect is illuminating. Hals's brilliant impressionistic technique was fully developed in the twenties and one may wonder why the young Rembrandt did not come at once under the influence of this most spirited painter of the preceding generation. The reason was probably that Rembrandt in his youth felt the need to gain first a thorough grasp of three-dimensional form, before he could go into brilliant surface animation.[14] In fact, whenever we compare Rembrandt and Frans Hals, the young artist is found to surpass the older one in plastic intensity and spatial depth, while remaining behind—at least in his early work—in the spirited freedom of brushwork. Later Rembrandt outstrips the Haarlem master in flexibility of treatment, in the variety of touch, and in the richer interpenetration of tones. By then, Rembrandt's technique (figs. 263, 264) has not only a wider range of accents from the most powerful impasto to the subtlest glazing, but it also keeps more open and transparent in the interplay of the successive layers. There is an up-and-down movement from the surface into the depth of the picture which Frans Hals's painting does not have. His fluid, zigzag touches seem rather to glide along the surface. In his work, therefore, figure and space are not as convincingly related as in Rembrandt's. The remark of the painter, Max Liebermann—'Whenever I see a Frans Hals, I feel the desire to paint; but when I see a Rembrandt, I want to give it up'—is a clear indication that Rembrandt's technique embraced many more aspects than a gifted Impressionist was able to grasp.

When it comes to questions of authenticity, one is well advised to give full consideration to both style and technique. Only if the technique fulfils the stylistic function which it serves in the master's authentic works, can we be convinced about

265. PORTRAIT OF NICOLAES RUTS. Detail. 1631. New York, Frick Collection.
Oil on panel (120 × 90)

the originality of a painting. For such an investigation appropriately chosen details
are often as revealing as the whole work. Thus, in the head of an authentic early
portrait in the Frick Collection (fig. 265) we see a characteristic technical manipu-
lation which achieves a powerful modelling along with a forceful effect of chiaro-
scuro. The plastic quality is considerably softened, yet the tonal play is enriched in

266. PORTRAIT OF A MAN WITH A MAGNIFYING GLASS. New York, Metropolitan Museum.
Detail from fig. 75

the late head of the *Man with a Magnifying Glass*, in the Metropolitan Museum (fig. 266). Here a fluid impasto technique fuses the three-dimensional quality with a vibrant painterly impression which provides a veil of atmosphere in front of the form; the appeal to our sense of touch is lessened in the interest of pictorial animation.

267. ST. BARTHOLOMEW. Detail. Worcester, Massachusetts, Art Museum.
Oil on panel (63·2 × 47·6)

Two comparisons of an original Rembrandt, first with a contemporary copy, then with a pupil's work, may prove that a follower cannot apply Rembrandt's technique with the same full results as the master himself, early or late. The *St. Bartholomew* in the Worcester Art Museum (fig. 267) is juxtaposed with a contemporary copy from the Friedsam Estate (fig. 268) which in the Rembrandt literature figures as an

268. Pupil's copy: ST. BARTHOLOMEW. Detail. New York, Friedsam Estate.
Oil on canvas (74 × 54·5)

original. A comparison of the two heads shows at once how much of the plastic quality is lost by a manipulation of the brush that imitates Rembrandt's strokes but loses control of their modelling function. The transitional tones, so essential for bringing out the modelling in its full range, are gone and the face has become much flatter in detail and harsher in its value contrasts.

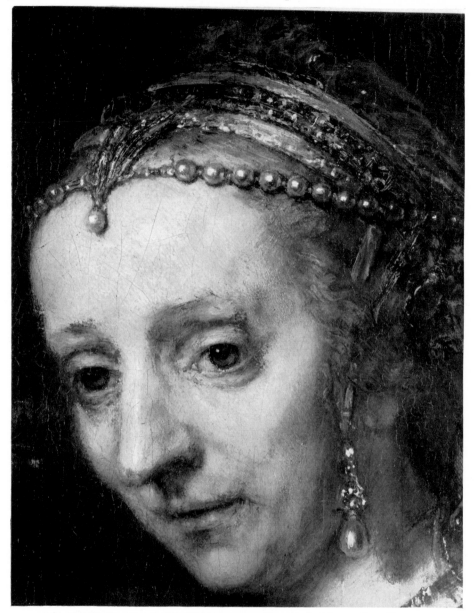

269. PORTRAIT OF A LADY WITH A PINK. New York, Metropolitan Museum.
Detail from fig. 76

The comparison of details of the head of the *Lady with a Pink* (fig. 269) and the so-called *Sibyl* (fig. 270), both in the Metropolitan Museum, is also revealing. Here we have a pupil—Valentiner suggested Drost[15]—imitating Rembrandt's late, bold impasto technique, yet his rather loose splashes of paint fail to suggest any substantial form. The treatment of the jewellery and the headdress in the two cases is,

270. Rembrandt pupil (Willem Drost?): THE SIBYL. Detail. New York, Metropolitan Museum. Oil on canvas (96 × 76)

indeed, most instructive for any student who wishes to learn the difference between the hand of a master and a weaker follower. Unless one watches constantly for the fundamental qualities of Rembrandt's authentic work, and tries to realize the full interrelationship between technique and style, one can easily be deceived by a certain dashiness of stroke and apparent brilliance of painterly treatment.

ETCHING

'Wherein this artist truly distinguished himself was in a certain most bizarre manner which he invented for etching on copper plates. This manner too was entirely his own, neither used by others nor seen again; with certain scratches of varying strength and irregular and isolated strokes, he produced a deep chiaroscuro of great strength . . . And truth to tell, in this particular branch of engraving Rembrandt was much more highly esteemed by the professors of art than in painting, in which it seems he had exceptional luck rather than merit.'[16]

This statement of Baldinucci's reflects the international reputation which Rembrandt's etchings enjoyed even during the artist's lifetime. The same point was made clear by the letter which Guercino wrote to Don Antonio Ruffo in 1660.[17] When Baldinucci speaks of a 'most bizarre manner', he is obviously comparing Rembrandt's work with Italian etchings of the Bolognese School, so popular at his time, which show a clear and smooth linearism as their primary graphic feature.

Etching, before the time of Rembrandt, was regarded, with a few exceptions,[18] as a graphic technique which could produce the same effect as line engraving, but much more easily. In the process of etching the artist is relieved of the arduous physical work that engraving with a burin[19] imposes on him. Instead of pushing this burin across the resisting copper, he holds an etching needle with the ease of a pencil and lightly scratches the design through a thin protective layer of resin which covers the copper plate. Wherever the metal surface is exposed by the strokes of the needle, lines will be bitten by the acid in which the plate is then immersed. Even as ingenious an etcher as Jacques Callot, the most outstanding graphic artist of the period immediately before Rembrandt, did not think of exploiting the etching technique for its own peculiar graphic charm. His ambition was still to rival the smooth calligraphic effect, and also the extreme refinement and finish, which is characteristic of engraving.[20]

Although the young Rembrandt owed something to Callot—he seems to have derived from the French master the 'beggar' subjects as well as an utmost delicacy of treatment in etching—he immediately liberated this technique from its traditional bonds. Rembrandt's scribbling strokes leave to the etched line the freedom and vibration that are natural to this process, since the somewhat irregular biting of the acid into the copper plate gives the lines a slightly wavering quality. Rembrandt, with his extraordinary instinct for the nature and potentialities of every medium, thus exploited at once the character of etching to conform to his more pictorial tendencies in draughtsmanship. He handled the etching needle with all the ease that this technique allowed, and produced a line of extreme mobility. His fertile imagination was led to fanciful narration as well as to sensitive rendering of nature. The technique lent itself readily to intimate and refined, but also to broad, open

effects, and both were within the range of Rembrandt's artistic tendencies. The fact that graphic art offered an opportunity to reach a larger public, through the output of many hundred prints from a single plate, can only have stimulated his natural inclination to express himself in the art of black and white.

During his Leyden years and first decade in Amsterdam it seemed that pure etching was sufficient to satisfy the artist's desire to create a pictorial effect by graphic means. In his earliest works in this medium, as we have seen, his line was scribbling and playful, his draughtsmanship full of nervous refinement. The portrait etching of his mother, of 1628 (H. 1), is a superb example. A light, silvery tonality prevails, with delicate gradations, often resembling the effects in his early paintings. There are also a few etchings in a rough, broad manner, like the *Self-portrait, Bareheaded*, of 1629 (H. 4, fig. 1); in this print Rembrandt used a double-pointed instrument, an experiment which he did not repeat. The bold sketchiness is close to that of a vigorous pen drawing.

Shortly after his move to Amsterdam Rembrandt began to strive for an increased power of contrast and colourful glow in his chiaroscuro. He still kept to pure etching and enhanced the pictorial charm by a dense and varied hatching. The darks predominate over the lights and are full of sparkle. Such etchings as the portrait of the preacher, Jan Cornelis Sylvius (H. 111), the *Annunciation to the Shepherds* (H. 120), both of 1634, and the so-called *Great Jewish Bride* of 1635 (H. 127),[21] represent this phase in which the artist reached a virtuosity and richness of treatment unequalled in his time. But his ambition to rival the pictorial brilliance of High Baroque painting by an abundance of graphic manipulation brought him dangerously close to overstraining the medium.

In Rembrandt's etching, as in his painting, the decisive change came about at the turn of the thirties to the forties. The *Death of the Virgin* of 1639 (H. 161) shows the first clear indication of this change, while the landscape etchings of the early forties reveal it more fully. Although he still worked primarily with pure etching, the artist now realized new and more modern possibilities in this technique. He gave up the ambition to rival painting by a dense meshwork of strokes; instead he exploited with greater economy the natural potentialities of the etched line, finding in the whiteness of the paper a source of light. The individual line gains its full and free play, but now with a broader sweep than before, and still combined with scribbling strokes. This light and open sketchiness produces an airy, daylight atmosphere and heightens the effect of spaciousness. A comparison of the large and the small plates of the *Raising of Lazarus*, the former of 1632 (H. 96), the latter of 1642 (H. 198), clearly reveals the changes which came about in his etching style during the course of that decade.

Once Rembrandt had developed this open, tonal manner of the early forties, and attained a delightful sketchiness that brought his etching closer to draughtsmanship

than to painting, he began to seek new means of pictorial enrichment. This time, however, he needed technical touches that would not endanger the transparency which he had just gained, yet would add both delicate and powerful accents. The solution to this problem Rembrandt found in the use of the dry-point needle which could be employed for both these purposes. At times also he added burin work which produced very delicate layers of shading comparable to the glazing touches in his painting.

As for his use of the dry-point needle and the specific effect of the 'burr' that results, a few technical comments may be welcome, since this was the most important innovation in Rembrandt's mature graphic work. The dry-point needle, much stronger than the etching needle, but held in the same way, enables the artist to scratch directly into the clean copper plate, with delicate or powerful strokes. The burr is a by-product of the dry-point needle's work. Whereas in etching the acid consumes the metal within the exposed lines, leaving no noticeable ridges along their edges, the dry-point needle simply pushes the metal aside, making it stand out at the borders of the lines as along ploughed furrows. In the old technique of engraving it was the custom to remove these ridges with the scraper. Rembrandt, however, in his search for stronger pictorial accents, discovered that these rough curls of copper, the so-called 'burr', held the printing ink and produced just the tonal effect he wanted—soft yet powerful, of a velvety depth and beauty.

From the end of the forties on Rembrandt used all three techniques—etching, dry point, and burin work—in varying combinations, but also etching and dry point each for itself. This greatly widened his range of graphic treatment and pictorial accentuation, from the intimate to the monumental. His draughtsmanship shows a steadily increasing breadth. The scribbling stroke is more and more replaced by straight lines which, however, never become rigid. Thus his simplified parallel shading by no means diminishes the liveliness of his draughtsmanship; on the contrary, by maintaining a slight and vibrating irregularity, it serves the double purpose of expressing form more massively than before and, at the same time, suggesting light and air around it.

The *Hundred Guilder Print* (H. 236; figs. 169, 194), although its origins go back to the late thirties, shows in its final graphic treatment the rich combination of etching, dry point, and burin work which often marks Rembrandt's mature style. Most of the basic design is done in etching; the burin's work adds delicate shading to parts of the background by laying a fine, airy tone over the rougher shading underneath. And the dry-point needle reinforces the foreground design by the rich tonal accents of the burr and lends a more vigorous immediacy to the graphic touches.

From the *Hundred Guilder Print* to the two very large plates of the *Three Crosses* of 1653 (H. 270; figs. 176, 177) and the *Ecce Homo* of 1655 (H. 271), Rembrandt's

271. THE PRESENTATION IN THE TEMPLE. Etching (H.279). Enlarged detail from fig. 153

draughtsmanship broadened considerably. In these two works the artist reached the peak of his pictorial power in graphic art, by the full employment of the dry-point needle. But he also experienced the limitations of this medium; these huge, costly copper plates, relying too much upon the effect of the perishable burr (which wears down quickly under the pressure of the copper-plate press) were capable of producing only a few dozen brilliant impressions. After that they had to be heavily

272. CHRIST PREACHING ('La Petite Tombe'). Etching (H.256). Enlarged detail from fig. 171

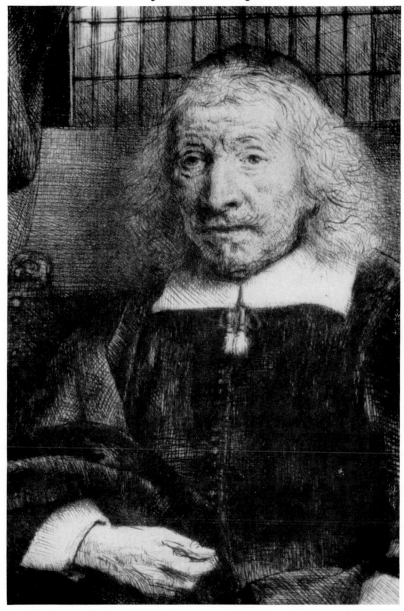

273. PORTRAIT OF JACOB HAARING. Enlarged detail. Etching (H.287)

reworked in order to allow even a modest profit by printing. For that reason Rembrandt did not again attempt dry point on any such large scale. During the fifties, however, he continued to vary the application of the three techniques, etching, dry point, and burin, in the most ingenious manner. There is forceful, pure etching with a broadened and simplified lineament, as we see in the head of the

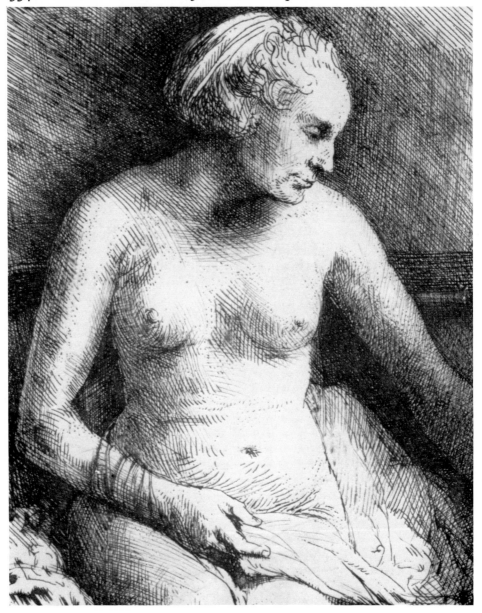

274. WOMAN AT THE BATH. Enlarged detail. 1658. Etching (H.297)

Simeon (fig. 271) from the late *Presentation in the Temple* (H. 279; fig. 153).[22] Then there is etching with additional touches by the burin to create delicate transitions from the darks into the lights, noticeable in the enlarged detail (fig. 274) of the *Woman at the Bath* of 1658 (H. 297). Most often dry point, with its effect of the burr, is employed to add dark accents of great depth and softness to the etched

design. This is shown in the enlarged detail (fig. 272) of *Christ Preaching*, also called 'La Petite Tombe' (H. 256; fig. 171). Finally, Rembrandt also takes advantage of the dry-point needle for a most delicate sketchy handling such as we find in the head of *Jacob Haaring* (H. 287; fig. 273). Here the face of the aged sitter is suffused with a warm glow by the sensitive lighting and utmost subtlety of graphic treatment.

Rembrandt seems to have abandoned etching during the sixties. The portrait of van der Linden of 1665 (H. 268) was probably his latest work, and was done as a special commission.[23] The ageing Rembrandt obviously felt that in graphic art he had reached the limits of pictorial breadth and power which he was still able to increase in his latest paintings.

DRAWING

Roger de Piles[24] placed Rembrandt's drawings higher than his etchings. The latter, thought the French critic, were not invented 'avec le même esprit,' although he gave to them a reasonable amount of credit: 'On y voit néanmoins un clair-obscur et des expressions d'une beauté peu commune.' If such preference for Rembrandt's drawings is shared today, the reasons are somewhat different. We are often inclined to put freedom and spontaneity of execution above all other artistic qualities, and from this point of view Rembrandt's drawings exert a greater attraction than his printed work. It is true that his etchings, progressive as they were in his own period, were not always free from the traditional tendency toward refinement and finish of execution. Rembrandt himself seems to have had times, in painting as well as in etching, when he preferred intimacy and refinement to breadth and monumentality. In other words, the occurrence of rather laboured work in his graphic art does not necessarily mean that he was simply conforming to the contemporary taste. Such was his own choice, now and then.

If we observe different degrees of spontaneity in Rembrandt's three forms of artistic expression, this is largely due to the nature of the media and the tools which he employed. There is little doubt that he responded with genuine feeling for their potentialities and proper application. It is understandable that it took him much longer to attain the freest kind of technique in painting than it did in etching, and longer in etching than in drawing. This was a natural consequence of the degree of complexity in each of these techniques. Furthermore, he did not aim at a uniform type of spontaneity; his handling of the three techniques varied considerably. Thus it was ultimately in painting that Rembrandt discovered his greatest vehicle for powerful, spontaneous treatment. In graphic art he came to realize that there were limits to the artist's freedom of manipulation, that a certain regularity of procedure was required for the printing process in order to provide fairly even results. This

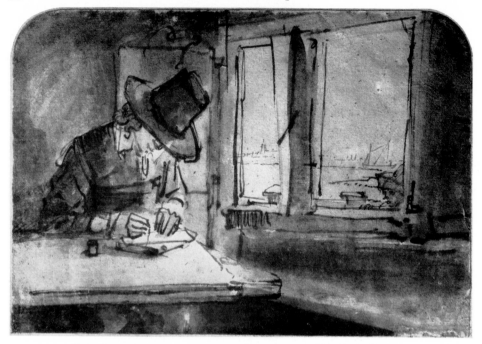

275. JAN SIX WRITING AT HIS ESTATE IJMOND(?). Paris, Louvre.
Drawing (13·5 × 19·7)

very quality, on the other hand, is part of the peculiar charm that distinguishes fine prints from other forms of art.

Frits Lugt, the eminent Dutch connoisseur, in the introduction to his catalogue of the Rembrandt drawings in the Louvre[25] makes the following rather poetic remark about the differences between the three forms of art in which Rembrandt excelled: 'Un tableau chante ou récite, une estampe raconte ou cause, mais un dessin avoue, chuchote et fredonne, souvent d'un timbre qui échappe à certaines oreilles. Il faut une attention soutenue pour savourer les intentions et les délicatesses de ce langage'.

The language of Rembrandt's drawing is surely more articulate and intimate, more immediate and more expressive than anything known in the seventeenth century, though this period did not lack genius in draughtsmanship. Rembrandt employed the art of drawing not only in the usual way, as a means of studying the visual world, of storing motifs, or preparing compositions for etching and painting. To him drawing became an art for its own sake, which allowed him to express his visions more speedily, yet no less articulately than any other technique. In the development of many of his favourite subjects which he created ever anew, Rembrandt's genius had a means of moving constantly along various paths. And it is in his drawings that we can best follow the inventive activity of his mind.

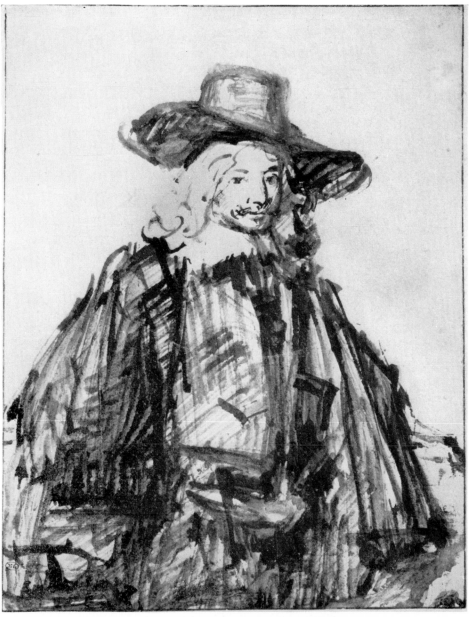

276. PORTRAIT STUDY. Paris, Louvre, Drawing (24·7 × 19·2)

Earlier in this book we had the opportunity to appreciate the artistic qualities of Rembrandt's draughtsmanship—its rare, electrifying vividness and suggestiveness, its extraordinary directness and pictorial sensitiveness. Here we need only add, without any claim to completeness,[26] a few technical remarks on the drawing media which Rembrandt used. In his earlier period, up to about 1640, he not infrequently

277. CHRIST AND THE WOMAN OF CANAAN. Formerly Major H. E. Morritt Collection.
Drawing (19·9 × 27·9)

278. NOAH'S ARK. Chicago, Art Institute. Drawing (19·9 × 24·3)

279. JACOB'S DREAM. Paris, Louvre. Drawing (25 × 20·8)

used chalk, more often black than red, always with great vigour and exploiting the grainy character of this medium to obtain a certain transparency in his strokes. But his most favoured media for draughtsmanship were, beyond a doubt, pen and ink on white paper. First he used the quill pen, later the reed pen, and he handled both with an unsurpassable skill and flexibility. He always used it *alla prima*, disdaining any preparatory draught by chalk or pencil, a step which was necessary for less gifted draughtsmen. Therefore, whenever we find an underdrawing by chalk or

pencil in a pen sketch attributed to Rembrandt—and there are many of this kind—we may be sure that it is the work of a follower or a copyist.

A preference for the reed pen developed about the same time as Rembrandt's use of the dry-point needle to reinforce his etching. The artistic intentions were the same. With both these instruments he could produce a powerful stroke that also had soft tonal qualities. In addition, the angularity of the reed pen's line was perfectly suited to the structural tendency of his late draughtsmanship. The *Portrait Study of a Man* in the Louvre, which we reproduce here (fig. 276), shows a very late and vigorous application of the reed pen, with the peculiar angularity and also the breadth and transparency of its strokes (the transparency is the result of half-dry touches) so appropriate for bringing out the cubic impact and the tonal richness of Rembrandt's late style.

Very often we find combined pen- and brushwork, usually with a warm bistre, rather than cooler tones, for the wash. The subtle integration of pen line and brush stroke is one of the clearest indications of Rembrandt's supreme mastery of sensitive pictorial draughtsmanship, although in his early period the pen- and brushwork is not yet as delicately fused. The drawing of a *Young Woman at Her Toilet*, in the Albertina (fig. 280), dating from the early thirties,[27] shows the two media still somewhat dramatically contrasted with little effort at a complex integration. The result is a chiaroscuro similar to that in the etchings of those years. But *Jacob's Dream*, in the Louvre (fig. 279), which Lugt dates in the beginning of the middle period,[28] shows that sensitive fusion of pen- and brushwork, of linear and tonal accents which, from that time on, characterizes Rembrandt's draughtsmanship. In this drawing the line is still rather scratchy, but the wash is put on very delicately, sometimes with a half-dry brush, throwing a veil of atmosphere over certain areas in perfect co-operation with the sharper accents of the pen.

A few years later, in the beautiful drawing of *Christ and the Woman of Canaan* (fig. 277), we feel an increase of tonal softness in the masterly combination of pen line with a few touches of the brush. The result is an exquisite airiness and spaciousness around the figures. The subtle accents on their faces and gestures gain in significance within this delicate atmosphere. The meaning of Rembrandt's suggestive brevity has not always been properly understood, nor the sensitiveness of his integration of pen- and brushwork. Thus, in the course of the centuries, many a precious Rembrandt drawing has been spoiled by later hands, with lines, but more often brushwork, added to make the drawing more 'complete'.[29] One must be on guard against such additions which, in most cases, cannot be removed and seriously impair the full enjoyment of the original drawing. One such example can be found among our illustrations. It is the otherwise very impressive late drawing of *Christ Healing a Blind Man*, in Rotterdam (fig. 151), where the brushwork has no sensible function, nor shows a proper integration with the whole, while the pen stroke,

280. YOUNG WOMAN AT HER TOILET. Vienna, Albertina. Drawing (23·8 × 18·4)

which fortunately still dominates, gives a full idea of the mastery of Rembrandt's late style.[30]

In the fifties, with the increase of Rembrandt's pictorial breadth, his drawings, too, gain in richness of tonality and power. *Noah's Ark*, from the Chicago Art Institute (fig. 278), dating from about 1660, shows the combination of the reed pen with brushwork in Rembrandt's latest manner. The chiaroscuro effect is both luminous and broad. The painterly quality dominates here over the graphic one, a general feature of this period. The *Jan Six, Writing at His Estate Ijmond*, in the

281. TOWER OF THE WESTERKERK IN AMSTERDAM.
Amsterdam, Fodor Museum. Drawing (19 × 14·8)

Louvre (fig. 275), is from the mid-fifties, when Rembrandt's draughtsmanship reached perhaps its ultimate height in the combination of line and tone, of pen and brush. Another example, slightly earlier, is the drawing of the *Tower of the Westerkerk*, in the Fodor Museum in Amsterdam (fig. 281). Here one can admire both the precision of Rembrandt's observation—since the church still stands[31]—and the spirited treatment of light and shade. While the lines define the form, they also fuse flexibly with the lights or the darks, in the interest of a broader pictorial coherence. The interplay of sunshine and clouds, so characteristic of Holland's breezy sky, seems reflected on this slender structure. Some twenty years after the artist had drawn this tower with such keen interest, he was buried at its foot, in the Westerkerk of Amsterdam.

NOTES

SELECTED BIBLIOGRAPHY

NOTE ON THE PROBLEM OF AUTHENTICITY

INDEX OF WORKS

INDEX OF PERSONS AND PLACES

NOTES

CHAPTER I. REMBRANDT'S LIFE

1. So famous a foreigner as Descartes was highly appreciative of this atmosphere. He said once that he preferred Amsterdam to the peace of any Capuchin or Carthusian cloister (Gustave Cohen, *Ecrivains français en Hollande*, Paris, 1920, p. 463).

1a. There is some uncertainty whether the portraits usually called *Rembrandt's Father* really represent Harmen Gerritsz van Rijn. An authentic drawing in the Ashmolean Museum, Oxford (Catalogue by K. T. Parker, No. 182), with a seventeenth-century inscription: 'Harman Gerrits van de Rhijn' represents an old man asleep. His features do not differ enough from the portraits to exclude the probability that it is the same person. In Rembrandt's early self-portraits there is a tremendous variation of expression and appearance, for artistic purposes—to the point that in some of them the identity has been doubted. Why should not this be the case also when he used his father as a model? Rembrandt even conceivably used the type of his father in the painting of a noble Oriental (Br. 169) two years after the old man's death. Moreover, Rembrandt's pupil Gerard Dou, who entered his workshop in 1628, used the same model for a companion-piece to his own portrait of Rembrandt's mother (Kassel, Museum).

2. Urk. 11.

3. Mario Praz, *Studies in Seventeenth Century Imagery* (London: Warburg Institute, 1939).

4. Urk. 18. Both Rembrandt and Lievens justified their attitude by the remark that then, in the flower of their youth, they could not spare the time for an Italian journey, and that the best of Italian art could be seen outside of Italy, which in Italy they could only see with much trouble, in widely separated places.

5. The few paintings of van Swanenburgh's which have survived reveal a very mediocre talent.

6. Frederik Schmidt-Degener has convincingly identified the subject in *Oud Holland* LVIII (1941), 106 ff.

7. According to Houbraken (see note 21), Rembrandt worked also with Jacob Pynas 'for some months' after his apprenticeship with Lastman. For the whole question of Rembrandt's earliest works see the excellent critical survey by Seymour Slive: 'The Young Rembrandt,' *Allen Memorial Art Museum Bulletin*, Oberlin College, Spring, 1963, pp. 120 ff. I agree with the author's opinion and his well taken point that even in these earliest productions Rembrandt shows an amazing range from a broad, forceful and daring treatment that is still somewhat crude, to an intimate, delicate and minute one. Otherwise it would be hard to explain the varied character of these earliest works as by the same young artist. The occasional collaboration with Lievens, as well as some influence of the Utrecht School (Gerard Honthorst) complicate the clear attribution of unsigned works like the *Feast of Esther*. But Slive has given good reasons for Rembrandt's authorship and some possible co-operation of Lievens.

8. Hans Schneider, *Jan Lievens* (Haarlem: Bohn, 1932), p. 2. Cornelius Müller made a successful effort to separate the hands of the two young artists ('Studien zu Lastman und Rembrandt', *Jahrbuch der preussischen Kunstsammlungen*, L, 1929, 61 ff.). Further valuable contributions to this question were made by Kurt Bauch ('Rembrandt und Lievens',

Wallraf-Richartz Jahrbuch, XI, 1939, 241 ff.). See also S. Slive in the article cited in note 7 above.

9. Urk. 20.

10. See J. Orlers, *Beschrijvinge der Stadt Leyden*, 2nd ed. (Leyden, 1641), p. 375 (Urk. 86); also Philips Angel's appraisal of Rembrandt as a Biblical painter, in 1641 (Urk. 91).

11. Filippo Baldinucci, *Cominciamento e progresso dell' arte d'intagliare in rame colla vita de' piu eccelenti maestri della stessa professione* (Florence, 1686). English translations from *Rembrandt, Selected Paintings*, edited by Tancred Borenius (London: Phaidon Press, 1942).

12. The famous *Rembrandthuis* was built in 1606. The façade is still original except for the third storey and the roof. The interior is completely reconstructed (1908–11).

13. In 1638 Rembrandt and Saskia brought an action for libel against two residents of Saskia's town who had accused Saskia and Rembrandt of wasting her rich inheritance with *prunken und prangen*. The suit was unsuccessful (Urk. 59).

14. A closer contact with the Rabbi whom he had already portrayed in an etching of 1636 (H. 146) may be assumed from the fact that in 1655 Rembrandt etched four illustrations for Manasseh's mystical work in Spanish, *Piedra gloriosa o de la estatua de Nebuchadnesar*, printed in Amsterdam in that year. Of Dr. Ephraim Bonus we know an etched portrait of 1647 (H. 226) and a small oil sketch in the Rijksmuseum, Amsterdam (Br. 252), which may have served as a preparatory study.

15. The first sale took place in December 1657; in February 1658, the house and furnishings were sold, and in September the collection of graphic art. Rembrandt's collections were evaluated at more than 17,000 florins, but brought only about 5,000 florins, and the house was sold for 1,800 florins less than its purchase price.

16. Urk. 233.

17. For an interesting discussion of this complicated arrangement see Carl Neumann, *Rembrandt* (Munich, 1924), II, 195 ff.

18. Urk. 169.

19. See W. R. Valentiner, *Rembrandt und seine Umgebung* (Strasbourg, 1905), p. 64 ff.

20. Urk. 244.

21. Arnold Houbraken, *De Groote Schouburgh der Nederlantsche Konstschilders en Schilderessen*, Vol. I (Amsterdam, 1718). English translation from *Rembrandt, Selected Paintings*, edited by Tancred Borenius (London: Phaidon Press, 1942), p. 28. This description refers obviously to Hendrickje, not to Saskia, although Houbraken is not clear in his statement.

22. Urk. 179 and 182.

22a. Hendrickje was buried on July 24, 1663, in the Westerkerk, Amsterdam (see I. H. van Eeghen, 'Hendrickje Stoffels: Jeugd en Sterven II', *Amstelodamum*, XLIII, 1956, p. 116).

23. Joachim von Sandrart, *Teutsche Academie der Edlen Bau- Bild- und Mahlerey-Künste* (Nuremberg, 1675). English translation from *Rembrandt, Selected Paintings*, edited by Tancred Borenius (London: Phaidon Press, 1942), p. 21.

24. Houbraken, *op. cit.*, p. 28.

25. Baldinucci, *op. cit.*, p. 23.

26. Houbraken, *op. cit.*, p. 26.

27. It came from a pupil of Rembrandt, the Danish painter Bernhardt Keil.

28. Equally significant were the purchases by the Sicilian nobleman, Don Antonio Ruffo. See Chapter V.

CHAPTER II. PORTRAITURE

1. When Sophie of Hanover met Henrietta Maria of England, whom she had known only from Van Dyck's portraits, she was amazed at the queen's crooked and ill-proportioned figure and her ugly, protruding teeth. ('Les beaux portraits de Van Dyck m'avaient donné une si belle idée de toutes les dames d'Angleterre.') See 'Memoirs of Sophie of Hanover' in *Autobiographers of the Seventeenth Century*, Vol. V, *University Library of Autobiography* (New York, 1918–). Original French quotation taken from Marianne Beyer-Fröhlich, *Selbstzeugnisse aus dem dreissigjährigen Krieg und dem Barock* (Leipzig, 1930), p. 261 ff.

A generation later Roger de Piles, in his *Cours de peinture* (Paris, 1708), mentions that he has met noble ladies who cared little for painters who stressed the likeness in portraiture, but preferred those artists who made them appear 'with more beauty and less verisimilitude.' A similar remark is reported of Mignard. See Werner Weisbach, *Französische Malerei des siebzehnten Jahrhunderts* (Berlin: Keller, 1932), p. 266, 271.

2. Princely collectors were beginning to take an interest in the self-portraits of well-known artists. For example, Charles I as Prince of Wales asked Rubens for a portrait by his own hand, and at the Florentine court the collection of artists' self-portraits, founded by Cardinal Leopoldo de' Medici (now in the Pitti) was steadily growing. But, on the whole, there was little demand, and accordingly little production of self-portraits during the seventeenth century.

2a. The buyer of Raphael's *Castiglione* at the Amsterdam auction of 1639 was Alfonso Lopez, who worked as an agent in Holland for the French crown. About 1640 Lopez also owned Titian's so-called *Ariosto* and *Flora*. There can be little doubt that Rembrandt had an opportunity to study both of these pictures. Traces of the *Ariosto* are found in the London *Self-portrait* of 1640 as well as in the *Falconer* of 1643 (London, Trustees of the Second Duke of Westminster); the influence of Titian's *Flora* can be seen in the portrait of Saskia of 1641 in Dresden. See E. Maurice Bloch, 'Rembrandt and the Lopez Collection', *Gazette des Beaux-Arts*, v. 29 (1946), 175 ff.

3. Frederik Schmidt-Degener, *De Gids*, LXXXIII (1919) pt. I, p. 222; German edition: *Rembrandt und der holländische Barock* (Leipzig, 1928), p. 39. See also W. R. Valentiner, *Kunstchronik*, N.F., XXXII (1920), p. 219. Valentiner connects this self-portrait with a series of 'Apostles,' painted in 1661, including among them the *St. James* in the Stephen C. Clark Collection (Br. 617), the *Monks* in Amsterdam, Helsinki, and London (Br. 306-08), and the *Old Man Praying* in the Barreiss Collection (Br. 616), as well as the *Risen Christ* in Munich (Br. 630). A newly discovered *St. Simon* of 1661 in an English private collection can now be added (see L. Münz in the *Burlington Magazine*, XC, March 1948, 64 ff.). To this series Valentiner relates a group of the four 'Evangelists', also dated 1661, of which the *St. Matthew* in the Louvre is the most outstanding. The other three he identifies as the writing 'Evangelists' in Rotterdam (Br. 618, St. Luke ?), in Boston (Br. 619, St. Mark ?), and in Munich (HdG. 184). This last painting, however, cannot be convincingly ascribed to Rembrandt's own hand.

4. Wolfgang Stechow, *The Art Quarterly*, VII (1944), 233 ff.

5. We do not go so far as to say that there was no market for these fanciful portraits. In fact, it appears that during Rembrandt's prosperous period he found it easy to sell any subject by his hand. The important point here is the artist's free choice of subject and arrangement.

6. Compare: self-portraits with Flinck's portrait of Rembrandt; etched portrait of Jan Coppenol by Rembrandt and engraving by Cornelis Visscher; portraits of Jacob Trip and his wife by Rembrandt and by Nicolaes Maes; etched portrait of Manasseh Ben Israel by Rembrandt and painting by Flinck; etched portraits of Ephraim Bonus by Rembrandt and Lievens; portraits of Swalmius by Rembrandt and by Frans Hals (the latter engraved by Suyderhoef), etc. In contrast to these and other cases the complaint of a Portuguese patron, Diego Andrada (Urk. 154), about the lack of similarity in the portrait of a girl ordered by him does not have very much weight.

6a. The old identification as Maerten Day and his wife Machteld van Doorn has been convincingly corrected by I. H. van Eeghen ('Marten Soolmans en Oopjen Coppit', *Amstelodamum*, XLIII, 1956, 85 ff.).

7. Wilhelm Martin, *De hollandsche Schilderkunst in de zeventiende Eeuw* (Amsterdam: Meulenhoff, 1936), fig. 180.

8. Suggestion of C. Hofstede de Groot in his *Catalogue Raisonné of the Most Eminent Dutch Painters of the Seventeenth Century* (London, 1916), VI, No. 341.

8a. Isabella H. van Eeghen, *Een Amsterdamsche Burgermeesters dochter van Rembrandt in Buckingham Palace* (Amsterdam, 1958).

9. Carl Neumann, *Rembrandt*, II, 533.

10. J. Zwarts, *The Jewish Bride* (London, 1929). J. Goekoop de Jongh, in *Bredius Feest-Bundel* (Amsterdam, 1915), p. 53 ff., identifies the man (erroneously) as Spinoza. He stresses also the Spanish-Jewish character in his features. Frits Lugt, in *Art in America*, XXX (1942), 174 ff., suggests the goldsmith, Lutma the younger, as the person portrayed, on the basis of Lutma's engraved self-portrait. There is a similarity, but it is not fully conclusive. If Lugt is right, this would still be the portrait of a person rather close to Rembrandt, with whom the artist could take more liberties than in ordinary portraits. The X-ray of the woman's portrait shows the head of a child in the lower left corner. This Rembrandt painted out in the final execution, perhaps for compositional reasons.

11. Valentiner, *Rembrandt und seine Umgebung*, p. 40 ff.

12. A document of 1649 gives Hendrickje's age as twenty-three in that year (Urk. 120).

13. See Otto Benesch, 'The Rembrandt Paintings in the National Gallery of Art', *The Art Quarterly*, 1943, p. 26.

14. Urk. 137.

15. The absence of the strong local colour which is found so often in Rembrandt's late work may have led Hofstede de Groot to make the remark that this picture was unfinished.

16. Compare the hands in *The Return of the Prodigal Son*, the so-called *Jewish Bride*, and the *Family Portrait* in Brunswick. Emil Kieser ('Rembrandts Verhältnis zur Antike', *Zeitschrift für Kunstgeschichte*, X, 1941–2, p. 140), sees a connexion between the composition of *Hendrickje as Venus* in the Louvre and a Madonna motif of Quentin Massys.

17. Otto Benesch, *Rembrandt, Werk und Forschung* (Vienna: Gilhofer and Ranschburg, 1935), p. 65: 'das letzte bekannte, von Todesahnungen verklärte Bildnis Hendrickjes'.

18. See Joachim von Sandrart, *Teutsche Academie*, Vol. I, ed. by A. R. Peltzer (Munich, 1925), p. 203.

19. Inventory of etchings by Rembrandt in the possession of the art dealer, Clement de Jonghe, on his death, February 11, 1679 (the earliest list known containing any considerable number of Rembrandt's prints). See also Urk. 346, No. 57.

20. Valentiner (*Rembrandt und seine Umgebung*, p. 49 ff.) seems to have gone too far in his identification of portraits of Titus.

21. The blond boy with a feather hat, in the Cook Collection, Richmond (Br. 119), somewhat reminiscent of a prince by Holbein, has often been called Titus, but the face differs slightly in type, and the eyes are grey-blue.

22. The condition of this picture is not fully satisfactory. There are dubious passages, particularly on the hand. A closer investigation may bring more clarity. Yet the expression is convincing and the composition is well documented by a pen drawing by Mathys van den Berghe, signed and dated 1682, in the Berlin Print Room (No. 524).

23. Wilhelm Bode, *Oud Holland*, IX (1891), p. 1 ff.; Valentiner, *Rembrandt und seine Umgebung*, p. 47 ff.

24. Hofstede de Groot in his *Catalogue*, VI, No. 261.

25. The two portraits by Karel van der Pluym, formerly in the Julius Porgès Collection, Paris (reproduced in *Rembrandt, Klassiker der Kunst*, edited by W. R. Valentiner; 3rd ed., Stuttgart and Berlin, 1908; Nos. 332, 333); the woman by Carel Fabritius (?), reproduced by Valentiner in the *Art Bulletin*, XIV, No. 3 (1932), p. 212 ff., fig. 10.

26. As great a Christian thinker as Thomas Aquinas declared that the Jews must remain in eternal servitude. See J. Elbogen, *Geschichte der Juden* (Leipzig, 1920), p. 40.

27. See Franz Landsberger, 'Rembrandt's Synagogue,' in *Historia Judaica*, Vol. VI, No. 1 (1944), p. 69 ff.; also his *Rembrandt, the Jews and the Bible* (Philadelphia: Jewish Publication Society, 1946).

28. Hofstede de Groot, *Catalogue*, VI, No. 383, model for the *Monk* of 1661 in Helsinki. Rembrandt also painted Titus disguised in a monk's hood, in 1660 (Br. 306).

29. *Jahrbuch der preussischen Kunstsammlungen*, XXXVIII (1917), 107.

30. According to Ludwig Münz (*Burlington Magazine*, LXXXIX, 1947, 253 ff.) the picture has been cut down on top (about one-tenth of its original height). An etching by J. de Frey, of about 1800, shows it in the more complete condition.

31. There is no certainty that Anslo's wife is represented here, although the tradition goes back to the eighteenth century. Bode gives some reasons against this assumption (*Jahrbuch der preussischen Kunstsammlungen*, XVI, 1895, 3 and 197 ff.). A preliminary study of Anslo's figure exists in the E. de Rothschild Collection (Val. 725); the still life of the books is taken from a drawing of an Oriental scholar in his study (HdG. 998), formerly in the Heseltine Collection.

32. See Martin, *op. cit.*, I, 40 ff.

33. J. Zwarts (*The Jewish Bride*, London, 1929) suggested as the patrons Miguel de Barrios and Abigail de Piña. The evidence is not striking but it is possible, because of the types, the slightly extravagant costumes, and the rich jewellery, that some wealthy Portuguese-Jewish pair is here portrayed. We came to a similar conclusion in discussing the two portraits in the Metropolitan Museum, which appear to represent the same man and woman a few years later.

34. Otto Benesch, *Rembrandt, Werk und Forschung*, p. 68, and Otto Benesch, *Rembrandt Drawings*, vol. V, p. 284 (cat. 988).

35. This observation was first made by Cornelius Müller. See footnote by Valentiner in *Die Handzeichnungen Rembrandts* (New York, 1925), I, 478.

35a. Recent X-ray investigation has shown that the figures were first represented as seated, thus more similar to those in the drawing (oral information given by A. van Schendel).

36. See Curt Glaser, *Holbein Zeichnungen* (Basel, 1924), fig. 74. Dr. R. Wittkower kindly called my attention to this representation.

37. Jan Veth, in *Oud Holland*, XXIV (1906), 4 ff., assumes the influence of a Giorgion-esque composition, a copy of which is preserved in the Casa Buonarroti in Florence. For additional remarks on this composition see Lionel Cust, in *Burlington Magazine*, XXIX (1916), 373. Charles de Tolnay, in *L'Amour de l'art*, October 1935, p. 277 ff., assumes that Rembrandt derived the motif of the *Jewish Bride* from Cesare Ripa's *Iconologia* (Padua, 1625). Here, however, the differences seem more striking than the common features.

38. For this point see in particular Charles Holmes, *Notes on the Art of Rembrandt* (London, 1911), pp. 187 ff.

39. See A. Riegl, *Das holländische Gruppenporträt* (Vienna, 1931), 2 vols. (first published in the *Jahrbuch der kunsthistorischen Sammlungen des allerhöchsten Kaiserhauses*, Vienna, 1902).

40. A rare exception was the decoration of the *Huis ten Bosch*, near the Hague.

41. Only in the earliest known example, the *Anatomy Lesson of Dr. Sebastiaen Egbertsz* of 1603 by Aert Pietersz (Amsterdam, St. Anthoniswaag), does the entire Guild seem to be portrayed, since twenty-eight doctors attend the dissection. See Riegl, *op. cit.*, pl. 31.

42. The Anatomy Book of the Guild in Amsterdam records only one dissection during the entire year of 1632. The corpse in Rembrandt's *Anatomy Lesson* was therefore probably that of the criminal, Adriaen Adriaensz, whose body was dissected after his execution on January 31, 1632. In Leyden the Board of Anatomy dissected only sixty corpses during a period of twenty-two years.

42a. W. S. Heckscher, *Anatomy of Dr. Tulp: An Iconographical Study* (New York, 1958) brings no convincing results except for the author's finding that only two of the men represented were foremen of the Guild during 1631–2 and that therefore the painting cannot be a traditional group portrait of the foremen of the Guild—as had been assumed—but must have been commissioned privately. Most of the other conclusions of Heckscher have been effectively criticized by C. K. Kellet (*Burlington Magazine*, CI, 1959, 150 ff.) and J. Richard Judson (*The Art Bulletin*, XLII, 1960, 305 ff.). Kellet points out that this was a private, not a public dissection as Heckscher assumes (only the latter took place in the evening under artificial light). Kellet also observes that the great folio volume at the feet of the corpse is not a copy of Vesalius—because there is no comparable Vesalius plate—and he made the important discovery that, for the central motif of the dissection of the arm, Rembrandt has used Adriaen van der Spieg(h)el's *Anatomy* (Venice, 1627, pl. 22, fig. 2). Moreover, it can be said that the painting itself contradicts Heckscher's assumptions that Rembrandt has here depicted a night scene in an anatomical theatre and that Dr. Tulp addresses a large audience outside the painting. It contradicts also Heck-scher's opinion that two of the men (the one at the far left and the topmost one) are not painted by Rembrandt but added by another hand. As far as I can see (and the Director of the Mauritshuis has expressed to me the same opinion), there is no difference in the style of painting between these figures and the others.

43. E. Michel (*Rembrandt*, London, 1894, p. 285) points to the cock hanging to the little girl's girdle as the possible prize for which the marksmen were to compete. Another more generally accepted suggestion is that the occasion may have been the parade of the Amsterdam burgher companies in honour of Marie de' Medici, the exiled Queen-Mother of France, on her visit to the Dutch capital in 1638. Several shooting companies ordered paintings to commemorate this event, for the decoration of their common buildings. See Martin, *op. cit.*, p. 218 ff., and the literature quoted.

44. The title *Night Watch* goes back to the end of the eighteenth century; the picture was

transferred from the Town Hall to the Trippenhuis in 1808. At this time it was repeatedly referred to as the *Nagtwagt*.

For full discussion of the *Night Watch* see Schmidt-Degener, 'Het Genetische Probleem van de Nachtwacht', *Onze Kunst*, XXVI (1914), 1, 37, XXIX (1916), 61, XXX (1916), 29, XXXI (1917), 1, 97; also W. Martin, *Van Nachtwacht tot Feeststoet*, Amsterdam, 1947.

45. The picture contained originally thirty-four persons altogether. The shield on a pillar in the background lists only eighteen names of members of the company to be portrayed. Rembrandt added the other sixteen figures simply to animate the composition.

In 1658–9 Jan Pietersz, the draper, one of the company represented, testified before the court, at the request of Titus' guardian, that he and fifteen other members of the company had been portrayed by Rembrandt, that the average contribution of the individual members was one hundred guilders but that some paid more and others less, according to the position they occupied in the picture (Urk. 205).

46. Gustav Glück dates Gerrit Lundens' copy in the 1640's (*Niederländische Gemälde aus der Sammlung . . . Tritsch*, Vienna, 1907, p. 18). The doubts cast on Lundens' authorship of this copy, in the National Gallery Catalogue of the Dutch School, by Neil Maclaren (London, 1960), pp. 343 ff. are not fully conclusive.

47. Hofstede de Groot (*Catalogue*, VI, No. 926) estimates the original size as 387 × 502 cm.; the present dimensions are 365 × 438 cm.

48. This family album was started by Captain Frans Banning Cocq and completed at the time of his death (1655). The inscription on the water-colour copy of the *Night Watch* reads as follows: 'Schets van de Schilderije op de groote Sael van de Cleveniers Doelen daerinne de Jonge Heer van Purmerlandt als Capiteijn, geeft last aen zijnen Lieutenant, de Heer van Vlaerdingen, om syn Compaignie Burgers to doen marcheren'. See *Oud Holland*, IV (1886), 204; and Urk. 139.

49. Recent X-ray investigation has confirmed this assumption. See note 52.

50. Their names, as inscribed on the shield, were Jan Visscher Corneliszoon, Rombout Kemp, and Reinier Engelen.

51. For the arbitrary choice of picturesque uniforms, see Werner Weisbach, *Rembrandt* (Berlin and Leipzig, 1926), p. 342; also W. Martin, *Van Nachtwacht tot Feeststoet*, p. 30.

52. The *Night Watch* was cleaned in 1946–7. According to the official report (Ton Koot, *Rembrandt's Nachtwacht in Nieuwen Luister*, Amsterdam, Meulenhoff, 1947), the general impression has changed to greater brightness and richness. After the removal of the brownish varnish the tonality, as was to be expected, is cooler, more nuances have come out and it is possible to realize more distinctly that the group is marching out through a dark door into the sunlight. The general changes in colour Ton Koot describes as follows (translation by R. S. Magurn):

'What we knew as pale green and indeterminate brown has become bright blue, beige and grey, the doubtful blacks have gained their original depth, the dull red its sparkle. Even the strokes of Rembrandt's brush have become again perceptible.'

In the following passage (pp. 43 ff.) Ton Koot sums up the new features which the restoration has revealed:

'The architrave showing through the shield proves that the shield was added later.

'On the shield the first name of van Schellingwou is to be read as Walich.

'On the shield an eighteenth name is found: Paulus Schoonhoove.

'Above the right shoulder of Sergeant Kemp appears the face of an additional unknown thirty-fourth person.

'Various heads which one could not see clearly before, such as the one above Kemp's outstretched right hand, the one above the left shoulder of the fellow with the tall hat, or the one under the right elbow of the standard-bearer and to the left of the right hand of Sergeant Engelen, are now plainly visible.

'The colour of the lieutenant's jacket is no longer golden brown, but pale yellow, and the embroidery on the border shows on each side a lion with the arms of Amsterdam.

'Ruytenburgh's pike is a masterpiece of painting; the "greenish yellow" tassel is a splendid blue and white, and the question why Rembrandt had left out the cast shadow of the pike is answered. The foreground had become so dirty that the shadow was no longer visible. Now it is again recognizable.

'In the foreground, which was yellow-brown, appear tufts of grass.

'The so-called "carving knife" at the girdle of the yellow girl with the gold-green cape appears to be a pistol. She seems also to have cartridges on her dress.

'The green girl is not seen from the back, as was thought; one distinguishes clearly (at due distance from the place of her eye) her right ear and cheek.

'The ball on the ground in front of the powder-bearer is a fruit.

'The upraised sword near the seated Sergeant Engelen, which was thought to be in the hand of the man with the Spanish helmet, appears to be in the hand of the "rondassier" with the turned-up hat.

'Fine details are brought out in the dark parts of the musket of the red-clad rifleman, in the halberd of the seated "vaandrig" [*sic!*], the costume of the man firing his gun, and in the cuirass of de Roy, which formerly looked like a simple coat with steel shoulder pieces. It is clear that on the figure of de Roy some remaining linseed oil was the reason that this pike-bearer had become so dark that one could no longer recognize even his armour.'

See also A. van Schendel and H. H. Mertens, 'De Restauraties van Rembrandt's Nachtwacht', *Oud Holland*, LXII (1947), 1 ff.

52a. Of the recent literature on the *Night Watch* we mention W. G. Hellinga, *Rembrandt fecit* 1642 (Amsterdam, 1956). Hellinga reads the *Night Watch* as a huge Baroque allegory inspired by Vondel's drama, *Gijsbrecht van Amstel*. He tries to connect every detail and allusion in the picture with Vondel's play, and concludes that Rembrandt personified Amsterdam's hero Gijsbrecht in Captain Cocq and that the group portrait proclaims the triumph of Amsterdam. This is hardly convincing when one considers how little inclination the artist had for such allegorical treatment. Moreover, none of the various contemporary sources mentions such a symbolical meaning of the painting.

53. For quotations see Neumann, *Rembrandt*, II, 497 ff.

53a. H. van de Waal, 'De Staalmeesters en hun Legende', *Oud Holland*, LXXI (1956), 61ff.

53b. An X-ray examination of the picture (the X-rays were published by A. van Schendel: 'De Schimmer van de Staalmeesters. Een röntgenologisch Onderzoek', *Oud Holland*, LXXI, 1956, 51 ff.) shows how Rembrandt struggled to attain the proper balance in this composition. While he worked on the painting he shifted all the figures, but the one he most experimented with was the servant. He tried two different positions and finally, taking some liberties with perspective, placed him behind the two syndics in the centre.

54. We cannot follow Charles de Tolnay (*Gazette des Beaux Arts*, 6th series, XXIII, 1943, 31 ff.) in his symbolical interpretation of the picture over the fireplace, nor read into the faces of the Syndics any haughtiness. He says that Rembrandt reveals here 'how worldly power transforms man's soul and degrades his human sentiments'.

CHAPTER III. LANDSCAPE

1. Benesch lists 257 drawings.

2. For the percentage of losses see Max Eisler, *Rembrandt als Landschafter* (Munich, 1918), p. 219.

2a. Benesch (796) dates this drawing 1640–1.

3. Frits Lugt, *Mit Rembrandt in Amsterdam* (Berlin, 1920), p. 94. According to this author the name 'Omval' does not refer to the turning point of the Amstel river in this region (as might easily be thought), but to a neck of land that stretches between the Amstel river and the 'Diemermeer'. Benesch (1321) dates this drawing about 1653, but its relationship to the etching *The Omval* (H. 210) makes a date in the forties more probable.

4. *Ibid.*, pp. 81 ff.

4a. Benesch (1253) dates this drawing about 1650.

4b. Benesch (1367) dates this drawing about 1657–8.

5. *Ibid.*, pp. 131 ff. Lugt has corrected the assumption that this view is taken from the banks of the Y, to the northwest of the capital. He states that Rembrandt was at this point not very far from his own home, having left the city by the St. Anthoniespoort and, after a fifteen-minute walk in a southeasterly direction, reached the spot from which Amsterdam appears in the etching, although with directions reversed.

6. See Jan Six in *Oud Holland*, XXVII (1909), 97 ff. Rembrandt had portrayed this Jan Uytenbogaert, weighing gold, in an etching of 1639 (H. 167). Lugt doubts the identification of this landscape as the 'goldweigher's field', but does not suggest any definite place instead. According to him the town in the distance resembles Haarlem, or possibly Alkmaar (*op. cit.*, p. 157). J. Q. van Regteren Altena ('Retouches van ons Rembrandt Beeld', *Oud Holland*, LXIX, 1954, 1 ff.) has shown that this etching represents Saxenburg, a country house built at the foot of the dunes near Haarlem, and that the artist took his view from the high spot still called 'Het Kopje'. The house belonged to Christoffel Thijsz, to whom the artist was in debt. Thijsz cannot be identified with the Goldweigher who has also been considered to be Jan Uytenbogaert, Receiver General in Amsterdam. The latter possessed a country house near Amsterdam, but van Regteren Altena believes it to be the house called 'Het Torrentje', situated on the left of the road to Amsterdam.

7. See Arthur M. Hind, *Rembrandt's Etchings* (2nd edition, London, 1923), No. 209. Lugt, *op. cit.*, pp. 113 ff., has pointed out that this tradition, although erroneous with regard to the place, may have a kernel of truth in it. According to him the landscape represented is probably the region of the estate of 'Klein Kostverloren,' with Ouderkerk in the distance. This estate was owned, at the time of the etching, by Albert Coenraadszoon Burgh, the Burgomaster of Amsterdam. Lugt believes that in the Gersaint story this Burgh family was possibly confused with the Six family, an understandable error if one considers that Jan Six was also a Burgomaster of Amsterdam, although at a later date, and the two families became closely allied in the course of the seventeenth century.

8. For the exact location see Lugt, *op. cit.*, pp. 90 ff.

9. Neumann, *Rembrandt*, I, 251.

CHAPTER IV. BIBLICAL SUBJECTS

1. Léon Wencelius, *Calvin et Rembrandt* (Paris, 1937), pp. 169 ff.

2. The case which Baldinucci reports of a Rembrandt drawing sold by auction for thirty

scudi was something of an exception. As far as I can see, drawings did not bring noteworthy prices in seventeenth-century Holland.

3. The only outstanding commission is that for the series of the 'Passion' paintings, done for the Prince of Orange (Urk. 47).

4. Urk. 407, paragraph 32.

5. One might assume the same for his paintings, at least as long as Rembrandt was the leading artist in Amsterdam. The fact that a religious painting of his (*Christ and the Adulteress*, 1644, Br. 566, now in London) was evaluated by an expert, as late as 1657, at the exceptionally high price of fifteen hundred guilders (Urk. 177), seems to prove that his authorship mattered more for the market value than did the subject. This, however, is a fairly isolated record of a high evaluation of Rembrandt's paintings in his late period. The reason may be that this particular picture, because of its minute execution and rather early character, was of greater appeal to the public than his late work. In any case, the list of paintings that remained unsold in Rembrandt's possession at the time of his bankruptcy in 1656 does not indicate that religious subjects were less saleable than others. Comparatively few of them are to be found in this list.

6. See Fritz Saxl's study, *Rembrandt's Sacrifice of Manoah* (London: Warburg Institute, 1939); also H. van de Waal's article, 'Hagar in de woestijn, door Rembrandt en zijn school', *Nederlandsch Kunsthistorisch Jaarboek voor Prof. Martin* (The Hague: Daamen, 1947), with the pertinent literature.

7. Erich Frank, *Philosophical Understanding and Religious Truth* (London and New York: Oxford University Press, 1945), p. 163: 'Analogy is the ultimate foundation on which logic and philosophy must be built. The only truth that can be taken literally is that of mathematics'.

8. Lastman's *Sacrifice of Abraham* in Amsterdam. Rembrandt's second version of 1636, in Munich, with the angel coming from the rear, is based on one of his own drawings (Val. 48), executed by a pupil and corrected by the master. The signature, *Rembrandt verandert and overgeschildert* 1636, informs us about these facts.

9. Charles Blanc, *L'Oeuvre complet de Rembrandt* (Paris, 1859–61), p. 67: 'Isaac tend le cou à son père avec la confiance et la douceur d'un agneau'.

10. This interpretation has recently been advanced by Wencelius, *op. cit.*

11. Wencelius, *op. cit.* This author goes too far in stressing the identity of the religious concepts of Rembrandt and Calvin.

12. See in particular K. Vos, 'Rembrandts geloof', in *De Gids*, III (1909), pp. 49 ff. This author assumes that Rembrandt was a Mennonite and belonged to the Waterlander group. Schmidt-Degener contradicted this in 'Mennist Portretten', *Onze Kunst* (1914), pt. I, p. 1. His arguments are not convincing. H. M. Rotermund ('Rembrandt und die religiösen Laienbewegungen in den Niederlanden im 17. Jahrhundert', *Nederlands Kunsthistorisch Jaarboek*, 1952–3, 104 ff.) thoroughly investigates the problem of Rembrandt's connexion with the Mennonites and comes to conclusions similar to those in this book.

13. Neumann, *Rembrandt*, II. 684 ff.

14. Baldinucci, *op. cit.*, p. 22.

15. See the painted portrait of Anslo (Br. 409), the portrait etching (H. 187), and the drawings for these (Val. 724, 725).

16. Urk. 157.

17. Menno Simons, *Foundation and Plain Instruction of the Saving Doctrine of Our Lord Jesus Christ*, English translation of the edition of 1565 (Lancaster, Pa., 1863), p. 63.

18. *Ibid.*, p. 9, and Matthew, chapter 11.

19. We refer with this remark to a difference of accentuation within the Christian dogma, rather than to a difference of dogma.

20. Menno, *Foundation*, pp. 282 ff. and 391 ff.

21. *Ibid.*, pp. 389 ff.

22. *Ibid.*, pp. 23, 98, etc.

23. *Ibid.*, pp. 46, 51.

24. From the various records still extant as to the church affiliations in Rembrandt's family one cannot come to any definite conclusions for or against assuming his adherence to the Mennonite creed. The fact that neither Saskia nor Hendrickje (nor their children) became Mennonites has been interpreted as indicating that Rembrandt was a Mennonite by choice rather than by inheritance (see Neumann, II, p. 685). Saskia's son Titus as well as Hendrickje's daughter Cornelia were baptized shortly after birth, but not as adults. The Mennonites, however, left considerable freedom to their own children in the choice of creed and did not enforce their conversion. Hendrickje obviously belonged to the official Calvinistic church, as we have seen from her admonishment and punishment by the Church Council for her illegal relationship with Rembrandt (Urk. 157). Three times she was called before the Council without any response on her part, until finally the church authorities themselves took action. Rembrandt, on the other hand, was summoned only once in this same matter, and there was no second summons after he had ignored it. One assumes, therefore, that the church authorities realized that the artist was no longer a member of the Calvinistic church and, this being so, that further action would in his case be futile.

25. Menno, *Foundation*, p. 149.

26. Hofstede de Groot, in his *Catalogue*, VI, No. 80, identifies this figure as the high priest, but this seems improbable in view of the fact that Rembrandt consistently includes Hannah in his early 'Presentations'. See also the two etchings (H. 18 and 162) and the various drawings of the forties. Wolfgang Stechow ('Rembrandt's Presentation in the Dark Manner', *Print Collector's Quarterly*, XXVII, 1940, 371) corrected this mistaken interpretation of Hofstede de Groot's.

27. Urk. 47, 48, 65-69. See Horst Gerson, *Seven Letters by Rembrandt* (The Hague, 1961), with excellent critical comments.

28. Urk. 48. Also Urk. 67, where Rembrandt writes that a certain picture should be hung in a strong light and in such a way that the spectator can stand far enough away from it to appreciate its effect from a distance. This remark, however, does not refer to one of the 'Passion' pictures, but to the large painting, probably the *Blinding of Samson*, which Rembrandt sent to Huygens as a present in return for his good services.

29. H. G. van Gelder (*Oud Holland*, LX, 1943, 148 ff.) stresses that seventeenth-century authors frequently used the word *beweeglijkheid* to express 'emotion' and not 'physical movement'. See also Lydia de Pauw-de Veen, 'Over de betekenis van het woord beweeglijkheid in de zeventiende eeuw', *Oud Holland*, LXXV (1959), 202 ff.

30. See Neumann, *Rembrandt*, I, 116 ff.

31. The composition is certainly Rubens' own invention, although the execution may be by the hand of Van Dyck.

31a. The dependence on Caravaggio's *Martyrdom of St. Matthew* is not as absolutely convincing as Wolfgang Stechow assumes (review of this book in *The Art Quarterly*, XXXII, 1950, 255 ff.). The coincidence of certain compositional features can be explained

by the common adherence to Baroque devices, for which, however, Caravaggio was an initiator.

32. See also the etching of the *Angel Leaving the Family of Tobias* of 1641 (H. 185), which, although of the same date as the *Sacrifice of Manoah*, still shows some theatrical features. These features, however, are toned down in comparison to those in the Louvre painting of 1637, mentioned in the text.

33. Fritz Saxl, *op. cit.*

34. Saxl interprets this change as a closer adherence to the Biblical text, but, on the whole, the older Rembrandt is likely to interpret the Bible with more freedom, rather than less.

35. *Rubens, Klassiker der Kunst*, edited by R. Oldenbourg (4th ed., Stuttgart and Leipzig, 1921), p. 342, left.

36. W. R. Valentiner, *Nicolaes Maes* (Stuttgart, 1924), pl. 23.

37. Bredius' doubts of this head seem to me unjustified.

38. Apocryphal Book of Susanna, 22, 23.

39. There exist several preliminary drawings (see fig. 168) and oil sketches of the individual figures, proving by their style that the picture in its present form must be the work of the later forties. Kauffmann's assumption (*Jahrbuch der preussischen Kunstsammlungen*, XLV, 1924, p. 72) that a composition of 1635 lies underneath may be correct. However, the drawing in Dresden (Val. 260) which is the basis of his conclusions, must be discarded as a crude imitation, as Valentiner rightly says. The pentimenti noticeable in the painting indicate some changes in the course of the work, but what we see now shows consistently the style of the late forties and confirms the date of 1647 which Rembrandt added to his signature. The Susanna figure of 1637 in The Hague shows the same general attitude, but in the Berlin Susanna there is less of a sensual appeal, and greater emphasis upon the expression of inner feeling. As for the pentimenti shown in the X-ray of the Berlin painting see the article by Alan Burroughs in the *Burlington Magazine*, LIX (1931), 9.

40. Urk. 390.

41. Hind, *Rembrandt's Etchings*, p. 138.

42. H. F. Waterloos, a contemporary of Rembrandt, wrote some descriptive verses on the back of an impression of the *Hundred Guilder Print* now in the Bibliothèque Nationale, Paris. His lines refer specifically to this chapter of Matthew (Urk. 266).

43. St. Peter's features show some resemblance to traditional portraits of Socrates. Blanc (*op. cit.*, p. 178) and others see in this coincidence a deeper meaning.

44. Charles H. Middleton, *The Etched Work of Rembrandt van Rhyn* (London, 1878), p. xxxiii.

45. In addition to the compositional resemblance to the *Presentation*, Rembrandt's studies of the blind beggar led by his wife, in the Louvre (fig. 170), and of the group of the sick at Christ's feet, in Berlin (Val. 429), indicate an earlier occupation with the *Hundred Guilder Print* before its final and decisive execution in 1648–50. One feels the transition from a very detailed to a broader treatment in the print itself, but the chiaroscuro, in its final form, integrates this contrast.

46. In addition to pure etching, with which he laid the foundation of the composition, Rembrandt here employs the dry point in the more vigorous foreground accents and even the burin in the finer shading. These technical reasons alone make it improbable that the print was finished before the end of the forties. Also the fact that for the head of Christ as well as for various other types Rembrandt employed studies of Jewish faces which he had done in 1645–7 supports this dating.

47. We may recall at this point Manasseh Ben Israel's mystical book, *Piedra gloriosa* (see note 14, Chapter I), where the Messianic hope of seventeenth-century Jewry is also based upon Daniel's prophecy.

47a. Ludwig Münz (*The Etchings of Rembrandt*, II, p. 104) rightly observes that the figure of the kneeling centurion is derived from an engraving of 1532 by the Master of the Die.

47b. T. Musper (*Kunst- und Antiquitäten Rundschau*, 1935, 135 ff.) dates this late state in the early 1660's, as do others after him, such as Münz (*op. cit.*, p. 104), because of the completely different character which Rembrandt brought into the etching through this final alteration. It is difficult to prove this point and to exclude the possibility that, as in the large *Ecce Homo* of 1655, the fast deterioration of the dry point necessitated substantial changes which had to cover the old design. Therefore uncertain also is Stechow's interesting suggestion (review of this book in *The Art Bulletin*, XXXII, 1950, p. 254) that Rembrandt made this late change to correct an iconographical mistake (that the Good Thief appears on Christ's left).

48. A document published by Bredius (*Oud Holland*, XXVII, 1909, 238 ff.) informs us that only a few months before his death Rembrandt received from the dealer, Dirck van Cattenburgh, a number of copper plates on which to etch a Passion.

49. Blanc, *op. cit.*, p. 184.

50. Both representations are in accord with the Biblical text (Luke 24:30), 'And it came to pass, as he sat at meat with them, he took bread, and blessed it, and brake, and gave to them. And their eyes were opened and they knew him. . . .' For the iconographical tradition in this subject see W. Stechow (*Zeitschrift für Kunstgeschichte*, III, pp. 329 ff.), who rightly observes an influence of Leonardo's *Last Supper* in the Christ figure and the canopy behind Him. See also J. Q. van Regteren Altena, 'Rembrandt's Way to Emmaus', *Kunstmuseets Årsskrift*, 1948–9.

51. For the development of the *Descent from the Cross* subject in Rembrandt's work see W. Stechow's article in the *Jahrbuch der preussischen Kunstsammlungen*, L (1929), 217 ff.

52. See Léon Bonnat's account of the opening of the 'Salle Lacaze' in 1869; it was with this collection that the *Bathsheba* came to the Louvre (Neumann, *Rembrandt*, II, 382).

53. Br. 492, 495, 513.

54. II Samuel, 11:3. The X-ray of this painting, published by the Louvre (*Rembrandt, Etude Photographique et Radiographique*, No. 15) shows different positions of Bathsheba's head and reveals that the artist only gradually arrived at the final one.

55. Urk. 157, 158.

55a. Ilse Manke ('Zu Rembrandt's Jakob-Segen', *Zeitschrift für Kunstgeschichte*, XXIII, 1960, 252 ff.) has rightly observed the positions of Jacob's left hand and of Joseph's right hand. Seymour Slive and the author made the same observation on a recent visit to the Kassel Museum, without knowing of Miss Manke's article. As for Rembrandt's adherence to the Biblical text, she comes to the same conclusions as the author did in the first edition of this book, which, in turn, she did not know.

56. For other interpretations see Wolfgang Stechow, 'Jacob Blessing the Sons of Joseph, from Early Christian Times to Rembrandt', *Gazette des Beaux-Arts*, 6th series, XXIII (1943), 193 ff., and Herbert von Einem, *Rembrandt's Segen Jakobs* (Bonn, 1950).

57. The quasi-Burgundian shape of this headdress has been related to the early fifteenth-century bronze figures, probably parts of a tomb, cast by Jacques de Gervins and belonging to the Rijksmuseum in Amsterdam. See Neumann, *Rembrandt*, II, 432.

58. *Ibid.*, p. 432.

59. See M. D. Henkel, in *Burlington Magazine*, LXIV (1934), 153 ff., and LXV (1934), 187. Henkel points to an engraving after Gerhart Seghers' painting as the source of Rembrandt's composition. Benesch (in the text to No. 1050) considers this drawing a work of the Rembrandt School. It is accepted by Lippmann-Hofstede de Groot (141), Valentiner (465), F. Lugt (1950 catalogue, 480), and S. Slive (new edition of Lippmann).

60. Reproduced in *Grabados y Dibujos de Rembrandt en la Biblioteca Nacionale, Madrid* (1934), pl. XII.

61. There may be some relationship between this motif of the one uncovered eye and the same feature in the outstanding figure of one of the damned in Michelangelo's *Last Judgement* (Klassiker der Kunst, 4th edition, 1912, p. 121).

62. According to Hofstede de Groot this composition was suggested to Rembrandt by a print of Maerten van Heemskerk. See also J. L. van Rijckevorsel, *Rembrandt en de Traditie* (Rotterdam: Brusse, 1932), p. 134 and fig. 159.

CHAPTER V. GENRE, MYTHOLOGY AND HISTORY

1. Adriaen Brouwer alone could be called a forerunner of Rembrandt in his impulsive sketches. His motifs, however, were limited to tavern scenes and peasant life. These spirited drawings may have influenced Rembrandt, who owned a number of them. See A. Heppner, 'Brouwer's Influence on Rembrandt,' *Art Quarterly*, IV (1941), pp. 40 ff.

1a. Benesch (II, A12) does not accept this drawing but calls it 'one of the most outstanding works of the School'. It is accepted by Hofstede de Groot (1123), Lippmann (III, 173), C. Neumann (*Rembrandts Handzeichnungen*, Nr. 8), Hind (29), and S. Slive (new edition of Lippmann). See also my review of the Benesch Catalogue (*The Art Bulletin*, March, 1956, p. 70).

2. If this drawing is only a copy, as Kruse assumes, it must be a fairly reliable one, showing at least the character of a first draft for such a large painting (John Kruse, *Die Zeichnungen Rembrandts im National Museum zu Stockholm*, The Hague, 1920, p. 48).

2a. See Chapter VII, note 8b (p.364).

2b. The *Beggar Woman and Child* (fig. 211) was stolen from the Fogg Art Museum in 1937.

3. *Art Bulletin*, XXVI (1944), 246 ff. Dr. W. R. Valentiner kindly sent me the manuscript of his forthcoming article, to be published in the *Art Quarterly*, on Rembrandt's conception of historical portraiture. Here he suggests a new interpretation of the *Polish Rider*, identifying him as Gijsbrecht van Amstel, the medieval Dutch hero.

4. Valentiner says 'perhaps a copy', while Felix Becker, obviously following Hofstede de Groot, publishes the drawing as an original (*Handzeichnungen holländ. Meister aus der Slg. H. de Groot im Haag*, Neue Folge, 1923, pl. 26). Both authors date the drawing too early, relating it to the etching of 1639, *Death Appearing to a Wedded Couple* (H. 165), while it clearly shows the draughtsmanship of the fifties. If it is a copy, it reproduces faithfully a Rembrandt original of that period.

5. Rembrandt's inventory of 1656 (Urk. 169, No. 239) listed 'een boeck, vol teeckeninge van Rembrandt gedaen, bestaende in mans en vrouwe; naekt sijnde' (a book full of drawings of nudes, male and female, by Rembrandt). See Hofstede de Groot in *Bredius Feest-Bundel*, pp. 79 ff.

6. The drawing from the Heseltine Collection, which was reproduced as fig. 224 in the first edition, is now replaced by the drawing of the male nude in the Albertina, an uncontested original and a preliminary study for the etching H. 222 (fig. 223).

7. See Valentiner, *Nicolaes Maes*, pp. 20 ff.

8. See Valentiner, 'Rembrandts Tierstudien', in *Rembrandt und seine Umgebung*, pp. 147 ff. Rembrandt's inventory of 1656 (Urk. 169, No. 249) listed 'een cunstboeck, vol teeckeninge van Rembrant, bestaende in beesten nae 't leven' (a book full of drawings by Rembrandt, of animals from life).

9. Neumann, *Rembrandt*, I, 229 ff.

10. *Kunstchronik*, N.F., XXX (1918), 3 ff.

11. See Bernard Lemann in the *Bulletin of the Fogg Art Museum*, VI (1936), 13 ff.

12. E. F. Gersaint, *Catalogue raisonné . . . avec les augmentations nécessaires par les sieurs Helle et Glomy* (Paris, 1751).

13. Pierre Yver, *Supplément au catalogue raisonné de MM. Gersaint, Helle et Glomy* (Amsterdam, 1756).

13a. See in particular Ludwig Münz, *The Etchings of Rembrandt*, No. 275, vol. II, p. 117.

14. Urk. 346

15. Weisbach, *Rembrandt*, p. 573.

16. Martin Bojanowski, 'Das Anagramm in Rembrandts *Faust*', *Deutsche Vierteljahresschrift für Literaturwissenschaft und Geistesgeschichte*, XVI (1938), 527 ff. and XVIII (1940), p. 467. See also E. Kieser, in *Deutsche Vierteljahresschrift*, XVIII (1940), p. 112.

17. H. M. Rotermund, 'Untersuchungen zu Rembrandts Faustradierung', *Oud Holland*, LXXII (1957), 151 ff.

18. It is clear that the representation alludes to the union of the Dutch cities in their struggle against a common enemy, Spain. Schmidt-Degener (*Onze Kunst*, XXI, 1912) suggested that the picture represents a project for an over-mantel in the great room of the Cloveniersdoelen and that it was meant to be an allegorical glorification of Amsterdam's civic military organizations. Another suggestion (Jan Six, *Onze Kunst*, XXXIII, 1918, p. 141; also Weisbach, *Rembrandt*, p. 326 ff., who modifies Six's interpretation) is that this oil sketch had been commissioned by Prince Frederick Henry and that the subject alludes to the desirability of a strong national leadership under the House of Orange, with the specific hint that the united country should offer the throne of the States to Frederick Henry's son and successor. For a still different interpretation see Clara Bille, 'Rembrandts Eendracht van het Land,' *Oud Holland*, LXXI (1956), 25 ff.

19. For the influence of Rubens on the composition of the *Rape of Proserpina* see J. L. van Rijckevorsel, *op. cit.*, p. 97, and Emil Kieser ('Über Rembrandts Verhältnis zur Antike', *Zeitschrift für Kunstgeschichte*, X, 1941–2, p. 13). Though the difference is great, and Rembrandt transformed the Rubens composition considerably, there can be little doubt that he was familiar with Pieter Soutman's etching after the Rubens painting.

20. S. Rosenthal in *Jahrbuch für Kunstwissenschaft*, V (1928), p. 105.

21. Weisbach, *Rembrandt*, p. 242.

22. W. Niemeyer, in *Repertorium für Kunstwissenschaft*, LII (1931), 58 ff.

22a. See Clothilde Brière-Misme, 'La Danaë de Rembrandt et son Véritable Sujet', *Gazette des Beaux-Arts*, XXXIX (1952), 305 ff., XLI (1953), 27 ff., XLII (1953), 291 ff., XLIII (1954), 67 ff.

23. E. Panofsky, in *Oud Holland*, L (1933), 193 ff.

24. Bredius, in *Oud Holland*, XXVII (1908), 222. Neumann, *Rembrandt*, II, 444.

24a. The drawing was published as a Rembrandt by K. Bauch (*Der junge Rembrandt*, p. 58) but is also given to Bol (Lugt, Lütjens). Even if it is a Bol it most probably reflects a Rembrandt composition, but I believe it is a very hasty sketch by the master himself.

25. The etchings of the *Sacrifice of Abraham* (H. 283) and *Christ at Emmaus* (H. 282).

26. Panofsky, in *Oud Holland*, L (1933), 210.

27. I owe this information to Julius Held's lecture on the origin of the *Flora* motif, delivered at the meeting of the College Art Association in New York in 1946. See also the comments of Emil Kieser ('Über Rembrandts Verhältnis zur Antike', *Zeitschrift für Kunstgeschichte*, X, 1941–2, p. 138).

28. *Bollettino d'Arte*, X (1916), 100 ff.; also G. J. Hoogewerff, in *Oud Holland*, XXXV (1917), 129 ff.; Corrado Ricci, *Rembrandt in Italia* (Milan, 1918); H. Schneider, in *Kunstchronik*, n.f., XXX (1918), 69 ff.

29. The translation of this and the following passages from the Ruffo documents by Ruth S. Magurn.

30. Jakob Rosenberg in *The Art Quarterly* (Spring, 1944), pp. 129 ff. It may be added that this Guercino drawing was copied in an engraving by G. Zaoli in the late eighteenth century, when it was in the collection of Count Cesare Massimiliano Gini. See Augusto Calabi, *La Gravure Italienne au XVIIIième Siècle* (Paris, 1931), p. 61 and pl. LXXXI.

31. The closest resemblance among the known busts of Homer occurs in the one in Naples. See Schmidt-Degener in *Bredius Feest-Bundel*, pp. 15 ff.

31a. It will be of interest to note that Rembrandt used for the Aristotle the same model as for his portrait of a Rabbi in the National Gallery, London (Br. 283), and for the *Bearded Man* in the Hermitage (Br. 309). See J. Rosenberg, *Bulletin of the California Palace of the Legion of Honour*, February 1949, p. 87.

32. H. Voss, *Die Malerei des Barock in Rom* (Berlin, 1924), pl. 286.

33. *Bollettino d'Arte*, X (1916), 186; *Oud Holland*, XXXV (1917), 144, 148.

33a. W. Stechow (*The Art Bulletin*, Sept., 1950, pp. 254–55) has rightly criticized my previous interpretation of the picture. In his article 'Lucretia Statua' (*Essays in honor of Georg Swarzenski*, Chicago, 1951, p. 125) he has pointed to the possible connexion of the Washington painting with the Marcantonio engraving of this subject.

34. *Inwijdinge van 't Stadhuis t' Amsterdam.*

35. Flink died on February 2, 1660. Concerning his sketches see H. Schneider in *Oud Holland*, XLIII (1925), 265 ff.

36. Urk. 253. For the entire history of the *Civilis* painting see Neumann, *Aus der Werkstatt Rembrandts* (Heidelberg, 1918), pp. 1 ff., also Schmidt-Degener, *Rembrandt und der holländische Barock* (Leipzig, 1928), pp. 31 ff. Valuable new information is contained in the articles of a special issue on the Julius Civilis picture in *Konsthistorisk Tidskrift*, XXV (1956).

37. The other drawings in Munich, which have also been considered preliminary studies, are not convincing (see note on Val. 588). Perhaps HdG. 412 is by Rembrandt's own hand, but it is mutilated and of little help for the interpretation of the final work. See Cornelius Müller, in *Konsthistorisk Tidskrift*, XXV (1956), pp. 1 ff.

38. Neumann, *Aus der Werkstatt Rembrandts*, pp. 34 ff.

39. According to Arnoldus Noach, in *Oud Holland*, LVI (1939), 145-157, the changes asked of Rembrandt by the town authorities were necessitated by architectural alterations rather than by objection to his style; and after Rembrandt had made a sketch (HdG. 409) complying with these alterations, the picture was returned to him because his charges for this additional work were too high. Another theory is offered by H. van de Waal, in *Oud Holland*, LVI (1939), pp. 49-65. This author assumes an influence upon the Town Hall series by Tempesta's etchings after van Veen, and suggests that Rembrandt's work was

rejected because he ignored this model, against the wishes of the Burgomasters of Amsterdam. See the report on this controversy by W. Stechow in the *Art Bulletin*, XXIII, No. 3 (1941), pp. 227, 228.

CHAPTER VI. REMBRANDT IN HIS CENTURY

1. We use the term 'Baroque' here in its broadest sense, meaning the whole of seventeenth-century art, not excluding the classicistic trends within that period. This is possible, since Baroque features are found throughout the century, though in varying degree. In other parts of the book, however, we use 'Baroque' in the more specific sense, that is, Baroque as opposed to Classicism. We hope that this rather loose and flexible application of the term (somewhat common in art history) will not confuse the reader. Up to now, better words have not been found to define either the broad meaning of the term, embracing the whole century, or the more specific meaning that signifies only certain characteristic features within this period.

2. Fromentin called Rembrandt 'the least Dutch among the Dutch painters'. Alois Riegl expressed the same idea somewhat differently in describing him as 'the greatest Romanist among the Dutch of the seventeenth century'. See Weisbach, *Rembrandt*, p. 595.

3. Rembrandt's predilection for excessive Baroque ornamentation (*Ohrmuschelstil*) may also be mentioned in this connexion. Neumann, *Rembrandt*, II, 758 ff., devotes to this feature an interesting study.

4. Frank J. Mather, Jr., *Western European Painting of the Renaissance* (New York: Holt, 1939), p. 475, calls Rembrandt 'the first rebel genius in painting, the first painter of the modern sort'.

5. Paul Chantelou, *Journal de voyage du Cavalier Bernin en France* (Paris, 1885); Filippo Baldinucci, *Vita des Giovanni Lorenzo Bernini, mit Übersetzung und Kommentar von Alois Riegl* (Vienna, 1912).

6. G. P. Bellori, *Vite de' pittori, scultori e architetti moderni* (Rome, 1672); André Félibien, *Entretiens sur les vies et les ouvrages des plus excellens peintres anciens et modernes* (1st ed., pt. IV, Paris, 1685); *Correspondance de Nicolas Poussin*, edited by Jouanny (Paris, 1911).

7. *Correspondance de Rubens* (*Codex Diplomaticus Rubenianus*), edited by C. Ruelens and Max Rooses, 6 vols. (Antwerp, 1887–1909).

8. Urk. 329; also J. von Sandrart, *Rembrandt, Selected Paintings*, ed. Borenius, p. 21.

9. Rotterdam, 1678 (Urk. 337).

10. 'Dat hy niet alleen schijne de konst te beminnen, maer dat hy in der daet, in de aerdicheden der bevallijke natuur uit te beelden, verlieft is.'

11. In 1641 Philips Angel, in a speech delivered in Leyden on St. Luke's Day (published as *Philips Angels Lof der Schilder Konst*, Leyden, 1642), praised Rembrandt's *Marriage of Samson* because it showed intimate knowledge of the story as well as the artist's own thoughtfulness (Urk. 91).

12. Urk. 338: 'De rechte meesters brengen te weeg, dat haer geheele werk eenwezich is . . . Rembrandt heeft dit in zijn stuk op den Doele tot Amsterdam zeer wel, maer na veeler gevoelen al te veel, waergenomen.'

13. J. von Sandrart, *Rembrandt, Selected Paintings*, edited by Borenius, p. 21.

14. See Hofstede de Groot, 'Rembrandt onderwijs aan zijne leerlingen', *Bredius Feest-Bundel*, pp. 74 ff.; also G. Falck, in *Jahrbuch der preussischen Kunstsammlungen*, XLV (1924), 192 ff.

15. Houbraken, *op. cit.*, p. 25.

16. The German painter, Mathias Scheits, who had studied in Holland under Philips Wouwerman, wrote in 1679 some notes about deceased contemporary masters in his copy of van Mander's *Schilderboek*. The remark about Rembrandt contains the following passage which confirms the decline of the artist's reputation toward the end of his life: 'Rembrandt . . . wass achtbaer ende groht van aensien door sein konst geworden, het welck doch in 't lest mit hem wat verminderde . . .' (Urk. 348).

17. The keen French critic, Roger de Piles, went perhaps farthest in the positive appreciation of Rembrandt's art.

18. The term 'historical' painting included Biblical subjects, and, according to the Classicists, ranked highest among the various categories of subject matter. See Félibien, *op. cit.*, and Rensselaer W. Lee, 'Ut Pictura Poesis', *Art Bulletin*, XXII (1940), 213.

19. Baldinucci, *op. cit.*, p. 23: 'But after it had become commonly known that whoever wanted to be portrayed by him had to sit to him for some two or three months, there were few who came forward. The cause of this slowness was that, immediately after the first work had dried, he took it up again, repainting it with great and small strokes, so that at times the pigment in a given place was raised more than half the thickness of a finger. Hence it may be said of him that he always toiled without rest, painted much and completed very few pictures.'

Houbraken, *op. cit.*, p. 25: 'But it is to be regretted that, with such a bent towards alterations or easily driven towards something else, he should have but half carried out many of his pictures, and even more of his etchings, so that only the completed ones can give us an idea of all the beauty that we would possess from his hand if he had finished everything the way he had begun it.'

20. Andries Pels, in his *Gebruik en misbruik des tooneels* (Amsterdam, 1681), devotes a long passage to Rembrandt, whom he holds up as a warning to those who tend to depart from the traditional paths of art. He ends his criticism with the following lines, lamenting the waste of Rembrandt's genius, his neglect of principles and his excessive independence:

> 'What a loss it was for art that such a master hand
> Did not use its native strength to better purpose.
> Who surpassed him in the matter of painting?
> But oh! the greater the talent, the more numerous the aberrations
> When it attaches itself to no principles, no rules,
> But imagines it knows everything of itself'.

See Urk. 352. English translation, *Rembrandt, Selected Paintings*, ed. by Borenius, p. 26.

21. Johan Huizinga, *Holländische Kultur des siebzehnten Jahrhunderts* (Jena: Diederichs, 1933), pp. 57-58.

22. See Wolfgang Stechow's article on 'The Myth of Philemon and Baucis in Art', *Journal of the Warburg Institute*, IV, 1940-2, 103 ff. Emil Kieser (*op. cit.*, pp. 129 ff.), gives an account of Rembrandt's dealing with classical motives. He also stresses the fact that Rembrandt endows his classical subjects with a Biblical flavour.

23. See J. L. van Rijckevorsel, *Rembrandt en de Traditie*.

24. See Heinrich Wölfflin's *Principles of Art History* (7th ed., New York: Holt, 1932). This author uses the terms 'absolute' versus 'relative' clarity, and 'multiplicity' versus 'unity', to distinguish between the Renaissance and Baroque Styles.

25. Book IV, particularly lines 272-365.

26. *Oeuvres de Blaise Pascal* (Paris, 1904-14), XIII, *Pensées*, 277, 278, XIV, *Pensées*, 586.

Another passage of particular interest is the following (*ibid.*, XIII, 525): 'Les philosophes ne prescrivaient point des sentiments proportionnés aux deux états. Ils inspiraient des mouvements de grandeur pure, et ce n'est pas l'état de l'homme. Ils inspiraient des mouvements de bassesse pure, et ce n'est pas l'état de l'homme. Il faut des mouvements de bassesse, non de nature, mais de pénitence; non pour y demeurer, mais pour aller à la grandeur. Il faut des mouvements de grandeur, non de mérite, mais de grâce, et après avoir passé par la bassesse.' See also the chapter on the Jews and the Christians beginning with the sentence, 'Pour montrer que les vrais Juifs et les vrais Chrétiens n'ont qu'une même religion' (*ibid.*, XIV, 610).

27. *De Gids*, LXXXIII (1919), pt. I, p. 222. German edition: *Rembrandt und der holländische Barock* (Leipzig, 1928). See the review by Hans Jantzen in *Deutsche Literaturzeitung*, Feb. 1, 1930, pp. 226 ff.

28. 'Hollands Wesen spricht aus dem Besten, das Lukas van Leyden schuf und das hat etwas Scheues und Verschlossenes' (*Rembrandt und der holländische Barock*, p. 35).

29. 'Von Rembrandts Hand würde die Folge riesenhafter Kompositionen die Fortsetzung des siebzehnten Jahrhunderts zu Raffaels Stanzen gewesen sein . . . Mit Rembrandt erscheint der Letzte der Renaissancisten, der Letzte der grossen universalen Meister . . . Rembrandt erweist Europa den Dienst, die Renaissance aus der Barockphase zu retten, in der sie im Begriff war zu versanden' (*ibid.*, pp. 36, 43). For a discussion of Rembrandt's relationship to Classicism see also Ludwig Münz, 'Rembrandts Altersstil und die Barockklassik', *Jahrbuch der kunsthistorischen Sammlungen in Wien*, N.F., IX, 1935, 183 ff.

30. Huizinga, *op. cit.*

31. 'Niemals predigt er Religion. Seine Darstellung der heiligen Geschichten bringt einen gewissen Rationalismus' (*ibid.*, p. 45). Later, in his introduction to the catalogue of the 1935 Rembrandt exhibition (Amsterdam: Rijksmuseum, 1935), Schmidt-Degener slightly modified his point of view without any basic changes.

CHAPTER VII. STYLE AND TECHNIQUE

1. The author has treated this subject also in *Technical Studies*, VIII (1940), 193 ff.

1a. Heinrich Wölfflin, *op. cit.*

2. Max Doerner, *The Materials of the Artist and Their Use in Painting* (New York: Harcourt, 1934), pp. 365 ff.

3. A. P. Laurie, *A Study of Rembrandt and the Paintings of His School by Means of Magnified Photographs* (London: Walker, 1930), hereafter referred to as Laurie I; A. P. Laurie, *The Brushwork of Rembrandt and His School* (London: Oxford University Press, 1932), hereafter referred to as Laurie II.

4. Hans Hell, 'Die spaeten Handzeichnungen Rembrandts', *Repertorium für Kunstwissenschaft*, LI (1930), 4 ff. and 92 ff.

5. For a discussion of the X-ray investigation of Rembrandt's technique see the article by Alan Burroughs, 'New Illustrations of Rembrandt's Style', in the *Burlington Magazine*, LIX (1931), 3 ff. Since then many X-ray investigations have been published, prominent among them being A. van Schendel's article on the 'Syndics' (*Oud Holland*, LXXI, 1956, 51 ff.), and the Louvre publication, *Rembrandt, Etude photographique et radiographique* (Paris, 1955). See also C. Müller-Hofstede's account of the technical investigation of the newly discovered *Self-portrait* by Rembrandt, now in the Stuttgart State Gallery (*Pantheon*, 1963, pp. 65 ff.).

6. G. P. Bellori, *Vite de' pittori, scultori e architetti moderni* (Rome, 1672), I, 204 ff., 211. Translation quoted from A. K. McComb, *The Baroque Painters of Italy* (Cambridge: Harvard University Press, 1934), p. 37.

7. Caravaggio's authorship has recently been questioned. Even if the painting is an old copy, as Matteo Marangoni considers it (*Boll. d'Arte*, N.S. II, 1922–3, p. 220), it is a typical example of the Caravaggio style. Hermann Voss (*Die Malerei des Barock in Rom*, Berlin, 1924, p. 440) assumes that it is the original picture documented by Bellori.

8. Arthur von Schneider, *Caravaggio und die Niederländer* (Marburg: Seminar Verlag, 1933), pp. 67 ff. and J. R. Judson, *Gerrit van Honthorst* (The Hague, 1959).

8a. The earliest known example of Honthorst's influence is Rembrandt's *Feast of Esther* (Br. 631); see above, footnote 6a of the chapter 'Life', and the comments of Seymour Slive in 'The Young Rembrandt', *Allen Memorial Art Museum Bulletin*, Oberlin College, Spring, 1963, pp. 120 ff.

8b. Recent investigation, for which I am indebted to Mr. Theodore Rousseau of the Metropolitan Museum, has shown that the signature and date are not authentic, and that the attribution to Rembrandt is not fully convincing. The comparative weakness of the Nicolaes Maes in regard to the spatial definition of the form remains, however, true.

9. See in particular C. J. Holmes, *loc. cit.* (note 38, Chapter II).

10. Arnold Houbraken, *De Groote Schouburgh*, III, 207 ff. Translation by R. S. Magurn.

11. As early a critic as von Sandrart spoke in Rembrandt's praise with his distinction between a painter and a dyer. Roger de Piles repeated this remark, presenting it as coming from Rembrandt: 'Et comme on luy reprochoit un jour la singularité de sa manière d'employer les couleurs qui rendoient ses tableaux raboteux, il répondit, qu'il étoit Peintre, non pas Teinturier' (Urk. 381).

12. Most of these and the following observations are found in Laurie II.

13. Laurie II, 7.

14. Laurie I, 13: 'Hals's quick, nervous, angular strokes, full of vitality, are so different from Rembrandt's thoughtful, patient manner of producing far more subtle effects, suggesting a deliberate slowness of execution which has been rapid and decisive in practice. Frans Hals paints with sharp, acute angles, with thin, slick paint, Rembrandt in curves with elaborate loaded impasto.'

15. Bredius and others accept the painting as a Rembrandt.

16. Baldinucci, *op. cit.*, p. 23; also Urk. 360.

17. See Chapter V, p. 281.

18. See Ludwig Burchard, *Die holländischen Radierer vor Rembrandt* (Berlin, 1927).

19. A small steel rod of square or lozenge-shaped section, sharpened obliquely.

20. In order to obtain the desired calligraphic effect, Callot chose a special type of etching needle, the so-called *échoppe*, which has a broader end, sharpened in an oval section. By holding its point at varying angles, he was able to vary the width of the line and to give it the swelling character which is typical of the engraved line. See Arthur M. Hind, *A History of Engraving and Etching*, 3rd edition (Boston, 1927), pp. 6 and 160; also Ludwig Burchard, *op. cit.*, p. 10.

21. The suggestion of Weisbach (*Rembrandt*, p. 233) that Rembrandt intended to represent a 'Sibyl' seems plausible.

22. These and the following details come from William M. Ivins, Jr., *The Unseen Rembrandt* (New York: Metropolitan Museum of Art, 1942), a publication showing characteristic details of Rembrandt's work in clear and effective magnifications.

As for the date of the *Presentation in the Temple* the opinions vary between 1654 (Hind 279), 1657-8 (Benesch 1032 and Münz 240), and the early 1660's (Valentiner, *Kunst-chronik*, N.F. XXXII, 1920-1, p. 215, and Stechow, *Print Collectors' Quarterly*, XXVII, 1940, 365 ff.). The late drawing in Rotterdam (Val. 319) seems to be a preparatory sketch and justifies, I believe, a date in the early 1660's.

23. There exists a document (see A. Bredius, *Oud Holland*, XXVII, 1909, p. 238) that, only a few months before his death, Rembrandt received a batch of copper plates from the artist-dealer Dirck van Cattenburgh on which to etch a 'Passion' series.

24. Urk. 381, paragraphs 12 and 13.

25. Frits Lugt, *Musée du Louvre, Inventaire général des Dessins des Ecoles du Nord, Ecole Hollandaise, III, Rembrandt* (Paris, 1933), pp. ix f.

26. For a more complete survey of Rembrandt's techniques see the publication by Otto Benesch, *Rembrandt, Choix de Dessins* (Paris: Editions Phaidon, 1947); also the informative study on the style and technique of Rembrandt's late drawings by Hans Hell, *op. cit.*, of considerable interest for the specialist.

27. See Benesch, *Rembrandt, Choix de Dessins*, pl. 37 ('ca. 1632-4').

28. *Musée du Louvre, Inventaire, Ecole Hollandaise*, III, pl. 1111 ('1638-42').

29. Often these additions betray themselves as being later by the fact that they were done with 'sepia', a medium which was unknown before the second half of the eighteenth century. See J. Meder, *Die Handzeichnung* (Vienna, 1919), p. 70.

30. In the reproduction in the *Klassiker der Kunst* volume (Val. 411) the later brushwork has been covered up by retouches.

31. See Frits Lugt, *Mit Rembrandt in Amsterdam*, pp. 12 ff. Here a reproduction of the drawing and a photograph of the actual tower are side by side. Benesch (A62) considers this drawing a pupil's work, following J. Q. van Regteren Altena (*Maanblad voor Beeldende Kunsten*, II Jaargang, Amsterdam, 1925, pp. 170-172), who suggested the authorship of Abraham Furnerius. Even for this gifted pupil the drawing seems too good. Frits Lugt's dating in the 1640's (1640-50) was accepted by E. Haverkamp Begemann (Rembrandt Exhibition of 1956, cat. No. 143) and is probable. For similar drawings see Benesch 788 and 825. But a dating in the early 1650's is not impossible, because not all the architectural drawings of that time show the more typical parallel shading. A similar linear treatment is found in Benesch 1278, which is signed and dated 1652.

SELECTED BIBLIOGRAPHY

BIBLIOGRAPHIES

Benesch, Otto, *Rembrandt, Werk und Forschung* (Vienna: Gilhofer & Ranschburg, 1935), pp. 72 ff.

Van Hall, H., *Repertorium voor de Geschiedenis der Nederlandsche Schilder- en Graveerkunst* (The Hague: Martinus Nijhoff, 1936), pp. 528-591 (a continuation of Van Hall's bibliography covering the years 1933-43 is in progress and will be issued in due time).

The Bibliography of the Rijksbureau voor Kunsthistorische Documentatie, The Hague, 1943– (a periodical bibliography on Dutch and Flemish painting and graphic art, with sections on Rembrandt).

The Art Index, 1929– (New York: H. W. Wilson Co., 1933–) (sections referring to Rembrandt).

SELECTED LITERARY SOURCES

1629-31: Constantyn Huygens, *Autobiographie,* published by A. Worp in *Oud Holland,* IX (1891), 106-136, 307 ff.

1675: Joachim von Sandrart, *Teutsche Academie der Bau-, Bild- und Mahlerey-Künste,* Nuremberg, p. 326a.

1678: Samuel van Hoogstraten, *Inleyding to de Hooge Schoole der Schilderkonst,* Rotterdam.

1685: André Félibien, *Entretiens sur les vies et sur les ouvrages des plus excellens peintres anciens et modernes,* Paris, IV, 150, 151, 157.

1686: Filippo Baldinucci, *Cominciamento e progresso dell' arte d'intagliare in rame . . .* Florence, p. 78 (E. Michel, *Oud Holland,* VIII, 1890, p. 161).

1699: F. le Comte, *Cabinet des Singularitez,* Paris, III, 334-336.

1699: Roger de Piles, *Abregé de la Vie des Peintres,* Paris, p. 433-438.

1714: Gérard de Lairesse, *Groot Schilderboek,* Amsterdam.

1718: Arnold Houbraken, *De groote Schouburgh der nederlantsche konstschilders en schilderessen,* Amsterdam, I, 254-273.

Seymour Slive, *Rembrandt and his Critics* (The Hague, 1953).

COMPREHENSIVE COMPILATION OF DOCUMENTARY DATA

Hofstede de Groot, Cornelis, *Die Urkunden über Rembrandt (1575-1721),* The Hague, 1906.

MONOGRAPHS

Vosmaer, C., *Rembrandt* (Dutch edition, The Hague, 1868; French edition, The Hague, 1877).

Michel, Emile, *Rembrandt, sa vie, son oeuvre et son temps* (Paris, 1893; English edition, London, 1894).

Bode, Wilhelm, *Rembrandt und seine Zeitgenossen* (Leipzig, 1906; English edition, New York, 1909).

Veth, Jan, *Rembrandt's Leven en Kunst* (Amsterdam, 1906; German edition, Leipzig, 1908).

Holmes, C. J., *Notes on the Art of Rembrandt* (London, 1911).

Neumann, Carl, *Rembrandt*, 2 vols., 4th edition (Munich, 1924).

Weisbach, Werner, *Rembrandt* (Berlin, 1926).

Hind, Arthur M., *Rembrandt* (Cambridge, Mass: Harvard University Press, 1932).

Bauch, K., *Die Kunst des jungen Rembrandt* (Heidelberger kunstgeschichtliche Abhandlungen 14, 1933).

Benesch, Otto, article on Rembrandt in Thieme-Becker, *Allgemeine Lexikon der bildenden Künstler*, vol. XXVIII, 1935.

Bauch, K., *Der frühe Rembrandt und seine Zeit* (Berlin, 1960).

PAINTINGS

Bode, Wilhelm, and Cornelis Hofstede de Groot, *The Complete Work of Rembrandt*, 8 vols. (Paris, 1897–1906).

Hofstede de Groot, Cornelis, *A Catalogue Raisonné of the Works of the Most Eminent Dutch Painters of the Seventeenth Century*, based on the work of John Smith; translated by Edward G. Hawke; vol. VI, *Rembrandt and Maes* (London, 1916).

Valentiner, W. R., *Rembrandt, Des Meisters Gemälde; Klassiker der Kunst* (3rd edition, Stuttgart and Berlin, 1908).

Valentiner, W. R., *Rembrandt, Wiedergefundene Gemälde (1910–1922); Klassiker der Kunst* (2nd edition, Berlin and Leipzig, 1923).

Valentiner, W. R., *Rembrandt Paintings in America* (New York: S. W. Frankel, 1932).

Borenius, Tancred, ed., *Rembrandt, Selected Paintings* (London: Phaidon Press, 1942).

Bredius, Abraham, ed., *The Paintings of Rembrandt*, Phaidon Edition (New York: Oxford University Press, 1942).

ETCHINGS

Bartsch, Adam, *Catalogue raisonné de toutes les estampes qui forment l'oeuvre de Rembrandt et ceux de ses principaux imitateurs*. 'Composé par Gersaint, Helle, Glomy et Yver. Nouvelle édition entièrement refondue, corrigée et considérablement augmentée' (Vienna, 1797).

Rovinski, Dmitri, *L'oeuvre gravé de Rembrandt*, text, 1 vol.; plates, 3 vols. (St. Petersburg, 1890).

Von Seidlitz, Woldemar, *Die Radierungen Rembrandts mit einem kritischen Verzeichnis und Abbildung sämmtlicher Radierungen* (Leipzig, 1922).

Hind, Arthur M., *A Catalogue of Rembrandt's Etchings Chronologically Arranged and Completely Illustrated*, 2 vols., 2nd edition (London, 1923).

De Bruijn, J., *Catalogus van de Verzameling Etsen van Rembrandt in het bezit van J. de Bruijn en J. G. de Bruijn-van der Leeuw* (The Hague, 1932).

Münz, Ludwig, *The Etchings of Rembrandt*, 2 vols. (London, 1952).

Biörklund, George, *Rembrandt's Etchings, True and False* (Stockholm, London, New York, 1955).

DRAWINGS

Hofstede de Groot, Cornelis, *Die Handzeichnungen Rembrandts* (Haarlem, 1906).

Lippmann, F., and C. Hofstede de Groot, *Original Drawings by Rembrandt Harmensz van Ryn*. Series I. 1-200 (4 portfolios), 1888–1892; Series II. 1-100 (2 portfolios), 1898, 1901; Series III. 1-100 (2 portfolios), 1903, 1906; Series IV. 1-100 (2 portfolios), 1909, 1911 (London and Berlin). New edition with critical comments by Seymour Slive (New York, 1964).

Valentiner, W. R., *Die Handzeichnungen Rembrandts; Klassiker der Kunst*, 2 vols. (New York: E. Weyhe, 1925, 1934).

Hind, Arthur M., *Catalogue of Drawings by Dutch and Flemish Artists Preserved in the Department of Prints and Drawings in the British Museum*, I, *Drawings by Rembrandt and His School* (London, 1915).

Kruse, John, *Die Zeichnungen Rembrandts und seiner Schule im National-Museum zu Stockholm* (The Hague, 1920).

Bock, Elfried, and Jakob Rosenberg, *Staatliche Museen zu Berlin, Die niederländischen Meister; beschreibendes Verzeichnis sämtlicher Zeichnungen* (Berlin, 1930).

Lugt, Frits, *Musée du Louvre, Inventaire général des dessins des écoles du nord, Ecole Hollandaise*, III, *Rembrandt et ses élèves* (Paris, 1933).

Henkel, M. D., *Catalogus van de nederlandsche teekeningen in het Rijksmuseum te Amsterdam*, I, *Rembrandt en zijn School* (The Hague: Algemeene Landsdrukkerij, 1942).

Benesch, Otto, *Rembrandt, Choix de Dessins* (Paris: Editions Phaidon, 1947).

Benesch, Otto, *The Drawings of Rembrandt*, 6 vols. (London, 1954-7).

NOTE ON THE PROBLEM OF AUTHENTICITY

THE Concordance of Paintings which appeared in the first edition is here replaced by the following brief lists, indicating the opinion of this author as to authenticity:

A. From the Bredius catalogue, *The Paintings of Rembrandt*, Phaidon Edition (New York: Oxford University Press, 1942), the following paintings are the only ones not accepted as authentic. In those cases where the author has not seen the original an asterisk* is added.

Bredius:

14*	127*	209	260	438	581	636*
40	136	220	273*	506	582	637
46	137	233	386	540	595	
67	147	248	421	541	597	
72*	151	254	429	556	606	
75	153*	259*	436	580	635	

B. The Bredius catalogue has omitted (as unauthentic) a number of paintings included in the *Klassiker der Kunst: Rembrandt, Des Meisters Gemälde*, 3rd edition by W. R. Valentiner (Stuttgart and Berlin, 1908), and *Klassiker der Kunst* (Supplement): *Rembrandt, Wiedergefundene Gemälde (1910–22)*, by W. R. Valentiner, 2nd edition (Berlin and Leipzig, 1923). The author agrees with these omissions except for the following numbers, which indicate paintings here considered authentic. In this list also an asterisk is added when the author has not seen the original.

Klassiker der Kunst:

51 left	217	355 left
52	251 left	355 right
111 top	270 left	356 left
124	270 right	363 left*
203 right	313	389
205*	322*	444 right

Klassiker der Kunst (*Suppl.*)

14	62	103*
17	69*	112
24*	83*	115
28*	97	
33*	98*	
45	102*	

INDEX OF WORKS BY REMBRANDT
MENTIONED IN THE TEXT

The Index of Works is arranged as follows:

A. PAINTINGS

1. PORTRAITS
 a. Self-portraits
 b. Rembrandt's family
 c. Known persons
 d. Unknown men
 e. Unknown women
 f. Group portraits

2. LANDSCAPES

3. BIBLICAL SUBJECTS
 a. Old Testament
 b. New Testament
 c. Saints

4. GENRE, MYTHOLOGY AND HISTORY

B. ETCHINGS

(Arranged according to Hind's catalogue numbers)

C. DRAWINGS

1. PORTRAITS

2. LANDSCAPES

3. BIBLICAL SUBJECTS

4. GENRE, MYTHOLOGY AND HISTORY

A. PAINTINGS

I. PORTRAITS

a. Self-portraits

Self-portrait in the studio, Boston, Museum of Fine Arts 309, *fig. 255*

Self-portrait, 1630, Aerdenhout, I. H. Loudon Collection 39–40, *fig. 34*

Self-portrait, 1634, Berlin-Dahlem, Staatliche Museen 40, *fig. 35*

Self-portrait with Saskia, Dresden, Museum, *fig. 21*

Self-portrait with a dead bittern, 1639, Dresden, Museum 265

Self-portrait, 1640, London, National Gallery 40, *fig. 36*

Self-portrait, 1650, Washington, National Gallery 42–45, 53, 317, *fig. 37*

Self-portrait, 1658, New York, Frick Collection 47, 287, 318, *fig. 40*

Self-portrait, 1659, Washington, National Gallery 47, *frontispiece*

Self-portrait, London, National Gallery 50, *fig. 42*

Self-portrait, Aix-en-Provence, Museum 51–52, *fig. 43*

Self-portrait, Stuttgart, State Gallery, 363

Self-portrait, 1660, New York, Metropolitan Museum 98

Self-portrait at an easel, 1660, Paris, Louvre 47–49, 287, *fig. 41*

Self-portrait, 1661, Amsterdam, Rijksmuseum 52–53, 287, *fig. 44*

Self-portrait, Vienna, Museum 47, *fig. 39*

Self-portrait, Florence, Uffizi 53–54, *fig. 45*

Self-portrait, Cologne, Museum 53–55, *fig. 46*

Self-portrait, 1669, The Hague, Mauritshuis 55, *fig. 30*

b. Rembrandt's Family

Rembrandt's father, The Hague, Mauritshuis, *fig. 5*

Rembrandt's father, Leningrad, Hermitage, *fig. 11*

Rembrandt's father, Chicago, Art Institute 71, *fig. 60*

Rembrandt's mother, The Hague, Mauritshuis, *fig. 4*

Rembrandt's mother as the prophetess Hannah, 1631, Amsterdam, Rijksmuseum, *fig. 7*

Rembrandt's sister, 1632, Boston, Richard C. Paine Collection, *fig. 10*

Saskia, Kassel, Museum 73, *fig. 62*

Saskia, 1633, Dresden, Museum, *fig. 18*

Saskia as Flora, 1634, Leningrad, Hermitage 72, *fig. 61*

Saskia as Flora, 1635, London, National Gallery 277, *fig. 239*

Hendrickje Stoffels in bed, 164[9], Edinburgh, National Gallery 89, 95, *fig. 83*

Hendrickje Stoffels at a window, Berlin-Dahlem, Staatliche Museen 95–96, 318, *fig. 84*

Hendrickje Stoffels, Munich, Alte Pinakothek 95–96, *fig. 82*

Hendrickje Stoffels as Flora, New York, Metropolitan Museum 97, 277, *fig. 240*

Hendrickje Stoffels, Paris, Louvre 95, *fig. 28*

Hendrickje Stoffels as Venus, Paris, Louvre 97, 348, *fig. 85*

Hendrickje Stoffels, 1660, New York, Metropolitan Museum 98, *fig. 86*

Titus at a desk, 1655, Rotterdam, Boymans-van Beuningen Museum 101, *fig. 87*

Titus, London, Wallace Collection 102–103, *fig. 89*

Titus reading, Vienna, Museum 102–103, *fig. 90*

Titus, 1660, Baltimore, Museum 103–104, *fig. 91*

Titus, Amsterdam, Rijksmuseum (on loan from the Louvre) 104, *fig. 92*

Man with a gilt helmet (Rembrandt's brother?), Berlin-Dahlem, Staatliche Museen 106, 317, *fig. 93*

Woman seated in an armchair (wife of Rembrandt's brother?), 1654, Leningrad, Hermitage 106, *fig. 94*

c. Known Persons

Nicolaas van Bambeek, 1641, Brussels, Museum 74–75, *fig. 63*

Agatha Bas, wife of Nicolaas van Bambeek, 1641, London, Buckingham Palace 74–75, *fig. 64*

Dr. Ephraim Bonus, Amsterdam, Rijksmuseum 346

B. ETCHINGS

(Arranged according to Hind's catalogue numbers)

C. DRAWINGS

INDEX OF PERSONS AND PLACES